COLLECTING SHAKESPEARE

Collecting Shakespeare

❧ ❧ ❧

The Story of Henry and Emily Folger

STEPHEN H. GRANT

Johns Hopkins University Press *Baltimore*

This book has been brought to publication with the generous assistance of the Folger Shakespeare Library.

4 6 8 9 7 5 3

Johns Hopkins University Press
2715 North Charles Street
Baltimore, Maryland 21218-4363
www.press.jhu.edu

Library of Congress Cataloging-in-Publication Data

Grant, Stephen H., 1941–
Collecting Shakespeare : the story of Henry and Emily Folger / Stephen H. Grant.
pages cm
Includes bibliographical references and index.
ISBN 978-1-4214-1187-3 (hardcover : alk. paper) — ISBN 978-1-4214-1188-0 (electronic) — ISBN 1-4214-1187-3 (hardcover : alk. paper) — ISBN 1-4214-1188-1 (electronic) 1. Folger, Henry Clay, 1857–1930. 2. Folger, Emily C. J. (Emily Clara Jordan), 1858–1936. 3. Book collectors—New York (State)—Biography. 4. Folger, Henry Clay, 1857–1930—Library. 5. Folger, Emily C. J. (Emily Clara Jordan), 1858–1936—Library. 6. Private libraries—New York (State)—History. 7. Shakespeare, William, 1564–1616—Bibliography. 8. Folger Shakespeare Library—History. 9. Research libraries—Washington (D.C.)—History. I. Title.
PR2933.F64G73 2014
026.8223'3—dc23
2013022682

A catalog record for this book is available from the British Library.

Special discounts are available for bulk purchases of this book. For more information, please contact Special Sales at 410-516-6936 or specialsales@press.jhu.edu.

For Abigail

Contents

Prologue ix
Acknowledgments xv

1 Well Read in Poetry, Fair in Knowledge: *Henry and Emily Form a Team* 1

2 Thou Lovest Me, My Name Is Will: *Smitten by Shakespeare* 27

3 Wise, Circumspect, and Trusted: *Five Decades at Standard Oil* 43

4 Leading on to Fortune: *Henry Invests to Buy the Bard* 65

5 The Hunt Is Up, the Fields Are Fragrant: *Building a Collection* 75

6 Whole Volumes in Folio: *The Ultimate Prize for Collectors* 95

7 What News on the Rialto: *Maneuvers in the Rare Book Market* 108

8 Hotspur and Hal: *Two Henrys Compete* 125

9 A Monument to Gentle Verse: *Designing a Treasure House* 139

10 Dear, Blessed Plot of Land: *The Folgers' Gift to America* 163

Epilogue Praise in the Eyes of Posterity: *The Folger after the Folgers* 187

Appendix: Directors of the Folger Shakespeare Library 207
Notes 209
Bibliography 225
Index 235

The Folger Library was unlike other private libraries assembled during the Gilded Age by peers in the Folgers' social class. It was not a gentleman's library, which includes a wide range of recognized literary masterpieces rather than esoteric volumes or a specialized collection. It was not a cabinet library, a small collection of highly significant titles where complete works from authors give way to a particular subset of volumes. Nor was it a rich man's library, more for show than substance, where sumptuous bindings protect gilt-edged pages, sets of books dwarf single editions, and the browser would not find commonplace editions or a sophisticated range of subjects. For many wealthy peers in the Folgers' milieu, first- or second-generation barons of trade and industry, books mattered for their aesthetic look, as furniture of wealth, not food for the mind.

A century after Thomas Jefferson, Emily and Henry Folger built their library not out of social aspiration but out of a Jeffersonian respect for learning. The third American president drew from his library of English and Continental books on political theory, architecture, and agriculture to write the Declaration of Independence, design the University of Virginia, and develop Monticello's horticulture and vineyards. The Folgers followed his example of developing a scholarly library, whose books would be read and studied with the aim of adding to knowledge. Whereas Jefferson's library represented the Enlightenment in America, the Folgers' reached back further in time to collect Renaissance works. Both assembled their libraries largely of books printed in Europe. Jefferson's 6,487 volumes—in 1814 the largest private library in America—became the seed collection for the Library of Congress. It is more than serendipitous that the two libraries sit across from one another within sight of the Capitol. The Folgers cherished the idea of locating their private and more specialized collection close to—but not as part of—the country's largest public repository.

The Folger Shakespeare Library is a privately endowed research center. Its main users—professors, scholars, graduate students, researchers, and staff—pore over Fol-

ger treasures with the intent of sharing their findings. Long-term, their inquiries advance knowledge through journal articles, books, and lectures that reach educational institutions and the intellectual community at large. Since the Folgers founded it more than eighty years ago, their library has broadened its mandate. The current mission of the Folger Shakespeare Library is

- To preserve and enhance our collection.
- To make our collection accessible to scholars and others who can use it productively.
- To advance understanding and appreciation of Shakespeare's writings and the culture of the early modern world.[1]

Historically, the Folger was, first, a library of research for scholars, and second, a center for education and performance reaching the general public.

❧ The story of the Folgers is a double love story: first, about the love between Henry (1857–1930) and Emily (1858–1936) Folger and, second, about their common love of Shakespeare and his writings. Their story displays a rare single-mindedness of purpose. During their college years, both Emily and Henry fell under the spell of British and American literary giants. Early in their married life, they were particularly attracted to Shakespeare (1564–1616) and his times. They began a collection of antiquarian books and other objects related to the bard from Stratford-upon-Avon. In every phase of developing the collection the couple worked as a team. They remained childless throughout their marriage. A journalist reported that Henry Folger referred to his books as "the boys."[2] The Folgers knew that their collecting obsession turned them into recluses. Such was the price to pay for the enterprise and its lofty goal. They established limits to the time they could spare for family visits. They opened their doors only twice a year, on Thanksgiving and New Year's. Nieces and nephews, grandnieces and grandnephews described with awe and delight these rare occasions. The young visitors were free to run about the Brooklyn house, opening doors on all floors and discovering only books.

I have met some of those grandnieces, now in their eighties. They shared with me recollections of family events at Aunt Emily's in Glen Cove, Long Island. "We sat at a long table. At each place we found a tiny little red book that was a miniature calendar to take home as a present. The menu was always the same. Aunt Emily gave us 'samp,' or corn meal mush. We hated it. But we loved the dessert, ice cream. Every child was expected to recite a poem. Often it was from Robert Louis Stevenson's *A Child's Garden of Verses*. Some of us were quite anxious about it. One recited with gusto 'Horatio at the Bridge.' As a prize Aunt Emily would give each child a book

with five dollars inside. A Thanksgiving gift came in handy for buying Christmas presents. After the meal, we went outside into the backyard. One of us tried to take a shortcut and fell into the goldfish pond. She was embarrassed, wrapped in a heavy blanket, and taken home. After a long walk, everybody stayed for dinner of creamed oysters." Even today one senior child sometimes sends five dollars to another in memory of those early days.

Of most interest to me among items the grandnieces inherited from their parents were a few dozen letters and family photographs. The families had preserved several physical objects, the most striking being sections from Emily's satin wedding dress with Duchesse lace sleeves and buttons down the front, a sterling silver tea set and water pitcher, and a second edition of Louisa May Alcott's *Little Women* (1869). Family also brought out from chests, drawers, and racks Emily's monogrammed facecloth and bathmat, a pewter coaster with golf motif, and an ashtray from the last Folger reunion, August 26–28, 1959, in Nantucket, which gathered 120 family participants. Folgers are still collectors.

After learning of Henry Folger's setting up limits to see family, I was not surprised to find him eschewing social and business engagements. Regretting one more invitation, Folger explained, "For some years I have, under the advice of my physician, excused myself from attending luncheons and other functions, much as I would desire to attend them in many cases, and the result has been quite satisfactory so far as my health and strength are concerned. So I will have to once more excuse myself, apologizing as best I can. I would feel rather disturbed at having to do so were it not that I am devoting all my energies and means in the interests of Shakespeare."[3]

While some people characterized Folger as an obsessed collector, others found him frustratingly elusive. One wrote, "Henry Clay Folger was a shy, taciturn Phi Beta Kappa who lived by three rules: Never tell what you've done, what you are doing, or what you are going to do."[4] Folger was more than reserved; he could be downright secretive. This attribute provided challenges for the researcher.

As one of John D. Rockefeller's right-hand men with Standard Oil, Folger often found his mailbox at 26 Broadway in Manhattan packed with solicitations for financial contributions. A man of few words, he responded generally by a curt, polite letter of apology. When asked to help finance the Shakespeare Memorial Library in Stratford-upon-Avon, however, he hesitated some moments before declining. What wouldn't Folger do for Shakespeare? His reply concealed a confession, a most apt descriptor of Folger's entire adult life: "I started collecting Shakespeare expecting that it would prove an agreeable recreation; it soon became a delightful hobby, but of late I find it rather a tyrannical master."[5] Being a collector can take over one's life. I know that because I am one.

Collectors can be subject to ambush. One day, Rockefeller cornered Folger on the golf course. As they were walking off the green, the titan remarked ever so softly, "Henry, I see from the papers that you just paid $100,000 for a book." Folger abhorred publicity leveled at his book purchases, fearing a lack of discretion would boost market prices. Evasively, he responded with a chuckle. "Now, John. You know better than anybody else how newspapers exaggerate, especially about things like that. If you buy something for $10,000, it becomes $100,000 in print." After a long pause, Rockefeller declared, "Well, I'm glad to hear you say that, Henry. We—that is, my son and I and the board of directors—were disturbed. We wouldn't want to think that the president of one of our major companies would be the kind of man foolish enough to pay $100,000 for a book."[6] The volume today is worth millions. What Rockefeller regarded as folly would prove to be wisdom itself, transcending the more narrow dictates of the worlds of business and finance.

The volume in question contained the Pavier quartos, the first attempted publication of collected works of William Shakespeare in 1619. As we shall see, it was the sudden availability for purchase of this volume that gave the Philadelphia bookseller Abraham Rosenbach the courage to interrupt an executive committee meeting at the Standard Oil Company to inform Henry Folger. It was the volume Folger clasped in both hands when Frank Salisbury painted his portrait.

The Folgers sat only once for formal portraits, in which they each appear seated, bedecked in their colorful academic gowns. Hidden in a recessed niche behind a bronze plaque and between the two portraits in the Folger Library's Gail Kern Paster reading room lie two urns with their ashes. In addition to being a library and a theater, the building is a mausoleum. Henry and Emily traveled eleven times by slow cattle steamer to England on a pilgrimage to Stratford-upon-Avon. When they saw the bust of William Shakespeare on the wall of the Holy Trinity Church overlooking the stone floor beneath which lay the Bard's bones, they had an idea about their own resting place. The Folgers purchased an exact replica of the bust and had it mounted in their library's reading room above their own remains.

Guests at the library dedication in 1932 were eager to finally learn about the extent and exact nature of the Folgers' collection. Shakespeare scholars had been furious with Folger, who for years responded to their letters explaining that he hoped "soon" to be able to make his collection available. It never happened in his lifetime; there was always another book, manuscript, or relic to obtain.

What lay hidden in the wooden cases the United States Trucking Company had transported from New York to Washington to be unloaded under cover of darkness, people wondered? Some remembered reading a newspaper headline in 1931, "Loaded guns guard books as famed library moves." When the small library staff

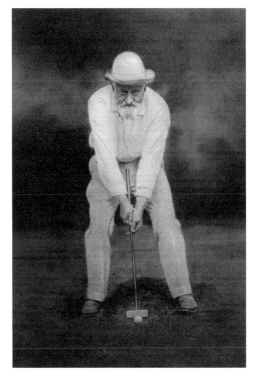

Henry Folger prepares to address the ball with his trademark rectangular putter club, 1921. His nephew recounted how when Uncle Henry sank a long putt, his golfing companion, John D. Rockefeller Sr., presented his Standard Oil colleague with a shiny dime. *By permission of the Folger Shakespeare Library*

finally unpacked the items carefully wrapped in the cases, they felt like Egyptologist Howard Carter, the first to look upon the gems in King Tutankhamun's tomb unearthed in the Valley of the Kings a decade earlier. Carter whispered in amazement, "I see wonderful things!"

Two wonderfully surprising items were not books but brollies. In 2011, Christopher Wright, formerly of the Library of Congress, phoned the Folger. He had come across the Folgers' umbrellas that had been stashed behind a door in his parents' home. Chris's father was Louis B. Wright, Folger director from the 1940s to the 1960s. It was my privilege to bring two Folger umbrellas back to the Folger after a half-century's absence.

These are no ordinary bumbershoots. The wooden handle top of Emily's straight-style black umbrella is carved with a leaf motif, and the tip is of sterling silver. Henry's initials are monogrammed on a one-inch-high fourteen-carat-gold

collar ring affixed under the handle of his. Between the collar ring and the top of the curved handle is a gold-capped brown pencil that fits into the crook of the handle. The lead pencil shows signs of having been sharpened with a penknife. A gold cap pivots for easy extraction. The pencil fits tightly into a fourteen-carat-gold pencil casing on which is inscribed the identical hallmark as on the collar ring. The pencil was for keeping records, presumably such as a tally sheet in horse racing. Rather than following a filly's time around the track at Ascot, another owner would use the pencil to note an antiquarian book to obtain. It is quite possible that the time the Folgers were delayed in their train connections at Union Station during inclement weather, they opened these very umbrellas and walked with determined gait up to and around East Capitol Street, on a mission to identify a site on which to build a library for their Shakespeare collection. The notes Henry made on his map of Capitol Hill attached to his February 18, 1918, letter to real estate agent McCreary were indeed written in pencil.

Note to the Reader

All Shakespeare quotations in this volume are taken from the individual New Folger Library Shakespeare Editions, edited by Barbara A. Mowat and Paul Werstine (New York: Simon & Schuster, 1992–2010, with continuing updated volumes and ebook availability).

Acknowledgments

The Folger Shakespeare Library generously offered me, an independent scholar, a fellowship in 2007 to delve into its Folger Collection and begin writing the first biography of the institution's founders. I systematically went through what staff refer to as "Folger Coll," dozens and dozens of gray or black archival boxes of correspondence and personal papers turned over to the Library by Emily Jordan Folger in 1931. In addition, many file cabinets in the vault contain "Folger case files," folders marked with the number of one of 2,109 wooden cases and related to books and other material inside which arrived from New York and were unpacked in the library basement for classification and shelving.

I suspected that most of my primary sources for the book lay in the bowels of the library. Escorted by the head of reader services, Betsy Walsh, and armed with a tape measure, I made my first descent into the low-temperature, low-humidity underground vault to assess what I was taking on. We calculated 166 linear feet of personal Folger papers. One could add 258 linear feet of book auction catalogs, the indispensable reference of the antiquarian book collector. This collection dwarfed the Folger papers I found in over thirty other archives in the United States and United Kingdom (see the bibliography for a full list). At the end of my research, the Folger kindly offered a stipend to the publisher to increase the number of illustrations in the book.

Three Folger directors—Werner Gundersheimer, Gail Kern Paster, and Michael Witmore—plus two Folger librarians—Richard Kuhta and Steve Enniss—sat for interviews or gave feedback on draft chapters. Marifrancis Hardison, whose husband directed the Folger from the late 1960s, in several discussions spoke of developments at the institution during the 1970s. Their collective experience spans more than forty years, half the Folger's life. Betsy Walsh and her staff, head of reference Georgianna Ziegler, curators Erin Blake and Heather Wolfe, and former curator Laetitia Yeandle responded promptly and with extensive expertise to my countless queries.

Robert L. Harrison, cousin of Henry Folger's mother, provided reams of documents on the Folger and Dimock families and guided me on a visit to Folger and Pratt residences on Long Island. Cynthia Farrell Johnson took me to the Folger neighborhoods in Brooklyn. I am grateful for the opportunity to visit or conduct phone interviews with Folger or Jordan relatives: Emily Smith Carter, George Dimock, Peter Dimock, John Folger, Peter Folger, Lucy Lieberfeld, Carolyn Smith Malmborg, Emmie Mattingly, Mary Susannah Robbins, and Suzanne Stahler.

The Washington Biography Group, led by Marc Pachter, provided stimulation and support during its monthly meetings. The newer Biographers International Organization through its monthly newsletter, *The Biographer's Craft*, and annual conferences presented a forum for biographers to share ideas and apply new skills, and it is a group in which I participate actively.

My literary agent, Amanda Mecke, provided unfailing support and superb guidance. Freelance editor Judith Dollenmayer applied her vast knowledge and skill to the writing. Abigail B. Wiebenson and Mary Z. Gray carefully read every chapter and shared ideas for strengthening the narrative. Ralph Johanson, Deborah Curren-Aquino, Richard Linenthal, Ken Jadin, and William Becker shared their expertise on specific chapters. Marcia Carter lent me works on book collecting. Elizabeth Pohland and Sylviane Grant assisted with digital photo management; Yonel Grant, with tables and data management. I thank my editor at the Johns Hopkins University Press, Greg Nicholl, who demonstrated confident and creative skill as he guided my manuscript through to publication, and my copy editor, Glenn Perkins, for his alert and precise attention to textual presentation.

Collecting Shakespeare

❧ ❧ ❧

Well Read in Poetry, Fair in Knowledge

Henry and Emily Form a Team

And by good fortune I have lighted well
On this young man, . . . well read in poetry
And other books—good ones, I warrant you.
The Taming of the Shrew, 1.2.169–72

Thou art as fair in knowledge as in hue.

Sonnet 82.5

AFTER THE CIVIL WAR, a newly muscular American economy became seriously competitive with Europe in international affairs. Culturally, too, the affluent middle and upper classes began, at about the time of the centennial, to resent the long-nosed disapproval of foreign commentators. For every Alexis de Tocqueville and James Bryce who mostly admired American individualism and risk-taking daring, there had been a Frances Trollope or dyspeptic Charles Dickens mocking the country's rough-hewn manners. Henry James and Henry Adams were among the vocal cultural critics who despaired that America was fated to play merely a cameo role in the grand civilizing drama of Continental culture, which honored a past America ignored. In historic Boston, where Henry James returned in 1904 after a twenty-year absence, he sniffed, "What was taking place was a perpetual repudiation of the past, so far as there had been a past to repudiate . . . The *will to grow* was everywhere written large, and to grow at no matter what or whose expense."[1]

The drive for material success over all would doom the nation's cultural institutions to the second rank. To be sure, wealthy Americans such as Jenny Jerome were eagerly sought-after marriage material for land-poor English aristocrats like the Duke of Marlborough, but the exchange was perceived, as the novels of Edith Wharton and Henry James show, as trading money for lineage and social gloss. Frances Trollope's younger son, Anthony, took his second-generation shots in books

like *The American Senator* (1877) and other novels where American visitors are usually foils, bumptious and crude.

Many native-born American industry leaders and inheritors of wealth supported the arts and wanted the United States to equal Europe as a patron. Henry Clay Frick may have been one of "the Worst American CEOs of All Time," rivaling John D. Rockefeller for the dubious sobriquet "most hated man in America," but the opulent Frick Collection opened to the public on Fifth Avenue in 1935 housed a treasure trove of Rembrandts, El Grecos, Corots, Goyas, and more.[2] Frick's close friend Andrew Mellon endowed the National Gallery of Art, and Rockefeller's philanthropies continue today in the fourth generation of that family. The story of Henry Clay Folger—self-effacing, self-made colleague of John D. Rockefeller and Charles Pratt and ultimately president of Standard Oil of New York—is another American story giving the lie to the notion that every Gilded Age striver cared only for personal wealth.

The seed of the world-renowned Folger Shakespeare Library was sown when Emily Jordan, "fair in knowledge," and Henry Folger, "well read in poetry and other books," attended a beach picnic and realized they shared a passion for Shakespeare. On June 7, 1882, members of the Irving Literary Circle of Brooklyn traveled to nearby Sands Point on Long Island Sound. The menu for the club's third annual excursion was hearty and extensive in the Edwardian mode: mock turtle soup, baked black bass with white wine sauce, ribs of beef, lamb, spring chicken, vegetables, pickles—and, to refresh the palate if not trim the waistline, plum pudding with vanilla ice cream. After the feast, toastmaster Charles Pratt, the oil refiner and philanthropist, proudly turned to twenty-five-year-old Henry, who quoted lines from *As You Like It*. With a twinkle, Pratt then asked Emily Clara Jordan for a toast, which included a passage from *Othello*. Young Charlie Pratt and his sister Lillie, a Vassar chum of Emily, may have been up to a little matchmaking. But the young picnickers could hardly foresee that the bookish Henry and Emily would marry three years later, much less build a world-class research library in the depths of the Great Depression.

Henry Folger's quiet presence at the picnic showed a scholarly demeanor that had already impressed Pratt. Henry revered Pratt not only because he had paid for part of Folger's junior year at Amherst after Henry's father went bankrupt but also because, one week after college graduation, Pratt became his boss. Anxious to pay off his debt, Henry entered Pratt's oil business in June 1879.

Although new to the literary circle at the picnic, Emily Jordan had just been elected its president and recently begun her first teaching job in Brooklyn. Unlike Henry, who had grown up only in Brooklyn, Emily and her family had roamed from

Ironton, Ohio, to Flushing, New York, to Elizabeth, New Jersey. Like Henry, but unlike most women of her generation, she, too, attended college. Graduating from Vassar in 1879, she became a teacher in the collegiate department at Miss Hotchkiss's School, also known as the Nassau Institute. She rented a flat at 65 Quincy Street, right across the street from the Folger family home.

Lillie Pratt had introduced Emily to Henry at a meeting of the Irving Literary Circle at the stately Pratt home at 232 Clinton Avenue in Brooklyn. Henry attended these meetings as early as 1880. By then he had compiled a chart in his small, fine clerk's hand in violet ink, noting the strengths, weaknesses, and stylistic differences among Burns, Byron, Elizabeth Barrett Browning, Longfellow, and Tennyson. The studious group also explored American political and social history, discussing the colonial and federal periods, slavery, and reconstruction. Emily and Henry met occasionally at the Literary Circle and soon realized they shared a similar upbringing, education, and interests. Each carefully preserved the Sands Point picnic program, one of the few identical items to be found in both their scrapbooks. Perhaps they knew this picnic had begun their lifelong partnership with William Shakespeare and with each other.

❦ Henry's blue-eyed ancestors had little interest in literature. Enterprise and business acumen distinguished the Folgers, who had lived on Nantucket Island off the Massachusetts coast for three hundred years and continue there today. Blacksmiths, carpenters, and seamen, they supported the bustling whaling trade. They were too busy to collect scrimshaw, decorated quarterboards, or barrel staves. Of Flemish descent, Peter Folger (originally spelled Foulger)—the first and most colorful of the island's Folger clan—was born in Norwich, England, in 1617. He sailed with his parents to Massachusetts in the late 1620s. On Nantucket, he apprenticed for many trades: surveyor and blacksmith, miller and joiner, court clerk and recorder, schoolteacher and missionary. Adept in languages, he learned the Algonquian tongue of the Wampanoags. Practical, he fabricated and used machinery. Literary, he wrote poetry. Peter was a baptized Congregationalist who became a Baptist and showed sympathy with Quakers. Folger's last child with Mary Morrel was a daughter, Abiah, born in 1667. Abiah became the second wife of Boston soap maker Josiah Franklin, and at age forty-one she gave birth to Benjamin Franklin. In homage to this distant connection, Henry Folger maintained that had he not collected Shakespeareana, he would have collected Frankliniana.[3]

Samuel Brown Folger (1795–1864), Henry's grandfather, was a master blacksmith in Nantucket shipbuilding and harbor works when whaling was at its apogee and islanders manufactured candles and sold sperm oil for lighting. From time to time,

antiques auctions still turn up double-flued harpoons or cutting-in spades stamped with the initials "SBF."[4] Samuel named his son Henry, third of nine children, after Henry Clay, the statesman he most admired. In the 1840s, Nantucket died as a whaling center because oil extracted from the ground and refined as kerosene became a better source of light and its byproducts were in demand. The Folger children scattered. A fragile child, Henry Clay Folger Sr. left school at fourteen to work in a Nantucket bookstore run by Andrew Macy, brother of the founder of Macy's department store. Two years later, Henry paid three dollars to sail to New York. Headwinds, storms, and a cautious captain prolonged the trip to two weeks.

Two more of Samuel's sons also left Nantucket heading west. Edward, followed by his youngest brother James A. Folger, was lured by the Gold Rush. The brothers boarded steamers for California by way of the Isthmus of Panama. Fifteen-year-old James, who had to stay in San Francisco to pay off his travel costs, built a coffee mill. At mid-century, well-roasted select coffee was still a considerable luxury. James did well and, in 1872, started Folger's Coffee, providing the first industrial service in San Francisco to roast, grind, and package coffee. The company still exists, producing popular coffee and a jingle:

> The best part of waking up
> Is Folger's in your cup.

After seeing off Edward, Henry Folger Sr. doubted he could find a good job back in Nantucket, and determined to become financially independent. Just seventeen, he took a job at the wholesale milliners Blake & Brown on 71 William Street in Manhattan. Known for industry and reliability, he stayed with the firm a dozen years. In spring 1856 he married a grade-school teacher, Eliza Jane Clark, a young woman with fourteen siblings whose family had lived in New York City since the eighteenth century. The Presbyterian wedding ceremony lasted only fifteen minutes before the Folgers sped off in a carriage to catch the Fall River boat to Nantucket for a two-week honeymoon. The bridal couple settled in at 142 Franklin Street in Manhattan, where Henry Clay Folger Jr. was born in 1857. Seven more children came along, but his mother's love of teaching and learning passed mostly to her eldest. One of Henry Jr.'s earliest memories was reading while rocking a cradle with his foot. Young Henry had a propensity for holding a book, as a photograph shows him. It was to be the first of 92,000 books. The first five children arrived before the oldest was five, a "good average," wryly pronounced the father, reflecting at age 74.[5] Twins George and James died in infancy, and sister Lizzie died when a teenager.

We know little about Eliza (called "Lida") Jane Clark Folger, Henry Jr.'s mother, though her face is animated by warmth and devotion in a portrait with her baby son.

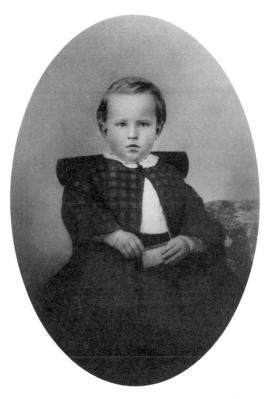

Eldest of eight children, Henry Clay Folger Jr. clutches the first of his 92,000 books, ca. 1862. *By permission of the Folger Shakespeare Library*

In a simple black dress with white lace collar, hair neatly pulled back and parted in the middle, the young woman with the steady gaze whom Henry Sr. courted and married in 1856 affirms his laconic description of her as "a very nice pretty girl." She was good with figures—a skill young Henry inherited—and ably managed a large household. Emily Folger recalled that her mother-in-law was beloved for her unassuming presence and energetic arrangement of children's picnics and Coney Island excursions.

Henry Folger Sr.'s wavy hair and horseshoe mustache cut a handsome figure. He was known as a crack salesman, giving up millinery to work in water meters. He became partner, and later president, of Dynamometer and later worked with three other firms. His name appears as a witness when his boss John Thomson applied for a U.S. patent on a more accurate, dependable water meter. Henry invested, too, but his fortunes plunged during the Panic of 1873, when he "went out of business with 75 cents in my pocket." Retiring on half pay, the aged Henry Sr. occasionally sent

cash to his son to buy a few shares of Standard Oil stock. When he died in 1914 he had amassed a modest 116 shares through his own contributions and his son's help.[6]

Henry Sr. changed residences even more often than jobs. He moved his family twelve times in Manhattan and Brooklyn and lived for three years in upstate Troy, New York. Looking back, he wrote, "I had a hard struggle to earn enough by selling goods on commission to keep my household expenses going for two or three years, but my family were loyal and did all they could to help, and our struggles cemented our love."[7]

Henry Sr. left solid legacies. By example, he taught his children a firm Protestant work ethic. Valuing every cent he earned, he had a survivor's ability to adapt to changing markets. He had strong faith that he could provide for his brood and the self-reliance to weather temporary adversities. In this family of teetotalers, regular churchgoing was expected and music was encouraged. The father conveyed to his children his love of music. He played the organ in several churches, led the congregation and Sunday school in hymn singing, and assembled a quartet choir. At home, he taught young Henry to play the organ. On Sundays he drove his children (and later, the grandchildren) in his trap, a small horse-drawn carriage.

The Folger family exuded affection, frugality and trust in divine wisdom. Henry Sr. customarily gave his children, no matter their age, a symbolic birthday gift of 100 pennies, challenging them to see how far the coppers could go. As his wife lay dying, in 1889 he wrote his daughter-in-law Emily:

> It is possible that I shall be called out of the city the last of this or first of next week, so I enclose to you 100 cents to put under the Jr's plate, or in the toe of his stocking, or any where else you may think best, on the 18th inst, and it is with pleasure that I send it as a reminder of our love for him, and at this time he seems more dear to us as we realize how much his mother loves him, and how soon she will be called up to her other loved ones waiting for her, and will be waiting for us to follow, which I feel will not be long. You also share our love, and we wish you all the happiness that can be given to you both, and may your lives be free from sorrow as God in His goodness thinks is best. With love from us all, Your Afft Father[8]

Henry Jr.'s three brothers, William, Edward, and Stephen, followed him into the oil business. Edward and Stephen worked at Standard Oil, both becoming executives. William worked as a stockbroker and Stephen had a sideline as a jeweler. Mary Folger—the only female Folger sibling to survive into adulthood married Enoch Harden Wells and bore three daughters. After Enoch died young, childless Emily and Henry heaped generosity and affection on the Wells girls. Each received

a ring—one with diamonds and emeralds, one with diamonds and sapphires, the third with rubies—and Henry financed their Vassar education.[9]

Years later, after Henry died, Emily lured his niece's husband, Owen Fithian Smith, from an executive post at National City Bank in New York to serve as her banker, financial secretary, and executor of Henry's will in negotiating with Amherst trustees on Folger Library plans, personnel, and policies. The Folger family was close-knit, exchanging regular notes, Christmas presents, and birthday gifts. By far the most affluent, Henry regularly showered his sister and brothers with significant cash payments.

Henry never strayed far from his New England roots. He was an avid collector of books on Nantucket, although he professed limited interest in his own genealogy, and no record exists that he visited the island.[10] Even so, Nantucket appeared as a candidate on the list of possible sites for Henry's monumental Shakespeare library. He became an accomplished sailor, after many boyhood summers spent in Camden, Maine, on Penobscot Bay. He took the Eastern Steamship Corporation steamer overnight from Boston and arrived at Mrs. Clara E. Palmer's guesthouse, Cedarcrest, on upper Chestnut Street, in a barouche, in the early morning.

As a schoolboy, Henry Folger showed academic promise early. The first sign took the form of engraved certificates from P.S. 15 in Brooklyn. Not one to creep "like snail / Unwillingly to school" (*As You Like It,* 2.7.153–54), at thirteen, Henry showed his parents the first of what would become a stack of merit awards: "As an honorable testimony of approbation for industry, punctuality and good conduct during the last month."[11] These certificates bore the signature of P.S. 15's principal, Stephen Gale Taylor, who moved to nearby Adelphi Academy as principal in 1875, tracking Henry's school career. Mementos from Henry's school days include a poem, an essay on Cicero, and "Scenes at an Auction." The auction room he describes would become a familiar haunt in later book-collecting years. Henry read widely, too: Tennyson, Goldsmith, Longfellow, Keats, Milton, but apparently no Shakespeare or Emerson. Perhaps Henry was indeed drawn to the Bard as much by Emily as by his early love of reading.

In 1875, as he packed for freshman year at Amherst, Henry received the first of many solicitations that arrived throughout his long life. Startlingly, his elementary school needed money. We can imagine young, earnest Folger studying the constitution and by-laws of the Graduates' Association of P.S. 15. He must have nodded as he read, "Object: to promote in every proper way the interests of the School, and to foster among the graduates a sentiment of regard for each other, and an attachment to their alma mater." By the end of his life, Folger would lavishly redefine the concept of devotion to one's alma mater.

His college preparatory school, Adelphi Academy, deeply affected Henry. When the cornerstone was laid at 412 Adelphi Street in northwest Brooklyn in 1863, founding supporter Reverend Henry Ward Beecher in his address declared this was no ordinary school: "No man can give any reason why a woman should not be educated as well as and in the same respect which, a man is educated." This rare coeducational institution later boasted the first gymnasium in Brooklyn. Dedicated to building both strong minds and bodies, the school adopted a strangely stark motto: "Life without Learning Is Death."

Folger was impressed by Adelphi's emphasis on strong moral values and academic excellence. Besides Beecher, two other founding members greatly influenced the school, Brooklyn notables Horace Greeley and Charles Pratt. All three served on a committee that helped Adelphi expand its physical plant and academic programs. Greeley was a teacher, lecturer, newspaperman, and moral leader who spoke out for labor unions and against slavery and capital punishment. Beecher, a fiery abolitionist and mesmerizing preacher, was named the first pastor of Brooklyn's Plymouth Congregational Church in 1847 and remained there forty years, despite being defendant in a notorious 1875 trial for adultery with a congregant, the wife of a friend. Henry was conscious of his good fortune in being exposed to an unusually progressive education.

Charles Pratt was wealthy mentor and friend to young Henry. But at ten, in 1840, he had been selling newspapers on a corner in Watertown, Massachusetts. At forty-four, in 1874, Pratt became president of the Adelphi board of trustees, endowing a scholarship fund and introducing prizes for academic excellence. Emily Folger wrote later that, as early as 1868, Henry was one of the first students to win a Pratt prize at P.S. 15.[12] Pratt conceived of a curriculum in technical and mechanical training, founding the Pratt Institute in 1887. He died in his office in 1891 on return from lunch, suffering a heart attack while writing a $5,000 check to a charity.

In 1903, Folger was asked to speak at a Pratt Institute ceremony honoring the founder. He invoked Charles Pratt's personal motto: "The giving which counts is the giving of one's self." Folger, who agreed with the motto, continued, "In business Charles Pratt was the soul of honor. Shrewd, sagacious, far-sighted—but the trait which helped him most was trustfulness . . . he coupled thrift with sagacity, industry with patience. Yes, he was an untiring worker. Wealth came naturally to such a combination of traits."[13] With the utmost respect for Pratt as an educational visionary and innovator, an early leader in the petroleum industry who turned his business achievement into philanthropy, and a mentor who took a personal interest in him, Henry studied Pratt's path and followed it all his life.

During his years at Adelphi between 1873 and 1875, Folger studied under Homer

Baxter Sprague. In 1870, Sprague had come out of journalism to direct Adelphi Academy, but he also taught Greek, Latin, rhetoric, and English literature. Sprague's ferocious anti-slavery views had led to confrontations with slaveholders and even a Civil War general. Known as a fearless Union soldier, he survived months in Confederate prisons. After five years at Adelphi, he became president of the University of North Dakota and, in 1902, published in the *Yale Law Journal* "Shakespeare's Alleged Blunders in Legal Terminology." No one knows for sure whether Henry Folger heard Homer Sprague discuss William Shakespeare, but chances are he did.

At Adelphi, Henry was one of 550 pupils, girls and boys, divided among three departments: preparatory, academic, and collegiate. His activities included chapel, art, chemistry, and recitation, with a heavy dose of classics. In neatly penned compositions Henry addressed the characters of Caesar and Virgil, a Roman camp, Greek and Latin language and literature. He wrote a current events paper on the press and another on his journey to the top of the pier of the East River Bridge. Folger was chosen president of the literary association at Adelphi, a harbinger of his later mission.

In a graduating class of twenty-two, Folger ranked in the top five. He gave the salutatory oration at Adelphi's June 1875 commencement. That oration, "Every man is the architect of his own fortune," held prophetic metaphors. He declared in institution-building rhetoric that everyone has a life-work, a mission:

> On observing the lives and characters, not only of illustrious men, but also of those belonging to the lower and common classes, there is perhaps no better simile for the course of human existence, than the comparison of it to the rearing of a building, whose foundations are laid in early youth, and the loftiness and grandeur of whose completed structure depend upon the architect's abilities and intentions . . . It is for us to decide, whether our characters shall be grand and lofty structures, or groveling hovels; whether, at death, we shall leave them lasting monuments of imperishable marble, or the mouldering remains of abandoned ruins.[14]

At eighteen, Folger eerily presaged his own lifework's culmination in a great marble monument devoted to literature.

🍂 Amherst, Massachusetts, east of the Berkshires and the Connecticut River, is surrounded by farmland even today. The Pioneer Valley is best known for tobacco fields that produced one of the finest cigar wrappers in the world; it is home to four colleges and a state university. Amherst College was founded in 1821 "for the classical education of indigent young men of piety and talents for the Christian Ministry." Today, a coed Amherst has 1,700 students; in Henry's time, it was more like an

advanced academy of several hundred men. During their senior year at Adelphi, Henry Folger and his pal Charlie Pratt visited the college with alumnus William Clark Peckham, an Adelphi science teacher. Unlike Henry, Charlie was wealthy. But both boys were part of a post–Civil War generation for whom a college education was quickly becoming a prerequisite of success. After their campus visit, they told their fathers Amherst was for them. Henry Sr. agreed. Charles Sr. may have preferred Harvard but let his son choose.

Henry Folger arrived at Amherst in September 1875 with the proverbial ten dollars in his pocket. During his first year, he neatly penned over two dozen letters to his parents in Brooklyn; curiously, however, no letter was addressed to both. To his mother he described homework and campus activities; his father heard about money matters. No correspondence from the parents has survived. Henry opened his letters with "My dear Mother" and "My dear Father." He often closed with "from your loving son Henry" or "from your aff [affectionate] son Henry." He wrote in brown ink on both sides of folded blue-lined composition sheets, using a fountain pen. Not one for waste, Folger wrote lengthwise, then filled the page margins. His parents saved the envelopes with their canceled green George Washington three-cent stamps. (Henry and Emily also saved letters in their original envelopes, which remained intact save for a few where Henry passed the postage stamps to his nephew, Edward.)

In his first letters to the Folgers at 476 Adelphi Street from Amherst, 140 miles north, young Folger readily admitted he was homesick but proposed a remedy: "If you and Father write Sundays, and Mary and Will twice a week, I'll receive a letter every day."[15] Henry was mortified when classmates received mail, but he didn't. Convinced that letter writing was good compositional practice, he regularly wrote his family on Wednesday and Sunday, apologizing whenever a heavy academic workload threw off this schedule. Henry let his family know how much their letters lifted his spirits: "I received three letters from home this past week, and you can hardly imagine how much more quickly the week passes when I receive a letter or two during the middle of it."

Henry was far from flush, even monitoring his postage: "I enclose this in a monogram envelope. We like it very much, but each envelope costs a cent and a half, so we don't use them often." His father had set the tone, questioning his son's need for a table in his off-campus "boarding-place" shared with Charlie Pratt. Henry wrote to assure his parents that the table was well used, piled high with books.

The elder Folgers' suggestions on housekeeping and economy irked Henry, who thought the two boys could handle their own affairs: "We thank you much for your advice about house keeping but consider ourselves quite adept chambermen." When

it came to washing clothes, however, Henry confessed frugality gone awry. He decided to buy a warming-stove to better endure Massachusetts winters. He opted for this after rejecting the expense of shipping a stove from the family in New York; he was sure he could sell the stove later for half the original cost. Henry was also sure he could save money by doing his own laundry. He made a fire, heated water in his wash basin, and managed to burn himself in three places, blistering four fingers:

> After wringing the "things" as dry as my fingers, now almost useless, could make them, I laid them on the top of the stove to dry. There were two pairs of stockings, three towels, and a handkerchief, in all twenty-five cents worth of washing saved. I then set out for a skate with a clear conscience, thinking that I had saved a quarter of a dollar, or in other terms was fifty cents richer. After enjoying myself immensely I started towards home, with the idea that . . . I must still iron those "things." When I came in the front door I noticed a peculiar odor, and on entering the room it became still more observable. As I crossed the threshold . . . and looked a little more closely, I found my "things" reduced to cinders, if burnt rags may be honored with that name.[16]

Another time, without injury, Henry sewed up a pair of pants, ripped in climbing a tree to pick five quarts of chestnuts. Like today's urban foragers, he also delighted in finding free fresh produce: "We have splendid pears in our yard opposite the window and a slipper brings down just enough for us two." After giving up the idea of having towels sent from home, Henry bought two towels for thirty-three cents, then asked his mother: "Write how much towels should cost so that I can have the satisfaction of knowing whether I have been *cheated.*"

Folger adapted well to college life and the bracing New England weather. Exploring the Connecticut River Valley, he thought nothing of the seven-mile walk to Northampton. He reported sleighing with friends, admiring a sunset, staying warm at home, playing whist, and occasionally having a "sing" in the parlor. Leaving Amherst, he thought he would miss singing more than almost anything. An early freeze prompted Folger to wax poetic, "A late November rain freezes and produced iced foliage, each twig supporting pendant icicles, that glistened in the light of the rising sun like so many diamonds." Although an Amherst fall and spring could be muddy, and the winter well below freezing, the climate invigorated young Folger: "Never in better health in my life, I find this air agrees with me."

In the 1870s, fraternities at Amherst served as vibrant bonding institutions. Students joined a fraternity house early in their first year, to live there. Like most Adelphi alums, Folger chose Alpha Delta Phi, perhaps because Adelphi professor Peckham had joined it. Henry noted in his college papers that Henry Ward Beecher,

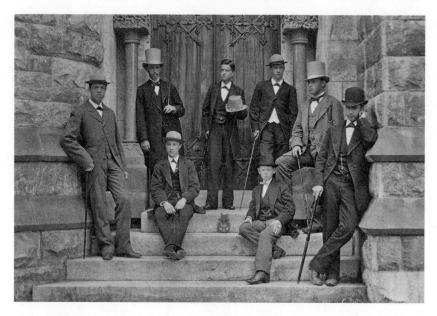

Alpha Delta Phi brothers at Amherst College pose for local photographer J. L. Lovell, 1879. Henry Folger stands top center, to his left, Charles M. Pratt. Sporting canes was a college tradition. *Amherst College Archives and Special Collections*

class of 1834, who often came to Amherst to preach, belonged to the same fraternity. (Beecher had advocated coeducation at Amherst, as he had at Adelphi, but it took until 1975 to achieve it.) Henry explained that "Freshman River," where he loved to ice skate, got its name in a bygone era when hazing was in vogue and upperclassmen "ducked" freshmen. As a sophomore, one was allowed to wear a top hat and carry a cane, as Henry's class photograph shows. Food packages from home offered treats to the fraternity brothers. While Mrs. Folger sent a plum cake, she was outdone by what Henry approvingly called "Pratt's spread," featuring Mrs. Charles Pratt's pickled oysters. Other mothers sent tongue and crackers, jellies and pies, treating the boys to fraternity feasts. Overindulgence was not unknown. "Last night," Henry confessed to his mother, "I was not as well as I would like to be always. I suppose it was the remnants of our 'delegation bum' [class drunk] that was the cause of it. But I laid abed till after ten, ate no breakfast, and now feel as good as new." Although abstemious in later life, in college Folger was one of the boys.

Henry shared his daily schedule and a self-assessment of his academic performance. "We usually rise at six, and study till seven fifteen, then we have breakfast. At 7:53 we are due at the chapel, and immediately after have calisthenics, and our first recitation follows directly afterwards." Henry confirmed taking Greek, passing

a Latin exam, and doing well in Geometry. His three daily recitations required eight hours of study or more, and he found history most difficult. He announced to his father that, in order to increase his chances of doing well in recitation, he employed a fraternity brother to drill him, at a dollar an hour. As an upperclassman, Henry himself tutored younger students at Alpha Delta Phi.

Henry was undecided about how much he should care about class rank. Initially he judged himself twelfth of a class of seventy-four, but believed as many as twenty-five peers were more able than he. Henry was more concerned with his self-image: "I feel that I have been faithful to myself in study and I don't care how I stand." Learning that he ranked first among classmates from Adelphi Academy, he revised his earlier judgment: "I am more than satisfied with my standing." After his first year, Henry's steady stream of letters to his parents ran dry, indicating he felt he had made an adult life for himself. Unfortunately, his parsimony in prose continued, allowing his talent for expression to lie fallow all his life. Henry wrote a few letters home as graduation approached, and tried to console his parents by empathizing with their decision not to make the journey due to the cost.

Henry Folger's Amherst education was classical. As the college had fashioned a curriculum designed in part to train clergymen, required courses were orthography, elocution, and declamation, as well as exercises in English sentences, rhetoric, and extemporaneous speaking. While physics was mandatory for students headed for a B.S. degree, English literature, political economy, government, and history were marginal electives for all. Like many New England colleges, Amherst evolved into a liberal arts institution of higher learning that sent men into many professions besides the church.

Folger excelled, compiling a four-year average of 89 of 100. A solid achiever, as a freshman he scored 88 and as a senior, 91. Folger's lowest grade was 85 in Greek. In modern languages—French and German—Henry scored 88. While far from fluent, he would later use his reading knowledge to scour book auction catalogs from many countries. In mathematics, a subject vitally important to people in the oil business, Folger landed a 90 average over four years. He was elected to Phi Beta Kappa in his junior year and graduated fifth in his class. Graduating first in the class was twenty-year-old John Franklin Jameson, who would play a role in where the Folger Library would eventually be located.

❧ The woman who would become Henry's wife and partner in bibliomania was born Emily Clara Jordan on May 15, 1858, in Ironton, Ohio. The industrial town sat along the Ohio River in the southern tip of the state, drawing its name from assets of iron ore and coal. Her mother was Augusta Woodbury Ricker, born in Bath, New

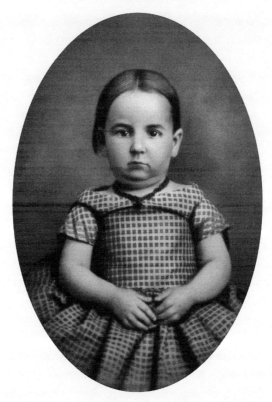

The youngest of three sisters, as a child Emily Clara Jordan moved from Ironton, Ohio, to Washington, DC, to Flushing, New York, to Elizabeth, New Jersey, ca. 1862. *By permission of the Folger Shakespeare Library*

Hampshire. Her father, Edward W. Jordan, came from Moriah, New York. When asked in college to name "other nationalities in your ancestry," Emily responded with "French Huguenot, Scotch, and English."[17]

A lawyer and newspaper editor, Edward Jordan campaigned to elect Abraham Lincoln president. Lincoln responded by giving "Jerdan," as he called him, a commission as Solicitor of the Treasury, where he stayed until the end of the Andrew Johnson administration. In Washington, where the Jordans lived on the corner of 12th and M Streets during the Civil War, Edward once took young Emily to meet President Lincoln in the White House. She was so moved by the encounter that she wrote a short story about it, scribbling in pencil in her 1908 diary a tale, "The President and the Little Girl." Her (unpublished) story reveals a child's sensitivity to pain and suffering during the Civil War. The little girl's request to the president

was simple: "I want one wounded soldier on the battlefield taken care of." "Father Abraham's" reply was, "I do, too."[18]

With her sisters, Mary Augusta and Elizabeth, Emily went to Miss Ranney's School on 211 S. Broad Street in Elizabeth, New Jersey, after the family relocated. From 1861 to 1881, Nancy D. Ranney prepared women for teaching or further study. Brother Francis would read law. From their parents—neither of whom had gone to college—the Jordan children inherited "an enlightened mind, a sense of humor, and a critical love of books."[19]

❧ Eighty-five miles west of Amherst, in the old river port of Poughkeepsie, New York, in 1861, English immigrant and retired beer-brewer Matthew Vassar, prompted by a bright niece's desire for education, founded a collegiate institution for women on the grounds of an old racetrack several miles from his estate at "Springside." The college's first (and only) building for a time, stately Main Hall, was designed in the French mansard-roof style and built near the center of the thousand-acre campus. Unusual for a businessman of his time, and allying himself with Reverend Henry Ward Beecher, Vassar declared boldly that "woman, having received from her Creator the same intellectual constitution as man, has the same right as man to intellectual culture and development."[20] Advocating that women, whenever possible, serve on the college faculty and administration, Matthew Vassar announced at the first meeting of the college trustees that "the course of study should embrace English language and its literature, other modern languages, mathematics, natural science, intellectual philosophy, political economy, and moral science." His college would be no "finishing school."

Ever since the Revolutionary War, pioneering New England teachers such as Sarah Pierce in Litchfield, Connecticut; Catherine Beecher in Hartford; and Emma Willard in Troy, New York, had sought to train women in academic as well as "domestic sciences" and decorative arts. The women who graduated from these schools, they insisted, would be partners to the second generation of Founding Fathers. They—and their daughters after them—would need, in order to be good Mothers of the Republic, more formal education than had been available to Abigail Adams, Martha Washington, or Dolly Madison.

This curriculum at Vassar, the first large endowed women's college in America, differed from its classical counterpart at men's institutions. While Latin and mathematics were required of all freshmen, French replaced Greek. Mental and moral philosophy were mandatory in the second and third years. Matthew Vassar was a devout Baptist who assured that theology and Christian studies entered the curriculum. Only unmarried women were allowed to teach in women's colleges. Vassar

did not teach domestic economy, judging that students could obtain these skills at home. English literature and expression were offered, but no history until 1887. Like other women's colleges at the time, Vassar tried to provide a useful education that could lead to a profession; science was privileged. Offered opportunity for serious study, college women of the first generation—the 1860s through 1880s—were expected to pursue it conscientiously. In 1870, 11,000 women attended college in America, compared to about 41,000 men. The total population of the country at the time was about 38 million.

The three Jordan sisters thrived in this rich environment. Mary Augusta Jordan entered Vassar as a freshman in 1872. Her younger sisters, Emily and Elizabeth, followed in 1875. The two proudly saw their older sister graduate in June 1876, then stay on as college librarian, validating one of Matthew Vassar's goals. In this family of modest means, Mary Augusta was able partly to finance her younger sisters' studies. Emily was chosen president of her class of thirty-six—an honor that lasted a lifetime. Winning a Phi Beta Kappa key, as did Mary Augusta, Emily's best subjects were English composition, French, and astronomy. Close behind ranked botany, chemistry, math, and English criticism. Academic proficiency in both science and letters prepared Emily well for her later roles as teacher in a Brooklyn secondary school and, eventually, as life partner of a business executive with wide-ranging literary interests.

A worn green buckram-covered volume with the words "Scrap Book" embossed in gold letters contains mementoes of Emily's college days. Interspersed with pressed leaves and flower petals lie souvenirs of her academic, cultural, and social life from seventeen to twenty-three.[21] The scrapbook contains several items about Maria Mitchell, the country's first woman astronomer and the first professor hired when Vassar opened in 1865. Despite criticism, Professor Mitchell encouraged scores of students through the 1880s to prepare for scholarly careers. Emily and her classmates keenly admired Mitchell as an intellectual role model. Emily saved several pictures of Saturn's rings from her classwork and, a real treasure, a booklet, *Notes on the Satellites of Saturn*, from her favorite professor, inscribed: "Miss Jordan, with love from Maria Mitchell."

Each year's astronomy class culminated in a "dome-party." Dressed in their finest, students would file up the stairs into the observatory dome a few hundred yards from Main Hall—boasting the third most powerful telescope in the country—for a breakfast party celebrating science and literature. Tables were set in a circle, at each place a name card, a rosebud, and a small photo of the observatory. Silver-haired Professor Mitchell, in plain Quaker dress, presided. After chicken croquettes followed by strawberries, came poetry. Each student drew a neatly folded paper from

a large basket the professor ceremoniously circulated. The notes contained poems, many of which made scientific allusions, and most of which Maria Mitchell herself handwrote in block letters. The students went around the circle, reading aloud to general merriment:

> With my views it's according
> to prize highly Miss Jordan;
> Few are richer & rarer
> Than Emily Clara,
> her head is clear and her logic the same,
> But when it comes to rhyming
> I don't like her name.

Many messages concentrated on a student's personal traits. Here lies a rare glimpse of how a professor viewed young Emily as a clear, logical thinker. (Would her mental sharpness remind her future husband of a Portia, a Beatrice, a Rosalind, or a Viola?) The evening ended with the girls forming an impromptu choir on the movable observatory steps to sing popular melodies. This grande dame of the dome endeared herself to scores of Vassar students. Born in a Quaker family in Nantucket, Maria Mitchell was a descendant of Peter Foulger. When Professor Mitchell died, Emily took charge of ensuring part of the noted astronomer's legacy. Mitchell's ambition had been to render her department independent and self-supporting. Emily assumed the chair of the Maria Mitchell Endowment Fund and organized pledge drives, proudly announcing to donors that the money invested was earning eight percent.

Besides receiving written invitations from faculty to parlor teas, coffees, or desserts, Emily joined class outings. A leaf of sorrel became a memento of a ride with Julia, and a forget-me-not of an excursion with K. S. Hawley. Students would send cards to special friends with "compliments" to each other. They circulated affectionate poems and sent flowers or other gifts. Such ritualistic demonstrations of fondness among students, and sometimes with faculty, were called "smashing."

The college looked toward a class president for special duties. Members of the faculty wrote notes to Emily, asking her to contact the whole class on matters such as canceled classes or lists of students who would be traveling at Christmas. Emily often presided over the dinner table, occasionally inviting her older sister to sit with her.

Vassar offered many opportunities for cultural enrichment and social interaction, the latter with chaperones. Classmate Sophia Richardson, secretary of the Shakespeare Club, "cordially invites Miss Jordan" to become a member on September 28, 1876. We can assume she joined. Emily put much energy into the Philalethean So-

ciety, a cultural organization. The society produced plays, including George Eliot's *Spanish Gypsy*, planned "literary entertainments," organized debates, and sponsored concerts. Emily's fervor for the Philalethean put her on the organizing committee in senior year. In a Thanksgiving musical performance, Emily played the triangle. On stage she took the role of Fanny in *Everybody's Friend*, a three-act comedy. Pough-keepsie has an Opera House, the Bardavon, which Emily frequented; like Henry, she saved her concert and theater ticket stubs. Three years after graduation, she returned to campus to address the Philalethean Society in the chapel. Emily was the rare recent graduate to display so much dedication to her alma mater and keep in such close touch with fellow students. With similar Jordan enthusiasm, her sister Mary Augusta became secretary of the Vassar College Alumnae Association.

At a period when many young women did not know how to dance, Emily went to class "sociables," "hops," and lancier and quadrille dances with West Pointers twenty miles down the Hudson River. With other Vassar young ladies, she made the voyage via carriage, train, and then ferry. A pressed leaf from May 1877 and pressed grass in February 1878 bear small white labels with the initials L. J. Emily, however, did not have her heart and mind set on a cadet. She kept handy the New York Central and Hudson River Railroad timetable, traveling home for vacations with one trunk from room #26 at Main Hall by taking the 6:30 A.M. "Mary Powell," the side-wheeler steamboat known as the Queen of the River, for New York.

Five commencement programs from 1876 to 1880 list the girls Emily would have lived, laughed, dined, studied, and talked with at Vassar. Two were the daughters of suffragist Elizabeth Cady Stanton: Margaret (class of 1876) and Harriot (class of 1878). For all its liberal views, Vassar did not go so far as to invite their firebrand mother to lecture on campus while they were students. Nevertheless, Ms. Stanton managed to meet informally with student groups to spread the gospel of women's rights. Activism in voting rights followed apace behind more open opportunities in women's higher education.

On commencement day at Vassar—June 25, 1879—the same day Henry Folger graduated from Amherst, Emily's classmates said goodbye.

> Miss Jordan, as President of the class of '79, you, like the rest of us, are soon to leave "Alma mater"; but your connection with us is not to be severed. You, who have led us through this, our last year, will still be at our head. It may be that we shall never meet again as an unbroken class, but we trust that those who are permit-ted to attend our reunions may always find you ready to fill the President's chair. As an emblem of what you have been, are, and will be, we present you with this ruler, hoping you may have many occasions for exercising your mild sway over us.

Emily was about to enter the world of work, buoyed by expressions of confidence from the faculty and students. She was a leader, very effective without wielding a big stick.

Pleased with her college mementos, Emily assembled a second scrapbook containing programs, invitations, and notes covering her six years of teaching in the Nassau Institute in Brooklyn, where she was hired right out of Vassar. The boarding school sat on the corner of Classon and Quincy Streets, within walking distance of Emily's home. Started in 1868 by two sisters named Hotchkiss, the school prided itself on thoroughly training young ladies under the vigilant eye of a nearby Presbyterian Church. Educational principles included character development, ethics, and physical culture. Busier now, and less concerned with neat presentation than with saving fugitive documents, Emily was more likely to insert material in her scrapbook between pages than to use paste. Among the twenty questions in the literature/history tests she devised to keep her pupils on their toes were: "Where does Longfellow live? For what is the town celebrated? Who went to France for his struggling countrymen?" In rhetoric, "What are the elements of discourse? What is the use of the 'a priori' argument?" The young teacher stressed factual knowledge. Emily wrote an essay on printing and Gutenberg, perhaps as a model for her students. To help prepare for classes, she frequented the Brooklyn Library reading rooms on Montague Street in Brooklyn Heights.

Emily received many Tiffany-engraved invitations to receptions and soirées, teas and weddings. She traveled to New Jersey to hear the Princeton College Glee and Instrumental Clubs. She saved a program of *HMS Pinafore* by Gilbert and Sullivan. Christmas and New Year greetings arrived printed on small business cards. Emily participated in several religious organizations, one a Brooklyn "Sunday-School Union," with singing, scripture readings, prayer, address, and benediction. She attended a painting and statuary exhibit in the Presbyterian Church of Elizabeth, New Jersey. Taking a rare break, Emily went to Brighton Beach on Coney Island. She took home a verification of her "Correct Weight" of 133 pounds and a Brighton Beach concert program advertising "Waterproof linen cuffs, collars and bosoms perspiration proof."

❧ Similarly, Henry recorded his Amherst career in a violet cloth-covered scrapbook whose stiff green pages covered all four undergraduate years and mainly featured academic programs, athletic contests, cultural events, extracurricular activities—mostly choral performances—and fraternity dinners.[22] In contrast to Emily's generous pagination, almost all of Henry's mementos were neatly pasted, leaving almost no margins. No waste.

The first loose sheet, surprisingly, consists of vital statistics the college collected

on all incoming freshmen. (Amazingly, these albums of freshman physical statis-tics continued at many Eastern colleges, including Vassar, into the mid-twentieth century.) Folger, at eighteen, stood five feet four and weighed only 110 lbs. The shoe size of this slight, left-handed man was seven. An Amherst fraternity mate re-ferred to him as "little Folger." While only five feet tall herself, Emily also remarked occasionally on Henry's slight stature. Later on, Henry grew first a mustache then a beard—perhaps due to his underbite, perhaps trying for additional gravitas, perhaps both. His grandnieces—some with the hereditary underbite—believe that Emily was behind these changes.

Henry's admitted lack of athletic prowess (though in middle age he would take up golf and play quite well, being an ace on the putting green and entering senior competitions) did not translate to athletic indifference. He pasted into his memory book ticket stubs from Amherst's football games against Brown and Yale. He not only attended games and meets; he minutely recorded in program margins the com-petitor's class, distance, times, and scores. In an athletic association program from his sophomore year, he entered times for a half-mile run, a 100-yard dash, and lengths and heights for jumping events.

Henry was always attracted to winning. He noted the highest achievements in a field even if they were not his own. His notes also reflect the meticulous record-keeping that would flower in his collecting mania. Later, Henry closely followed the market price for thousands of volumes in bookstores and at auction, even when he was not the bidder.

Folger's scrapbook conveys the flavor of his academic life. He saved the Latin, Greek, and English grammar exam booklets from his Amherst admissions. He kept an 1876 rhetoric exam and one in French from 1877. He noted two subjects—declamation and recitation—with his grades over four years. At least once a year, Henry received the top grade of 100 in both subjects. His lowest term grade in reci-tation was 86; in declamation, 98. Seniors at Amherst took recitation two or three times a week and declamation once.

Shakespeare commanded an unassailable place in recitation. Folger saved his essays on the characters of Shylock, Portia, and Macbeth. He found Shylock a "won-derful example of the power and scope in dramatic art" that "makes our blood tingle." His professor wrote in the margin, "Apart from the matter of clearness, and facility in the use of language, you need to pay especial attention to smoothness of style; since, though graphic, you are sometimes abrupt."[23] After Folger charac-terized Portia as womanly, intellectual, attracted by pure motives, and buoyant of spirit, the professor penciled in the margin, "The style is good, but more grace and beauty must be added." He made no more corrections on Folger's essay on Mac-

beth. Folger's class may have been one of the first at Amherst to study Shakespeare's plays. Folger's friend George A. Plimpton wrote that Amherst professors lectured on Shakespeare the writer without reading his plays.[24]

With tongue in cheek, alluding to a Shakespearean line, Folger wrote above his grades, "O, my offense is *rank* it smells to heaven." He seems unsatisfied with less than being the best in academic competition. Another list, signed "Folger" at the bottom, indicates his partial readings in English literature while at Amherst: Bacon, Jonson, Marlowe, Massinger, Dryden, Addison, Pope, and Milton. Later, Folger would collect their first editions and, in some cases, manuscripts and autograph letters as well.

In Folger's day, Amherst students enthusiastically competed for annual prizes sponsored by college icons named Kellogg, Hardy, and Hyde. Amherst awarded first, second, and third cash prizes for the best essays read publicly by the authors. Oratorical contests became popular, prestigious college events, with orchestral preludes and postludes. Henry's scrapbook holds tickets and programs for these competitions. A clipping from the *Brooklyn Eagle* reported that local boy Folger was chosen to compete for the Kellogg Prize. His name figured among the winners of the Kellogg in 1876 for his essay, "Pericles before the Areopagus." He pocketed $100 with the Hyde in 1879 for a first-prize paper on Tennyson.

That may not sound like an enormous sum today. Then, it paid for a whole year's tuition at Amherst. Henry's oratorical prowess was a godsend to the money-strapped Folgers, who lacked the funds to visit their eldest at college, even for commencement. The same year, Folger competed for the Hardy Prize on the theme "Has a college course of study a tendency to repress independence of thought?" The Amherst *Student* reported that Folger won the First Junior Prize with an essay on "Dickens as a preacher."[25] Folger saw the competitions as opportunities to excel and further hone his speaking skills. His model was Daniel Webster, whose oratorical style he dissected in an essay.

Henry Folger sang a solid bass-baritone in the Amherst College Glee Club. The club sang often at Amherst, elsewhere in the Connecticut Valley, and, on occasion, in more distant locations. Henry saved the ticket for the Boston & Albany railroad trip that took the Glee Club to perform for the first time in Boston. In early 1879 he traveled with the Glee Club to Brooklyn to sing a benefit concert at the Academy of Music to support his alma mater, Adelphi. In his senior year, Amherst mounted one of the early (most likely pirated) American performances of *HMS Pinafore*. Henry played a major role as Dick Deadeye. His scrapbook contains a sheet of music on which he wrote the notes and lyrics he had to learn. The local Amherst newspaper reported, "Folger was a superb Deadeye. His part throughout was a great

hit." Someone commented on how surprising it was to hear such a loud, deep voice emanate from such a slight man. When Emily later learned of his success in the role, she began affectionately to call him "Dick."

Folger's scrapbook contains a tuition bill, signed by the college treasurer, William Austin Dickinson, the poet Emily's older brother. Folger, who later paid a small fortune for manuscripts and famous Elizabethan signatures, would have been amused to learn that recently on eBay a vintage Amherst tuition bill was for sale at ninety-five dollars, due to the Dickinson connection. He would have been incredulous to learn that another Web site peddling historical documents offered for $5,000 a certificate of "100 shares of the Standard Oil Trust" made out to Henry C. Folger Jr. and signed by John D. Rockefeller.

Although nothing in his scrapbook suggests that Folger was following Amherst College's earlier path toward Christian ministry, Folger clearly felt a spiritual dimension. He saved invitations to prayer meetings. He also kept tickets to lectures by the American evangelist Joseph Cook, who influenced many students when he spoke on the importance of Christianity for men and nations. With more than a dozen classmates, Henry was baptized at the college church in May 1876. Calvin Stowe, Harriet Beecher Stowe's husband, performed the rites. Religious seeds sowed at Amherst encouraged Henry to become a lifelong active Congregationalist.

At commencement, Folger feasted at class suppers and engaged in musical and speaking events that marked this rite of passage. "Class Day" was a solemn occasion for odes and orations, a milieu in which Folger flourished, and he was chosen to deliver the coveted Ivy Oration. It is perhaps no surprise that the scrapbook of such a dutiful, self-contained young man contains almost no mention of social life. One of the last items in Henry's scrapbook was marked "Senior Promenade." Twenty slots were available for partners' names on the prom dance card, but Henry's card was blank. A lone dried leaf is affixed to one page, vestige perhaps of some undisclosed walk in the woods or brief whimsy. Emily and Henry's college scrapbooks—preserving what each valued—were parallel tracks to a common destiny, though Miss Jordan was the more social one.

🌿 Rain poured down on October 6, 1885, as Emily and Henry were wed in the Westminster Presbyterian Church in Elizabeth, New Jersey. Mr. Jordan gave away his daughter, whom six bridesmaids, with Lillie Pratt as maid of honor, preceded to the altar. Two weeks after their wedding, a British Sunday newspaper published an article titled "The Mystery of an Autograph." The article about an autograph of William Shakespeare came to the attention of the Folgers, and the couple's Shakespeare collection was under way.

The Folgers shared a home with Henry's parents at the modest 72 Quincy Avenue, Brooklyn, before they rented their first house in 1895 at 212 Lefferts Place in Bedford-Stuyvesant. In 1910, they moved around the corner to rent a large six-story brownstone at 24 Brevoort Place. In 1929, after Henry retired from Standard Oil, they bought their first home at 11 Andrews Lane on the edge of the exclusive North Shore enclave of Glen Cove, Long Island. After her marriage, Emily stopped teaching at Nassau Institute but continued to lead Sunday school classes at the Plymouth Church in Brooklyn Heights.

Henry and Emily exchanged no love letters that we know of, yet after the wedding, they were inseparable. When Henry took the rare business trip, he sent laconic postcards to "EJF" from "HCF." From Abilene, Texas, in November 1910, one message—longer than most of Henry's missives—read "All in fine health and spirits."

As the couple pursued collecting Shakespeare, on several occasions Henry carefully respected Emily's preferences. He wrote a dealer, "Will you please have sent to my house in Brooklyn, 24 Brevoort Place, the Shakespeare bronze about which you saw me the other day? I will take it, provided, without fail, you send the one which Mrs. Folger saw." Writing another dealer, he made sure not to slight Emily's own choice: "My wife, when we were abroad last Summer, made quite an elaborate collection of similar souvenirs and she will not understand why I think it worth while to supplement what she has done, so I return it herewith."[26]

Folger's most assiduous bookseller, Dr. A. S. W. Rosenbach from Philadelphia, often saw the Folgers together: "She would hunt up bibliographical details and investigate difficult allusions, and frequently she would advise him to purchase a book or manuscript when he was wavering and undecided. It was a very rare and beautiful thing, this complete harmony with a husband's hobby, and I know of no more perfect example of it."[27]

Henry Folger always credited his wife. In a letter to book dealer John Howell he wrote:

> Mrs. Folger is quite an expert on Lincoln autographs, her father having been an official in Washington under Lincoln, she having a number of autographs, and she questions the authenticity of the signature in the volume of Shakespeare. I told her I thought you had a history of the volume to show the ownership from Lincoln down to the present time. If so, can you reassure us on the subject? Lincoln read Shakespeare, but, according to his own statement, specialized in *Macbeth*. As it happens, this play in your volume shows no indication of ever having been studied; it is one of the freshest plays in the book.[28]

Folger must have been pleased to present his wife as an expert, and, adding his own clever sleuthing, used her expertise to back Howell against a wall.

The Folgers were a couple that, for the most part, saw things the same way and delighted in looking in the same direction. But not always. In August 1910, Emily accompanied Henry on Standard Oil business to Paris. Like royal visitors, they stayed in the posh Hotel Meurice on the Rue de Rivoli overlooking the Tuileries. Like an ordinary tourist, Emily admired the Louvre's Winged Victory and Venus de Milo. She noted in her trip diary that her husband liked Notre Dame, but not as much as Westminster Abbey. While Henry found the French capital "dirty and disappointing," Emily "loved it."[29]

Emily's address book showed a woman prepared for all eventualities on their European jaunt, but especially for a grand spree. Yes, if it came to that, she knew where to find a watch repairman, druggist, and three doctors. Four addresses showed where she could have her hair done with Parisian flair, seven offered the latest fashions in ladies' hats, no fewer than fourteen listed pâtisseries, and twenty-one were tempting dress shops.[30]

A Christmas poem for "Dick" sweetly manifests Emily's playfulness and awareness of Henry's frugality despite a solid marital bond:

Dear Santa says he brought my man a fur coat
But on my life as I'm his wife, I'd not, sir, know't
'twas 1907
Exactly when Santa financed it.

He says I'll one day see a coat and picture,
Our joy and love continuing without mixture,
For 1908
Towards your portrait
His throne has chanced it.[31]

It seemed to Horace Howard Furness, Shakespearean scholar and editor and Emily's mentor for her master's thesis at Vassar, that the couple was perfectly suited to each other by common literary and scholarly tastes. "My dear Emily," he wrote, "thank you heartily for all your kind words. It is always a source of continual pleasure to me to reflect that there are in this world two such happy people as you and Henry, who can read and study side by side." Furness wittily addresses them: "Dear HenryandEmily (man and wife are one, and should not be separated even by hyphens)."[32] Charlie Pratt, Henry's boyhood chum, college roommate, and Standard Oil colleague, knew the Folger couple better than most: "I find much comfort in thinking of you, Emily and the steady unchanging philosophy of life which each of

Newlyweds Charles (standing) and Mary Pratt and Henry and Emily (in brimmed black hat) Folger, 1885. Two Amherst-Vassar weddings were the prelude for lifelong friendships, and fortunes, thanks to a common employer, Standard Oil. *By permission of the Folger Shakespeare Library*

you has never varied since I first knew you."[33] He spoke for others in recognizing the constancy and reliability of the Folgers' "marriage of true minds" after thirty-five years together.

Other measures of Henry's affection and concern for his wife appeared as they aged. Henry cared for Emily's state of health as much as for his own. While he hated to decline an invitation to see a New Haven performance of *King Lear*, he wrote a friend, "I must now give our personal health first consideration, for a time at least. I am afraid the trip might prove too fatiguing for one or both of us." Every spring from 1914 until 1929 a chauffeur drove them in the family Lincoln to the Homestead in Hot Springs, Virginia. Emily would take medical baths ordered by her doctor, use the pool, and go to the hairdresser. Henry golfed with his friends. Rosenbach would often try to tempt Folger to stop off at his Philadelphia bookshop en route

to or from Virginia, but Folger had clear priorities: "I cannot leave Mrs. Folger here alone. She is taking the cure." Ever the quietly attentive husband, Henry arranged for flowers to be delivered to their room. Henry selected gifts for Emily that he knew pleased her: necklaces of pearl and onyx, a cameo and a carnelian brooch, a diamond watch bracelet. He bought her silver from Tiffany's and Gorham's. If his choice did not please her, as in the case of some rings, he returned them.

A rare family recollection of the couple has survived in the responses to a questionnaire composed in the late 1970s by Folger Library docent Elizabeth Griffith. Folger Library director O. B. Hardison had urged Griffith to obtain direct family recollections with a view to producing a short biography of Emily. (Unfortunately, the project ended in its early stages.) Emily's nephew and close adviser Judge Edward J. Dimock told Griffith that the marriage was affectionate and happy; he could recall "no hint of a single quarrel, disagreement or misunderstanding." The judge considered that Henry was "completely dominant" but that Emily "submerged herself to his life and interests and appeared to be completely happy to do so. She gave herself ungrudgingly." Dimock believed that his aunt's "sweetness and generosity of spirit were remarkable and utterly genuine." He never heard any comment on the Folgers' childlessness or any reports of a miscarriage or a stillbirth. He believed that "building the collection and planning the monument to house it was totally absorbing, a real substitute for children."[34]

James Waldo Fawcett, journalist at the *Washington Evening Star*, often covered the Folgers and their library. Emily hired him to write Henry's biography; they got as far as assembling lists, notes, an outline, and considering Houghton Mifflin as the preferred publisher. Regrettably, after Mrs. Folger's death, Fawcett abandoned the project, which he had seen as a love story, writing, "The Library itself . . . is the enduring fruition of the romance of Henry and Emily Folger. It is a living proof of the eternal values of work and love." Elsewhere in the article Fawcett called the story of the foundation "an authentic romance without recorded parallel in the history of American philanthropic idealism."[35]

Touchingly, for such a reserved man, Henry Folger showed his enduring faith in Emily in a singular notarized document: "I hereby give to my wife, Emily C. J. Folger, all my books, autographs, pictures, prints and other literary property, being largely Shakespeareana, to be her own to use and dispose of as she may see fit; the same being absolutely free from all debt or incumbrance of any nature whatsoever."[36] Emily Folger was a bluestocking, an educated, intellectual woman with a scholarly bent. More than Henry's life partner, she was his intellectual soulmate. Theirs was a happy marriage that bore unbelievable fruit.

CHAPTER TWO

❧ ❧ ❧

Thou Lovest Me, My Name is Will

Smitten by Shakespeare

Make but my name thy love, and love that still,
And then thou lovest me, for my name is Will.

Sonnet 136.13–14

BRITISH BOOTS, NOT BOOKS, made imprints in North America only a few years
before Shakespeare died in 1616. Virginia was settled in 1607, Bermuda in 1609,
Newfoundland in 1610. More than a century passed before an amateur acting com-
pany put on the first Shakespeare play in America, a performance of *Romeo and
Juliet* in New York in 1730, after which interest in the Bard grew quickly. Virginia
and Alden Vaughan write that the first production of Shakespeare in America by a
professional acting company occurred in 1750.[1]

America's founding fathers shared the growing ardor for Shakespeare. In 1744,
Benjamin Franklin was responsible for a six-volume set of the Bard's works to be de-
livered to the library company of Philadelphia. In 1772, John Adams hailed Shake-
speare as "that great Master of every Affection of the Heart and every sentiment of
the Mind as well as all the Powers of Expression." In 1787, George Washington at-
tended a performance of *The Tempest* in Philadelphia. Thomas Jefferson wrote that a
"lively and lasting sense of filial duty is more effectually impressed on the mind of a
son or daughter by reading *King Lear*, than by all the volumes of ethics and divinity
that ever were written."[2] A copy of Shakespeare's 1623 First Folio slipped into the
country first in 1791. By the early 1800s, editions of Shakespeare's works were being
printed in Philadelphia.

Especially in New England, reading Shakespeare was acceptable, but performing
him was tempting the devil. Baptist, Quaker, Presbyterian, and Lutheran pastors
adjured parishioners to avoid the theater, which could lead to debauchery. In the
Puritan atmosphere of mid-eighteenth-century Massachusetts, fines were levied on
both theater owners and actors, a stigma that lasted more than a century. Groups
gathering for a serious reading of Shakespeare, however, escaped recrimination. The

Shakespeare Society of Philadelphia was founded in 1851, principally by lawyers, who gathered in formal attire for evening readings and literary discussion after the remains of an elegant dinner were cleared from the table.

Early Shakespeare in America often appeared in altered, highly popularized versions. New characters and dialogue were introduced. Dance and music were added. In some performances, texts were bowdlerized to refrain from offending prudish audiences. In the not-always-friendly rivalry between American and British actors, some dialogues became burlesque. Some plays suffered extensive cuts. Ethnic stereotypes arose when Shakespeare was performed in blackface with plantation dialect. Some plays were interpreted as pantomimes or minstrel shows.

Shakespeare's works gradually permeated the country, until the playwright was idolized like no other writer. As scholar Michael Bristol noted in 1990, "Shakespeare is an American institution." Bristol perceives a "massive transfer of authority and cultural capital to American society," where "Shakespeare has been identified with general or universal human interests, or to put it another way, with social and cultural goodness."[3] Emerson turned Shakespeare into a verb: "Now literature, philosophy, and thought, are Shakespearized."[4] The Folgers, together, would cement the identification of Shakespeare with a newly confident American culture—"our national thought, our faith and our hope," as Emily put it later.[5]

❧ Emily and Henry Folger grew up in the mid-nineteenth century, when many American family bookshelves held only two volumes: the Bible and Shakespeare. Eliza Folger sang Shakespeare songs to Henry in his infancy. Although Shakespeare did not figure in his grade school curriculum, Henry likely was first exposed to the Bard by Homer Sprague, an English teacher at Adelphi Academy.

When he was only seven years old, Stephen Lane Folger gave his oldest brother, Henry, his first Shakespeare. Homesick Henry was eighteen when the freshman first returned from Amherst to Brooklyn for vacation. The thick single volume of *Complete Works* was fresh off the press that same year at the Philadelphia publisher's, Lippincott.[6] Had any other seven-year-old brother ever chosen such a consequential present? On an end paper the recipient inscribed in a large hand in dark pencil, "Henry C. Folger Jr, from his brother, Xmas 75."

While the pages with plays and poems are practically unmarked, Henry filled the title page and the blank pages at the beginning and end of the book with quotes about Shakespeare, as he would later do in the commonplace books he wrote with Emily. His annotations are all in the small clerk's hand of his later years, not the larger handwriting displayed during his college letters home to his parents. He penciled lines in poetry and prose written by Hippolyte Taine, Thomas Carlyle,

Elizabeth Barrett Browning, Ralph Waldo Emerson, Abraham Lincoln, Charles Lamb, Thomas Babington Macaulay, and David Garrick, before ending from Henry Hallam's *History of Literature*, "The name of Shakespeare is the greatest in our literature; it is the greatest in all literature." Henry quoted Emerson more than any other author, selecting most passages from "Shakespeare; or the Poet" from *Representative Men* (1850).

On the contents page, it is easy to miss that various numbers of tiny dots are indicated with a pencil before the name of each play.

Five dots: *Hamlet*

Three dots: *King Lear, The Merchant of Venice*

Two dots: *As You Like It, Richard III, Henry VIII, Julius Caesar, Romeo and Juliet, Othello*

One dot: *The Tempest, The Merry Wives of Windsor, Twelfth Night, Measure for Measure, A Midsummer Night's Dream, All's Well That Ends Well, The Winter's Tale, Macbeth, Henry IV Parts 1 and 2, Henry V, Troilus and Cressida, Timon of Athens, Coriolanus, Antony and Cleopatra, Cymbeline, Pericles*

No dot: *The Two Gentlemen of Verona, Much Ado About Nothing, Love's Labor's Lost, The Taming of the Shrew, The Comedy of Errors, King John, Richard II, Henry VI Parts 1, 2, and 3, Titus Andronicus*

Do the dots indicate readings? Appreciation? Impossible to say. If it were the more numerous the dots the higher the ranking, Emily was unequivocal that *Hamlet* did not remain in first place. "*King Lear* was his favorite," she wrote after her husband died, "doubtless because of the patriarchal element which is its motivating force. Mr. Folger felt its power, received into his heart its message. Again and again he turned to it, working over its values with untiring zeal, pondering its integral components, exploring its reserves of beauty and truth. The characters of Cordelia and Edgar he particularly admired; the poor, storm-beaten old King he respected as a symbol of fatherly love and sacrifice."[7] Perhaps as the collector aged he resonated more to an older dramatic character.

Henry probably did not study Shakespeare with Rev. Heman Humphrey Neill, Amherst's only professor of English literature because Folger later reported, "Quite by chance I started the reading of Shakespeare without instruction, and continued it simply because it gave me so much pleasure." Writing John D. Rockefeller in 1895, he implied that he first applied himself seriously to Shakespeare in 1877. In a letter to the president of Amherst College in 1909, Folger disclosed with some irony that "My own interest in Shakespeare started from writing for a Shakespeare prize, offered at Amherst for only a year or two, which, by the way, I failed to get."[8]

Emily joked that her husband turned assiduously to Shakespeare because he was piqued at not winning the prize.[9] Folger's Adelphi Academy classmate William W. Davis served as president of the Shakespeare Association at Amherst; Folger did not join. Folger did join a Shakespeare discussion group, however, that took place in the room of his Brooklyn friend and Amherst fraternity brother, Frank Babbott, in 1877–1878. The group read plays aloud. Henry quoted Shakespeare in his papers, as his scrapbook indicates.

In spite of these earlier examples of exposure, Emily considered that Henry's epiphany took place on Wednesday evening, March 19, 1879, when he sat on the edge of seat 33A in Amherst's College Hall. President Seelye introduced the speaker to a sparsely attended audience: several students, a few professors, several townspeople. The lecturer had been in failing health for five years and would succumb to tuberculosis three years later. It was his final visit to the college. Slowly, his daughter Ellen helped to accompany to the platform the seventy-six-year-old Ralph Waldo Emerson. He did not speak of his admiration for Shakespeare but lectured on a different topic, "The Superlative or Mental Temperance." Fascinated, Henry found Emerson's language to be of rare elegance and inspiration. As Emily later put it, Emerson packed so much thought and beauty into condensed sentences that Henry considered them to *sound* Shakespearean.[10] Hearing frail Emerson in person made a profound, lasting impact on the senior, almost ready to make his way in the world.

The Folger Library has preserved Henry's twenty-five-cent ticket stub to the lecture in the Founders' Room. The Folgers also asked for a Shakespeare quote by Emerson from his poem "Solutions" to occupy pride of place over the immense fireplace in the reading room.

England's genius filled all measure
Of heart and soul, of strength and pleasure.
Gave to the mind its emperor,

and life was larger than before.
Not sequent centuries could hit
Orbit and sum of Shakespeare's wit.
The men who lived with him became
Poets, for the air was fame.[11]

In 1882, Henry started the first of nine hefty journals called "commonplace books," in which he noted memorable literary passages and references to books he read by English or American writers. This volume contains mention of Shakespeare in a quote from Emerson from *Representative Men*. He was steeped in Transcendentalist thought

from mid-nineteenth century America, as well as that of the Romantics and their descendants in England. He began the second volume in 1883, where he quotes Henry David Thoreau from *Walden*. The third volume in 1884 contains quotation of Shakespeare by Samuel Taylor Coleridge, Victor Hugo, William Hazlitt, and Horace Howard Furness. Commonplace volumes in the later 1880s include both Henry's and Emily's handwriting. On occasion, she entered a Shakespeare quotation or commentary and he offered an interpretation of what she had copied. Sometimes their notes are commingled, showing already the Folger brand of team effort. The fifteen hundred pages of these commonplace books show the breadth and depth of the Folgers' literary sensibilities. Emily's role as writer in the commonplace books increased over time, while Henry's waned. In addition, Henry made many marginal notations in a few books from his personal library that Emily presented to the Folger Shakespeare Library in 1933. Notable among these are: Emerson's *Essays* in the second series published by Houghton, Osgood and Company, 1880; the 1870 edition of *The Poetical Works of Elizbeth Barrett Browning* in the James Miller publication; and *On Heroes and Hero-Worship* by Thomas Carlyle in Chapman and Hall's 1840 edition. On the flyleaf of the last book, and dated December 1879, Folger copied Emerson's phrase, "There is no history, only biography."

Among the many aspects that made Shakespeare irresistible to the Folgers was his breadth. They took pleasure in enumerating the number of crafts and professions the Bard knew intimately. Their astonishment echoed the worldwide audience who admired Shakespeare's familiarity with many trades. Sailors praised his knowledge of the sea. Physicians marveled at his grasp of medicine, which anticipated Harvey's discovery of blood circulation. Authors wrote diverse treatises on Shakespeare and the law, the Bible, botany, ornithology, classical antiquity, art, music, and folklore. They wrote on Shakespeare the archer, the angler, the horseman, the tailor, the Freemason, the dramatist. As Henry Folger declared, "There is a long shelf of books in my library, every one a tribute to Shakespeare's technical knowledge in the line of which the writer is at the head. As he becomes master of a subject, each expert finds that Shakespeare has anticipated and gone beyond him . . . Truly he came nigh to being all things to all men."[12] In the Emersonian language that Folger so respected, one loved and read Shakespeare as "the universal poet, the supremest master of human utterance." Folger wrote that he praised or blamed many authors; reading Shakespeare, however, elicited only wonder.

Another object of the Folgers' veneration became the best theatrical interpretations of Shakespeare's works. The couple's admiration of the British actress Ellen Terry illuminates how they expressed their love for Shakespeare. Emily and Henry appreciated Terry's portrayals of Shakespeare's strong women: Portia, Lady Macbeth,

Juliet, Queen Catherine, Cordelia, and Beatrice. When Terry performed in New York, she often gave dramatic readings. In 1910, at the Music Hall of the Brooklyn Academy of Music, she spoke on "Shakespeare's Heroines Triumphant." Emily wrote up the appearance in a commonplace book. After evoking the church scene between Benedict and Beatrice in *Much Ado about Nothing*, which Terry considered the finest love scene in literature, Emily scrawled in the margin, "Don't we agree with her!"

In addition to their immense enjoyment of Terry's live performances, Henry eyed the script she used for the staged reading. Standing, she read her lecture from a folio written in her own hand. Several days later, the actress opened her fan mail. "I am very desirous," one letter began, "of adding one of the manuscripts from which you have been reading on your American tour, and if I might choose, I would ask for the one entitled, 'Shakespeare Triumphant.' Is there any hope that I could persuade you to let me have it? I would of course expect to pay for it." The letter was signed "Henry C. Folger."[13] Folger never obtained this piece. The Folgers also purchased a terra cotta bas-relief bust of Ellen Terry in an ebony frame, a phonograph recording of her voice, autograph letters, and several photographs of her in starring roles.

Intent on learning how actresses were drawn to playing Shakespeare, Emily did not always have as much luck as her husband in her quests for Shakespeare memorabilia. From Terry's manager, Emily received this response to a request: "Miss Terry thanks you for your kind letter and regrets that her many engagements will not permit her to write you as you wish. Miss Terry feels that if she were to just snatch a minute to write you, she would not be able to express herself as she would wish on what is really so long a subject."[14] From another favorite Shakespearean actress, British-born Julia Marlowe, Emily again failed to extract a direct answer. She received only a message that the actress was first inclined to study Shakespeare by reading the plays as a child. Henry was delighted to add to their collection several of Julia's costumes.

Emily did not relegate these wardrobe treasures to storage as she would a book; she wore them. Guests taking the baths at the Homestead in Hot Springs, Virginia, had to walk from their hotel rooms to the baths through long serpentine corridors. To complete this promenade with grace and dignity, ladies adopted the habit of dressing up, often in trimmed chiffons and elaborately embroidered silks. But Emily Folger's bath costume was unique: she donned the purple robe Julia Marlowe wore as Portia in *The Merchant of Venice*.[15]

Beneath the Folgers' relentless pursuit of such physical tokens of Shakespeareana lay their conviction that Shakespeare's writings were unsurpassed in literature, and a source of national inspiration to Americans. Henry did not use the word "idealism"

in his correspondence or the few writings he left, but Emily employed the term in 1932 when speaking about her late husband at the Meridian Club in New York. Mr. Folger "visioned the cultural value, the ethical and social value of the beauty and idealism of Shakespeare. The poet is one of our best sources, one of the wells from which we Americans draw our national thought, our faith and our hope." Although they deeply revered Shakespeare's aesthetic value, the Folgers also saw the poet as a model to inspire their countrymen. In the same address, Mrs. Folger told the audience that her husband "understood the relation of Shakespeare to the Bible and to English literature in general and to American idealism in particular. It fascinated him, just as it had fascinated Washington and Lincoln."[16] In a recent biography of Lincoln, Fred Kaplan confirms this by observing that much of Lincoln's powerful rhetoric rests on his veneration of Shakespeare's language.[17]

When Henry Folger commented on Shakespeare or the interpretation of his plays, he was not just devotee and collector but scrupulous student. Folger studied the plays intently and watched performances with a critical eye on the interpretation of the playwright's word. While generally a bashful, restrained man, Henry could be forward when interpreting the Bard. He confidently laid out an extensive interpretation to actor Hugh Sothern:

> The glory of your Hamlet is not so much that it is improved with time as that it is fast becoming your personal rendering of the part. And it is that which encourages me to venture a suggestion of a bit of "business" which I believe will approve itself to you as you have time to ponder it.
>
> The killing of Polonius always seems rather brutal and an extreme punishment for his incompetence as a royal advisor. To many it is the only unreasonable thing that Hamlet does. Now Shakespeare is never unreasonable and a slight change will set this awkwardness right. Hamlet promises to come to his mother's chamber. Then follows the scene of the King at prayer. Use for this the room to which Hamlet comes to meet the Queen, putting a priedieu in an alcove at the side. Hamlet enters expecting to find his mother and stumbles upon the King kneeling in this alcove. Hamlet and the King, in turn, go out. In a few minutes Hamlet returns calling to his mother as he comes. The audience will understand he calls to warn away the King so that he may see his mother alone. But Polonius has entered with the Queen and hearing this calling, slips into the alcove where the King has been kneeling, drawing the arras across it. When the Queen cries for help Polonius responds from the alcove and the audience understands at once that Hamlet thinks it is the King he is stabbing because he last saw him in the alcove. This gives Hamlet a valid excuse for his act (taking the audience into his

confidence) and eliminates what now seems brutal and bloody, blemishing Hamlet's nature as nothing else does. It is quite in accord with the original text and certainly with the spirit of the play.[18]

It is not known whether the actor agreed with Henry's suggestions. Folger succeeded with Sothern's leading lady and wife, Julia Marlowe, in an epistolary exchange about interpretation. In 1904, Folger wrote her to suggest an improvement in the potion scene in Act IV of *Romeo and Juliet*. She agreed to try it. In 1907, Marlowe wrote to thank Folger for his further recommendation in how to deliver the "worm i' th' bud" line in *Twelfth Night* (2.4.123).

The line "Now Shakespeare is never unreasonable" slipped easily from Folger's pen, indicating the extent to which he elevated the Bard to something near the voice of God. While perhaps reproachable for Bardolatry—a common phenomenon into the twentieth century—Folger supported his position tenaciously. In 1900, the Folgers thrilled to the first elaborate production of *Hamlet* in America in fifteen years. They were especially rewarded that year, when Sarah Bernhardt also starred in a French prose version of *Hamlet* in New York. After Hugh Sothern retired from the stage, the Folgers still attended the dramatic recitals he gave in Elizabeth, New Jersey.

Emily kept a play diary from 1906 until 1930, in which she offered wide-ranging analyses of 125 Shakespearean performances—including a few in Italian, French, and German—that she saw in New York and occasionally in Stratford-upon-Avon. Often she attended matinees with family and friends. Henry managed to accompany her to half of them. Several times she returned a week or so later to attend a second performance of the same play to see whether the actors had benefited from criticism. She recorded the names of the actors and actresses, which actors "caught the spirit of the play," their vocal quality, glibness of speech, eye contact, facial mobility. She noted whether the costumes were "well-colored" and "historically accurate," if the scenery was "poor" or "elaborate," whether the waits were long, if the actors were well made up, which actors required prompting, how many "lispers" or actors showed deficient elocution, the quality of the orchestration, what the critics—often the celebrated William Winter—wrote in the press about the theatrical interpretation, how full the house was, how many encores. In this remarkable collection of personal observations, Emily also recorded comments by people sitting near her. In Emily's view, the greatest sin was committed when the "true text of Shakespeare" was cut; she would scornfully write "Cut! Cut! Cut!" To the Folgers, Shakespeare was serious and inviolable. While in 1906, Emily found Julia Marlowe "at her best," the following year Emily considered her "stagey" and her costumes worn and dingy.

In 1909, both Folgers were still down on Julia. In her play diary, Emily mused, "We still think that Miss Marlowe doesn't comprehend the part. One critic says that she makes Cleopatra into a Julia Marlowe. Quite true."[19] In 1910, Emily found the actress "not poetical." Even the best actors and actresses sometimes failed to meet the rigorous Folger standards. The final entry in the play diary was not a play at all but a "talking movie." On February 5, 1930, Emily saw Douglas Fairbanks and Mary Pickford in the first American feature-length talking Shakespearean film, *The Taming of the Shrew*, created the preceding year.[20] Emily judged it as "Of course not Shakespeare, but entertaining. Besides, it's amazing what 35 cents can offer!"[21]

Family and friends speculated about which Folger was the driving force behind the dynamic duo. Referring to Emily's obtaining a master's degree at Vassar in 1896 on Shakespeare, her nephew Judge Edward J. Dimock held that Emily "would not have pursued an interest in Shakespeare" had she not married Henry.[22] Pointing out that the Jordan family could not have financed graduate study for Emily, he speculated that her deep interest in Shakespeare evolved from her relationship with her husband. The journalist James Waldo Fawcett, who worked closely with Mrs. Folger in the last years of her life, observed,

> Especially as Mr. Folger's collection of books by and about the great Elizabethan poet grew did Mrs. Folger prove herself his invaluable helpmate. In the beginning Mr. Folger probably had a slight advantage over his wife. But Mrs. Folger adjusted the balance by taking her M.A. degree in Shakespeare, the course being laid out by Dr. Horace Howard Furness. As the years passed Mrs. Folger's acquaintance with Shakespeareana became as full and detailed as her husband's. She was his librarian, clerk, and amanuensis. It was her responsibility to maintain a catalogue of books offered for purchase, of books actually bought, of books to be acquired. She read the booksellers' lists, marking interesting items for Mr. Folger's consideration. She regularly reviewed the periodical publications referring to Shakespeare. She collected thousands of clippings, papers, magazines, and pamphlets dealing with their special theme.[23]

Henry and Emily showed their intense, total commitment to Shakespeare in complementary ways. It is hard to imagine that their personal mutual devotion was not strengthened by this common passion. Many peers commented that for this childless couple the Shakespeare books became surrogate children. If "no profit grows where is no pleasure ta'en," then it appears that Henry and Emily Folger heeded Tranio's advice in *The Taming of the Shrew* to "study what [they] most affect[ed]" (1.1.40).

Emily achieved serious academic credentials. In 1896, she was one of only 250 women in the country to be awarded a master's degree. Her degree also drew the Folgers close to a couple with equal passion for Shakespeare, Horace and Helen Furness. Delighted that Emily was one of the rare Vassar B.A.s to study for a master's in English literature, the college administration had been initially at a loss to offer her a Shakespeare mentor. Vassar accepted that Shakespearean scholar Furness, although not affiliated with the college, propose a study outline for Emily, monitor her progress, and determine in absentia her readiness to receive an advanced degree. Her thesis title, "The True Text of Shakespeare," is a critical theme for the Folger collection. The Folgers' relentless pursuit to acquire numerous copies of the 1623 First Folio expressed, in large part, their desire to ascertain the most accurate, genuine original text from Shakespeare's hand. All the texts differed in some ways, and Furness was one of the first Shakespeare scholars to research the question of a true text. First Folio specialist Peter Blayney wrote that Emily's thesis contained no original thinking but followed "the then-prevailing rules by arguing, point by point, to an unexceptional conclusion."[24] Emily most likely undertook the graduate program in certain belief that the exposure to Shakespeare's First Folio would make her a more competent, useful partner to her bibliophilic husband.

On Good Friday every year, the Folgers traveled to Wallingford, Pennsylvania, for a short visit to the Furnesses for what their host jokingly called "endless Shakespeare gossip." The visits always included Shakespeare readings and commentary by the erudite Furness that would leave Folger spellbound. The two couples looked forward to these visits as the social and intellectual apex of their year. Helen Furness had published a book on Shakespeare's poetry. Before he died in 1912, Horace Furness edited eighteen of the plays in "variorum" editions—that is, volumes providing copiously annotated texts filled with critical commentary spanning generations. When the Folgers walked up the front lawn, Furness burst out the door to blast a welcome on his trumpet. He thanked Emily for the poems she had sent him. One of Furness's many letters to Emily—posted in small white envelopes sealed in black wax—read, "The picture you draw of working with your husband moves me deeply."[25] After the guests settled in, Furness proudly showed off some recent acquisition or improvement, such as a new fireproof room to house their valuables. After dinner, the two couples repaired to the library of 12,000 volumes on Elizabethan drama for deep discussion. Folger visits to the Furnesses brought alive the past. In the late 1880s, before they had met Furness, Emily and Henry had copied in their commonplace books Shakespearean commentary by Furness to ponder and discuss. One line read, "If there is one quality in which Shakespeare is forever Shakespeare, it is in the unity of his characters, in the thorough individuality, in the absolute truth

to themselves."[26] Furness had become mentor and friend to an inner circle of Shakespeare worshipers. When Furness died in 1912, he was holding a rare Shakespeare volume he had had specially bound as a gift to the Folgers.

When Henry Folger received an honorary doctor of letters degree at his alma mater in 1914, he called it the greatest honor of his life. In a statement of gratitude that revealed the Bard's allure for him, he wrote for an Amherst audience: "Collect Shakespeare, and you will soon find yourself in the very best company. I have prompt books, annotated and thumbed by the great actors—Garrick, Kean, Irving and Booth; volumes studied by the great poets—Robert Browning and Elizabeth Barrett Browning, Lowell and Walt Whitman, Southey, Gray and Burns; and those used by the great masters of prose, Dr. Johnson, Hawthorne, Thackeray and Scott. One volume is crammed with notes made by John Stuart Mill and Thomas Carlyle."[27] When the Folgers went to college, they read those great authors; a third of a century later, they owned significant parts of their personal libraries.

Folger read Shakespeare the way he collected books: slowly. He savored words and phrases, concentrating not only on sense but also how lines would sound on the stage. Emily easily filled scores of pages in her play diary comparing a recent performance with expectations and with her detailed memory of previous Shakespeare stage productions. The Folgers knew the material so intimately that it gave the couple limitless opportunities to rail or to praise different interpretations, to discuss and admire the original text. The inexhaustibility of the subject constituted for them a final proof of Shakespeare's genius. After Henry died, Emily looked deeply into what she understood to be her husband's attraction to Shakespeare:

> Henry Folger's original interest in Shakespeare was instinctive. It was a natural expression of his own spiritual character. The inner light of his mind was reflected in the age-dimmed but still bright mirror of the poet's work. Science affords no satisfying explanation of such phenomena. Certain souls respond to certain souls, but no theory yet evolved is competent to furnish a complete analysis of the relation. The rich collection of books and manuscripts which Mr. Folger formed was, in effect, a bridge between the man he was and the man Shakespeare must have been. A certain maturity of the spirit on Mr. Folger's part is implied. Small-minded men do not entertain such enthusiasm. I think nothing else, perhaps, could be said of my husband that would be most just or more comprehending than that he was capable of appreciating Shakespeare to the full.[28]

Only rarely did the Folgers take time away from dogged pursuit of Shakespeareana. Each spring, and sometimes in summer, they motored in their chauffeur-driven Lincoln to the Homestead in Hot Springs, Virginia, where Emily took the

baths and Henry played golf. From suites no. 527 and no. 529, which they booked each year, they heard the country birds and admired the flower beds. Their vacation was only partial, for their luggage held an abbreviated catalog of the Shakespeare collection. Henry kept up a vigorous correspondence with friends and dealers; he sent urgent cables and checks, trying not to miss any important sales.

On the Homestead stationery on February 11, 1918, Henry Folger wrote portentously to a real estate agent to inquire cautiously about purchasing land on East Capitol Street for an eventual Shakespeare library. After Henry died in 1930, Emily continued to make the voyage to "The Hot," as she called it, for her health, and to see the many friends the couple had made there. She would also stop in Washington, DC, to monitor the progress of construction at the Folger Library.

Eleven times between 1903 and 1923, the Folgers took a slow cattle steamer across the north Atlantic to make pilgrimages to Stratford-upon-Avon. They made these voyages with John Robinson, a venerable, white-bearded, Shakespeare-spouting sea captain of the SS *Minnehaha*, operated by the Atlantic Transport Company. The Folgers preferred to travel across the ocean aboard this freighter with their friend at the helm. The 250 first-class passengers were kept far from their bovine traveling companions. Other bulky cargo included automobiles and grand pianos. The Folgers looked forward to the Sunday services with a choir made up of the stewards. Wrapped in a heavy coat, stretched out in a deck chair, Henry Folger read his favorite play for ocean voyages, *The Tempest*: "It is fragrant with salt spray picked up from wave crests by driving winds. The enchanted isle of Prospero seems to have risen out of the surf."[29]

No one accompanied the Folgers to the pier for their departures to England. That's how they wanted it. In contrast, when Samuel Clemens brought his family back to New York on the same SS *Minnehaha* in 1900 after three years in Europe, a clutch of reporters met them as they descended the gangplank.

In Stratford, the Folgers stayed at the Golden Lion Hotel, called Ye Peacocke Inn in Shakespeare's time.[30] They enjoyed plays at the Summer Shakespeare Festival and visited the Bard's birthplace. In London, they consulted rare Shakespeare volumes in the British Museum and sealed major book deals. At the Berkeley Hotel, the Folgers met John Anderson of Anderson Galleries, a New York City auction house. Emily jotted diary notes about her British stays. From their first trip in 1903, Folger brought back a First Folio.

One Christmas, Captain Robinson gave the Folgers his painting of Anne Hathaway's cottage. Touched by the gesture, Folger assured the captain that the painting hung in honorable company in the Folger house: "You may guess how satisfactory the painting is when I tell you that it has been hung over Hayman's portrait of Quinn as Falstaff, painted from life and used as the basis of the well-known engraving,

and at right angles to Sir Joshua Reynolds's portrait of Garrick."[31] The Folgers sent Robinson a complete set of the Furness variorum editions of Shakespeare. They gave Captain Robinson and his family seeds from Shakespeare's garden in Stratford, and Renee Robinson offered Emily poppy seeds to take back to America. A special treat for the Robinsons occurred when they motored from their residence in the north-west London suburb of Watford to Stratford-upon-Avon as guests of the Folgers to attend a Shakespeare performance.

The Folgers joined many Shakespeare societies in England, among them the Malone Society (named after the celebrated late-eighteenth–early-nineteenth-century editor of Shakespeare, Edmond Malone) and the Oxford Bibliographic Society. In Stratford-upon-Avon, they were asked in 1909 to subscribe to the Shakespeare Club. The rules: "to read, study, and discuss the works of the Poet and the historical memories of his town and neighborhood; also to encourage the delivery of original papers relating thereto, and in other ways, to do honour to the memory of the Poet." The mayor of the borough, who served as society president, handwrote from the "mayor's parlour" an elegant invitation festooned with his red insignia. "I need hardly say, as you are a student and admirer of our illustrious townsman I shall be delighted to propose you at our next meeting."[32] Both Folgers joined the club. When in 1929 Stratford mayor Sir Archibald Flower proposed Henry Folger to be elected governor of the Shakespeare Memorial Theatre, Folger declined. "I know my limitations, and am already quite overwhelmed with the work which has to be done—and will not be done by anyone if I fail to do it."[33] The British realized that American support for Shakespeare organizations and causes in England was substantial. English and American Shakespeareans united in successful efforts to rebuild the Stratford theater that burned in 1926. In America, the Folgers showed their admiration for Shakespeare by supporting various institutions dedicated to spreading the Bard's fame.

In America, they joined the American Shakespeare Foundation, the Shakespeare Club, and the Shakespeare Association of America in New York City, as well as the Shakespeare Society and the National Shakespeare Federation in Washington, DC. Federation officers wrote Folger a moving letter on May 14, 1930, less than a month before his death, reporting how Shakespeare's birthday was celebrated for the first time on the site of the Folger Library. While Folger disliked publicity, he must have felt a tinge of excitement that finally his long-planned Shakespeare memorial was taking shape. While the Folgers regularly paid dues to these organizations, they did not attend meetings or respond favorably when asked to loan materials for special exhibits. Not only were they totally focused on their collecting, their treasures were inaccessible, crated and stored. In April 1930, the Folgers heard from the Shakespeare Society of Philadelphia. A letter reported the death of Horace Howard Furness Jr.,

the society's dean. He knew Shakespeare's plays almost by heart and had carried on his father's work of elucidation through new variorum editions of Shakespeare's texts.[34]

Aware that Shakespearean gardens had grown very popular in the United Kingdom, the Folgers set about sponsoring offshoots in America. Frederick Law Olmsted Sr. designed two Shakespeare gardens in New York that the Folgers financed: in Prospect Park in Brooklyn and Central Park in Manhattan. Since Shakespeare's plays mention more than two hundred plant varieties, many gardeners find making gardens of them a challenge. The Permanent Shakespeare Birthday Committee of New York arranged for planting Shakespeare gardens on more than a dozen public school grounds. Ever the meticulous scholar, Folger insisted that park authorities prepare identifying labels for every plant. In Brooklyn, plant labels included excerpts from plays and sonnets, introducing children to botany and the Bard at the same time.[35]

Henry Folger turned to his alma mater when contemplating how he might deepen students' appreciation of Shakespeare. In November 1909, he wrote Amherst president George Harris with an offer: "I would like to do something to stimulate the reading and study of Shakespeare at Amherst."[36] The *Amherst Student* announced the "Folger Prize" for advanced students. First prize winner received $100, second $50, and third $25. Essays had to be at least ten thousand words, typewritten (a novelty), and submitted under a fictitious name, with identification of the author in a sealed envelope. In May, the English Department received the first batch of essays, with submissions by "Hyperion," "Dante," and "Cicero." Folger imposed one condition: the college must send the winning essays to him for his Shakespearean library, a mighty tribute to the undergraduate authors.

The donor managed the prize program with characteristic zeal and direct involvement. Disappointed, he admitted, by the standard of Shakespeare study in his Amherst days, Folger hoped many students would submit essays, a hope often disappointed. The crop of essays was especially lean in the war year of 1917, when students were dispersed on agricultural assignments or in military training. Folger communicated directly with George B. Churchill, head of the English Department, as well as with several of the prizewinners. He queried Churchill periodically to be sure the college still thought his essay project worthwhile. Churchill understood that the number of submissions was a factor of the extra work the contest essay demanded. Nevertheless, he enthusiastically approved of the incentive as a worthy climax to the Shakespeare course. When a prizewinner sent a letter of thanks to Folger, the collector wrote back, acknowledging that even as an Amherst student he had vowed to offer some Shakespeare prizes as soon as he had the means to do so. Faithfully each year, Folger sent a $175 check to Amherst for prize money.

Miniature color-tinted portrait of Henry Folger with bushy thicket, 1930. *By permission of the Folger Shakespeare Library*

Miniature color-tinted portrait of Emily Folger with brooch and necklace, 1931. *By permission of the Folger Shakespeare Library*

Buoyed by his success with the limited prize program, Folger wrote the Amherst president to suggest broadening students' exposure to the poet by creating a Shakespeare Room in the college library. The college responded with delight but asked that Folger agree instead to underwrite the establishment of an English reading room. (The college had already received financial backing from other alumni to purchase thousands of volumes for eleven other departmental collections.) Folger agreed immediately, and sent crate upon crate of English literary works, often duplicates from the many estate sales he had won at auction. One shipment consisted of forty-three volumes, a set of the Praetorious photographic facsimiles of the Shakespeare quartos. Folger explained to Churchill that "these volumes seem to me to be more serviceable than the original quartos." The gem of Folger's literary gifts to the Amherst library was two genuine leaves from a Gutenberg Bible. The college president thanked Folger profusely for the leaf, which was in exceptional condition, with "three chapter initials, as well as the very rare head watermark."[37] Folger drew the line in his largesse to Amherst campus life and resources, however, when fellow alumnus and Shakespeare collector George A. Plimpton suggested, "I hope sometime we can arrange for you to go to Amherst and give a course of talks on your collection. I am sure it would be most interesting and helpful to the men."[38] Henry Folger, besides being averse to the limelight, could not spare the time; he was nursing his plan for a far grander contribution.

In 1931, as the Folger Shakespeare Library was finally taking shape in Washington, lead architect Paul Cret, from his perspective, spoke of Henry Folger's love of Shakespeare:

> It was his love for the noble beauty of Shakespeare's poetry and his eagerness to inspire that love in others, which guided the whole development of his plan for the Shakespeare Library. The merely practical purpose of the merely practical man would have found their realization in an institution without interest for anyone but Shakespearean specialists. But Mr. Folger wished for something wider in its appeal—not a study hall for scholars only, but a shrine for his marvelous treasures that might awaken some sense of Shakespeare's living value even in the unlearned and unread. Thus, his project grew from a conception of a simple reading room into that of the building as it stands today.[39]

Cret worked closely with Henry Folger for only a matter of months, but it was long enough to take the measure of the man. When Henry and Emily Folger wrote their wills, bequeathing most of their estates to a well-endowed library in the nation's capital, it was the ultimate sign of their love for one another and for Shakespeare.

CHAPTER THREE

✻ ✻ ✻

Wise, Circumspect, and Trusted

Five Decades at Standard Oil

I do profess to . . . serve him truly that will put me in trust.

King Lear, 1.4.14–15

Be wise and circumspect.

2 Henry VI, 1.1.164

THE FIRST STORIES that the young child Henry Folger, in 1860, heard from his father about oil were about whales, not wells. For more than a century, the Folger family had plied the whaling trade on Nantucket Island, twenty-four miles off the Massachusetts coast. Henry's grandfather, Samuel Brown Folger, was a master blacksmith who crafted harpoons and lances for hunting sperm whales and sharp spades for cutting strips of blubber from the dead creatures. After flensing, the blubber was boiled down to produce sperm oil, a yellowish oily liquid that became candle wax and fuel for lamps. These products were an improvement over placing beef-tallow-soaked cloth in a dish and setting it aflame. For good reason, most people around the globe turned in at dusk and rose at dawn.

The Pennsylvania oil rush of 1859 involved drilling wells in the ground, a technique pioneered by Edwin Drake to obtain "rock oil"; this technological development spelled the end of what Nantucket author Nathaniel Philbrick called "a vast field of warm-blooded oil deposits known as sperm whales." Underground reservoirs of crude oil now served as the raw material for kerosene lighting. Cleaner than whale oil, kerosene was plentiful and reliable. Kerosene lamps reset man's clock, allowing people to extend and reconfigure their days by adding time for more labor, reading, travel, courtship, family, and diversions. Crude oil and kerosene in the 1860s and 1870s, however, were dangerous. Deadly problems could arise during refining and transportation, and incorrectly refined kerosene could kill. Five to six thousand oil workers, users, or bystanders died every year in explosions. In addition,

kerosene often smelled bad and its effectiveness fell as the lamp's interior glass chimney became coated with film.

Despite its early shortcomings, kerosene lighting became so popular that it provided steady profits for firms that successfully refined and marketed it. Kerosene made the founder and largest stockholder of the Standard Oil Company, John D. Rockefeller, extraordinarily wealthy. But then came electricity and the incandescent light bulb. When demand for kerosene shrank in the late nineteenth century, Standard Oil Company shifted gears, capitalizing on its diversity of crude oil byproducts. The firm turned to refining petroleum in service of another invention, the internal combustion engine. As it turned out, refined petroleum proved far more lucrative for propelling ships, trains, autos, and aircraft than it had for lighting.

As the world's military forces built up in the years before World War I, strategists concluded that coal-powered ships were outmoded. Aware that the Germans were building an oil-powered armada, Winston Churchill, First Lord of the Admiralty, convinced the Royal Navy that its vessels, too, should burn fuel oil rather than coal. Petroleum had evolved from a useful commodity to a vital determinant of global power. Oil changed warfare forever. In 1916, the first gasoline-powered tank saw action at the Battle of the Somme. The same year, in San Francisco, an oil tanker was christened and later carried refined oil products to Europe in convoys with a naval armed guard aboard. Its name was the SS *H. C. Folger*.

❦ In Cleveland, in 1870, John D. Rockefeller and Henry Flagler founded the Standard Oil Company of Ohio. The two ambitious young businessmen recognized the usefulness of oil and its byproducts, if quality and safety could be assured. They realized that they should look into the existing refineries and extensive markets of the populous Northeast, where a lucrative export trade could be based, and zeroed in on the world's largest kerosene refiner, Charles Pratt, who had developed more than fifty refineries along the banks of Newtown Creek, an estuary between Brooklyn and Queens that emptied into the East River. The creek ran through Greenpoint, the northernmost section of Brooklyn. Pratt, the owner, was already marketing around the world his high-quality "Astral Oil" kerosene under the quaint slogan "The holy lamps of Tibet are primed with Astral Oil."

Rockefeller bought out Pratt in 1872, swearing him to secrecy about the deal in characteristic fashion. The purchase absorbed Pratt's seaboard refineries and dock properties from which refined products were shipped in tin cans all over the world. In 1880, the founders moved operations to Manhattan, where Standard Oil opened offices at 140 Pearl Street. Rockefeller and Flagler frequented a lunchroom down the street at 128 Pearl, right above Pratt's office. With his sale to Rockefeller, Pratt

had become a major Standard Oil stockholder, a director, and very senior executive. The oil giants Rockefeller and Pratt saw eye-to-eye on few issues, but they did share four characteristics: they were fervent Baptists; they abhorred waste; they paid extreme attention to details; and they built their companies by carefully selecting and training assistants and successors. A taciturn, cautious man with a short, sandy chin-beard, Pratt felt uncomfortable with Rockefeller's aggressiveness.

Rockefeller set the tone for the daily executive meetings over lunch in the boardroom, festooned with fishing and hunting trophies and overlooking New York harbor. Establishing a seating pattern that lasted for years, Rockefeller strategically allowed Pratt, his senior, to preside. Managing partner Henry Flagler, ten years older than Rockefeller, sat on Pratt's right. Then came Rockefeller, and next to him sat John Archbold, who would succeed Rockefeller as head of the company. Archbold was short and stout, with a twinkle in his eye. He was asked once about his duties as a Standard Oil director. He replied obliquely, "I am a clamorer for dividends. That is the only function I have in connection with the Standard Oil Company." Archbold narrowly escaped an assassination attempt in 1915, thanks to the head gardener of his Tarrytown, New York, estate who discovered four sticks of dynamite hidden in a rut on the driveway.[1]

Henry Flagler was a tall, handsome man with hair parted in the middle, intense blue eyes, and a bushy mustache. His first fortune came from distilling whiskey in Ohio. Later, as the principal contract writer at Standard Oil, Flagler was a key partner due to his knowledge of the law and government relations. He and Rockefeller *were* the executive committee, where they set the pattern: major company decisions made quickly by a small group. The first president of Standard Oil of New Jersey, Flagler felt overshadowed by Rockefeller and yearned to control his own enterprise. He left the company early to become a railroad and real estate magnate in Florida.

During the 1870s, Pratt kept close interest in the welfare of Henry Folger, the Amherst roommate of his eldest son, Charlie. Henry had been forced to leave college in his junior year as his father could not afford the tuition, enrolling in the City College of New York for a few months and living with his parents. The Pratt family loaned Henry money so he could return to Amherst to complete his undergraduate education. Documents from Folger's college days include promissory notes demonstrating that, before he was twenty, he was practiced in the mechanics of borrowing with interest, repaying loans, and saving. Of necessity, he had begun to build the financial skills that would serve him well.

As Charlie Pratt's and Henry Folger's graduation from Amherst approached, Charles Pratt offered positions in his oil company to both young men. Charlie accepted immediately. Henry was considering two other possibilities. He had been

invited to teach public speaking in Minnesota, and Amherst wanted him as a tutor for undergraduates.[2] Henry's hesitation suggests that money was not his major objective, though he was unusually frugal. Learning and literature exerted equal force on him.

At last, Folger decided to attend graduate school in New York. His parents were in no position to help their eldest son financially, beyond providing room and board. Folger was accepted into the law school at Columbia College. He arranged to take night courses, leaving him free to work for Pratt's company during the day. Consequently, less than a week after receiving their Amherst diplomas, the two young men reported for work at Charles Pratt & Company. After two years, Henry was admitted to the New York bar. By then he had also repaid his college loan from the Pratts. While he might have sought a position in a law firm, he chose to stay at Standard Oil.

❧ Starting as clerk in Pratt's Queens County Works in 1879, Folger began to learn all aspects of the oil business. He absorbed masses of data, reports, charts, and tables, many of which related to the oil company's products. The Queens works' products were diverse and numerous; Pratt made twenty varieties of paraffin wax, seventy-five types of grease, and three hundred grades and sizes of candles, as well as other goods.

By the early 1880s, Rockefeller had put in place one of his most significant concepts for effectively managing a growing, diverse multinational enterprise: the use of departments or divisions, called "committees." Each committee specialized in one key activity. Early committees included case and can, cooperage, domestic trade, export trade, lubricating oil, manufacturing (now called refining), and transportation.[3] Other committees—such as securities and natural gas—were added as needed. The committees provided expert recommendations about their business areas to the most senior company committee, the executive committee; committees also developed "best practices" and guidelines for company operations.

In 1881, Folger was assigned as the first statistical clerk in Standard Oil's manufacturing committee, reporting to chairman Henry H. Rogers. Eyes close-set, hair parted down the middle, Rogers sported a long, bushy mustache. Charles Pratt had brought Rogers into the firm. The Pratts, Rogers, and Folger formed a clique at Standard Oil. Folger's natural talents and training in Pratt's Works combined to help him develop new ways to analyze Standard Oil business issues. He had inherited from his mother a natural aptitude for numbers. Colleagues at Standard Oil called him a mathematical genius. He relished statistical thinking and figures, which he set down in his small, fine hand.

Very early in his career, Folger made a major improvement in the firm's system of collecting and using data. In the record book known as "Manufacturing Book

A," he presented data on all phases of crude oil processing at the refineries of various subsidiaries. Folger's system, for the first time, noted and recorded comparative yields and costs. Armed with this information, the manufacturing committee could optimize petroleum flow through the subsidiaries' plants and scale manufacturing according to crude oil supply, market conditions, and demand for refined products. That same year, 1881, Folger began to send the secretary of the manufacturing committee periodic reports on individual products. He produced annual, semiannual, quarterly, and monthly reports on kerosene, naphtha, wax, and lubricating oils.

In 1882, the interests of stockholders in Standard Oil and several dozen affiliated companies were transferred to a trust formed under Ohio law, the Standard Oil Trust. At first, only forty-one men owned shares in the trust. Still a man of modest means, Folger was not among the fortunate forty-one. Nevertheless, he was gaining recognition through his widely distributed plethora of data-laden memoranda, using red and black ink to make his charts more readable. By 1886, Folger's work and innovations were rewarded by promotion to secretary of the manufacturing committee. Over time, the mandate of the manufacturing committee grew broader—encompassing the study of refinery processes as well as plant design, depreciation, customer demand, fuel charges, and labor issues.

The ambitious Folger regularly copied Rockefeller on his correspondence with senior members of the manufacturing committee. In these memoranda, Folger traced oil production in number of barrels by refineries in Baltimore, Philadelphia, and New York, highlighting increases and decreases from the previous year. He suggested that the company engage more oceangoing vessels in New York to boost petroleum product exports. One Folger message of 1885 prompted Rockefeller to send back a congratulatory letter composed on that new device, the typewriter:

H. C. Folger, Jr., Esq., No. 26 Broadway, New York

Dear Sir;

I am in receipt of yours of the 19th inst., with the interesting statement of the reduction of cost of manufacturing, being a copy of your communication to Mr. Barstow, Secretary of the Manufacturing committee, of the 16th inst.

I am much gratified. Let the good work go on. We must ever remember we are refining oil for the poor man and he must have it cheap and good. Please present my congratulations to the Manufacturing Committee, and say that I am confident we shall continue to make progress in different ways in our manufacturing department.

Yours truly, John D. Rockefeller, President[4]

From his vantage point surveilling activities of all Standard Oil committees, Rockefeller often dispatched brief messages to encourage, extol, and sometimes interrogate his staff. He would occasionally insert his professed aim to make oil "cheap and good" for the poor man. At a time of great formality in letter writing, even among close friends and colleagues, Rockefeller addressed his letters to Folger "Dear Sir" or "My dear Sir" for a decade before he adopted "Dear Mr. Folger."

While Rockefeller's prolific memo-writing was legendary in the company, Henry Folger must have been runner-up. He sent several thousand memos, each one carefully numbered at the top. Many not only transmitted information but also suggested uses for the data they contained. For example, Folger compiled data to support the argument that profits could be fattened by shipping more toward the eastern United States and less toward the west. In 1893, he analyzed raw U.S. Department of Treasury statistics showing refined oil production from 1864 through 1891 across the country. Finding the 1891 figure, astonishingly, forty-eight times that of 1864, Folger wrote and circulated memorandum no. 4645 to share this information.[5] Rockefeller came to depend upon the wise and circumspect Folger, twenty years his junior, for his analytical skills and so much more. Like Lear's faithful Kent, Folger would "serve [his boss] truly," validating Rockefeller's decision to "put [him] in trust."

One key aspect of the oil industry Folger followed conscientiously was the effort by scientists and engineers to propose and patent technical improvements. Aspiring inventors' ideas sent to the company came to the manufacturing committee. Petitions suggested better distillation devices, deodorizing processes, cooling systems, pumps, valves and tanks, and more efficient use of waste products. Folger dictated prompt, courteous replies to petitioners. When they sought subsidies from Standard Oil to test their inventions, Folger advised them that the company would consider testing only after an invention had been patented. For years, Folger subscribed to the U.S. Patent Office's monthly announcements of new patents to keep abreast of innovations.

By 1890, Folger knew all aspects of the petroleum business so thoroughly that when the Chambers Encyclopedia of London solicited an article from the company on the industry, the firm assigned Folger to write it. Three years later, he published a piece on "Petroleum: Its Production and Products in Pennsylvania."[6] In these articles, Folger demonstrated his mastery of the technical details of oil manufacturing: distilling and refining crude oil, the use of steam stills, treatment with chemicals and washing, and the manufacture of lubricating oils. Although not a roughneck who had toiled in a production field or refinery before rising through the ranks, Folger had acquired deep knowledge of the manufacturing process and, indeed, all aspects

of the oil business. Emily Folger noted after her husband's death in 1930 that "Only recently I discovered among his papers a notebook with maps and descriptions of the important oil fields in the world. It had been laboriously compiled. But it was but a fragment of evidence of Henry's thoroughness of study and earnestness of purpose."[7]

Folger was well aware of growing popular opposition to business trusts, hostility that resulted in the 1890 passage of the Sherman Antitrust Act, intended to curb monopolistic abuses associated with the trusts. Shortly after this law was enacted, the Supreme Court of Ohio effectively ordered dissolution of the Standard Oil Trust, and the trust's stockholders once again became stockholders of each of the companies whose stock the trust had held. Still, the committees Rockefeller had established continued to function as before.

In 1899, the company promoted Folger from secretary to chairman of the manufacturing committee. Arguing for his rise in the firm were outgoing chairman Rogers and Rockefeller's early, close associate John Archbold. Also in 1899, Standard Oil of New Jersey, a major operating company, became the holding company for the many companies whose stock had been held by individuals after the dissolution of the Standard Oil Trust. As a result, these individuals received Standard Oil Company of New Jersey stock and ultimately grew enormously wealthy.

In 1904, Folger was named assistant manager of Pratt Oil Works, a kerosene refinery in Brooklyn near the East River which his old patron had owned.[8] Realizing that their promising employee had no background in actual oil business operations, Standard Oil's senior executives most likely thought a line job would give Folger useful hands-on experience and operational responsibility. One night, a fire broke out in the oil works. Folger rushed to the scene, taking along Frederick S. Fales, assistant chairman of the manufacturing committee. Many years later, Fales sent to Emily Folger her husband's fire line badge, reminding her that Folger had stayed up until midnight with Engine Brigade no. 11, and on his way home had ordered cakes and doughnuts sent back to workers at the site.[9]

In 1908, Folger was elected assistant treasurer and one of sixteen directors of the Standard Oil Company of New Jersey, or "Jersey Standard." This major promotion made Folger one of the men who tightly controlled all Standard Oil activities. Keeping tabs on the affiliated companies of Jersey Standard constituted a huge undertaking for Folger. Rapidly expanding in America and abroad, the Standard Oil Company had made exhaustive use of subsidiaries and affiliates, in part due to early U.S. corporate law, which forbade companies to operate across state lines.

In his new role, Folger performed crucial services for the company. One of the most important was to prepare the firm's annual financial returns. He also provided

earnings and other financial analysis with respect to individual affiliates, as well as information on every stock sale. He calculated and circulated data on crude oil stocks, including their cost and production variations.

Later in 1908, Folger was elected to the all-powerful executive committee, which met every morning at ten. Members turned to Folger for his advice and recommendations on the many issues facing a growing company: how to manage risk, reduce manufacturing costs, and assess the relative value of oil fields in various states. Rockefeller greatly appreciated Folger as a capable business analyst who was always extremely thoughtful and analytical on issues that affected the future of the company. Although Folger was never assigned to the company's legal department, as a trained attorney he felt comfortable interacting with that department, especially on matters drawing public notoriety. In 1909, for example, Rockefeller thanked Folger, writing, "I like your logical communications to the lawyers, copies of which you enclosed."[10]

The death of Henry Rogers in 1909 rocked the Folgers. Rogers had championed Folger as an outstanding candidate to become company director and had become Henry's mentor after Charles Pratt died in 1891. Emily wrote that Henry "admired and loved H. H. Rogers."[11] The two differed in many ways. While Folger was unpretentious and self-effacing, Rogers had a magnetic, flamboyant personality. Rogers exuded charm with his "dash, glitter and wit." The quick-to-anger Rogers was a poker player and a gambler; Folger was neither. Folger acted deliberately, Rogers brashly: piqued with Rockefeller, Rogers surrendered all his Standard Oil stock. But he and Folger shared many qualities. Both men were able administrators, and they admired each other's hard work. Rogers declared to a journalist, "H. C. feels neglected if he hasn't a dozen men's work to do."[12] Philanthropist Rogers financed Helen Keller's education and saved Samuel Clemens from bankruptcy.

Despite being an employee with growing responsibilities, and someone who was considered an affable colleague, Folger had the company reputation of a loner. He eschewed the executive dining room, preferring to munch an apple during a lunchtime stroll in Battery Park. Colleagues remarked that even in the coldest weather, Folger rarely wore an overcoat; perhaps his sturdy New England constitution kept him warm. He bought peanuts to feed the pigeons in winter. As he circled the park, was he pondering how much to bid for a Shakespeare item?

Folger often stopped at the barber shop on the first floor of company headquarters at 26 Broadway on his way back from an invigorating stroll. Senior barber George Rohrer told how, after a trim, a distracted Folger left a book on the counter. Rohrer hastened to deliver it to him. Folger thanked him profusely. Rohrer ruefully noted that, although the recovered book might have been a volume worth $20,000,

Folger offered no tip.[13] His interest in Shakespeare was well known in the office. As one colleague remembered, "Time and again I have looked out to see him in a small anteroom handling with loving care some precious Shakespeareana. He was like a boy playing hookey from the petroleum business for a few minutes to indulge his passion for his collection."[14] At the end of the day, Folger walked to Fulton Street and took the elevated train over the Brooklyn Bridge. He got out at Franklin Avenue and walked to Brevoort Place, the first cross street to the south.

Folger joined several headquarters inspection teams that toured oil properties and facilities around the country. In 1910, he visited oil sites in Kentucky, Nebraska, Nevada, Utah, Colorado, Wyoming, California, and Texas. He reviewed and analyzed manufacturing issues, complementing the work of other team members who examined financial reports, technical issues, and marketing questions. Together, the team advised refinery managers on matters such as how best to enlarge a plant and how to improve labor relations. Folger shared no business details with his wife; the many picture postcards Henry sent to Emily from points along the way reported merely "beautiful day" and "all in fine health and spirits."

The first decade of the twentieth century saw zealous journalists intent on revealing injustice, corruption, and other evils in politics and business. They found an audience in President Theodore Roosevelt, who in 1906 used the term "muckrakers," after the expression "to rake muck" used in Bunyan's *Pilgrim's Progress*, to describe such writers. One was Ida Minerva Tarbell. Born in the oil region of northwestern Pennsylvania, Tarbell first heard of injustices in the oil business from her father, an oil worker in Titusville. She grew up with a visceral animosity toward the first American business trust, Standard Oil. Tarbell entered Allegheny College as the only woman in her class. During her prolific writing career, which made her America's first famous woman investigative journalist, she sighted John D. Rockefeller in her crosshairs.

Tarbell proved to be a meticulous investigator who was also able to explain the complicated nature of a large industry in terms everyone could understand. Samuel S. McClure serially published Tarbell's attacks on Rockefeller and the Standard Oil Company in *McClure's Magazine*. From 1902 to 1904, readers lined up to purchase nineteen issues containing her attacks as they appeared on newsstands. Even vociferous Tarbell, however, was obliged to recognize Rockefeller's genius as a king of industry, characterizing his genius as both "legitimate and illegitimate greatness." She acknowledged his "revolutionary management" techniques in successfully creating a smoothly operating enterprise despite its myriad worldwide parts. She concluded that the Standard Oil Company was as centralized as "the Napoleonic government." Mr. Rockefeller is "like all great generals: he never fails to foresee where the battle is

to be fought; he never fails to get the choice of positions."[15] Nevertheless, in her view, Rockefeller's illegitimate actions far outweighed the good they may have done. Her litany of his malpractices included rebates, bribery, blackmail, espionage, intimidation, secret agreements, underselling, price manipulation, and malicious litigation.

As the Standard Oil Company tightened its hold on the American oil industry, Rockefeller—far more than Folger or other senior company executives—became the object of intense criticism in Congress, the courts, and the press. Rockefeller turned to Folger as well as to his legal department for advice on how to defend the company, "so that in any event we would not be caught napping."[16]

Finally, in 1911, due in part to Tarbell and after the "greatest legal tussle to that date in the industrial history of the Republic," the Supreme Court ordered the Standard Oil Company of New Jersey to split up. A Supreme Court spokesman announced the judgment in succinct terms: "Seven men and a corporate machine have seized unlawfully the second greatest mineral product of this country, and are converting it into mountainous private fortunes. For the safety of the Republic, we now declare that this dangerous conspiracy must be ended by Nov. 15."[17]

The decision points up the prescience of Shakespeare's "Commodity" speech in *King John*:

> That smooth-faced gentleman, tickling Commodity,
> Commodity, the bias of the world—
>
>
>
> Gain, be my lord, for I will worship thee! (2.1.601–2, 626)

To comply with the decision, Standard Oil of New Jersey announced its breakup into thirty-four companies: the old parent company and thirty-three others. Stockholders of Standard Oil of New Jersey kept their proportionate stock ownership interests in that company; they also received the same proportionate stock ownership interests in each of the other thirty-three companies. The announcement of the breakup was signed on July 28, 1911, by Henry C. Folger as secretary of Standard Oil of New Jersey.

Charlie Pratt roundly praised Folger's performance during the trial. He wrote, "The considering by the Court of our case to a speedy trial has made your ready response to the many queries of the Court very essential features saving time and putting facts to a most clean-cut way."[18] Rockefeller, who received the most current case-related information from Folger, was also grateful: "Thank you for your kind note of the 4th. I have not yet received any paper of yesterday, so that your letter is the latest information."[19] *McClure's* recognized that upon Folger "and a few others fell the actual details of the dissolution."[20]

A worried-looking John D. Rockefeller leads a Standard Oil delegation from the New York Custom House after antitrust hearings in 1908. At his right strides Folger holding trial documents. *Courtesy of Brown Brothers*

Reports describing the company's defense during the trial suggested that it was masterminded by Rockefeller but that Folger played the second most important role. A press photo shows Rockefeller leading a gloomy Standard Oil delegation back on foot to 26 Broadway from Room 508 of the New York Custom House where pretrial hearings were held. A worried-looking Rockefeller wearing black gloves is trailed by two young lawyers who have in their wake a troop of messenger boys. At Rockefeller's right strides Folger, wearing an open coat and carrying what may be stenographic trial records under one arm. All sport derbies, their dark overcoats matching their mood.

Rockefeller regularly inundated the trusted Folger with questions about the case. He wanted Folger to "follow up industriously with our associates and with the attorneys" regarding questions about cash dividends. Specifically, to

> show that we did not receive in cash dividends more than six or eight per cent, and then show what an increase of ten, nine and eight per cent on the $70,000,000, from '81 to the present would amount to, with the collateral explanation that this increase of values was not alone from the accumulations of current business, but included the appreciation of properties, well selected, which we had secured way back thirty or forty years.[21]

<div align="center">

TABLE I
Standard Oil Company Cipher Code

</div>

Term	Code name
Standard Oil Company	Club, Napoleon
John D. Rockefeller	Chowder, Murkily
William Rockefeller	Jordan, Occult
John Archbold	Magpie
Stephen V. Harkness	Minaret
Confidential letter received	Recline
We expect higher prices	Dover
Telegram received	Kepler
Money is tight	Vesper
100,000	Cupola

Unfortunately, most of the documents Folger sent to Rockefeller at this time have disappeared. Some must have contained sensitive, or damaging, data. Indubitably, Folger would have been responsive to Rockefeller's requests for information. Clearly, Rockefeller was intent on projecting a favorable image of the firm. The destruction of documents (questionable though it may have been) was important to that cause. Rockefeller wrote Folger in February 1909 from the Hotel Bon Air in Augusta, Georgia: "Dear Mr. Folger: Thank you for yours of the 16th, and the data referred to, which we have destroyed. We will be pleased to review the memoranda from time to time, as suggested, and will be very careful to destroy them when read."[22]

The press called Standard Oil Company's headquarters at 26 Broadway the "Tower of Secrecy." Rockefeller followed a practice of tight-lipped security, despite his comments to the press claiming comprehensive record-keeping and espousing openness. Senior employees were rarely known to hold press conferences and published no memoirs. Doors to executive offices on the top floors were fitted with special locks. If you did not know the way to slide a mechanism on the door lock rim to open it, you were locked in. Standard Oil Company senior executives used a private telegraph line and when writing to each other employed a cipher code.[23] (See table above for a few examples of equivalents. Folger's name does not appear among the list of some 500 terms.)

❧ After the 1911 breakup of Standard Oil of New Jersey, the parent company and its subsidiaries and affiliates were "disaffiliated." All the disaffiliated companies were now expected to compete with one another, a situation the Supreme Court had envisaged. The surviving Standard Oil Company of New Jersey retained the largest share of the Standard Oil Company's assets, $660 million, or about 43 percent of

the assets of the former holding company. The next largest disaffiliated company, Standard Oil Company of New York (Socony), received assets of $60 million, or 9 percent. Both companies continued to occupy headquarters at 26 Broadway, which Socony owned.

In December 1911, Folger was elected the first president of the disaffiliated Socony, a post he held for twelve years, followed by five years as Socony's first chairman of the board. His principal task was to create a viable, profitable oil business despite the fact that the operation he took over was limited to refining and marketing oil products in New York and New England and exporting them. His biggest challenges were to obtain crude oil, crude oil production assets, and transportation assets, as Socony had none of its own, and to expand Socony's geographic base. Folger was very successful in this effort, in which the State of Texas and several courts, both state and federal, played leading roles. The extremely complicated judicial saga has been exhaustively described.[24] However, since Folger was deeply involved in this story both professionally and personally, some history seems warranted.

By the late 1890s, Standard Oil was not welcome in Texas. This was due generally to Texas's intense skepticism about business trusts, and specifically regarding the activities of a Missouri firm, the Waters-Pierce Oil Company, majority-owned by Standard Oil. Waters-Pierce was Standard Oil's exclusive marketing agent in Texas, and bought its supplies from refineries owned or controlled by Standard Oil. The attorney general of Texas ejected Waters-Pierce from Texas in the late 1890s because of its anticompetitive marketing practices and allowed a successor company to return only after its president (who had been president of the ousted company) delivered a highly questionable affidavit that the successor company was not part of a trust or business combination.

As a result of Texas's antipathy toward Standard Oil, when the developer of a refinery in Corsicana, Texas, sought financial help from Standard Oil in 1898, the company put up the funds but they were seen publicly as having been provided by Folger and another Standard Oil executive, Calvin Payne, partners who "nominally" owned the refinery company.[25] Similarly, several years later, another company that was building a much larger refinery in Beaumont, Texas, was financed by a Standard Oil subsidiary, Standard Oil Company of New York, but very indirectly by a large loan made to another, foreign subsidiary which then re-lent the funds to the Beaumont Refinery Company.

In 1906, when the federal government brought suit in the Federal Court of Appeals in Missouri to break up Standard Oil Company of New Jersey, both the Corsicana Refinery Company and the Beaumont Refinery Company were on the list of defendants controlled by Standard Oil, as was the Waters-Pierce Oil Company.

Folger was deposed in the breakup lawsuit in September 1907. He testified that while he and the other Standard Oil executive, Calvin Payne, had been mere "fronts" for Standard Oil from the time of its original investment in the Corsicana Refinery Company until 1906, in that year he and Payne had agreed to buy the company's refinery from Standard Oil for about $400,000 ($10.3 million in 2011 dollars).[26] He stated that the agreement was not in writing but was made orally with Standard Oil president, John Archbold.[27] Folger further testified that he and Payne expected to pay for the refinery out of the profits from the business, which, he said, were "substantial." Archbold was also deposed. Asked why Standard Oil would wish to sell a business with substantial profits, he stated that the "vexatious conditions in Texas were such that it seemed best for us at all hazards to get rid of the property."[28] As there was no documentation of this very large purported transaction, and as it was supposed to be paid for not by the buyers but from the profits from the business, Folger and Archbold's statements were not believed, and the Corsicana Refinery Company, the partnership between Folger and Calvin Payne, remained on the list of defendants.[29]

Just a week after Folger testified, Standard Oil formally transferred the Corsicana Refinery Company's properties to Folger and Payne, who immediately transferred them to a newly formed Texas company, Navarro Refining, in exchange for 89 percent of Navarro's stock. It seems highly likely that Folger and Payne paid Standard Oil little or nothing for these properties. This corporate transformation was meant to limit the fines that could be assessed against the Corsicana refining business in a Texas antitrust lawsuit, which Standard Oil believed was imminent. Indeed, the lawsuit was brought by the attorney general of Texas in November 1907 against both Navarro Refining and the Beaumont Refinery Company. The transformation did not, however, result in any change in the list of defendants in the breakup case, which continued to include the Corsicana Refinery Company, the partnership between Folger and Payne, even though that company no longer owned any property.

Toward the end of 1909, the Federal Court of Appeals in the breakup lawsuit began to consider its decree, which would require each defendant to be independent of the others and would prohibit agreements between defendants that owned potentially competitive refineries. Just before the decree became final, however, the antitrust lawsuit brought by the Texas attorney general in late 1907 was very hastily settled. The Navarro Refining Company, which now owned the Corsicana refinery, and the Beaumont Refinery Company, were each fined, forfeited their charters, and agreed that their properties would be sold at auction. In the end, the process was an elaborate charade, an effort—successful, it turns out—to prevent the decree in the breakup case from affecting the refineries owned by the two companies. The Navarro Refining Company was not a defendant in the breakup case so the decree

would not affect its Corsicana refinery, but even if the government had wished to substitute Navarro as a defendant in place of the Folger-Payne partnership, this could not be done because Navarro no longer existed. Similarly, the decree could not affect the Beaumont refinery because the company that had owned it no longer existed. The upshot was that operations of the refineries at Corsicana and Beaumont would escape the provisions of the decree in the breakup lawsuit—provisions that would have required the companies owning the refineries be independent of each other and, as the two refineries were potentially competitive, would have prohibited agreements between the companies that owned them.

In December 1909, at the auction required by the settlement of the Texas anti-trust lawsuit, the properties formerly owned by Navarro Refining and the Beaumont Refinery Company were purchased by a partnership headed by a Galveston banker, and the partnership undertook to operate the refineries at Corsicana and Beaumont exactly as before, with the same management and employees. Standard Oil representatives directed the formation of the partnership; Folger was a member of the partnership, and he agreed with the other partners that he and John Archbold, the head of Standard Oil, would, in due course, buy the properties from them.[30]

In April 1911, Folger and Archbold bought the refineries at Corsicana and Beaumont from the group of partners that had purchased them at the 1909 auction. A newly organized Texas company, Magnolia Petroleum Company, was the actual buyer, but Folger and Archbold owned almost all of Magnolia's stock. Unlikely though it may seem, Folger and Archbold did indeed purchase and own in their personal capacities almost all of the stock of Magnolia.

As Archbold testified in the breakup case, Standard Oil was eager, even desperate, to rid itself of its Texas interests and avoid further legal problems there. But Standard Oil also wanted these interests to continue operating as if they were still part of the Standard Oil corporate family, and Rockefeller and his associates concluded, with reason, that this would happen if the interests were owned by high-ranking Standard Oil executives—first, Folger and Payne and then Folger and Archbold.

Just as important, Standard Oil, and Rockefeller in particular, wanted to be sure that the very large loan made to finance the Beaumont refinery was repaid. As noted earlier, Socony had financed the Beaumont refinery indirectly via a loan. The obligation to repay that loan was evidenced by bonds, and each successive owner of the refinery (first the Beaumont Refinery Company, then the partnership headed by the Galveston banker, and finally Magnolia) assumed the responsibility to repay the bonds. As noted earlier, when the partnership was organized in 1909, Folger agreed with the other partners that he and Archbold would in due course purchase their interests, which they did in 1911 via Magnolia, which they owned. Thus, starting

in 1909, Folger and Archbold began to assume responsibility for Standard Oil's former interests in Texas—interests that included the debt owed to Socony. It is safe to assume that Rockefeller would have confidence that this debt would be repaid if Magnolia were owned by two of his oldest, most trusted associates. Doubtless Rockefeller also encouraged Folger's role in the 1909 partnership, his agreement that he and Archbold would in due course buy out the other partners, and the two men's purchase and ownership of Magnolia.

When Magnolia was organized, the amount of the debt owed to Socony, now evidenced by Magnolia bonds, had grown to $3.55 million (roughly $87 million in 2011 dollars). In 1911, however, Socony could not afford to be seen to have interests in the Texas oil business.[31] In April 1911, at a meeting held in Folger's New York office, an investment banker was given assurances that if he bought the bonds, they would be immediately taken off his hands by unnamed purchasers. After the investment banker bought the bonds from Socony, as promised Rockefeller and several of his associates immediately purchased most of them back from him. Rockefeller then gave his Magnolia bonds to his son, John D. Jr., and to the Rockefeller Foundation. It was extremely important to Rockefeller that these bonds be repaid, as can be seen from the letter he wrote to Folger on July 28, 1913: "Dear Mr. Folger: In view of the large interests of Mr. JDR, Jr, and the Rockefeller Foundation in the bonds of the Magnolia Petroleum Company, we should be glad to know the earnings since January, whether any dividends have been paid out, the present financial standing, and current monthly earnings, . . . and any other particulars which might be helpful to us. Any information along these lines will be appreciated."[32]

Once the repayment of the bonds was assured, Folger and Archbold, as Magnolia's owners, stood to benefit financially from their ownership, and (as discussed in the next chapter) their ownership did indeed yield huge financial returns to both men. Most probably, Archbold—by far the wealthier of the two—advanced funds to Folger to help Folger invest in the enterprise as it grew, and grow it did: it has been estimated that the value of Magnolia's properties when it was formed in 1911 was only 5 percent of the value of its properties in 1919. Archbold died on December 16, 1916. In December 1917, Folger wrote the largest check of his life—for $2,032,841 (roughly $36 million in 2011 dollars)—payable to Archbold's estate.[33] It cannot be said with absolute certainty, but it is extremely likely that all or most of this amount went to repay Magnolia-related advances Archbold had made to Folger.

Folger largely stayed out of the news and was rarely identified with skullduggery. The same could not be said of Archbold, Standard Oil of New Jersey's chief for twenty years. Archbold's name frequently appeared in the press in connection with bribery scandals. For political reasons, newspaper magnate William Randolph

Hearst once created a national uproar by reading aloud stolen letters that Archbold had written to a senator and a congressman accompanying bribes.[34] After Hearst published damaging Archbold letters, the public further vilified the head of Standard Oil. Outside the press but within the Standard Oil family, Archbold's drinking binges during nightly poker games were legendary. So, too, the cloves he would draw from a vest pocket to veil the smell of booze. Rockefeller made Archbold sign a temperance pledge, but it did not last. In the end, Rockefeller counted on Archbold for his optimism and good nature and was amused by his jokes and stories, the teetotaling Baptist giving way to the hardminded magnate who valued Archbold's business acumen.

In 1912, after the breakup of Standard Oil, Rockefeller and other major Standard Oil shareholders, who as individuals now owned collectively the majority of the stock of the Waters-Pierce Company, sued Waters-Pierce in Missouri state court, trying to replace its president with their own nominee. At first this lawsuit did not involve Magnolia Petroleum. However, in seeking to have the case dismissed, lawyers for Waters-Pierce dragged Magnolia into the case and into very public view. They argued that, despite the decree ordering the breakup, Rockefeller and his associates continued to control various Standard Oil companies, including Magnolia, and had engaged in a conspiracy to damage Waters-Pierce in violation of federal antitrust laws. Those conspiratorial actions included causing Magnolia to refuse to supply Waters-Pierce from its two refineries. The lawyers held public pretrial hearings, reported in great detail in the Texas press and the *New York Times*, and sent material to the Justice Department in Washington to persuade the federal government to act against these antitrust law violations. At first they were successful.

In August 1912, a federal grand jury in Dallas indicted the Standard Oil Company of New Jersey, Socony, Magnolia, Folger, Archbold, and several other individuals for an unlawful conspiracy in violation of federal antitrust laws. The alleged conspiracy involved the acts to damage Waters-Pierce publicized by the Waters-Pierce lawyers. The indictment stated that the two largest shareholders in Magnolia were Folger (by then president of Socony) and Archbold (by then president of Standard Oil Company of New Jersey), who each owned 10,798 of Magnolia's 24,500 authorized shares. The indictment even mentioned Emily Folger as owner of 105 shares.

Not long after, Rockefeller decided to settle his lawsuit against Waters-Pierce, which ended further public disclosures about Magnolia. But the federal indictment of Magnolia, Folger, and the others still stood, and the authorities sought to arrest the individual defendants. A *New York Times* headline datelined Dallas, January 29, 1913, trumpeted: "U.S. Marshals directed to arrest Archbold, Folger and Teagle, charged with violation of Sherman anti-trust laws." However, U.S. attorney general

George Wickersham, a former business trust lawyer in private practice in New York, ordered that Folger and the other two men not be arrested pending further examination of the indictment's validity. Wickersham had not always been so lenient with Standard Oil; a few years earlier he had been a driving force behind the lawsuit to break it up. An ideal villain for the press, the third man ordered to be arrested, Walter C. Teagle, was a six-foot-three, 250-pound colossus who beat down his adversaries with a booming voice and an unflinching stare. Known for smoking Havana cigars in an amber holder, Teagle later became the head of Standard Oil Company of New Jersey.

After the federal indictment, affidavits were submitted to the U.S. attorney stating that Folger and Archbold owned Magnolia in their personal capacities and that Magnolia was not a trust and was not affiliated with any trust. In February 1913, Attorney General Wickersham ordered that the federal grand jury indictment be dismissed. This dismissal was not well received in Texas, however; very soon, the Texas attorney general brought a Texas antitrust lawsuit against the same individuals and entities indicted by the federal grand jury in Dallas. It sought to oust Magnolia from the state and also sought more than $100 million in damages from the defendants—$8.15 million from Folger alone. After further legal skirmishing, however, this suit was settled via a compromise, in which Standard Oil of New Jersey paid a penalty of $500,000 and Folger and Archbold agreed to transfer their Magnolia stock to a completely independent trustee. Magnolia was allowed to continue doing business in Texas. One can only imagine the stress these lawsuits caused Folger, and his relief when they were resolved.

This account of Folger's role in Standard Oil's early investments in Texas reveals that he was indeed a "player" in that business. Up to this point in his business career, his persona within the company had been that of someone exceptionally bright, mathematical and detail-oriented, earnest, highly analytical, and somewhat private. But beginning in 1898, when Folger was a rising company employee, he willingly served as a front for his company in connection with an investment the company itself could not legally make. His actions allowed Standard Oil very early to put down deep roots in the petroleum business in Texas, a state very hostile to the company. While all the actions Folger took would have been taken only on the advice of Standard Oil lawyers, his training in the law would have made him well aware that they raised legal questions. Nevertheless, he took part, showing that he could become a key and willing player in a high-stakes business on the margins of the law. Folger had a shadowy duality: he maintained his shy, respected place in the firm while loyally allowing himself to walk on the dark side to foster and protect Rockefeller's Texas interests.

❧ Folger initially strove to run Socony as a "non-integrated" company that included refining, marketing, and exporting activities but produced no crude oil. This situation began to change in 1918, when Socony acquired a major interest in Magnolia (see chapter 4). In 1925, Socony purchased the rest of Magnolia, and Magnolia became a wholly owned subsidiary. By that time, Magnolia owned not only refineries but also production fields and pipelines in Oklahoma and Kansas. During the 1920s, Magnolia became Socony's "most important U.S. producing affiliate."[35] Magnolia recognized Folger annually during its Founders' Month for all his contributions to the company, starting with the financing and organization of its Corsicana refinery.

In 1926, Socony acquired the General Petroleum Company of California, a large, well-integrated oil enterprise with production fields, refineries, and an established market. General Petroleum's sprawling refinery in Vernon, California, was well situated to open new export markets in the Pacific and Far East. Under Folger's leadership, Socony's expansion into Texas, Oklahoma, and Kansas through Magnolia, and into California through General Petroleum, put the company in a position to thrive independent from former Standard Oil affiliates.

In 1922, Folger was called to testify before the subcommittee of U.S. senator Robert La Follette's committee on manufacturing, which was investigating the "high cost of gasoline and other petroleum products."[36] In his testimony, Folger provided basic information about Socony. He answered one question by saying that the company refined and distributed but did not produce oil. Its refineries were located in Buffalo, Long Island, and Brooklyn, New York, and in Providence, Rhode Island. Domestically, oil products were distributed in New York State and New England; abroad, oil products were distributed to China, Japan, India, Java, the Straits Settlements, and the Levant.[37] Folger said that Socony had spent over $3 million prospecting for crude oil in China but had found none.

The subcommittee learned details of Socony's past they may not have known. Folger declared that in 1913, the company had paid a stock dividend of 400 percent, and in 1923 a dividend of 200 percent, but that it had paid much lower dividends in other years. Over the years 1913–1922 Socony had paid out $85.05 million in dividends and $75.7 million in taxes. He stated that Socony owned 68 percent of the Magnolia Petroleum Company, having first bought a large portion of those shares in 1918 when it acquired Magnolia stock and rights from Archbold's estate and rights from Folger personally. He also stated that John D. Rockefeller owned 24.96 percent of Socony's stock.

The Socony president was one of many executives of the newly independent, disaffiliated former Standard Oil companies who testified before Congress. Any year

was likely to bring some congressional inquiry into oil marketing practices. In 1926, one senator charged price-fixing, stating, "Standard Oil Company of New Jersey advanced prices . . . simultaneously on the same day the Standard Oil Company of Kentucky advanced its prices."[38] Another in the same year claimed that "the oil industry . . . is run on higher ethical grounds than any other business in the Nation" and noted "less fluctuation in the price of crude oil and in the price of gasoline in the last 10 or 11 years than in any other one of the 400 commodities."[39] Strong voices were raised both for and against oil business practices.

Retiring "to ripe his growing fortunes" (*2 Henry IV*, 4.1.14), Folger left Socony on March 28, 1928, to devote himself to establishing his Shakespeare library. It is difficult to avoid speculating that retirement came with some relief that he was no longer in the public spotlight. But the longer he worked for the company, the more resources he acquired to pursue Shakespeareana. As the last of the second-generation company pioneers, Folger clearly enjoyed his executive status and the respect of younger employees. His request for retirement was characteristically modest:

> I have, very reluctantly, come to the conclusion that it will be best for me to be retired as a director and Officer of the Standard Oil Company of New York. There is no longer any excuse for my remaining. So I will ask you to present my name for retirement, in the usual way, as of Feb. 29, 1928. I have been so happy in my position, and my fellow-workers in Socony have made the work so easy, that the years have slipped by almost unnoticed. I owe them all a deep debt of gratitude and love.[40]

Folger retired with an annual pension of $81,500, plus a death benefit of $31,500.[41] As an executive retiree, he was allowed to maintain an office at 26 Broadway. For two years after retiring, he used his familiar partner's desk in a new office. He continued to receive calls from booksellers and chatted with former colleagues. He most likely met his two younger brothers whom he had helped to find positions with Standard Oil. Stephen Lane Folger reached executive rank in Socony. While working at the Standard Oil of New Jersey plant in Bayonne, Edward Pell Folger patented an apparatus for cooling wax-bearing oil for pressing.

A welcome coda to Folger's Socony years came in the form of an unexpected letter in 1956 from Albert L. Nickerson, president of Socony Mobil Oil, to Louis B. Wright, director of the Folger Shakespeare Library.

> We would be pleased to present to the Folger Library the ornamental desk of Henry Clay Folger, our former president and later chairman of the board. This desk was used by Mr. Folger for many years and he thought a great deal of it. We are making it available at this time because our company, after 71 years at 26 Broadway, is moving to the new Socony Mobil building on 42nd St.

Henry Folger's walnut partner's desk at Standard Oil was given to the Folger Library in 1956, and has been used since by the library director. ©*Robert C. Lautman Photography, National Building Museum*

The flat-topped desk is made of walnut, with ornamental disks carved on the corners, eight carved legs, and drawers on both sides. For the last half century, Henry Folger's partner's desk has been enjoyed by the Folger Library director, whose office window looks out on the Capitol. Folger would be proud to know that his desk stands near his books. He also would likely be pleased, though perhaps not surprised, to hear that, long after his passing, ExxonMobil Corporation—the result of a merger of the successor to the former Standard Oil of New Jersey with the successor to the former Standard Oil of New York—is today the world's largest publicly traded international oil and gas company.

❧ A tree is best measured when it is down. When a Standard Oil executive died, perceptions of the deceased's character and contributions circulated in private hands. No secrets were divulged, however. Mrs. Folger cared so deeply about her husband's legacy that she hired a Washington journalist, James Waldo Fawcett, to solicit letters from colleagues and friends that might help to define Henry Folger's character and contributions.

Among these letters, Socony executive A. F. Corwin remembered Folger as "a very shy man, almost bashful. He avoided all possible meetings and conventions,

or in fact any form of gatherings, due to his shyness." Through daily contacts at work, George W. McKnight "found him a man of gentle but forceful character, a quiet deep thinker, a resourceful executive, and a lovable Christian gentleman with a taste for the finer things of life." McKnight continued, "His devotion of a lifetime to the pursuit of Shakespeareana could not have been so successfully consummated without the ideals and attributes just named."[42] Frederick S. Fales also perceived a link between vocation and avocation: "It is my firm belief that he was a better business man because he knew his Shakespeare."[43] Henry Folger obviously admired the poetic and dramatic genius of Shakespeare, but perhaps he also sensed a more pragmatic kinship rooted in the worlds of business and law. Existing documentary records of Shakespeare's life point to his being a shareholder in his theatrical company (and therefore keenly sensitive to the vagaries of profit and loss), a respected owner of property, a buyer of goods, and a litigant.[44]

"Although he was not the aggressive type that impresses itself on the public consciousness," Walter Teagle declared, Folger "applied himself assiduously to his duties and was a real force in his company's policies." Herbert Pratt, who succeeded Folger as president and board chairman at Socony, knew him better than most. "Our business friendship was unusually close, as I had the satisfaction of being trained by him to be his successor as he made the three advancements in our company from vice president to president to chairman of the board. I feel therefore that I can speak with authority when I say that he was a man of remarkable foresight and broad imagination, as the company under his direction grew from a capital of $15,000,000 to over $600,000,000."

Among Folger's qualities as a businessman was the ability to focus intensely on the thorniest issues. He could be counted on to briefly, precisely recapitulate at the end of business meetings, and was known to inject humor into tense work sessions. Many of the younger staff looked upon Henry Folger as an outstanding mentor.

One tribute was special: an oil tanker named after him. No photographs show Henry Folger at the December 16, 1916, launch at San Francisco's Pier 70 of the SS *H. C. Folger*, commissioned and owned by the Atlantic Refining Company of Philadelphia, of which Folger had been president before the 1911 breakup of Standard Oil.[45] On the day the tanker was launched, instead of celebrating his eponymous ship, Folger was busy at his desk at 26 Broadway, filling out loan applications to borrow $20,000 from Brooklyn Trust Company to buy more Shakespeare.

CHAPTER FOUR

✦ ✦ ✦

Leading on to Fortune

Henry Invests to Buy the Bard

There is a tide in the affairs of men
Which, taken at the flood, leads on to fortune;
Omitted, all the voyage of their life
Is bound in shallows and in miseries. . . .
. . . we must take the current when it serves
Or lose our ventures.

Julius Caesar, 4.3.249–55

HENRY FOLGER CREATED THE WEALTH to buy Shakespeare in four major ways:
a five-decade salary from Standard Oil; investments in the company and its
affiliates that generated substantial dividends; careful money management; and a
major investment in Magnolia Petroleum Company, which generated very large
dividends and a huge profit when it was sold. He began his career in 1879 in a
precarious financial situation he was determined to overcome. His father had gone
bankrupt. Henry was clerking during the day and attending law school at night.
And he was in debt.

The Folgers lived frugally. They hosted no business dinners, and Folger studi-
ously avoided business luncheons, leaving other Standard Oil brass to enjoy the
executive dining room at 26 Broadway. Word of such thrifty habits crossed the
Atlantic. A noted British musicologist, Edmund Horace Fellowes, told the press,
"Every day he [Folger] goes to his palatial offices on Broadway with a bun and some
sandwiches in his pocket for lunch."[1] The *New Rochelle Standard Star* reported that
"on winter evenings the noted bibliophile would creep down the front steps with a
pan of water suspended before him, sniffing the air and hoping for a freeze. In that
case they [the Folgers] could spin the sign for the iceman around to '0' and save
fifteen or twenty cents." No ice blocks to deposit with big iron tongs in the Folger
icebox on the following day, as the horse-drawn delivery wagon made the rounds in
Brooklyn.[2]

The Folgers limited family get-togethers at their home to twice a year, Thanksgiving and New Year's. As many as two dozen places were set around a long festive table. For other family events, they sent sincere apologies. Henry was, however, generous toward his family in other ways. After he had erased some debt, he started paying his father's rent on a Brooklyn flat, a filial gesture he continued until his father died. Folger regularly gave cash presents to all his brothers (Stephen, Edward, and William) and to his sister Mary. When Mary's husband died, Henry covered many expenses for her children, including college tuition and medical services.

The Folgers dined at home, employing one maid for housework and one for cooking. When needed, they hired a horse and carriage until 1914; then they rented a motor car. Soon after his father's death in 1914, Henry moved his driver, named Smith, into the Quincy Street house where Henry Sr. had lived. Emily's indulgence was taking the waters at Hot Springs, Virginia, as suggested by her doctor. Henry's diversion was the golf links. He had no butlers, race horses, or private railway car. Folger did punch a hole in his reputation at home and abroad as a "goodhearted miser," however, when he purchased in 1921 an elegant, sporty six-cylinder, seven-passenger Pierce-Arrow vestibule sedan.

For most of their married life, the Folgers rented modest lodgings in Brooklyn. Their rent in 1895 for 212 Lefferts Place was $62.50 a month. Starting in 1910 their rent climbed to $270.84 for the more spacious 24 Brevoort Place brownstone. They even rented their furniture, in 1929 paying $500 for the rental of a complete set. In the late 1890s, they rented for the summer a small cottage in Glen Cove, Long Island, near the 700 acres where Pratt family members built their lavish secondary residences. First renting on Dosoris Lane, then on Duck Pond, and finally at 11 St. Andrew's Lane across from the Nassau Country Club and near the railway station, the Folgers paid $1,000 for the summer season in the early years, and in later years no more than $1,250. Finally, in August 1929, after his retirement, Henry was inspired to buy the first home the Folgers owned, the two-acre St. Andrew's Lane property. This purchase was providential, for when Henry died a year later Emily did not have to deal with this major issue by herself.

In 1910, before he was elected president of the newly disaffiliated Standard Oil Company of New York, Folger's annual salary was $50,000 (equivalent to $1.2 million in 2011 dollars).[3] In 1922, before being elected board chairman of Standard Oil of New York, his salary was $100,000 (equivalent to $1.3 million in 2011 dollars). Folger could now live comfortably and cover the interest on his bank loans. His handsome salary alone, however, could not have financed a vast collection of early modern books, purchased prime land on Capitol Hill for his library, and provided an endowment. Folger's canny investing made all that possible. Like

Autographed portrait of Henry Folger, by New York photographers Pach Bros., shortly before he became president of the Standard Oil Company of New York, ca. 1910. *Author's collection*

Antonio's in *The Merchant of Venice*, Henry Folger's "ventures [were] not in one bottom trusted,/Nor to one place" (1.1.43–44).

Up to and even beyond the 1911 breakup of Standard Oil Company of New Jersey, Folger followed (with the significant exception of Magnolia Petroleum Company) the golden rule of investing propounded by his mentor, John D.: buy Standard Oil stock and *never* sell it. Following this rule, up to 1911 he invested almost exclusively in Standard Oil of New Jersey stock. He began purchasing in 1901, periodically adding shares. The company encouraged its personnel to invest in the stock and made loans to its employees for these investments that were secured by the stock they bought.[4]

By August 1907, Folger had accumulated 2,145 shares of Standard Oil Company of New Jersey stock, the market value of which ranged that year between $836,550 and $1,209,780 (between $20.7 million and $29.9 million in 2011 dollars).[5] The high value of his stock enabled Folger to pledge relatively few shares to secure relatively large loans. Equally important, these shares were generating $85,800 per year in

dividends ($2.12 million in 2011 dollars).[6] Four years later, Folger's shares of Standard Oil Company of New Jersey stock had fallen to 1,616, almost certainly the result of gifts of stock to his family, especially his wife and father.[7] Still, the shares he retained in 1911 continued to produce plump dividends—generating $59,792 per year ($1.46 million in 2011 dollars).

Following the 1911 breakup of Standard Oil of New Jersey, Folger kept his shares of its stock. In addition, he received shares in each of the thirty-three former Jersey Standard subsidiaries disaffiliated by the breakup. He received the same proportion of the shares of each of these companies as the proportion of shares he owned in Jersey Standard. Over time, he disposed of his holdings in many of these disaffiliated companies while keeping and augmenting his holdings in a few others. After becoming president of Standard Oil of New York in late 1911, Folger purchased a substantial number of its shares over the years. Thus, at his death in 1930, the bulk of his estate consisted of stock in three disaffiliated companies—Standard Oil of New York, New Jersey and Indiana—with most of the balance consisting of stock in three other disaffiliated companies.

Folger made one exception to his practice of investing solely in the stock of Standard Oil of New Jersey, or in disaffiliated companies after the breakup. This was his investment in Magnolia Petroleum Company. As discussed in chapter 3, Folger and John Archbold, like Folger a director of the pre-breakup Standard Oil of New Jersey, each acquired 45 percent of Magnolia's stock in 1911. This stock was put into the hands of an independent trustee in 1913 to provide assurance to the Texas antitrust authorities that Magnolia was not still a part of the "old Standard Oil Trust." Over time, Folger increased his Magnolia holdings both by purchasing more shares and through dividends declared by Magnolia. Starting in 1915, Magnolia began to pay cash dividends on its stock, at the rate of 4 percent per year on the per share par value of $100.[8] This rate was subsequently raised to 6 percent.[9] As discussed below, by 1919, Folger's Magnolia shareholdings had reached 109,660, which at a dividend rate of 6 percent per year would have annually generated $657,960 ($8.55 million in 2011 dollars).

In 1918, Standard Oil of New York (Socony), with Folger as president, bought from the estate of John Archbold all of the Magnolia stock, and all of the rights to buy Magnolia stock at its par value, that the estate owned. It also bought from Folger roughly two-thirds of the same rights to buy Magnolia stock that he owned. By purchasing the stock and exercising the rights, Socony became the owner of 198,000 Magnolia shares, or about 45 percent of its outstanding stock.[10] Although the purchase price was never revealed, a February 2, 1918, article in the *New York Times* estimated that the shares and the rights would be appraised in the open market

at about $40 million. This would mean that each share of Magnolia stock was worth about $260. By January 1, 1919, after Folger exercised his remaining rights to buy Magnolia stock, he owned 109,660 Magnolia shares, or about 25 percent of Magnolia's outstanding stock. Valued at $260 per share, these were worth about $28.5 million, or about *$371 million* in 2011 dollars.

Between 1919 and 1925, Socony purchased substantial numbers of Folger's Magnolia shares. In 1925, his ownership had declined to 18,396 shares, and in that year, Socony bought all the Magnolia shares it did not then own, including Folger's remaining shares. While there appear to be no records detailing Socony's purchases of Folger's shares from 1919 through 1925, those purchases were almost certainly structured to minimize the capital gains taxes Folger would have to pay on his immense profits. In 1919, 1920, and 1921, the maximum tax on capital gains was 73 percent, while from 1922 through 1925 the maximum was only 12.5 percent. As detailed later in this chapter, Folger did not write checks for large federal tax payments in 1919, 1920, or 1921 but he wrote such checks each year from 1922 through 1925. This strongly suggests that Socony did not begin buying his Magnolia shares until 1922, when the capital gains rate was very low.

Henry Folger saved hundreds of invoices and receipts, bank statements, letters to and from bank officials, and advices of stock sales and purchases. He also preserved as many as ten thousand canceled personal checks (no stubs, however, which could have been more revealing) that he had signed over forty-six years, returned from the many banks and loan associations in which he held accounts. If a checkbook is one's autobiography, then Henry Folger's self-portrait goes into volumes and volumes.

Folger's irrepressible desire to possess Shakespeareana caused periodic cash shortfalls, which filled his life with short-term debt. As we have seen, as a college junior young Henry had gained experience with debt. He recorded his daily purchases in a bound black leather account book, no bigger than two by four inches. Folded up among the minuscule ledger pages is a promissory note with the message, "June 27, 1878. Three years after date, I promise to pay to the order of Charles M. Pratt $100 at 7% interest, (signed) Henry C. Folger Jr." The 1878 date marked the end of his junior year at Amherst, when Henry had dropped out due to the family's inability to pay tuition. For neither the first nor the last time, the Charles Pratt family came to his rescue.

The earliest check Folger saved consists of a $100 loan repayment to Charles Pratt on March 10, 1886. Through the last years of college until 1910, when Folger was already a director of Standard Oil of New Jersey, Folger borrowed money from the Pratts: Charles Sr. until he died in 1891, and then from Charles Jr. For gradually increasing loan amounts, Folger was repaying one Pratt or the other $5,000 a

quarter for thirteen years. It was all in the family, as both Pratts were Standard Oil colleagues, and they treated Henry like a son and brother.

Folger maintained accounts with over a half-dozen banks and brokerage institutions. With no FDIC insurance at this period, spreading out his assets protected against bank failure. Moreover, no single banking institution would know his total financial position. Folger obtained his first loan from a financial institution in 1903, when he borrowed $15,000 from the Long Island Loan & Trust Company on 203 Montague Street, not far from his Brooklyn residence. He was a good customer there, having opened his first checking account a year after his marriage. Folger used the brokerage firm of Ackermann and Coles to arrange for the loan. William C. Coles was a Brooklyn broker; senior partner Frederick Ackermann had worked for the Standard Oil Trust. The firm handled substantial business with Standard Oil, so Folger felt confident he was dealing with reliable entities.

When books he sought came on the market, Folger figured out how to borrow funds to snap them up. Contrary to Polonius's well-known precept, "Neither a borrower nor a lender be" (*Hamlet* 1.3.81), Folger spent a good part of his adult life borrowing money. But he was wise in his borrowing, investing money in Standard Oil stock in order to earn more money, and using that stock as collateral to borrow more money to buy more Shakespeareana. Consequently, he found himself spending more and more time managing his investments, keeping track of his loan objectives and repayments, and checking the balances of his accounts with the book dealers and commission agents who purchased books on his behalf. He admitted that he had little time to read the books he bought!

For over a decade, Folger renewed the initial loan from Long Island Loan & Trust Company whenever it came due—generally every six months—at the prevailing interest rate. He upped the loan amount from $15,000 to $30,000 and provided more collateral. When Folger became a Standard Oil director in 1908, with increased salary, he took out larger loans, choosing to deal with a favorite Standard Oil Company bank, the Seaboard National Bank on 18 Broadway, a few doors from the company's office building. In 1909, he borrowed from Seaboard $30,000, an amount renewed through 1914. In 1914 he borrowed $55,000 from Seaboard, and in 1917, $100,000. The $100,000 loan was still outstanding when he died in 1930.

Brooklyn Trust Company loaned Folger $15,000 and $30,000 in 1912, as well as $50,000 in 1917. Folger renewed some of these loans through 1928. The Columbia-Knickerbocker Trust Company loaned Folger $25,000 in 1913, $50,000 in 1915, and $100,000 in 1917. After Columbia merged with the Irving Bank, Folger borrowed $150,000 in 1924 from that bank, a loan that he renewed until 1928. Bankers Trust Company made a $100,000 loan to Folger in 1917. In 1919, the Farmers' Loan and

TABLE 2
Folger Checks Written to One Broker in 1917

Month	Number of checks written	Total value (1917 dollars)	Total value (2011 dollars)
January	35	351,534	5,923,221
February	17	87,430	1,473,164
March	30	220,376	3,713,256
April	22	79,104	1,332,873
May	19	42,044	708,426
Total	123	780,488	13,150,940

Trust Company made one loan to Folger of $200,000 that was outstanding when he died. The National City Bank of New York—a bank that Standard Oil used extensively—loaned Folger $100,000 from 1924 until he died.

After his death, Emily Folger, as executrix of her husband's estate, and her nephew Judge Edward Dimock, as legal counsel, pieced together for the first time the extent of Folger's banking and loan portfolio. They also came to appreciate the dramatic negative effect of the stock market crash on his assets. When he wrote his will in 1927, the value of Folger's stock portfolio would have been sufficient to endow the library at the level he had planned. The value of his assets may have dropped by as much as half by 1932, the rockiest year of the Depression.

Poring over Folger's financial records, one cannot but be impressed by the time that he would have had to devote to his ever-shifting accounts and positions, let alone to his purchases. Being collector and mathematician worked together in his favor. Folger's most active record of check writing to a brokerage firm, Emanuel Parker & Company, took place during the first five months of 1917. He was an active buyer in British auction houses during World War I.

On January 29, 1917, he wrote thirteen checks; on January 30, he wrote ten. On April 4, 1917, he wrote nine checks; on May 1, 1917, he wrote twelve. Many of the small amounts (seven checks for $6,265; two checks for $1,411; seven checks for $2,822) appear to be regular loan interest payments. Larger amounts ($35,455 or $15,437) from the lot could be repayment of principal or new investments. Folger wrote so many checks ostensibly to keep better track of his finances. This primitive record-keeping system exhibits an orderly, disciplined mind. Dispatching a separate check for a separate purpose would help him keep score. The amounts are quite staggering: nearly $14 million in 2011 dollars to buy Elizabethan literary works over a five-month period. Folger chased bargains in 1917, when England was waging war and its economy was in distress.

Folger developed personal relationships with bankers at different levels. For loans he most often corresponded with a vice-president in the bank or loan association, or sometimes with the president. For more routine matters, he received correspondence signed by a treasurer or cashier. Folger's familiarity with banking and lending grew due to his own affiliation with the Hamilton Trust Company of Brooklyn. In January 1913 Hamilton's stockholders elected him a trustee of the firm. Folger knew the company president, Willard E. Edmister, as they attended the same church. Although obliged to purchase twenty shares of stock as a trustee, Folger wisely did not borrow money from Hamilton.

Besides borrowing money from local banking and loan institutions, Folger also borrowed from Standard Oil and its founder. In August 1911, a month after Folger became secretary of Standard Oil of New Jersey, John D. Rockefeller loaned him $100,000 for six months at 6 percent. After renewing the loan over the next six years, Folger explained to Rockefeller his new investment objectives:

> I would like to bring my holdings of Standard Oil of New York stock up to 3,000 shares by buying 350 shares. Will you loan me $100,000 for this purpose? I can give as security 500 shares of Standard Oil of New York, will pay 6% and pay off the loan in two years. You did this for me when I added to my New Jersey stock a few years ago, and that obligation was duly liquidated.[11]

The following day, John D. agreed. Only three months later, Folger put forward a case to bring his holdings of Standard Oil of New York to 4,000 shares, over three years at five percent interest, where he would pay off one-third of the loan each year. John D. complied again, with the added encouragement, "and if you want any more, all you have to do is ask for it."[12]

Two years later, from his winter residence in Ormond Beach, Florida, Rockefeller wrote to Bertram Cutler who managed the family investments:

> I enclose copy of a letter from Mr. Folger requesting a loan of $200,000, and my answer. I would gladly do anything I could for Mr. Folger in this matter, and it occurs to me that it can be arranged through the Equitable Trust on terms mutually satisfactory to the Trust Co. and to Mr. Folger. I regard Mr. Folger's paper as good as gold and his collateral of the best.[13]

Of course Rockefeller would have approved of Folger's collateral—it was Standard Oil stock. Less than a week before, Folger sent Rockefeller a check for $53,000 ($792,000 in 2011 dollars) in repayment for an earlier loan.

Although the federal income tax was introduced in 1913, not until 1917 did the marginal rates rise to the point where the tax began to affect significantly the in-

Check for $53,000 Henry Folger sent John D. Rockefeller on January 29, 1918, as partial repayment for a loan to buy more Shakespeare. *By permission of the Folger Shakespeare Library*

comes of the highest earners such as Henry Folger. Now his handsome salary and the dividends from his investments would be subject to sharply higher tax rates, especially during World War I and the years just after. From 1917 through 1921, all income was subject to federal tax at the rate of about 70 percent. However, in 1922 and the remaining years of Folger's life, the tax rate on wages dropped each year, starting at 58 percent and reaching 25 percent, while the maximum capital gains tax rate for the entire period was only 12.5 percent. The amounts of Folger's checks to the Collector of Internal Revenue in the years 1917–1921 were small, suggesting that most of his tax liabilities during this period were met through withholdings, almost certainly from his salary and dividend payments. However, starting in 1922, Folger's checks to the Internal Revenue became very large. In 1922, the checks totaled $68,249; in 1923, $172,656; in 1924, $304,421; and in 1925, $76,313. While Folger's tax returns for this period do not survive, this payment history strongly suggests that he had to make these very large periodic payments because he was realizing large gains in these years which were not subject to normal withholding. It is almost certain that these gains were the result of Socony's purchases of Folger's Magnolia shares, which, as noted earlier, were worth, in 1919, more than $370 million in 2011 dollars. Socony almost surely did not begin to buy these shares until 1922, when the maximum tax on capital gains fell to 12.5 percent. Had Socony purchased Magnolia shares before 1922, Folger would have had to pay enormous capital gains taxes (the maximum rate was then about 70%), payments that would have shown up in his checks.

While Henry Folger himself was the financial wizard behind all this laborious check writing, he benefited from the services of a personal secretary on the Standard

Oil payroll. Alexander G. Welsh of Baldwin, New York, served Folger as a clerk, accountant, and secretary for his book purchases, as well as a secretary and gofer for his banking and investing. No doubt his office was next to Folger's at 26 Broadway. From 1910 until Folger's death in 1930, Welsh served his boss with unquestioned integrity. He became Folger's institutional memory. Welsh kept track of Folger's book and financial mail during his absences, and delivered and fetched financial documents. Welsh sent to the elderly Folger Sr. his dividend checks from Standard Oil of New Jersey and some of the newly disaffiliated companies. He deposited Folger's own dividend checks at the Long Island Loan & Trust. Folger appears to have reciprocated by investing a few shares on Welsh's behalf, perhaps as a gift. Dividends from his Socony shares allowed Welsh to keep his head above water during the depression, raising his four children on Long Island.

Folger never explained the details of how he financed his Shakespeare library. Clearly, frugal living, a sizable salary, and his investments in the stock of Standard Oil companies would have given him a solid financial base. But this base, while substantial, would not have allowed him to make his vast Shakespeareana purchases, to acquire the land for his library, to construct and endow it. What did allow Folger to do all this were the immense profits reaped from his involvement with Magnolia Petroleum Company. The last chapter recounted the murky details of this involvement, dating back to 1898. Folger was initially a "front" for Standard Oil in Texas and then, with a fellow Standard Oil executive, became a personal investor in Magnolia, a company whose two refineries had been financed by Standard Oil and were originally very much part of the Standard Oil group. This involvement seems to have been very out of character for Folger. But act as a "front" and then as an investor in Magnolia he did, and it is clear that it reaped huge financial rewards. He had "taken [the tide] at its flood," and it led "on to fortune." Assuming the article in the *New York Times* cited earlier is reasonably accurate, not only did his Magnolia investment spin off huge cash dividends, but when he sold it—to Socony, a company he headed—he would have received well over $370 *million* in 2011 dollars. Since Folger likely paid par value for only some of his shares of Magnolia stock (Magnolia had paid some dividends in stock), he would have realized a huge amount on his stock sales, the maximum capital gains tax rate during the time he likely sold being only 12.5 percent. It seems incontrovertible, therefore, that this uncharacteristic involvement with Magnolia yielded much, if not most, of the money Folger spent to create his dream, the Shakespeare Library.

CHAPTER FIVE

❧ ❧ ❧

The Hunt Is Up, the Fields Are Fragrant

Building a Collection

The hunt is up, the moon is bright and gray,
The fields are fragrant, and the woods are green.

.

And I have horse will follow where the game
Makes way and runs like swallows o'er the plain.

Titus Andronicus, 2.2.1–2, 26–27

ACCORDING TO THE ENDOWMENT created in their wills, the Folgers established their library "for the promotion and diffusion of knowledge in regard to the history and writings of Shakespeare."[1] The Folger Shakespeare Library has expanded considerably beyond the collection on the shelves (and still in storage cases) when the facility opened in 1932. Nevertheless, that original collection is a dazzling array of objects: books, manuscripts, essays, pamphlets, magazines, newspapers, playbills, prompt books, autograph letters, autographs, letters, diaries, journals, memoirs, commonplace books, scrapbooks, sheet music, phonograph records, maps, charts, public documents, prints, drawings, engravings, woodcuts, oil paintings, watercolors, mezzotints; furniture, building models, coins, weapons, armor, heraldic documents, tapestries, musical instruments, globes, costumes, scenic designs, stage properties, statues, busts, carvings, miniatures, medallions, figurines, relics, curios, works in stained glass, bronze, ivory, wood, china, ceramics, and marble.

The main thrust of the Folgers' collection was literary. They assembled a full range of literary works produced from 1476, the introduction of printing in England, to 1714, the death of Queen Anne. This is approximately the same period embraced by the more recent term, "early modern age." They enhanced that literary collection by seeking out other types of books from the early modern era, on politics, law, history, medicine, philosophy, psychology, travel, and the sciences. The couple wanted to offer students and scholars classics on European life to complement and illumine the basic Shakespeare collection. While they concentrated on

antiquarian volumes, the Folgers also acquired contemporary books that bore on their special interests.

Before the library was dedicated in 1932, its first director, William Adams Slade, defined what the Folgers had given to the nation: "The most complete and most valuable single collection of Shakespearean works in the United States or anywhere in the world."[2] The Folgers succeeded in gathering as many copies as they could of the Bard's plays: no fewer than 1,400 different copies of the collected works, amounting to 9,700 volumes. No other library in the world owns as many Shakespeare quartos. A quarto, which has been likened in size to a mass-market paperback, is made by folding a sheet of paper twice to yield eight pages [or four leaves] per sheet. The Folgers purchased 800 copies of *Hamlet*, more than 500 of *Macbeth*, and over 400 of both *Romeo & Juliet* and *The Merchant of Venice*. These figures include separate editions, translations, and duplicate copies.

The Folgers succeeded in amassing nearly two hundred Shakespeare folios—the four seventeenth-century editions of his collected plays—far more than any other library in the world. A folio is a large book size that consists of sheets of paper folded once to yield four pages (or two leaves) per sheet. The founders were particularly pleased to secure volumes that had belonged to well-known persons, from kings to literary giants, and volumes that contained interesting marginalia: comments, changes, interpretations written in the margins. Consider a few examples of their ceaseless acquisition:

First Folio (1623): 82 copies, including ones owned by King George III, Queen Victoria, William I King of Prussia, David Garrick, Samuel Johnson, and Edwin Forrest.

Second Folio (1632): 58 copies, including ones owned by Elizabeth (daughter of King James I), William Pitt, and Horace Walpole.

Third Folio (1663–64): 24 copies, including one probably owned by Alexander Pope.

Fourth Folio (1685): 36 copies, including ones owned by William Morris, John Ruskin, Edward Fitzgerald, and George Eliot.

The Folgers purposely sought books in categories that would enrich scholarly study. *Source books* are works that Shakespeare is thought to have used in composing his poems and plays. In addition to familiar source books by Plutarch and Holinshed, the Folgers purchased Thomas Lodge's *Rosalynd* (1590), which inspired *As You Like It*, and Robert Greene's *Pandosto* (1588), which influenced *The Winter's Tale*. They tracked down Christopher Marlowe's *Hero and Leander* (1598), which the Bard copied when he wrote, in *As You Like It*, "Whoever loved that loved not at first sight?"

The Folgers collected more than five thousand *allusion books*, volumes that contain references to Shakespeare or his writings. Concentrating on works published before 1700, they secured a rare copy of Greene's *Groatsworth of Witte* (1592), which derides Shakespeare as an "upstart crow" in the earliest known reference to him in print. Their copy of Thomas Middleton's *The Ghost of Lucrece* (1600) reflects inspiration from Shakespeare's poem, *Lucrece* (1594). One of Shakespeare's most popular works, *Lucrece* went through six editions during his lifetime.

Association books once belonged to theatrical, literary or political figures of renown. The celebrities marked passages that particularly impressed them or added words reflecting contemporary interpretations. The stellar list of former owners in this collection of several hundred Shakespeare editions covers three centuries of literary and political luminaries: John Dryden, Robert Burns, Thomas Gray, Charles Lamb, Sir Walter Scott, Samuel Coleridge, William Thackeray, Percy Bysshe Shelley, Thomas Carlyle, Robert Browning, Alfred Lord Tennyson, Nathaniel Hawthorne, George Bernard Shaw, Edwin Booth, Ellen Terry, George Washington, John Adams, Abraham Lincoln, King Louis XIV, Napoleon III, and King George IV. The last association book Folger purchased was the pocket edition of Shakespeare that Walt Whitman always carried.

A prompter uses *prompt books* to remind actors of their lines. A director fills interleaving pages in a prompt book with stage instructions: diagrams indicating positioning of actors; textual cuts or revisions; entrances and exits; lighting or sound effects; scenery changes. The Folgers collected 2,500 prompt books from the libraries of, among other theater greats of three centuries, David Garrick, Edwin Booth, Sir Henry Irving, Robert B. Mantell, Samuel Phelps, and Augustin Daly.

Extra-illustrated books reflect a curious collector's fetish begun by James Granger in the late 1700s. A collector bought a book or set of books and removed the bindings. Then he or she would add various items associated with the author and title—playbills, watercolors, portraits, prints, and autograph letters. Often with the help of a professional inlayer, the book was then rebound, swollen many times thicker than the original. The Folgers bought a "grangerized" set of Shakespeare owned by Augustin Daly, an eight-volume set metastasized to forty-two volumes. In another favorite acquisition, two volumes of David Garrick had become seventeen.

David Garrick was a special object of the Folgers' passion. The dramatist, actor, and manager of the Drury Lane Theatre in London celebrated Shakespeare and his works. Folger admired the "glorious actor" for, in his opinion, having stood by the early quartos and folios and not wandered into the territory of remodeling or rewriting the Bard's plays.[3] The Folgers' Garrick collection numbered several thousand items including four hundred autograph letters; one hundred manuscripts of

poems, prologues, and epilogues; ten oil portraits (three by Sir Joshua Reynolds), as well as Garrick's journal, marriage certificate, silver table service, death mask, and armchair designed by William Hogarth, the last item holding a place of honor in the library's new reading room. Twenty-five additional autograph letters never reached Folger's mailbox because they went down with the British ship SS *Arabia*, torpedoed by a German submarine in 1916.[4] As Folger insured book parcels against all risks including war, strikes, riots, and civil commotions, he received reimbursement; nevertheless the collector remained mournful about his lost prizes.

Folger always intended to allot Sir Francis Bacon a prominent place in his library, given his important contribution to English literature and thought. Rosenbach called the Folger collection of Baconiana "the most extensive ever gathered."[5] Henry became a member of the Bacon Society of America at its creation in 1923. (Emily's brother Francis was named after Francis Bacon.) Folger purchased books (including over four hundred from William T. Smedley's library), notes, and autograph letters related to Bacon. He bought several items from Bacon's personal library, many with the author's annotations. He questioned whether some of these were genuine, however, and declined to buy certain Bacon items if their relationship to Shakespeare seemed too remote.

Shakespeare authorship was a related category for collection. Who wrote the works generally attributed to Shakespeare? Was it really William Shakespeare, the man from Stratford-upon-Avon? Or could it have been Francis Bacon; Edward de Vere, 17th Earl of Oxford; or someone else? The Folgers were convinced that students and scholars would make good use of their significant library about the controversy. Indeed, one of these recent scholars, James Shapiro, has written a comprehensive study of the issue entitled *Contested Will: Who Wrote Shakespeare?* (2010). Emily and Henry, however, harbored no doubts. The year before he died, Folger wrote to his British book dealer, Broadbent, that "I . . . am coming towards the end of my interest in Bacon; for all the books I have seen, read by him, tend to prove that he could not have been in any way responsible for the Shakespeare Plays."[6]

Folger bought as many books from Ben Jonson's library as he thought he could afford. Part of Folger's interest in Jonson—the celebrated seventeenth-century poet, playwright, and writer of court masques—stemmed from the publication in 1616 of Jonson's collected works, a precursor to Shakespeare's First Folio of plays. Rosenbach believed another reason was that Jonson left so many illuminating marginal notes in his own hand, after marking on the title-page of the books he acquired, "Su[m] Ben Jonson" (I am Ben Jonson), followed by his motto "Tanquam Explorator" (Like an explorer).

Relatively few libraries developed at the time were based, as was Folger's, on

affirming the supreme importance of *manuscripts*. "Our collection is very rich in manuscripts, as I have felt that they are of really greater interest than printed books."[7] Although manuscripts with literary and dramatic interest prevail, others address topics like medicine, science, politics, royalty and the court, economics, religion, astrology, heraldry, military science, and travel. The Folgers acquired samples of different kinds of manuscript hands: among them, the italic or Italian hand (increasingly popular in England after 1550); the secretary or "workaday hand," used primarily in the sixteenth century for governmental and private business, recordkeeping, correspondence, and literary composition; and court hands such as the Chancery, the Common Pleas, and the Exchequer.[8] In addition to the hands cited above, Preston and Yeandle discuss textura, bastard secretary, and combinations of italic and secretary.

The Folgers purchased in 1924 a series of early fourteenth-century manuscripts of Aristotle, the first of which was called *Physica*. Interspersed in the margins were small pointing hands—often with long index fingers—indicating an important passage to remember. To indicate this mark, William Sherman borrowed the term "manicula" from manuscript catalogers and popularized it in his own writings.[9] One day in the Folger reading room I beckoned Bill over to my table to show him a document in which Folger had used the manicula in his own notetaking. In 1922, the Folgers acquired a letter (ca. 1590) from Queen Elizabeth to "mon tres cher et bon frere et cousin" King Henri IV of France in which the Queen, from personal experience, advises restraint in dealing with strife between Catholics and Protestants. In 1897 the Folgers bought the "Dering Manuscript," a five-act play (ca. 1623) that conflates parts 1 and 2 of Shakespeare's *Henry IV*. Sir Edward Dering organized an amateur performance of the play in his Kent home, demonstrating early interest in Shakespeare. This is the earliest extant manuscript of a play by Shakespeare.

Musical literature and period instruments also form an important part of the Folger collection. Henry Folger was a singer, organist, and enthusiastic member of the music committees at his college and church. He wrote that had he not been a collector of Shakespeare he would have specialized in early music. No surprise, then, that about a thousand titles concern "Shakespeare and Music." Thomas Morley's *First Booke of Ayres* (1600) contains the original setting of the ditty, "It was a lover and his lass," which appeared in *As You Like It*. Composer John Dowland's first (1600), second (1600), and third book of songs (1603) grace the collection.[10] From the Arnold Dolmetsch collection of ancient musical instruments, the Folgers bought a lute made by Michele Harton of Padua in 1598, an Italian pentagonal virginal, an Italian clavichord of cypress wood, an Italian clavicembalo, an English treble viol from 1570, and an English viola de gamba.

For Henry and Emily, their *painting collection* was never a priority. First, far and away their major dealings were with bibliophiles, not connoisseurs of art. Second, while they acquired over two hundred paintings, they spent more than $2,000 for only seven of them. Third, Folger admitted he was no discerning judge of visual art, buying objects "when they were cheap."[11] As one would expect, most subjects were scenes from Shakespeare's plays. The collection also contained several Shakespeare portraits. Some artists were renowned: Sir Joshua Reynolds, George Romney, Thomas Sully, Henry Fuseli, Sir Thomas Lawrence, and Benjamin West. Research by William L. Pressly has demonstrated, however, that as many as half the paintings purchased by the couple were misattributed. The Folgers mistakenly thought they owned Gainsboroughs and Turners.

Finding them curious and interesting, the Folgers bought examples of *plagiarism* of William Shakespeare. Folger believed the Shakespeare library ought to be complete. He wrote to Emily's older sister, "in a collection completeness outweighs merit."[12] One doesn't judge, or set aside, only the true, the best, the most beautiful; everything counts. They paid as much as £3,800 for Thomas Heywood's *Oenone and Paris* (1594), the only known copy of a plagiarized version of Shakespeare's *Venus and Adonis*, first published in 1593. They purchased several volumes of Shakespeare forgeries by William-Henry Ireland published around 1800. Folger branded Ireland a "scamp." Nevertheless, he thought their library must have the forger's book, titled *Confessions*.

Closely related to plagiarism was the constant lure of obtaining a genuine *Shakespeare signature*. The Chicago autograph dealer Oliver Barrett dangled more bait than anyone. Barrett visited Folger at 26 Broadway to discuss their approaches to collecting. As the visitor later put it, "Folger said he wanted Shakespeare, I wanted Lincoln. I let him have my Shakespeare and I bought Lincoln items I wanted."[13] The two collectors agreed to help each other out. Folger noted a bit regretfully that it would have been easier to collect Lincoln than Shakespeare.

Their parallel pursuit, however, had distinct limits. When Barrett agreed with some reluctance to sell him a Shakespeare signature for $25,000, Folger responded curtly, "I do not feel like taking your Shakespeare signature at the price you put on it. I would like to have it, but am too much of a business man to pay what seems to be such an excessive figure for it."[14] The signature in question had belonged to Charles Frederick Gunther, the German inventor of caramel candies, who died in 1920.

Folger purchased a copy of *Plutarch's Lives* (1579) with a signature "William Shakespeare" atop the first page of text. Could it be genuine? Folger librarians called in Theodor Hordyczak, an early architectural photographer in Washington,

to photograph documents from the Folger vaults in 1932 that included "two alleged Shakespeare autographs."[15] Later, all were judged to be forgeries. The Folger Library does not yet possess a Shakespeare signature considered genuine.

Another collector's item that Folger rarely declined was any piece of the legendary mulberry tree that stood in New Place, the Bard's last residence in Stratford, supposedly planted by Shakespeare himself from a cutting. A hundred and fifty years later, the owner of New Place destroyed the huge tree for firewood. A local craftsman and clever entrepreneur, Thomas Sharp, purchased many logs, soon launching a cottage industry carving Shakespeare memorabilia out of the ancient mulberry. Long before Folger, David Garrick and Ireland obtained every mulberry item within reach. Often the objects reproduced Shakespeare's head, or a crest and shield, or mulberries and leaves. One has to wonder how many mulberry trees besides the Ur-tree went into these apparently endless curios.

From the Warwick Castle sale, Folger walked away with a mulberry thimble. He added a mulberry statuette from Sotheby's and a tea caddy from Anderson Galleries. Then he came upon a mulberry goblet once in Garrick's collection. By 1922, Folger declared to Michelmore and Company, "I have many articles carved from the mulberry tree, so am not inclined to try to secure any more."[16]

Why then did the Folgers buy a mulberry cup in 1923, another goblet in 1926, a rolling pin in 1927, and an inkstand in 1929? Collectors have difficulty observing limits, and Emily loved such small objects. Relics, she wrote, "will help to enable us to catch the spirit of Shakespeare's time. We have always thought of the library as being like a book with illustrations. Of course, the relics will serve that purpose; they will illustrate the poet's text."[17] Emily later used the same curious metaphor, linking their building itself to a book, "the Library was to be the First Folio, illustrated."[18]

The prize for the largest Folger collection in any category, hands down, goes to *playbills*, with a quarter of a million.[19] Created in the eighteenth century, playbills are printed programs informing theater goers about an upcoming production.[20] They may include a cast list and information about scenes in the play. In the nineteenth century, playbills added advertisements. Most examples in the Folgers' collection advertise upcoming Shakespeare performances. Folger bought his first big lot of eighteenth-century playbills in Boston, where 180,000 playbills became "a good load for two horses."[21]

Although the Folgers were later reproached for failing to assemble enough basic *reference materials* for researchers, they did, in fact, purchase encyclopedias and dictionaries, including five editions from Shakespeare's period of Withals's English and Latin dictionary. They acquired 11,000 sales catalogs, 1,300 bibliographies, glossaries, and publications of learned societies. The Folgers accumulated the staggering

figure of 92,000 books. Over forty years of collecting, that averages six books added every day.

In *Making the Mummies Dance*, Thomas Hoving—former director of the Metropolitan Museum of Art in New York—identified three types of collectors: 1) those who buy every piece themselves, 2) those who get professional help, and 3) those who amass collections formed by other connoisseurs.[22] The Folgers stand closer to the first category than to the second, far from the third. Henry Folger's approach to collecting was a modern one. He valued marginalia in antiquarian volumes: comments or corrections, drawings or poems, additions to the text by famous or common readers, making the acquisition all the more interesting to scholars.

❧ Just as the Folgers' Shakespeare tale involves the love story of Emily and Henry and their shared devotion to the Bard, so too their collecting displays what Rosenbach called "a romance about every one of his great purchases."

Henry Folger bought his first rare book ten years after graduating from college. In 1889, he attended in person a book auction in New York City at Bangs and Company, the foremost auction house in America. The volume that caught his eye was a copy of Shakespeare's Fourth Folio (1685). When he discovered that his bid of $107.50 was a winner, he realized he didn't have the cash. He requested and easily obtained a one-month period of credit during which he paid in four installments. Thus began a forty-year Shakespearean hunt and half a century of figuring out how to pay for what caught his and Emily's discerning fancy.

In 1896, Emily made a list of the 1,200 most coveted Shakespeare books with the goal of adding them to their collection.[23] In the left-hand margin, she ranked each item on a scale from "1" to "4." As evidence of their collaboration, Henry penned the code for interpreting Emily's categories:

1. I wish under any circumstances.
2. I lack but think I can get.
3. I have, but think there may be better than mine.
4. I do not wish.

The Folgers' meticulous recordkeeping included detailed notes on each item's condition. They were constantly on the lookout for a more perfect specimen of an object they already owned. The couple also recognized the need to establish limits, unlike many collectors who have a problem stopping. The disciplined couple relentlessly scoured the market for desired items. Their want-list contained a section for very special pieces for which they were willing to make extraordinary financial sacrifices.

The Folgers also found highly efficient ways to build their collection. While not

excluding purchases from bookshop stock and individual books and manuscripts as they were offered, they concentrated on procuring through major book auctions in England and America. Rather than attending in person, Henry found it more efficient to go through professionals, book dealers who doubled as commission agents. This refined strategy paid off handsomely.

One example was their en bloc purchase in 1897 of the Warwick Castle Shakespeare Collection. Warwick Castle on the banks of the Avon in Warwickshire is known largely for its bloody history as a medieval fortress marked by intrigue, treachery, and murder. For the Folgers, however, Warwick Castle was only one room, the library, and its Shakespeare collection assembled in the 1850s and 1860s. In a rare talk to Amherst students after he received an honorary doctorate in 1914, Folger shared the reason why this collection meant so much to him. "The beautiful library of Shakespeareana from Warwick Castle, most comprehensive, is essentially valuable for its manuscripts, manuscripts about Shakespeare and his life, the original notebooks of early commentators, and best of all, early manuscript copies of the plays. Indeed, the catalog claims every known copy made before 1700. Until there appears a playhouse copy in Shakespeare's handwriting or in that of one of his contemporaries, these must be accepted as of prime importance."[24]

A rich backstory reveals the roles played by Folger and his agent, Henry Sotheran and Company, "Bookseller to the King." The Earl of Warwick had never given much thought to selling the Shakespeare collection. The books had been unread and unappreciated since his father, who acquired them, died in 1893. However, by 1897, when Sotheran first approached him, the Earl had begun to think he'd rather have cash than old Shakespeare volumes.

Utmost secrecy surrounded a flurry of correspondence, which Folger signed with the code name "Golfer." His messages use other coded terms: Roboro (telegram received); Obsono (offer is accepted); Aspicio (commission will be allowed of . . .).[25] Ultimately, with Folger's persistence and resolve, the Earl accepted Folger's price of £10,000 for the lot. Eight boxes of Warwick books duly arrived in New York, where Emily entered in her card catalog the relevant information on these gems, including a First Folio and twenty-six quartos. In their basement, the Folgers themselves repacked the Warwick trove, along with auction catalogs and relevant memoranda, and called the storage company to take them away. Emily's careful accounting recorded their disposition: Cases 12–25, Room 5B14, Eagle Warehouse and Storage Company, Fulton Street, Brooklyn.

Yet another dramatic story began to unfold on the morning of January 11, 1905. As was his habit, Folger picked up the *New York Times* for his morning read. Above the fold on the right side of page 1, eight lines halted his gaze. "LONDON, Wednesday,

Jan. 11.—The Morning Leader's Copenhagen correspondent reports the discovery at Lund, Sweden, of a book containing the text of Shakespeare's 'Titus Andronicus,' printed in London in 1594. The oldest edition hitherto known is the 1600 quarto." On his way to work that day, Folger stopped at a cable office and wired instructions to his trusted agent in London, Henry Sotheran, to dispatch a representative at once to Lund and obtain an option on the rediscovered *Titus*. Before the day was out, Sotheran, after confirming that a courier was en route, asked, "What is the highest you are willing to pay?"[26]

Folger couldn't make up his mind. He spent three hours pacing lower Manhattan, stewing over the right figure. Finally, he wired back, "£2,000." Over the course of the next few hours, two other hopeful buyers coincidentally offered exactly the same amount. Folger took home the prize, however, as his wire had arrived first, and he was prepared to pay cash. When the unique volume arrived, the Folgers were surprised to find it as new as when it had been purchased by playgoers for a few pence. Covered in soft, blue-gray paper, *Titus* had remained in its original wrapper for over 300 years. Folger placed it in his safest storage facility, the Franklin Trust Company, on March 10, 1905. The public did not see this rarity until 1936, when the Folger Shakespeare Library issued its first scholarly publication, a facsimile copy of *Titus*, which Charles Scribner's Sons published for the trustees of Amherst College. The uniqueness of this volume lies in its status as the only surviving copy of the first printing of *Titus*, and thus the closest we are able to come to the Shakespeare holograph of the play, in this case, the dramatist's foul papers, the bibliographic term used for the author's working, marked-up manuscript. The volume is also one of only two Shakespeare quartos printed in 1594 (the other being *Henry VI, Part 2*). When compared to Q2, which was copied from it in 1600, the 1594 Quarto shows several missing lines at the end of Act 5, which were then supplied by the later compositor.

Several years later, Henry Sotheran was again on the prowl, this time for another major library known as the Halliwell-Phillipps Shakespearean Rarities. Sotheran knew that Folger coveted this collection when he bought the Warwick Castle library. Alas, another American Shakespeare buyer, a Rhode Island railroad magnate from Providence, Marsden Perry, managed to acquire it in 1897. Perry was a collector with wide interests: porcelain, furniture, Dürer and Rembrandt paintings, as well as Shakespeare. Henry Sotheran patiently and cunningly followed not only the market but also his clients' fortunes. In 1908, he alerted Folger: "It is common talk in London that Mr. Marsden Perry has been very seriously affected by the financial disaster in America."[27] It was a false alarm; Perry wasn't ready to sell. Only more than a decade after the Panic of 1907 did Perry finally decide to sell his Shakespeare

collection, but not to the Folgers. Rosenbach bought it in 1919. The Philadelphia bookman did not deliberate long about which Shakespeare collector—Henry E. Huntington, William A. White, or Folger—to approach next for a huge deal.

"To 26 Broadway," Rosenbach commanded the cab driver. A familiar visitor to the "Tower of Secrecy," the bookseller was whisked to the thirteenth floor. When he asked the secretary outside Folger's office, room 1300, whether he could see Mr. Folger, he learned that the Standard Oil executive committee was in session. He scribbled a note and asked that it be delivered urgently to the collector. The secretary hesitated before opening the heavy padded door. Few, if any, had ever interrupted an executive committee meeting.

A moment later, the president of Standard Oil of New York rushed out of the meeting. He blurted, "Will you give me the first choice? I particularly want the 1619 volume that belonged to Edward Gwynn [seventeenth-century bookbuyer]."[28] Well acquainted with the Halliwell-Philipps collection, Folger knew what he wanted most, the Pavier quartos, the only known complete copy in its original binding of the first attempt at a collected edition of Shakespeare's plays. It was published four years before the First Folio, by the same printer, William Jaggard. Containing falsified title-pages, it is sometimes known as the false folio. Rosenbach, who relished the index written in Gwynn's quaint handwriting, was only too happy to comply.[29] As did Folger, Rosenbach considered the Pavier quartos the crown jewels of the Mardsen Perry collection.[30] With the treasure now within his grasp, Folger cleared his throat, straightened his tie, and returned to join the oil company directors.

Was Folger guilty as charged by Rockefeller (see prologue) of paying $100,000 for the Pavier quartos volume? How helpful for us now that Folger saved his cancelled checks! After a voyage from New York by train on July 12, 1919, the Folgers had settled into their usual accommodations in Hot Springs, Virginia, for their customary six-week summer stay. On July 21, the Folgers opened a Western Union telegram from Rosenbach: "Perry deal closed. Your secretary requested me to telegraph you. Pls wire me about payment."[31] The same day, Folger dispatched a telegram back to Rosenbach: "Check has been mailed direct to you in Philadelphia."[32] Folger followed up with a letter, "I have just telegraphed you . . . Enclosed please find check for $100,000, as agreed."[33]

However, no invoice explains exactly which item or items that check covered. Big collectors often bought entire libraries or lots. On July 23, Rosenbach sent an acknowledgment while adding a clarification. "Your check for $100,000 to be applied on account of your purchase of $128,500, of books from the Perry collection came to hand this morning."[34] On July 28, 1919, Folger wrote a second check to Rosenbach for $28,500.[35]

TABLE 3

Highest-Value Volumes Purchased from Perry Collection, July 1919,
with Itemized Prices Penciled in by Folger

Shakespeare title	Price (in 1919 dollars)
Quartos, 1619. Edward Gwynn copy	50,000
Henry VI, Part 2, 1594. 1st part Contention	18,500
Venus & Adonis, 1595	15,000
Pericles, 1611	12,500
Richard III, 1605. William Penn copy	7,500

Note: The Gwynn volume of 1619, priced at $50,000, or $650,000 in 2011 dollars, is one of the most expensive volumes Folger ever bought.

Suddenly, with the plural, "books," the amount of $100,000 takes on a wholly different meaning: The Pavier quartos appear to be part of a lot equaling $128,500. On July 29, Rosenbach wrote Folger, "I delivered yesterday to Mr. Welsh books and manuscripts according to our agreement, and received a check from him for $28,500."[36] Now we learn that not only books but manuscripts made up the lot, and the total cost to Folger was more than $100,000. In the Rosenbach Co. Perry Library file, Folger left behind many notes and calculations, lists of books with some titles crossed out or the marking, "other items omitted," such that it is not easy to figure out which books he finally bought for the amount in question. Folger was constantly haggling to lower the price; Rosenbach would "regret exceedingly" and they would haggle some more. Perhaps Rosenbach and Folger determined the final deal over a telephone conversation. In addition, Folger often bought books, and returned them if they were not to his liking.

The figure, $50,000, that Folger marked in pencil, appears on two typed documents entitled "Items to be retained from Perry Library," against the item, "Quartos Gwynn vol. 1619."[37] Nowhere in the Folger lists does one read $100,000 against this item. Rosenbach and Folger both signed one (undated) list of twelve items, without individual prices indicated but with this handwritten notation, "125,000 for lot."[38]

Rockefeller was not alone in reading that Folger had paid $100,000 for a book. Several newspapers carried the report. *World Magazine* published an article under the title: "The Costliest Book in the World, the unique Gwynn volume of nine Shakespeare plays on the original quarto reprint of 1619—Purchased by H. C. Folger, an American collector, for $100,000."[39] The article did not escape the eye of a fraternity brother of Folger at Amherst who had joined him working for Charles Pratt. After Walter Mossman questioned the veracity of the news report, Folger admitted, "Dear Mossman, I did buy the book referred to, but paid only a fraction of the price named—as you doubtless had guessed knowing me as you do."[40] Folger

Check for $100,000 Henry Folger sent the Rosenbach Company on July 22, 1919, to purchase several rare books from the Marsden Perry Library. *By permission of the Folger Shakespeare Library*

chose the word "fraction" carefully. And he loathed mention in the press of prices he might have paid.

Rosenbach, who was not beneath divulging book sale prices to journalists, wrote Folger with characteristic panache, "I want to congratulate you upon obtaining, what I consider, the FINEST SHAKESPEARIAN VOLUME IN EXISTENCE."[41] Edward Gwynn, the seventeenth-century owner of the volume, had his name stamped on the five-by-seven-inch wrinkled calf cover that contained crinkled pages. An image of the Pavier volume may be seen today in the Frank O. Salisbury portrait of Folger, which hangs in the library's Gail Kern Paster reading room—the one book the collector chose to hold in his hands for the sitting.

The Halliwell-Phillipps collection was now in Folger's hands, destined for the shelves of the Folger library. It consisted of four elements: early portraits of Shakespeare; artistic illustrations connected with Shakespeare; contemporaneous documents; and personal relics of the poet. Folger was especially interested in the fourth category, which contained title deeds to estates of which Shakespeare was owner or part owner.

Especially strong in manuscripts, the collection also included as many as sixty Folios. Also in the collection, the contents of 328 drawers, composed of "heaps of loose scraps of paper," posing a huge research challenge. But the Halliwell-Phillipps Shakespearean Rarities was the prize that almost got away. When he was less wealthy, Folger had suggested that the collection be donated to an American university. In 1895, he wrote his boss, John D. Rockefeller, suggesting that he buy it for $50,000. "My excuse for writing this at length is to beg permission to suggest that this magnificent collection be bought for the Chicago University . . . Had I the means, I would not hesitate as a business man, to buy the collection, with the expectation

that the profit on the reproductions and the money for the originals if sold at auction would net a handsome margin on the investment."[42]

Biographer Ron Chernow reminds us that in 1895 Rockefeller pledged $3 million for the University of Chicago's endowment.[43] What was another $50,000? Folger tried one more plea: "I trust before you come to an adverse decision you will let me have a word with you." The titan declined. Unschooled, Rockefeller was no man of books.

S. R. Christie-Miller was a voracious British book collector of the nineteenth century. When his collection sold as part of the Britwell-Court Library, it took fifty-three days at auction over a full decade—1916 to 1926—for Sotheby's to sell off the works. Folger sent bids first to one of the preeminent London book dealers, Bernard Quaritch, and subsequently to Rosenbach, to represent him at several sessions. Folger saved newspaper clippings after the March 1923 sale, during which Rosenbach carried off three-quarters of the items sold. The Brits labeled Rosenbach "The Invader," according to the *New York World*, and the *Times Literary Supplement* lamented that so many British treasures, sold for extravagant prices, would never come on the market again.

After announcing, then revising his bids to Rosenbach several times—and competing with J. P. Morgan, Henry E. Huntington, and William A. White—in 1924 Folger obtained much of his want list, including *Lucrece* (1632) for which he paid $33,144. Rosenbach ordered a specially constructed steel box to carry the treasures safely back to America. Ultimately, Folger kept the *Lucrece*, along with the 1924 Britwell-Court catalog, in his office safe at 26 Broadway. Folger had a special affection for the early printed copies of Shakespeare's poems and probably paid so much due to the rarity of this *Lucrece* edition, the last to be published before the outbreak of the English Civil War. He would come to own copies of the first edition of 1594, as well as those of 1600, 1624, 1632, and 1655.

The circuitous means that enlarged the Folger collection made for another memorable story centered on Brooklyn book collector William A. White. White was renowned for having agreed to part with very few literary treasures during his lifetime. One transaction took place spontaneously at his home, 158 Columbia Street in Brooklyn, in June 1922. He confided to his dinner guest, Dr. Rosenbach, "I've never sold a Shakespeare quarto in my life, but I'm sorely tempted. I'm itching to tell my skeptical family that I wasn't such a fool when I invested money in what they considered playthings." Rosenbach was at first incredulous when White asked him to name his price for his third edition of *Richard II* (1598). The book dealer knew that White's volume was not "a" third edition, but "the only complete" copy of that third edition in the world.[44] After White accepted on the spot the Doctor's offer of $45,000, he divulged to his guest, "In 1890 I paid $348 for it."[45]

Rosenbach immediately sent Folger a letter marked "very confidential." The opening salvo described the volume newly added to his inventory: "With the exception of the *Titus Andronicus* (1594), it is the *only unique* Shakespeare quarto published in the sixteenth century." He continued, "I am making you the first offer."[46] Folger and Rosenbach agreed on a price of $55,000. In less than a week, the canny dealer had made a profit of $10,000 on a single book. Generally the doctor's invoices included transportation costs. This time, after shuttling the three miles from White's home to Folger's, Rosenbach refrained from billing for the ten-cent taxi fare as he usually did.

When White died in May 1927 at age eighty-four, his family hired Dr. Rosenbach to dispose of his library, which Rosenbach claimed was "the last great Shakespeare collection in private hands."[47] Now people wanted to know who would get the rest of White's treasures. First, the White family donated to Princeton—which had awarded White an honorary L.D in 1926—the collector's First Folio, valued at $75,000. Second, the family wanted to announce a major gift to White's alma mater, Harvard, at commencement in June. They asked Rosenbach to make a selection; he chose eighty-eight Shakespeare quartos valued at $420,000.

Harvard was willing to buy more gems from White's library. The college set up a fund to purchase "on most liberal terms" three hundred volumes from the sixteenth and seventeenth centuries handpicked by Rosenbach.[48] The book dealer soon reported to Folger that Harvard was having difficulty raising money for the purchase and returned several books to the White estate. The doctor wrote, "Surprising to state, [Harvard] retained some of the volumes which it would be possible to replace and returned others that could probably never be secured again."[49]

Folger's turn came next, and he was ready for a bibliophilic binge. Between February and October 1928, he put together six different want lists of rarities from the White library that cost him $292,800.[50] Folger began his spree by spending $122,500—close to his entire annual salary—for twenty books from the White collection.[51] In his invoice, Rosenbach highlighted the rarity of Folger's new treasures by indicating the number of existing copies of each volume (see table 4).

The majority of the books Folger chose were from the *Short-Title Catalogue of Books Printed in England, Scotland, and Ireland (STC)*, a listing of books published in English between 1475 and 1640. Once such rarities had left private hands for institutional shelves and public availability, they were out of the market forever. Thus did Henry Folger ensure the importance of his collection, and ultimately of the Folger Library in Washington and beyond. He was playing a part in assuring America's arrival on the international cultural stage.

TABLE 4

Titles of Volumes from White Collection and Known Copies

Volume	Known copies
The ant and the nightingale (1604)	"Only one other copy known"
Armin, *Fools upon foole* (1605)	"Only one other copy known"
Armin, *Nest of Ninnies* (1608)	"Only one other copy known"
Austin, *Scourge of Venus* (1613)	"Only copy known"
Barnfield, *Affectionate shephard* (1594)	"Only one other copy known"
Barnfield, *Enconium of Lady Pecunia* (1598)	"Two others known"
Breton, *Poete with a Packet of Mad Letters* (1620)	"Only copy known"
Gordon, *Famous History of Penardo and Leissa* (1615)	"Only one other copy known"
Great Assises Holden in Parnassus (1645)	"Two others known"
Greene, *Menaphon* (1599)	"Two others known"
Greene, *Grotsworth of Witte* (1592)	"Only one other copy known"
Jones, *First books of songes or Ayres* (1600)	"Only one other copy known"
Look to it London (1648)	"Only one other copy known"
Marlowe, *Hero and Leander* (1598)	"Only copy known"
Nicholson, *Acolastus* his afterwit (1600)	"Only a few copies known
Ravenscroft, *Deuteromelia* (1609)	"Two others known"
Sait Marie Magdalen's conversion IHS (1603)	"Only one other copy known"
Cupid's Cabinet Unlock't (n.d.)	"Only copy known"
Sharpe, *More Fooles yet* (1610)	"Only one other copy known"
True Declaration of the Estate of Virginia (1610)	"Five others known"

Source: FSL FC B1, Rosenbach invoice, February 3, 1928

❧ Henry Folger's bibliophilia was not limited to literary works of the sixteenth and seventeenth centuries. As he perused thousands of auction catalogs, his gaze wandered to other book categories. His want lists and bid lists are peppered with titles he acquired that cannot be found in the library on Capitol Hill. He offered these volumes to a coterie of friends, and occasionally they stayed in the Folgers' home library.

By far the largest collection—1,400 volumes—consisted of books on butterflies. Every Christmas, and on other occasions over thirty years, Folger gave selections to his oldest, closest friends, Charlie and Mary Pratt. Each December 25, Mary would write a letter of thanks to Emily, with Charlie sending a second note of gratitude to Henry. After Vassar, Mary taught Latin and Greek, but lepidoptera were her hobby. Henry's carefully chosen butterfly books for Mary included Thomas Moffett's *Insectorum sive minimorum animalium theatrum* (1634). The next oldest item was *Muscarum scarabeorum* (1646) by Wenceslaus Hollar. Half-hidden in the back of this book, a handwritten note from Henry survives on the back of his business card, revealing his ever-analytical mind: "1646 strikes us as an early date for butterfly engravings—Sept. 30, 1906."[52]

Once, Folger returned a butterfly book in a pitiful state to Quaritch's in London due to what some would consider a minor flaw. As he explained: "You sent me recently a very nice lot of books on butterflies . . . I have these books rebound and use them for presents. When I sent to the binder Wright's *Butterflies of the West Coast of the United States*, 1906, he found, on checking it up for binding, that it lacked a signature, pp. 241 to 255, but in its place had a duplicate signature. This they did not discover until after they had torn off the binding. I am returning the volume for such disposition as you think can be made of it, and for such credit as you think is fair, as of course, I cannot use it in a scientific library."[53]

Discovered after his death were stacks of butterfly books Henry had set aside for future gifts. As Mary noted in 1931, Henry "even took the time and trouble to assemble and arrange groups of pamphlets and had them bound for us—surely a labor of love for one whose mind and hands were so full of matters of enduring importance that an interest in mere butterflies might well have been as transcient [*sic*] as the lives of the subject."[54]

Another non-Shakespearean interest was golf. Folger bought his first set of left-handed hickory clubs in 1902 and won a handicap tournament at the Nassau Country Club in Glen Cove, Long Island, the following year. He subscribed to *Golf Illustrated* and the *American Golfer*. In 1926, he won a seniors' competition on the couple's annual visit to the Homestead in Hot Springs.

The golf books he purchased, including the *Art of Golf* and a scrapbook of Warwickshire golf, he forwarded to Charlie's younger, more athletic brother, Herbert L. Pratt, also a Standard Oil executive. "Bert" had won the men's golf championship at Nassau. Six months after Henry died, his successor as chairman of the board of Standard Oil of New York, Herbert, wrote Emily, "Very many thanks [for the golf books]. I never look at one of my grand golf library but I am reminded again and again of my loss of my 'senior partner.' How I wish he were here today to help me on one or two pretty knotty problems."[55]

Henry Folger's top bureau drawer at home was the repository for dimes John D. Rockefeller had given him during their golf games together, generally Mondays at 10 a.m. One of Emily's nephews looked back on the dime collection: "It was crazy to me, Rockefeller's way of rewarding someone who did something extraordinary. Every time Uncle Henry would make a 16-foot putt or something, Mr. Rockefeller would reach into his pocket and hand him a bright shiny dime. How ironic, the richest man in the world giving out dimes for presents. It's a piece of American folklore."[56] Emily had a few of those dimes—all dated 1920—set in a silver watchband.

The Folgers' pastor also benefited from Henry's literary largesse. Continuing their churchgoing tradition, Henry and Emily rented a pew in the Central

Emily Folger used the dimes Rockefeller gave her husband after good golf shots to make a watchband. *By permission of the Folger Shakespeare Library*

Congregational Church on Hancock Street in Brooklyn. Their minister, Samuel Parkes Cadman, was born in Shropshire. The Cadmans and the Folgers became very close, carrying on a regular correspondence. Every year Henry gave his minister antiquarian books: editions of Shakespeare, old Bibles, even a 1616 book used by Luther to vindicate his attitude toward reform. Henry paid a shorthand reporter to take down Cadman's sermons, presenting them to the minister as a bound volume. When Cadman published a book on preaching, Folger purchased 150 copies of "Ambassadors of God," sending them to the pastor's family and others in the United Kingdom and America.

Henry's affinity for music drew him closer to the church. In honor of his late father, Henry paid for a harp stop for the church organ. He added his rich baritone to church service singing and gave financial support to the music program. He donated old musical scores to the church organist, in one instance selecting a volume of old French songs and suggesting that the musician "find somewhere in it a musical phrase upon which to build an Offertory or an Anthem."[57] Reverend Cadman gave the eulogies at the memorial services for both Henry and Emily.

Finally, Amherst College profited from Folger's generosity. From a New York bookseller he purchased fragments of an imperfect Gutenberg Bible. The college librarian noted that the "leaf is in exceptionally beautiful condition and has three chapter initials, as well as the very rare head watermark." Folger's purpose was to provide for Amherst students a "sample of this bible in the original form, a very suitable item for reference." To the college's president, George Olds, in 1926, Folger sent William Robertson's *History of America* (1777) in two volumes, carrying the bookplate and crest of Lord Amherst. Folger remained in close contact with the chairman of the English department at Amherst, frequently sending large crates of duplicate Shakespeare volumes to fill the shelves in the English seminar room of the college library.

❧ Henry Folger intended to write a book about acquiring his Shakespeare collection. The excitement of the chase postponed the project again and again. Relishing his acquisition stories, however, prompted Henry to start writing, curiously, in the third person. Or perhaps the distant third person was not so curious, given Folger's inborn modesty and shrewd secretiveness. Among his papers is a rare account, first in pencil, then typewritten, that reveals Henry the raconteur:

> In one of Sir Sidney Lee's articles tracing extant copies of the Shakespeare First Folio, a footnote states that Dr. John Gott, Bishop of Truro, has also a fine collection of the Quartos. That was enough to excite the curiosity of an avid American collector. A letter to the London firm through which he was then buying asked that a representative of the firm go at once to Truro, examine the Quartos, and, if possible, get an option for their purchase. The mail brought the reply that even a London bookdealer could not, without a letter of introduction, hope to see the books of a Bishop, and certainly not expect an interview with the great man himself.
>
> This didn't satisfy the eager American, and the request journeyed across the Atlantic to please send someone to sit on the Bishop's doorstep until he was admitted. In America such obstacles would be treated lightly, or be ignored. The reply to New York said the incident was closed, with no prospect of securing the treasures. An Englishman would have tried no further, for the present at least. But not so this ambitious American. "Do," he wrote, "send someone at my expense, and devise some way to get the books." Back the dealer went, with letters to the Bishop's neighbors, and patient waiting was rewarded by a chat, not with the Bishop, but with his son-in-law, a local barrister.
>
> Yes! The father-in-law had some Quartos, but they could not be bought. However, an opportunity to see them was at last granted. Beautiful books they were

found to be, in fine condition, uniformly bound in crimson levant, several of them being most rare. And it was further developed, from the now interested barrister, that the Doctor was in poor health, with a very limited income, leaving nothing for repairing a considerable estate rapidly falling into decay. The son-in-law actually found himself sympathetic with the notion of disposing of the books to a keen American. There the negotiations stopped.

The cable was now brought into service, and persistent correspondence pursued. An offer for the books would be laid before the Bishop, and, if it was ample, would be urged for acceptance. A generous offer found its way to Truro, and, at length, the barrister appeared with the volumes at the shop of the London dealer. He was relieved of them in exchange for a check, for the American had urged prompt action should an opportunity offer. This was on a Friday afternoon, and the well-satisfied seller journeyed back into the country.

He was amazed to learn, on reaching home, that the venerable Bishop had, early Saturday morning, passed on to his reward. A few hours' delay would have prevented the transfer of the books, and their acquisition would have become almost impossible. The obstacles of Chancery, and the delay and uncertainty of an auction sale to ascertain real values for tax purposes, would have loomed up. Had the mails, instead of cables, been used for the final negotiations, the shelf of lovely Shakespeare Quartos from the cloistered retreat of the sainted Bishop of Truro might never have found a final resting place in Washington, the United States Capitol.[58]

Henry Folger had shown promise as a writer at college, both in class and in correspondence with his parents, but his later correspondence consisted largely of short, business-like exchanges with book dealers. This rare anecdotal account of the chutzpah demonstrated by the "ambitious American" left Dr. Rosenbach and many others eager for more tales in the collector's wry style. But soon, writing gave way to chasing down his ultimate prize, First Folios, another opportunity Folger grasped with determination. Continuing the "hunt," he would follow wherever "the game [made] way."

❦ ❦ ❦

Whole Volumes in Folio

The Ultimate Prize for Collectors

> . . . I am sure I shall turn sonnet. Devise wit, write pen,
> for I am for whole volumes in folio.
>
> *Love's Labor's Lost* 1.2.183–85

SHAKESPEARE'S FIRST FOLIO (1623) is a large book with dense double-column pages printed in London seven years after Shakespeare's death. One scholar has described its printing as not "consistent," another as "careless."[1] The manuscripts for this volume have gone missing. Yet its pedigree is matchless. It became, early on, the ultimate prize for major collectors, and Henry Folger triumphed in assembling the greatest number of First Folios in the world.

The First Folio is important for many reasons. It is the first edition of the author's collected plays, thereby establishing the core of the Shakespeare dramatic canon.[2] It is the sole source for half of Shakespeare's dramatic production. Eighteen plays (including *Macbeth*, *Julius Caesar*, *The Tempest*, and *As You Like It*) had never been printed before and would not have survived without this early compilation. The large size of the folio represents a statement about the importance of dramatic works in an age where the stage was not usually deemed an elevated art form. Shakespeare's now iconic portrait, his steep forehead memorialized in the volume's preliminary pages, is one of only three representations of Shakespeare widely accepted as authentic.[3] Three subsequent editions followed: Folio 2 (1632), Folio 3 (1663–64), and Folio 4 (1685). Scholars assign textual preeminence to the 1623 folio because each of the others derives from the preceding editions and introduces its own corrections and errors.

The First Folio is not considered an extremely rare book. First Folio specialist Anthony James West has described in extraordinary detail 232 extant copies of the book out of an estimated 750 printed nearly four centuries ago.[4] By comparison, fewer than fifty Gutenberg bibles survive. Today 147 copies of the First Folio exist in North America, 47 in the British Isles, and 26 in other parts of the world, notably Japan.

Two of Shakespeare's friends, longtime fellow actors, and shareholders in the acting company first known as the Lord Chamberlain's Men and then as the King's Men—John Heminge and Henry Condell, neither of whom had any editorial experience as far as we know—took the initiative to gather Shakespeare's plays in a single, comprehensive edition and prepare the First Folio for publication. The substantial risks of financing the venture were borne by five London publishers: William and Isaac Jaggard, Edward Blount, John Smethwick, and William Aspley. William Jaggard had become blind, and died during the course of production of the First Folio; his son Isaac took over the family printing business. Without the enterprise of these seven men, the work might not have appeared at all.

The First Folio was approximately a foot high, most copies measuring about nine by thirteen inches.[5] With some exceptions, they were offered to the public unbound, with pages uncut. Due to the large-size format of the volume, and the quality of the handmade sheets of rag paper imported from northern France, the sales price was high—between fifteen shillings and a little over one pound (twenty shillings), or, as Paul Collins expresses it, the equivalent to buying forty loaves of bread.[6] No evidence exists that William Shakespeare cared about leaving a written record of his plays. In his era, performance *was* publication. Drama was written to be recited by actors, not read by the public. An author would have derived little to no financial benefit from the printing of his works, for the theater—not the author—owned the plays. Appearance of plays in print was feared to discourage potential spectators from attending performances. Hundreds of dramatic works produced during Shakespeare's time have thus disappeared, known only by their titles.[7]

❧ The first First Folio Henry Folger acquired cost him a mere $1.25. Soon after his college graduation in 1879, Henry bought a reduced facsimile edition prepared by the British collector Halliwell-Phillipps.[8] He had ample time to enjoy and scrutinize the volume before deciding to acquire a genuine First Folio in 1893, for an unrecorded price. We can only guess at the thirty-six-year-old Folger's feelings as he leafed through the partially mutilated volume, a few pages in facsimile, others supplied from another copy. His purchase had all of the 454 original text leaves, with some remargined and restored. Folger probably did not know that some London booksellers owned and operated basement "facsimile factories," where they stacked antique paper of First Folio vintage with crown watermarks, ready to use in repairing imperfect copies of the famous volume.[9]

In 1903, Folger bought no fewer than eight First Folios, for a total outlay of $56,275. One copy alone cost $48,730, the second highest amount he ever paid for the coveted volume. At this time, almost no one knew that Henry Folger had

bought multiple copies of the First Folio. In early 1904, reporting on his doings for his twenty-fifth Amherst reunion, Henry gave a hint in his understated way. "I . . . have made a collection of material illustrating Shakespeare which I believe will soon be notable."[10] Henry called the First Folio "the greatest contribution ever made to the world's secular literature. . . [and] the foundation volume of every notable library of English."[11] Emily later referred to the volume as "the cornerstone of the Shakespeare Library."[12]

It's one thing to consider the First Folio the most important book in the English language. It is another to yearn to accumulate multiple copies. Speaking of any other book, Folger claimed that he did not collect duplicates. Almost no one outside the Folger household had any idea how many volumes he had acquired and stashed away. In 1901, Shakespeare biographer Sidney Lee undertook to compile the first census of known First Folios. Indeed, it was the first census taken of *any* book. Over the following months, Lee sent the same questionnaire to Henry Folger three times, asking him to declare what he knew about the whereabouts of copies. Folger did not respond. Then Lee persuaded Folger's friend George Plimpton and a Brooklyn acquaintance to intercede with Folger to extract a reply, but to no avail. When the census appeared in 1902, Lee tentatively attributed one copy to Folger, declaring J. Pierpont Morgan to be the private collector with the largest number of copies, three. In fact, Folger had acquired six by then.

Henry's close friend Horace Howard Furness gleefully celebrated a milestone in 1911 by calling him "Forty-Folio Folger." It was only in 1914, after Folger had packed away in vaults and warehouses seven more copies of the First Folio that he wrote to clarify the volume's allure. "My collection, is, perhaps unnecessarily strong in First Folios—yet every one of the 47 copies seems to have an excuse for its presence."[13] He pointed to one copy that contained Shakespeare's portrait in an extraordinarily brilliant proof state. He singled out another that had come to him by way of an en bloc collection purchase. Further, Henry said that certain copies were special because they had belonged to people close to Shakespeare, his editors. The collector had become fascinated by the history of ownership, or *provenance*. He was also fastidious about the *condition* of the copies he obtained. Seeing each of his copies as having a unique history and story, Folger did not consider them simply duplicates.

Besides, these early books differed typographically. Two twentieth-century men analyzed the First Folio from the viewpoint of its printing. The U.S. Navy had provided large research grants to Charlton Hinman to compare before-and-after aerial photography of military operations during World War II. In peacetime, the cryptanalyst turned to comparing by a strobe effect the same page from two books in minute detail, using a machine he had invented, the Hinman Collator, which

works on each eye retina independently. After he had analyzed over fifty First Folios from the Folger collection using an electron microscope, he wrote two large volumes recounting his discoveries.[14] At this early stage in the history of printing, when no standard spelling existed, Hinman deduced that at least five compositors set type for the First Folio. For example, one (compositor B) would write a Shakespeare line "Do you . . . " while another compositor (A) would set the type as "Doe you . . . " Hinman's focus on individual pieces of type led to a new understanding of printing in Shakespeare's day.

Scholar Peter Blayney later referred to inconsistencies and compositors' errors, raising the probability that at least nine different men, including one teenage apprentice, set type for the volume.[15] Some errors were made by intentional emendations, others by accident. Folger was aware of printing inconsistencies in the folios, and had set for himself the goal of performing his own collation once he came to the Shakespeare Library to study his collection. That day, sadly, never arrived.

Textual differences aside, Folger realized that many of his First Folios contained valuable annotations in the margins. Some altered the text; others indicated stage directions; still others revealed readers' reactions over the centuries. Whenever a book was rebound, its pages were first trimmed, risking destroying part of the text line as well as marginalia. Folger favored unbound copies—despite that the overwhelming majority of his First Folios were bound by later owners—where more marginalia were intact. In preferring to preserve history and a volume's integrity rather than to parade personalized binding, Folger was ahead of his time. Today the Folger librarians will purchase an antiquarian book containing marginalia where they already possess a copy without marginalia, and they keep them both.

Shakespeare scholar Jean-Christophe Mayer has examined the Folger's First Folio collection in an original way. He has studied readers' markings in the margins of the plays, analyzed their variety, and speculated on their meaning and importance. In Folger copy 45, an eighteenth-century reader elegantly inscribed the words "The incomparable Shakespear" across one of the flyleaves, and "Knowledge & Wisdom" underneath. The book's owner felt empowered to record feelings of praise for the author. A reader wrote "W. M. died July 12, 1894" next to a speech in *The Merchant of Venice*. It is a line one might be more apt to read in a family bible than on a leaf of Shakespeare. Folger copy 78 displays several juvenile ink drawings near a signature, "Elizabeth Okell her Book 1729." The drawings depict a house, seen from the inside and outside. They may have reflected the book owner's imagination of her familiar world. Mayer writes that "books are part of social networks and the social value of the book increases its symbolic and intellectual value." He refers to the markings as "life-writing" in which book owners and readers relate Shakespeare's plays to their own lives.[16]

Amherst College honored Folger with a Doctor of Letters degree shortly after his purchase of a forty-ninth First Folio in April 1914. After the ceremonies, Folger was driven to a banquet with a recipient of the Doctor of Laws degree, William Howard Taft. The ex-president leaned over to Folger and joked, "Forty-nine folios? We have the fiftieth at Yale."[17] Folger knew that a Yale graduate had bought a First Folio and presented it to Yale's Elizabethan Club in 1911. Although the topic was comical to Taft, tracking the location of all First Folios was deadly serious to Folger. His copy of the Sidney Lee census is marked up by notes of auctions held, prices paid, and owners identified. Folger described the condition in which he found each copy and was careful to note if he had personally examined the volume.

In 1915, Folger purchased no new copy. Appearing to take a breather, instead he was taking stock. He admitted to the London bookseller A. H. Mayhew, "I need one more First Folio to bring my collection where I wish it."[18] He gave the initial impression that he would stop collecting First Folios once he reached the number fifty. But what he then proposed to Mayhew was an extraordinary scheme. From the Lee census, Folger knew the identities of as many as thirty-five private owners of First Folio in England. Folger petitioned Mayhew to write to each one, asking whether he would part with his copy, and, if so, at what price. Folger stood to gain several new copies by this aggressive maneuver. Not one owner accepted his invitation, and some replies were hostile. Over time, however, by persisting, Folger managed to acquire several First Folios from the recalcitrant collectors. As for the country parson who responded on a postcard, "Sir I have no intention of selling my First Folio Shakespeare. It is something to have one," his copy is now missing.[19] Being open to Folger's overture would have guaranteed the volume's survival.

The year 1923 was a big one for Henry Folger: he was elected as the first board chair of Standard Oil of New York. One day that year, Folger placed before him all his notes regarding the characteristics of his First Folios and started to assign each volume a distinct number. He did not choose to order his acquisitions chronologically. For instance, his first purchase in 1893 received the code Folger copy 55. Folger's numbering system remains somewhat enigmatic, but it seems based on a combination of factors: the provenance of ownership, condition, and the presence of unique traits that would add to the copy's value (such as marginal notations or the quality of the Shakespeare portrait).

A few transactions for Folger's First Folios consisted not of a single purchase but an entire collection. Folger copy 6 came from the library of the Earl of Warwick. Eight boxes of books from Warwick Castle Library arrived in New York in 1897 after Folger secretly acquired the collection for £10,000 ($48,000 at the time). In telegrams to his British agent Henry Sotheran, Folger used the code name "Golfer."

Folger realized that he could not make the en bloc purchase of the Warwick copy with his own funds. He turned to the Pratt family, as he had in the past, and received a conditional agreement from Charlie Pratt: "Tell Folger he may have the money provided he will agree to invite me to his house to dinner for a private lecture on the collection."[20]

Folger ascribed the place of honor as Folger copy 1 to the Vincent copy, not because it was the first one he obtained or the one for which he paid most. He referred to it as "the most precious book in the world" for other reasons. He bought it in 1903, from the London bookseller Henry Sotheran, Booksellers to the King, for the record price of $48,700. Although the volume is not complete, it was one of the very first to be struck off. The portrait of Shakespeare with the high brow on the title-page is unusually brilliant. The copy lay totally uncut and in its original binding.[21] Collectors favor large copies; this one is the largest in the world. Folger esteemed this folio as unsurpassed for another reason. It was one of two copies presented by the printer, Isaac Jaggard, on behalf of his father William Jaggard—the original printer of the First Folio—to Augustine Vincent the Herald, who wrote a Latin inscription dated 1623 at the top of the title page. Vincent's armorial stamp on the original binding was incorporated into the present binding.[22]

Folger loved to recount the circumstances in which this dusty volume was found in rural England. Sotheran's agent Alexander B. Railton had finished inspecting the library of Coningsby C. Sibthorp of Lincoln when he was taken to a coach house to weed out worthless items for a sales catalog. An assistant handed down several large books from atop a case, remarking to Railton about one of them that was bound tightly with cord, "That is no good, sir, it is only old poetry."[23] It was the Vincent First Folio. Railton stuck by Folger during the four years it took the collector to persuade the seller to part with it. The Folgers themselves boarded a steamship to London to carry the precious volume back to New York. In 1907, Henry published an article on it in the *Outlook*, illustrated with photos by his close friend, George D. Pratt. The *Outlook* was published by a Brooklyn friend of the Folgers, Lawrence F. Abbott, who enjoyed Standard Oil patronage. The magazine paid Folger twenty-five dollars, although the author had offered to forego any compensation. For a spell, Folger knew the disappointment of an author in search of a publisher: *Atlantic Monthly*, *Harpers*, the *Century*, and *Scribner's* all rejected his manuscript.

A pair of First Folios—Folger copies 25 and 26—belonging to Lord Amherst of Hackney and auctioned by Quaritch in 1909 at Sotheby's would almost certainly have interested Folger because of their link to his alma mater, Amherst College, whose name goes back to that of Lord Jeffrey Amherst, British commanding general in the French and Indian Wars. A Tyssen-Amherst bookplate appears in both

Title page of Shakespeare's First Folio, published in 1623, with the familiar portrait of the playwright by Droeshout. The Folger Library possesses eighty-two copies of the First Folio, all different in some respect. *By permission of the Folger Shakespeare Library*

volumes. Folger bought them for the modest price of $2,200 each. The copies contain facsimile leaves as well as leaves from another copy of the First Folio. Folger considered his two Lord Amherst copies complementary: one was imperfect at the beginning, the other at the end. However, he protested to Quaritch when he read in the auction catalog that the two copies formed one complete copy. Folger had examined them carefully and discovered that "neither one has an original fly-leaf."[24] Folger's attempt to acquire the pair at a private sale before auction went awry, as Lord Amherst suddenly died, thus complicating any special arrangements with his heirs.

In the spring of 1911, Folger informed a London bookseller that not only was he intent on obtaining complete First Folios but he would also be eager to secure "any parts" of a First Folio.[25] When a bibliophile shifts from the whole to parts, he enters a new level of collecting. Collectors raise a fuss about fragments only with respect

to the most highly prized literary items in the world. For example, single medieval illuminated manuscript leaves are popular. Leaves from the most significant antiquarian books bring good prices; in this category figure the Gutenberg Bible and Shakespeare's First Folio. At the time Folger was widening his collecting objectives, he was also enduring a complicated, trying period in his business life. In the spring of 1911 he was prominent in representing Standard Oil facing an antitrust lawsuit in the Supreme Court (see chapter 3). Professional vicissitudes, however, did not derail his ferocious determination as a collector.

Folger was attracted to the Thomas Hanmer First Folio (Folger copy 16 bought for $6,650 in 1911 from the New York dealer John Anderson) because Hanmer was one of the earliest editors of Shakespeare's *Works* in the eighteenth century (Hanmer's edition was published in 1744).[26] Buyer and seller were quite close. Anderson was prone to emphasize in his correspondence the extraordinary pains he had taken to obtain an item for Folger, adding that some details could be divulged only later, and orally. In this case, Anderson claimed he had run to a nearby drugstore to phone, presumably to avoid being overheard in the office. For his part, Folger flatly laid out to Anderson his terms for capturing the prey: "I consider $4500 a full price for it today. I do not wish to lose it even at 7500. But I feel that 6500 is all I should pay."[27] Anderson enabled Folger to obtain the item at a private sale even after it had been included in the auction catalog. Folger sealed the winning bid on December 14, ten days after his election as president of Standard Oil of New York.

Folger was delighted to obtain the Earl of Roden copy—Folger copy 2—purchased in 1912 for $13,750 from Frank T. Sabin in London, before the volume was offered in public sale. The feature that pleased Folger most was the copy's proof-state portrait of the Bard. London book trade expert Peter Blayney explains that the first few copies of the First Folio displayed a portrait of Shakespeare in which his head appeared to float in space. Folger always sought completeness in his library, buying all manner of First Folio varieties, even if only for their unique illustration, without regard to text.

Although Folger (unlike his California rival Henry E. Huntington) affirmed that he never bought a book for its binding alone, he nevertheless admired the best binders' skill. Roger Payne (1738–1797) inherited his father's trade to become the greatest of British bookbinders. Payne was renowned for the bright red, straight-grained morocco leather and rich gold ornamental tooling of his bindings. In addition, he made an effort to match the tooling of the binding with the contents of the book. In the Beaufoy copy of the First Folio, the front cover and spine display Shakespeare's coat of arms. In 1914 Folger purchased the Beaufoy copy—Folger copy 11—from Quaritch for $15,500.

Folger also learned that he was acquiring the only book Payne bound in which he had laid in his bill for services. His bill in about 1780 for cleaning and mending was one pound, five shillings, and nine pence—presenting a full week of labor. Payne was cognizant of his binding skills. He wrote in the bill, "Six Leaves Inlay'd in so exceeding neat Manner as not to be seen without being told of it."[28] He had taken six leaves from *another* copy of the First Folio to replace the damaged or missing leaves. The fee for the binding itself came to three pounds, eight shillings.

As the bidding correspondence in letters and cables with Quaritch reached a climax, the collector made a startling claim.

> My dear sir, I find I need just one more copy of the First Folio to bring my collec-tion up to the number I have been planning to secure. Just now I am being offered a notable copy, but I do not wish to decide to take it until I have made sure that I cannot purchase your Beaufoy copy. Will you accept for it 3150 pounds? This will be the highest price, with one exception, that I have paid for a First Folio, and af-ter buying this, or some other copy, I will be out of the market. Yours very truly.[29]

Folger out of the market? Not for another sixteen years, and only upon his death. During the intervening years, he purchased thirty more copies of the First Folio.

A mere hint to Folger that an item was somehow connected to the Bard would stimulate the collector to pursue it. The Samuel Gilburne copy has that name signed next to the same printed name on the page of the First Folio preliminaries listing the twenty-six "Principall Actors" on Shakespeare's plays, actors presumably known to the playwright, who was also an actor and company shareholder. The copy was listed for sale in a London catalog in 1919, with a claim that Gilburne had probably owned the volume. Contacting one of his steady agents, Gabriel Wells of New York, Folger learned that the copy had been sold to a Shakespeare collector from Buffalo. Folger chased it down and offered twice the sales price, to no avail. Finally, in 1920, Folger ob-tained the coveted Folger copy 12, exchanging it for another First Folio from his collection, now in the Buffalo and Erie County Public Library.

After he had accumulated fifty-nine copies, Folger admitted that he already had "several" copies and was "looking only for such first folios as occur having very special interest."[30] Such an opportunity arose in just a few months. A First Folio belonging to the richest heiress in England, Baroness Angela Burdett-Coutts, had retained all its original 454 leaves in excellent condition, undamaged and unmarked. The volume went on sale at Sotheby's in May 1922 and fell to Folger. From Rosen-bach, he bought Folger copy 5 for $52,070, a figure that established a new sales price record for a First Folio lasting a decade. The Folger purchase came only a few months after a buying coup by Huntington, who acquired the best-known English

AUTOLYCUS, U.S.A.

Uncle Sam. "NOW, THAT'S REAL DISAPPOINTING. I'D SET MY HEART ON THAT SKELETON."
Shade of Shakespeare. "BUT ALL THE SAME I SHOULD FEEL MORE COMFORTABLE IF IT WAS INSURED."

A 1922 *Punch* cartoon by Bernard Partridge portraying Uncle Sam, embodying American collectors Henry Folger and Henry Huntington, carrying away a First Folio and Gainsborough's *Blue Boy* from the United Kingdom to America. *Reproduced with permission of Punch Ltd., www.punch.co.uk*

portrait in the world, *The Blue Boy* by Thomas Gainsborough, for $728,000. A week after Folger's purchase, the British satirical magazine, *Punch*, published a cartoon of Uncle Sam carrying off a folio under his right arm and a Gainsborough portrait under his left.[31] As the British press lamented national treasures crossing the Atlantic for good, Uncle Sam is shown looking down enviously on Shakespeare's tomb, dismayed that the Bard's skeleton does not appear to be for sale. It was clear to the Brits that these two wealthy men represented a newly muscular American culture determined to include British gems in the new institutions they were planning to build one day.

Folger demonstrated in 1923 that he could pass up a fragment from the First Folio. He wrote to Maggs, "Replying to your inquiry of Sept. 3, about the play of

Julius Caesar taken from a First Folio; I am, of course, interested in this, as I am in any plays from the First Folio, but could not consider paying anything like the price [£63] you name for it; so I will not trouble you to send it over for examination."[32]

His acquisition of the Earl of Kimberley copy—Folger copy 68, purchased in 1924 for $37,000 from Quaritch Bookshop, London—is significant because it shows how Folger came to understand a little-appreciated aspect of the First Folio, the paper stock. Quaritch's E. H. Dring speculated in a letter to Folger that paper thickness could vary from one folio to another, differentiating one stock of mill paper from another. The bookseller pointed to watermarks evident on certain leaves in this copy, noting that some were upside down. Furthermore, he suggested that a bookbinder's washing with chloride of lime prior to rebinding could spoil a leaf. Admitting he had not previously paid attention to paper thickness, Folger appreciated all such bookseller suggestions about how to exploit his growing collection. Replying to Dring, he shared his intention "at some day in the near future, to compare my Shakespeare First Folios for any points of difference." Such comparisons were greatly facilitated by assembling so many copies in a single location.

For eighty years, the Folger Shakespeare Library touted the seventy-nine First Folios Henry Folger had collected as the single most striking feature of the library's collection. In 2011, the number suddenly grew to eighty-two, without any new acquisitions. How did this happen? What constitutes a folio, as opposed to a fragment of a folio, is subject to debate since some of the groups of fragments contain more leaves than are found in some of the copies included in the original estimate of seventy-nine Folger First Folios. First Folio experts Peter Blayney and Anthony James West and Shakespeare editor Paul Werstine for several years now have claimed that the Folger possessed eighty-two folios.[33] During a 2011 Folger exhibit on the First Folio, the library officially recognized the three additional folios in the new count.

The distinguishing feature of Folger copy 80 arises from the purchase by bookseller Maggs Bros. in June 1926 of an incomplete folio already separated play by play. In a letter five months later, Folger offered £1300 for the lot. Maggs apologized that by the time Folger's bid arrived, they had already sold two of the plays. They gave Folger the equivalent for the remaining broken-up folio at £1215. Folger's copy now contained only thirty-one of the original thirty-six plays.

The collector bought Folger copy 81 from Gabriel Wells in 1923. The volume similarly consisted of thirty-one plays, bound separately. However, what set this incomplete copy above others was the richness of its marginalia. *The Comedy of Errors* and *As You Like It* included marginal notes on the play's sources. The copy of *Macbeth* included notes attributing authorship of certain scenes to Thomas Middleton,

not Shakespeare. *Much Ado About Nothing* gives the date when the play was presented at court. These annotations represent the added value Folger loved to acquire and show why he zealously hunted down imperfect copies of the First Folio.

Wells also sold him Folger copy 82, containing twenty-one plays.[34] Particularly attractive in this copy were the annotations and autograph interlineations apparently made by actors on two plays. The Folger Library also houses a stack of more minor fragments the collector purchased, none of which has been elevated to the status of a Folger First Folio copy.

Once Folger proposed parting with a First Folio in an ingenious horse trade. An eighty-eight-year-old Harvard professor, George H. Palmer, had decided to donate his Shakespeare collection to Wellesley College in memory of his wife, but he lacked the ace of spades. Folger hoped he could upgrade one of his own copies by persuading Rosenbach to participate in a three-way deal: "It has occurred to me that perhaps there *is* a way you can meet the call upon you by Prof. Palmer for a Shakespeare First Folio. If you will make some sacrifice in the price of your very fine copy, and will take from me in part payment, a folio good enough to sell to Prof. Palmer, allowing on the cost to me of your copy what he pays for the copy you sell him, we will both (that is, Prof. Palmer and myself) benefit from the transaction. If you are willing to do this, I will hunt up the one I could spare, in exchange, good enough for the purpose."[35] Rosenbach refused the trade, writing back to Folger that giving up his First Folio would be "like performing *Hamlet* without the Prince of Denmark."

❧ Today, an author's collected plays seems a reasonable, ordinary volume to assemble and publish. Shakespeare's First Folio, however, was the first ever single-author drama collection in the English language. While Ben Jonson's folio of "Workes" preceded Shakespeare's collected plays, Jonson's was not limited to drama but also included his poetry, court masques, and prose. Critical study of the First Folio has established its own precedents as well. For the first time in history, a census has been developed to trace every copy of a single book. Anthony James West has completed three volumes on the history of Shakespeare's First Folio, with plans for more to come. A multivolume set devoted to a single book is also a first.

A measure of the importance given the First Folio is the space devoted to it in auction catalogs. Early listings gave only the book title and place and year of publication. By contrast, before auctioning off the First Folio from Dr. John Williams's library for £2,808,000 in 2006, Sotheby's produced a sixty-page catalog devoted to that single copy.

In 1876, America could boast eighteen First Folios. A half-century later, Folger had singlehandedly quadrupled that number. Folger's achievement is unique in the

history of book collecting, in terms of both the rate and quantity of acquisition. By the end of the nineteenth century, the First Folio had attained prestige status and fetched lofty prices. In England, inheritance taxes had become prohibitive, and many collectors felt obliged to part with the gems in their libraries. Across the Atlantic, more and more rich Americans had disposable money for building collections. A significant migration of First Folios from Britain to the United States accelerated. At the same time, the volumes shifted from private hands to public ownership, making them unattainable for individual collectors.

Henry and Emily Folger gave only one interview. During summer holiday in 1924, they welcomed *Brooklyn Eagle* journalist William V. Hester Jr. to their rented home in Glen Cove, Long Island. When the discussion turned to the First Folio, Emily wanted the journalist to know that in honor of the tercentenary of the volume's registration, a British Shakespeare scholar had suggested that all the copies in the United Kingdom—estimated at forty-three held in public or private hands—be given to the British Museum. Hester pondered this information. What Emily concealed, and what no one in Britain or America realized, was that at the time, the Folgers had already quietly squirreled away in storage warehouses sixty-seven copies of the First Folio.

Henry turned the subject of the interview to the purposes of the Shakespeare library he was intending to build. He wanted "to give the generations yet to come a better working knowledge and understanding of William Shakespeare and the literary works of the Seventeenth Century."[36] Henry Folger was on the scene at the right time, with his fortune, fortitude, and determination to build a great American patrimony, allowing him to assemble the greatest collection of Shakespeare in the world. Emily Folger was his equal in spoofing the press.

✄ ✄ ✄

What News on the Rialto

Maneuvers in the Rare Book Market

What news on the Rialto?

The Merchant of Venice, 1.3.38

THE SCENE: SOTHEBY'S, London, December 1919. Tension was palpable in the hushed auction room. At stake was ownership of the only known 1599 copy of Shakespeare's first printed work, *Venus and Adonis*. Key collectors vying for this treasure, however, were absent. They were home in America.

While many collectors frequented local shops for antiquarian and rare books, the wealthy few used commission agents to represent them at book auctions. The "knocking-down" of an item to a new owner after a brief, fast-paced public sale often followed strategic discussions between buyer and agent, emanating from a solid relationship built on trust and a determined belief that both could emerge big winners.

Sir Montague Barlow, who had been knighted the year before, wielded the auction gavel at the December 16 Britwell Court sale at Sotheby's. Bald and mustachioed, a white carnation in his lapel, he stood at a wooden rostrum towering above two dozen hopeful bidders seated around a horseshoe-shaped table.[1] Clad in dark business suits, seated uncomfortably close to one another, the agents held pencils poised above a heavily marked forty-page itemized sale catalog and a sheaf of notes—bids from distant clients. A clerk positioned at a nearby table recorded every bid, intoned clearly and loudly by Sir Montague. A sales team porter, when signaled, carried an item to a bidder's seat for closer examination. Behind the principal bidders stood several gentlemen, some wearing hats, keenly observing every move.

Representing Henry Folger from New York was E. H. Dring, chief bookman at Quaritch's of London. Representing Henry E. Huntington from California was George D. Smith, bookseller extraordinaire of New York. Early on, bids for lot 85 came from several spots in the room. As the price climbed above £13,000, however, Dring and Smith—sitting apart from each other—were the only ones still bidding.

Neither said a word, but each bid with a different gesture: Dring nodded slightly; Smith flicked his thumb. In increments of £100, the bid rose to £14,000 after five nods and five flicks. Stifled excitement mounted as bidders watched Dring's forehead, then Smith's hand. Soon, Dring nodded at £15,000. Smith flicked at £15,100. Dring sat without moving.

Sir Montague bit his mustache, his face as white as his lapel carnation. After a pause, he asked if there were another bid, then brought down the hammer. The audience erupted in cheers and applause. Smith's purchase of the Shakespeare gem for Huntington at £15,100 ($60,000) was the highest price ever paid for a printed book at a public sale.[2]

❧ Far away from such high drama, the Folgers—like any collectors of art, furniture, or books—used their home to plot their collecting strategies. Together they established mechanisms and followed patterns for discovery, communications, delivery, payment, recordkeeping, and storage. Henry and Emily's "Rialto" lay not in Venice but on the dock of New York harbor and in the auction house, book dealer shops, and news accounts of pending estate sales on both sides of the Atlantic.

The Folgers discovered items to enhance their collection by subscribing to European and American book auction catalogs. A single catalog might run more than a hundred pages and describe more than a thousand items. The Folgers' catalog collection would stretch over two-thirds of a football field. Emily studied the catalogs first, turning down the top corner of the page, then making a wavy line or inserting a penciled question mark by items that caught her eye. At the end of the day, she would greet her husband at the door with her "finds." Henry found an auction catalog "as fascinating as a novel."

Another element in their discovery system consisted of a network of clipping bureaus. Starting about 1910, Folger subscribed to the services of several companies: four in New York, one in Washington, one in Boston, and two abroad. One, the Manhattan Press Clipping Bureau, culled 12,000 newspapers and periodicals every week, charging clients $35 per thousand clippings. Some of these firms were created in the late 1800s and could retrieve useful notices of old sales. Emily took charge of organizing the sheaves of clippings that arrived in the mail.

The Folgers followed closely who bought what and for how much. During this golden age of book collecting, many newspapers found such information newsworthy. The items shed light on how the wealthy spent part of their fortunes. Once the news spread that the Folgers were collecting Shakespearean items, friends, family, and colleagues sent them news clippings. Enterprising book dealers sent other essential references: Maggs forwarded copies of *Bookman Journal*; Edgar Rogers regularly

sent the *Times Literary Supplement*; and Rosenbach dispatched issues of the *London Mercury*.

Folger chose as his agents the leading booksellers of the day, who regularly bought at auction for designated clients or to stock their shops. Auction houses supplied his book dealers with advance or "proof" auction catalogs that they shared with him. Then Folger put together a bid list for his representatives.

Immediately after an auction, Folger's agent reported how well he had done. A few weeks later, Folger often requested a "priced list," divulging prices and buyers' names. The Folgers studied these lists assiduously to assess their competition and master the market. If Folger was unsuccessful in obtaining an item, he sometimes wrote the winning bidder and asked to buy it privately.

Over time, Folger emerged as the booksellers' most desirable client for Shakespeare items. He won the loyalty of the two foremost American dealers of the time, George D. Smith and A. S. W. Rosenbach. Dealings with Smith started in 1896, when Folger bought Ben Jonson's *Works* (1616–1631) for a mere $12. Soon after Smith died, in 1920, Folger expressed interest in obtaining from his estate two Shakespeare quartos, *Lucrece* (1594) and *Pericles* (1609). Smith had purchased them in a lot of quartos from Henry E. Huntington's duplicates. Recognizing Folger's stature, the executor wrote, "we will accept $23,500 for the *Lucrece* and the *Pericles* . . . There are several collectors of Shakespeare who want these books, but they were offered to you the day that they were released from the bank."[3] Ever the canny businessman, Folger talked down the final price to $20,500.

In similar style, Rosenbach once wrote Folger, "It is our policy to make you first offers of any rare items of Shakespeareana that come into our possession, and are always willing to send them on approval."[4] British booksellers also gave Folger first pick. At times, he shared that privilege with Henry E. Huntington, who displayed wider tastes and had deeper pockets.

Rosenbach, ever astute at baiting the hook, reminded Folger that he was receiving good deals, special treatment, and that competitors were always lurking in the wings. "It may interest you to know," Rosenbach wrote in 1926, "that Mr. W. A. White was in last week and offered me a large profit on the Lodge [*Scillaes Metamorphosis* (1589)]. I told him, however, that I purchased it for you."[5] Another time he wrote, "Mr. Henry E. Huntington does not possess a copy, and I do not wish to show it to him until I have your definite answer."[6]

Over a forty-year career chasing books, Folger maintained correspondence with a prodigious army of booksellers: six hundred in all, one hundred fifty in London alone. Initially he corresponded by handwritten letter. The firm of Bernard Quaritch Ltd. in London still has Folger letters bound together with the corresponding

marked-up auction catalogs. In the early 1900s, Mrs. L. M. Swift, one of only two female employees in Standard Oil's New York headquarters, was assigned to Folger, taking dictation on book deals as well as oil matters.

In the competitive world of book collectors, rapid communication was vital. To contact Folger quickly, Rosenbach relied on the telephone and personal visits. Folger used Western Union cablegrams and night letters when urgent. His cable address was simply "FOLGER NEWYORK." In 1929, both Folger and his Amherst friend George A. Plimpton (grandfather of mid-twentieth-century author and *Paris Review* editor George Plimpton) were keen on acquiring a corset reputed to have been Queen Elizabeth's. When they met on the street "Plimpton chortled and told Folger that he had written for the prize curio. Folger replied, "I cabled for it."[7]

Folger developed habits of communicating effectively with himself. Front and center on his polished walnut partners desk at 26 Broadway sat a "want list," showing which book acquisitions were on his mind every working day. He carried an umbrella with a pencil embedded in the crook of the handle. He kept pad and pencil by his bed to jot book ideas that came to him during sleep. He learned and used Pittman shorthand, leaving private notes on the backs of envelopes or small sheets of notepaper. By day, he used Standard Oil's cipher code; by night, his own.

As a team, the Folgers gradually generated a double system of recordkeeping, accommodating their pattern of leaving their Brooklyn residence for long periods. According to the season, they moved by train "to the country"—Glen Cove, Long Island—and by car or train "to the south" at Hot Springs, Virginia. They returned "to the city."

Their main card catalog remained in Brooklyn. Emily kept what became sixty deep metal drawers of 4-by-6 cards, each listing the item type, title, author, dealer, date of publication, size, year of purchase, and precise description of condition. On journeys out of town, they packed what they called a "memorandum catalogue" and "rough check lists" lacking indications of book condition. Even without comprehensive references, the Folgers continued to order items, by letter or cable, from their secondary locations. Vacation produced a furious stream of transatlantic orders and counterorders if a London auction was under way. It wasn't a perfect system. The Folgers sometimes discovered they had inadvertently purchased two identical editions, as when they noted the author St. Evremont under "S" in one case and "E" in another. They returned one book, apologized, and asked for credit.

Alexander G. Welsh of Baldwin, Long Island, Folger's personal secretary at Standard Oil for twenty years, substantially assisted in recordkeeping and many other tasks. At the senior executive's beck and call, Welsh ran book errands, sorted complicated financial records, deposited Folger's dividend checks in the bank, kept track

of stored material, filed carbon copies of book correspondence, and opened Folger's mail when he was away. Folger trained Welsh to take over the bulk of routine correspondence. Following meager directives (for example "Do not wish, many thanks" penciled in the margin of an incoming book offer), Welsh typed a well-crafted business letter for his boss's signature. Folger's laconic "Have it" became twenty courteous words of rejection, dashing the hopes of scores of booksellers. Looking back on his career, Welsh wrote revealingly, "I will always have at heart a feeling of participating in the collection on account of my many years with Mr. Folger . . . His Shakespeare collection was incidental to my other works, although perhaps the company thought the oil business was incidental to the collection."[8]

How Folger paid for the merchandise he bought created more complexity. For American purchases, Folger paid from the checkbooks in his name he maintained in many New York banks and trust companies. For purchases in foreign currency, he benefited from Standard Oil's European presence and the exchange courtesies that were executive perks. He contacted his colleagues, R. J. Thompson and F. H. Bedford, in the Standard Oil of New York treasurer's department, who notified a Standard Oil subsidiary in London, the Anglo-American Oil Company. It sent a check in pounds for Folger's books, noting the exchange rate and amounts paid. For example, Standard Oil headquarters cabled the oil subsidiary in London to pay the bookseller Henry Sotheran £1200 at $4.8975 or $5,877. Folger reimbursed headquarters with a personal check. When he needed to move fast to beat a rival buyer, Folger would cable the London branch of Standard Oil to pay in his behalf, directly and immediately.

For major acquisitions, often Folger could not pay the full price at once. For example, he purchased from Rosenbach a *Richard II* (1598) quarto for $55,000 from the William A. White collection by paying in two monthly installments. He informed dealers of his preference to await quarterly Standard Oil dividends before making his larger payments.

Folger drove a hard bargain. Negotiating with the seller's British intermediary to purchase a major portion of Marsden Perry's collection in 1908, Folger thought he had a deal. He wrote Perry, "Will you kindly ratify the purchase made by me today from you of the collection of books and other material known as the Halliwell-Phillipps rarities, as described in his catalogue . . . The price for the whole being $69,000 to be paid, one-third in cash on the delivery of the collection to my agent at Providence, one-third in four months and one-third in six months from today, covered by notes to be delivered at the time of first payment." When Perry responded that he counted on Folger to pay 6 percent interest on the deferred payments, Folger flatly refused, as the charge was absent from the agreement negotiated with the

intermediary. Perry dropped the request. It's tempting to think that at such a time Folger may have been remembering Portia's exact reading of the bond that Shylock, up to a certain point in the trial scene, has been so eager to see strictly enforced (*Merchant of Venice* 4.1.318–25).

Occasionally, Folger lost track of his intense money and cable traffic across the Atlantic. In 1927, he wrote Maggs, "I have just received the enclosed receipted bill of Oct. 14, and find that I made a mistake in calculation. There is an item of £3-3-0 deducted, which had been already paid. This was deducted from the total before adding in the consular invoice and postage, but I failed to report that deduction from the final total, so that in sending a draft for £398-11-6 I overpaid £3-3/-. The first total, after the deduction, should be £437-5-, with the invoice and postage £439-3-, less 10% £43-14-6 makes the final total £395-8-6, against which I paid £398-11-6. If I am correct please credit my account with £3-3-0, returning to me the enclosed receipted bill." Maggs's baffled accountant was left to respond.

Total costs included packing, insurance, handling, and shipping, plus London consular and New York entry fees. While many packages arrived without incident, Folger's book purchases occasionally became tangled in New York customs procedures. When London bookseller Broadbent sent Folger sixty-four packages of books with one stamped and signed consular invoice, the parcels arrived so irregularly that officials requested additional copies of the consular approvals. Long delays ensued. Each mailing label from Broadbent disingenuously announced, "Old books, duty free, printed over 20 years ago." Importing antiquarian books was expensive in many ways but escaped duty fees.

Book collectors and dealers soon learned that in dealing with Henry Clay Folger they were up against a man with a disarmingly transparent set of principles and values he applied consistently. He educated his providers about what he did and did not collect, what he would and would not pay. By explaining his position up front, he expected his agents and sellers to be better able to reach an agreement. Folger's drive, ambition, and good faith led his purveyors to scour the countryside, attics, and warehouses for requested items and lurking treasures. Folger could be counted on to pay, but only on his terms.

His buying strategy was transparent but complex. Folger's several thousand letters to booksellers reveal how he limited his collection. For example, when refusing a copy of Richard Barnfield's *Encomion of Lady Pecunia; or, the Praise of Money* (1598) in 1909, he identified two areas he was not pursuing. "I would prize it highly were I collecting early English literature, or in some line of poetry."[9] To a bookseller trying to interest Folger in fine bindings, the collector responded in 1914 that he had never attempted to secure bindings in his book buying.[10] To yet another seller in 1927 he

made clear that he never "sought uncut copies of anything."[11] In 1929 he declared himself "not at all interested in Incunabula [books printed before 1501]." While his collection included examples of the disparaged items, they were not prime objects of pursuit.

Folger's priority was collecting literary items of any period related to Shakespeare; but given Shakespeare's dates (1564–1616), he especially favored Elizabethan- and Jacobean-era works. Contemplating the suggested purchase of a non-Shakespearean work from 1633, Folger wrote Rosenbach in 1927 that it was "rather late" for his collection. To Pickering & Chatto, Folger wrote in 1928 regarding another item, "it is late for my line of collecting. Of course at a much smaller figure I would not hesitate a moment in asking you to send it."[12] Even though Folger applied a period criterion, a bargain might trump it.

But Folger mostly stuck to his line of collecting. In 1905, he wrote to one of his principal book providers, George D. Smith, "I am trying to buy nothing but books and other literary items illustrative of Shakespeare." The year before he died, Folger wrote Thomas S. Forsyth, "My collecting is strictly limited to Shakespeareana." It is not surprising that Rosenbach called Folger "the most consistent book collector" he ever knew.

Sellers appreciated that Folger was in it for the long haul. Some collectors dipped in and out of the market; others threw in the towel when they suffered financial reverses. Still others expanded or shifted their collecting interests dramatically. Folger was a far cry from some collectors today who ravenously accumulate Chippendale or mid-twentieth-century modernist furniture, then sell up and move on to another line of obsessive collecting. Dogged and patient, Folger persevered for four decades. He might negotiate the price of a single item for several years. When Rosenbach offered Folger a copy of the tragic play *Insatiate Countesse* (1613) by Marston for $8,650, containing an important reference to *Hamlet*, Folger demurred. "I will wait for a cheaper copy."[13] Folger never purchased the Marston tragedy, but he would have been delighted to know that the Folger Library bought it at a 1945 Sotheby's auction for a mere £65.[14]

Folger mostly offered cash for his purchases. In order to have ready cash, he could perform gyrations with lenders and brokers. As early as 1895, Folger promised immediate payment to Robert Dodd, founder of "Dodd, Mead, Rare Books and Manuscripts." It worked. As the dealer wrote, "Although your offer for the third folio Shakespeare is very low, and leaves us but a small commission, we have decided to take it, as it is for immediate cash."[15]

Folger's cash-on-the-barrelhead tactic succeeded in England as well. In 1900, he wrote New York City bookseller J. O. Wright, "Several times abroad, where friends

have been watching for me to pick up books desired, we have succeeded, when there seemed to be no hope except to wait, by making a plump generous offer of cash—the sum seeming large enough to the seller to make the sale possible."[16] Wright responded to Folger that he would now urge some book collectors to give up their gems for ready cash and pay off their debts.

Putting on a squeeze, Folger next announced to his providers that, in return for prompt payment, he expected 10 percent discounts. He baited a New York dealer: "If you can allow me a discount of 10% for prompt cash payment—the discount which I get from all dealers, both here and abroad—I will keep it."[17] Folger confessed that a 10 percent discount encouraged him to buy more freely, a bookseller's dream.

Folger developed and applied his own scale of "Shakespeareness" to the items he considered acquiring. He explained to Charles Sessler, antiquarian bookseller in Philadelphia, that he'd like to keep a Swinburne manuscript—*Seventeen Poems on the Early British Dramatists* (1882)—that he found beautiful. But he already had copies of fifteen of the poems and since the missing two on Charles Lamb were not directly Shakespearean, he decided to pass.[18] With Maggs, he considered three proposed Bacon items—a speech at the House of Lords, a royal commission, and a search warrant—but decided they were not "closely enough Shakespearean" to enter his collection.[19]

Despite his professed narrow collecting line, Folger was so attracted to the aesthetic appeal of some books that he wavered when struck by their visual beauty. In these instances, Emily helped him to decide. To a dealer he wrote that the watercolor drawing of *Hamlet* by Godwin was a "beautiful picture," but as a Shakespearean subject did not appeal to him very strongly. Smart dealers who heeded Folger's hints on why a work did not please learned how to craft more appealing deals. Regarding a modern edition of the *Tempest* published by the Rowfant Club, he wrote, "It is a book not directly in the line of my collecting, as I do not pay much attention to bindings and other special features, but it is so beautiful that I hesitate to return it." He didn't return it.[20]

As soon as it was off the press in London in 1926, the Folgers bought a manuscript edition of Shakespeare's *Sonnets and Poems* produced for the tercentenary of his death, April 23, 1916. They purchased this book as an object rather than a text. They already owned copies of the sonnets and poems on their own and within collected works. This volume was unique due to the craftsmanship of Alberto Sangorski, responsible for the design, illuminated manuscript, and binding. The latter included a sapphire mounted on each corner of the front cover, with crest and motto of Shakespeare in eighteen-carat gold in the center. And the volume had meaning for the Folgers, besides its visual appeal. The Shakespeare scholar who wrote the commentary,

Sir Sidney Lee, had tried in vain to find out how many First Folios Folger had acquired. And New York institutions had tried in vain to persuade Folger to loan some of his Shakespeare gems for the tercentenary.

In 1915 correspondence, Folger clarified the purpose of his Shakespeare focus and how it influenced his overall vision. "My collecting of Shakespeareana is entirely along the literary line, indeed so much so that I am not over-anxious to secure in the books bought unusually good conditions if in doing so I have to pay high prices. I hope to use my collection in the line of literary work, and have not made it for the purposes of exhibition, or to satisfy the ambitions of the mere collector."[21]

Whenever possible, Folger insisted on personally inspecting every item before adding it definitively to the collection. The physical examination of books and manuscripts allowed Folger to verify the accuracy of the catalog description, check whether the volume might be of some new variety, and ascertain whether a new copy of the same work was enough better than one he already owned. The articles were charged to him, and in case of a return, Folger asked to be credited, or he deducted the value from a following bill. He clearly relished the sport of collecting, returning hundreds of items to booksellers with courteous gratitude.

In his 1928 dealings with the London bookseller Pickering & Chatto, Folger returned ten books in January and sixteen in February, explaining the details in as many as eight letters. Without respite, the following month he was again ordering from the firm, sending two different want lists, each for eight books, on March 28. In 1928, the year he retired from Standard Oil, Folger's pace of purchases escalated frantically, as though he sensed his remaining time was short.

Rosenbach remarked on the enormous amount of physical work the Folgers did in handling their collection. In his own writing, Folger did not often mention the physical tasks of correspondence, packaging, and storing. Rather, he described his burdens as mental and financial.

The variety of reasons Henry offered for his book returns is revealing. Sometimes Folger would buy a book in order to replace the one in his collection with a better copy. When Rosenbach sent him *Laneham* (1575) in 1919, Folger sent it back. The dealer's copy was better than Folger's, he admitted, but not enough to keep it.[22] Folger returned a set of the Polish Shakespeare by Biegeleisen because "I do not of course need a duplicate copy."[23]

Questioning the accuracy of a publication date could constitute grounds for a return. After studying a Renaissance Pictorial Commonplace Book manuscript, Folger sent it back to Maggs; he did not believe it was written as early as claimed, 1608.[24] It was not in Folger's habits to seek out textual scholars and ask their opinion. He probably would have consulted only Emily. The bibliographic detective skills he

developed were homegrown. In a 1928 letter to Broadbent he doubted the authenticity of a royal signature. "I am much interested in your letter of the 1st and the description of the volume with Queen Elizabeth's signature. Are you sure that this is a genuine signature? I ask because I have 35 or 40 of her signatures, all of them, to be sure, attached to Deeds, Proclamations and other documents. They are all alike and quite different from this signature. You are of course as familiar as I am with the ordinary signature with the "E" angular and rather square."[25] Folger didn't buy this one.

Once, returning an item, Folger gave a London bookseller a lesson in watermarks. In 1913, Arthur Reader had sent him a Shakespeare portrait. Folger wrote, "I am afraid someone has taken advantage of you in stating that it is an original. It is not from the original plate, nor is the water-mark in the paper like any of the watermarks in the First Folio. You hold the paper up to the light to see the watermark. With the First Folio it is in the middle of the paper."[26]

Folger's predilection for early editions was nuanced. Three months before he died, Folger returned "with great reluctance" a fourth edition of Lodge's *A Looking Glass for London and England* (1617); he would stay on the lookout for an earlier edition.[27] There were exceptions to this early-edition preference. Folger "reluctantly" returned to Rosenbach Withals's *Dictionary* (1553), due to the "beauty of the book itself." He explained, "I already have five editions issued during what I call the Shakespearean period, and while none is as early as this there are two early enough to have been used by Shakespeare as a student and a playwright."[28] The chances that the Bard owned, handled, or might have used a volume greatly enhanced its value in Folger's eyes. Nevertheless, in this case, he passed up the earlier edition.

Folger collected "extra-illustrated books," in which related documents such as paintings, engravings, letters, and playbills were carefully inserted in a rebound book. Although one of his favorite subjects, Folger returned to Rosenbach in 1922 the "lovely volumes" of an "extra illustrated Garrick" as too many of the added pages fell outside the collector's interest.[29] The following year Folger refused an extra-illustrated set of Baron Grimm, explaining to Rosenbach that the book's relation to his line of collecting was tenuous and he would not have been tempted even by a much cheaper ordinary set.[30]

Ever canny about driving down prices, Folger impressed upon his booksellers how dear their material was and how reasonably he had been able to procure the same items elsewhere. In 1918 he informed Rosenbach, "I return herewith the four items you were good enough to leave with me yesterday. I have a fine copy of the 'Davies,' bought long ago, costing me only $38. I have a copy of the Holmes letter, just like the one you offer, except that it is Holmes's own copy: I paid $20 for it."[31] Good recordkeeping came in handy for making his point.

Folger wasn't sure what might happen to book prices during a world war. During 1915 and 1916, he found the market flat, much to his disappointment. Seeing British trade dwindle, he had hoped to secure bargains. But in 1917, to his surprise, private sellers and dealers reduced their prices. He noted with glee that past Folger offers, once rejected, were now acceptable. "I feel very bad to have to decline them," he wrote his nephew wryly.[32]

Eventually Folger saw that his collection had grown so large that he had better raise his standards for selection. He thanked Curtis Walters in New York for sending him a Shakespeare portrait but responded that he had decided to keep only "notable items."[33] In the late 1920s, he wrote Charles Sessler that he had enough Dickens items relating to Shakespeare. Folger also stopped collecting items relating to the British Shakespearean actor Charles Kean. Still fond of David Garrick, Folger refined his purchases of Garrick's autograph letters to concentrate on those with a clear Shakespearean link.

Most book collectors lived in close touch with their libraries. The Folgers' modest house, voluminous collection, and commitment to fire protection dictated a different policy, though it was difficult for them not to be able to live with and enjoy their prizes. They kept few valuable books at home. Rare books went to bank vaults, less rare items to several fireproof storage warehouses in Brooklyn and New York in Emily's name. Folger occasionally lamented that he was so busy buying books he had little time to read them.

The Folgers packed their books for storage like no other book collectors: they used wooden ten-gallon oil cases. Frederick S. Fales, the man who shared an office with Folger at Standard Oil for five years, had the wooden cases made in his division and on his order. Fales explained they were "made to hold two five-gallon cans of oil, and so constructed as to be practically air tight."[34]

The inaccessibility of the collection in storage enraged scholars, who were eager to consult works Folger owned. Belle da Costa Greene, director of J. P. Morgan's library, who requested a book on behalf of a Harvard professor, was one of many who were rebuffed. Loan requests for exhibitions or Shakespeare tercentenary displays in 1916 met with polite but firm refusals. All this fed the mostly inaccurate perception of Folger as a cantankerous hoarder. The aloof, reclusive ways of the obsessive collector may have given him a bad reputation, but he never lost his courteous manner. By keeping the treasured items together in storage, cataloged but not curated, Folger protected the growing value of the collection. He also saved the money that would have been required for security and scholarly access, spending it on more acquisitions and, eventually, on a safe building.

One tactic Folger used rarely, but with marked success, was buying an item privately, before an auction. He began one such adventure in February 1920 by noting an item he received from two clipping services that a unique volume would be auctioned off in March at Sotheby's London. It would be, that is, unless Folger could get there first. He did. Five books were bound together in a tiny 5-by-3⅛ inch volume:

> *Passionate Pilgrim* (1599) by Shakespeare, *Venus and Adonis* (1599) by Shakespeare, *Lucrece* (1600) by Shakespeare, *Ghost of Lucrece* (1600) by Thomas Middleton, and *Emaricdulfe: Sonnets* (1595) by E. C. Esquier.

Folger had closely tracked this volume for four years, through his persistent agent E. H. Dring of Bernard Quaritch. The features that drew collectors were that only one other known copy existed of this edition of *Venus and Adonis*; further, the *Passionate Pilgrim* issue was totally unknown. Dring finally tracked down the volume that had lain undiscovered in a lumber room near Shrewsbury, England. He explained to Folger that cash up front might induce the Welsh nobleman to sell; an auction would not only risk a lower price but delay payment to the owner for several weeks. It worked. The Dring deal was clinched for $3,813—on the morning of the auction. Folger's eleventh-hour coup was an unwelcome blow to collectors who had come to bid. After Folger showed his gratitude, Dring wrote back, "I thank you for your cheque and for the additional commission that you added to it. I am the more pleased because it shows definitely that you appreciate the efforts I made to get the Shakespeare volume as cheaply as possible."[35]

Dring's boss, Bernard Alfred Quaritch Jr., also knew how to ingratiate himself with Folger. Quaritch Jr. wrote, "you asked for 9 numbers of 'The Times' of 1901. About 4 are out-of-print and the publishers want me to pay 5/- each for the other 5 numbers. I refused to do that as I think the price exorbitant, and I am seeking them second hand."[36] While this might seem like small change, the principle of saving was dear to Folger, and Quaritch knew it.

In addition to buying, Folger agreed to exchange and to sell books. In 1906, he traded four of his books to George D. Smith, receiving in return two single plays, including Edwin Booth's working copy of *Othello*.[37] One notable exchange in 1919 was with the book and autograph dealer Oliver Barrett of Chicago. Folger traded his 1611 quarto of *Titus Andronicus* for a 1639 quarto of *Henry IV, Part 1*. Barrett was always hopeful he could build his autograph collection by exchanging Shakespeare items from his library to Folger in return for autograph letters or manuscripts.[38] From time to time Folger sold articles, too. Early in his collecting he wrote Robert

Dodd regarding a Second Folio, hoping to recoup the $100 he had paid for it, but agreeing to settle for $75 if need be.[39]

More than once, Folger proved he collected with a clear focus. He didn't want to speculate to finance further collecting. In 1925 he wrote to the late George D. Smith's firm, "I am very sorry not to keep the *Henry V*, which you offer at a bargain price, but I would have to buy it with the plan of selling it again, and that is not my business. In confidence, I will tell you I already have five copies of this edition of the play, all of them better than your copy. So you can see, no matter how cheaply you offer it, I could not buy it excepting for speculation."[40] Now and then, as this letter illustrates, Folger hinted at the extent of his collection. In a letter to Smith in 1915, Folger apologized that he could not "find an excuse" for keeping a set of proposed books.[41] Book collecting was a serious game of acquisition and comprehensiveness.

Buying large collections, as Folger occasionally did, invariably produced duplicate volumes—which he generally gave away. "I would like also to know your price for the Ashbee-Halliwell Facsimiles of the Quartos, 48 vols. I buy these when they offer, and give them to some college library, where they are much appreciated," Folger wrote Rosenbach in 1921. The predominant recipient of his largesse was the English Department at Amherst College. Folger gave First Folio facsimiles to many of his relatives and student friends at graduation. Folger was such a good client that some of his major sellers, such as Pickering & Chatto, allowed him to return any duplicates.

For Folger, what was in the books always trumped their value as artifacts. Unlike other big collectors, including Morgan and Huntington, he was willing to purchase books that were judged imperfect or incomplete. In 1902, Folger asked Henry Sotheran to acquire for him as many Shakespeare quartos as he could for up to £100 per play, with a publication date no later than 1650. Folger added that he would accept imperfect copies if the price was reasonable. He wrote Maggs in 1926 to inform the dealer that he would wait for an imperfect set of "Elizabethan Trenchers" rather than pay the price of a better set.[42] Morgan, by contrast, branded imperfect copies "the lepers of a library."

Folger worried about the effect of his aggressive buying. Perhaps his own behavior was forcing up prices. He wrote Rosenbach in 1925, "I cannot help feeling that much of the present prices is due to my own buying, and often think it might be well to stop buying altogether for a year, to let them get back to a sound basis." He never resorted to that drastic measure, however. Consistently, cost was an overwhelming factor. In 1929, his last full year of collecting, he wrote Gabriel Wells, "the prices seem to me so very high that I am not willing to ask you to send them, even for examination."[43]

Rosenbach relented and lowered his price when Folger asked him to offer a discount on a set of Owen Jones's drawings for *The Winter's Tale*. Even then, Folger found the figure excessive. He explained his position, "I buy illustrations only when they appeal to me as being very cheap. I do not doubt but that the price you name is a fair one, still it is not low enough to tempt me."[44]

While Folger never articulated his bidding strategy, his correspondence reveals his calculation. In 1925 he explained to Rosenbach in an accompanying letter: "These bids I know are low, but in many cases I have the same books only not in as good condition as these seem to be, and in others have other editions which fit better, on account of their dates, into a collection of Shakespeareana." Folger was tight with his money, for a reason. His goal was to accrue the best possible collection, which meant making his money go as far as it could.

Still, many times, Folger increased bids in a flurry of cables as a sale neared and he feared he might lose his prize. Some booksellers gave the number-one client a heads-up. On the day of an auction, J. O. Wright regularly informed Folger if his bids appeared in danger. "We regret to state that on two items 494 and 504 we have much higher bids."[45] Folger could decide in the final hours whether he wanted to raise or stand pat.

Correspondence from a New York dealer to Folger shed light on London bidding practices. Gabriel Wells alerted Folger in 1929, "I know how Maggs used to make special efforts to outbid Quaritch, and knowing they were bidding for you, and then offer the items to you at an increased cost through their severely competitive bidding."[46]

Rosenbach frequently let Folger know how far his low bids had come up short. From the dealer Folger learned that his bid of £1000 for Nichols's *Acolantes* lost to a winning bid of £1450 and his bid of £450 for Woodhouse's *The Flea* compared to £900, which carried away the volume.[47] Rosenbach frequently got away with exceeding Folger's bids, in which case he sensibly cabled that he had done so with regret.[48] On occasion, Folger instructed his dealers acting as agents that they could consider his bids as "discretion bids," meaning the dealer could use his own judgment and increase a bid.

When Folger failed to win an auction item, he never despaired or gave up the chase. He continued to go after his prey by direct negotiation. He wrote auctioneers to learn the price at which the book sold and the address of the buyer if it were a dealer. Then he'd offer a slightly higher price. If the winning bidder were a collector, Folger's response was the same. When William A. White purchased a fourth edition of *Othello* (1655) from the Boston auctioneer C. F. Libbie in 1898, Folger wrote White and named a price. White wrote back, "I think you are offering more than

the book is really worth as it lacks a leaf, but as I do not need the money I prefer to keep the book."[49]

Folger did not shy away from purchasing large collections, although he was no match for Henry Huntington, who bought two hundred entire collections. The per-item cost must have appealed to Folger. In 1898 for £973 he bought from Henry Sotheran 110 volumes relating to Shakespeare. From the same source, he gained forty-two volumes containing letters and papers relating to Warwickshire, the county of Shakespeare's birth. In 1926, he purchased at one time 101 titles from Pickering & Chatto. It is astounding to think of the Folgers themselves, at home, poring over all these documents and preparing to order more. The collection absorbed them totally. As Henry wrote after his retirement, "I find it so engrossing that I cannot undertake anything outside of it; indeed, I cannot very successfully keep up with it myself, doing nothing else."[50]

Folger believed firmly that keeping his collecting and his winning bids out of the public eye was the best strategy to prevent soaring market prices for Shakespeareana. Even among collectors he sought anonymity. In 1907 he wrote Marsden Perry, whose Shakespeare collection he would later buy: "Should you feel inclined to sell the Halliwell-Phillipps Shakespeare collection, will you be good enough to give me an opportunity to make an offer for it? . . . I trust you will treat this letter as confidential, as I do not care to have my collecting of Shakespeareana advertised."[51] Twenty years later Folger had not modified his attitude, as he wrote Herbert Putnam, "I have persistently avoided all publicity, feeling that book buying could be done more cheaply and successfully if there were no advertising."[52] Folger feared exposure so much that he turned down requests to write articles on his collection, declined to have a book dedicated to him, and even refused to allow Columbia University to give him an honorary degree.[53]

The more Folger collected, the more intense his desire to learn more about the objects he bought. He was persuaded of the value of such information for scholars. In 1910, he admitted to Bronx bookseller Chait that he was interested in acquiring a proposed portrait of Shakespeare, on oak panel in an oval in a square, but that since the portrait had no pedigree he found it "quite impossible to trace the ownership or prove the workmanship."[54]

Broadbent and Rosenbach, two of Folger's favorite dealers, understood the importance of provenance, that is, the origin and source of the object in question. For $32,500 in 1927, Broadbent sold Folger 126 Elizabethan volumes, each with a description of where and when he had procured them.[55] One of Folger's most revealing letters went to Broadbent, when the collector pointed out the value of well-documented discoveries in the present that could prove useful later:

It is my hope that, at some time in the future, these annotated books will be carefully studied. I would take it as a great favor if you would now send me every bit of information you have, even though trivial, about them, especially as to their origin, that is where found, and who was the former owner of each. This information will not be shown for some years, but may be valuable as discoveries are made or deductions drawn as the result of study and comparisons. Of course, due credit will always be given to you as the discoverer.[56]

Scholars consulting the Folger collection appreciate the founder's respect for annotated volumes, many holding valuable information about early readers and their interests.

Folger's extensive collection and knowledge of Shakespeare-related works gained immense respect among dealers. In 1926, Charles Sessler returned from a European voyage, his trunks packed with literary gems. He hurried to offer Folger an unusually tall copy of a folio, measuring 13 3/8 inches. Folger surprised Sessler by responding that he owned corrected copies, one of which was 13 7/8 inches tall.[57] Maggs wrote Folger the same year, offering a copy of the first Russian translation of *Hamlet*, in 1748, stating that the firm had never seen or heard of it. Folger replied that he already had one.[58]

When Rosenbach sent Folger an 1833 volume of poems by Louis Sewell, Folger was disappointed. Although Rosenbach had described the volume as a first edition, Folger pointed out bluntly that the book included a "Preface to the Second Edition." Rosenbach replied that the book was important because it contained "an imitation of Shakespeare's Sir John Falstaff, in which an American is the so-called hero."[59] Enlightened, Folger accepted Rosenbach's interpretation, keeping the volume "in view of what you say about it." True to form, he tried to bring the price down to $40, whereupon Rosenbach insisted that $57.50 was the lowest he could go. Folger bought it.

No dealer was more imaginative than Rosenbach in devising ways to hook Henry Folger. E. Millicent Sowerby established her reputation as the first woman to work for the Rare Book Department at Sotheby's. Later in her career she worked as cataloger at Rosenbach and Company. Whenever Rosenbach needed cash, he would bring her something printed in the Shakespearean period and plead, "Can you make this into Shakespeareana? I want to sell it to Folger." On one occasion, Sowerby stared at the fragment of a musical score from the sixteenth century that the doctor had dropped on her desk. The basso line reminded her of Sir John Falstaff. Then she found a line in the text that included the word "Denmark." She wrote up the item and Rosenbach sent the description to Folger, who bought the fragment.[60]

In April 1929 Folger began to cut back his buying to save for the proposed library's expenses in Washington. He explained to Rosenbach that he'd like to keep the nine books the dealer delivered to his office, as the dates (1567–1606) fit his preferred period, but their price and his new restraint prompted the collector to send back five volumes.[61]

Rosenbach had seen his phenomenal sales to Huntington plummet when the collector began building his library, museum, and garden in the exclusive San Gabriel valley suburb of San Marino. He knew that Folger would follow suit one day. By 1930, Folger resisted temptations such as this alluring Elizabethan item: "I cannot tell you how reluctant I am to return herewith the copy of Greene, *A Maidens dreame* (1591), which you left with me two or three weeks ago. I would certainly keep it if I were not husbanding my resources in connection with the starting of our building in Washington."[62] Rosenbach had asked $11,650.

Henry C. Folger and Henry E. Huntington were Rosenbach's all-time best clients. In the next chapter we look further into their personalities, collecting habits, and manner of competition. Few men have ever devised such effective book-collecting systems.

CHAPTER EIGHT

❧ ❧ ❧

Hotspur and Hal

Two Henrys Compete

HOTSPUR: If I mistake not, thou art Harry Monmouth.
PRINCE: Thou speak'st as if I would deny my name.
HOTSPUR: My name is Harry Percy.
PRINCE: Why then I see
 A very valiant rebel of the name.
 I am the Prince of Wales; and think not, Percy,
 To share with me in glory any more.
 Two stars keep not their motion in one sphere,
 Nor can one England brook a double reign
 Of Harry Percy and the Prince of Wales.

1 Henry IV, 5.4.59–68

ALTHOUGH FAR MORE CORDIAL than the military rivalry of Shakespeare's Hot-spur and Hal, the bibliographic duels Henry Folger and Henry Huntington intensely fought were not on the battlefield but in auction bids, and not for a crown but for the plays of the very man who created the "Harry vs. Harry" of *1 Henry IV*.

Three published biographies and 200 acres in a posh Southern California suburb tell us a lot about Henry E. Huntington. Aided by nepotism, he trained as a railroad executive under the tutelage of his uncle, Collis P. Huntington of New York. Later president of the Pacific Electric Railway, Henry developed southern California rail lines as well as water and power companies. The "king of trolleys" built an extensive network of streetcars in Los Angeles. He inherited, but he also made, a large fortune.

Huntington's dominance in both art and book markets fascinated the American and British press. When he purchased in New York a two-volume vellum set of the Gutenberg Bible, he paid $50,000—twice the highest amount ever paid for a book at auction. From the Duke of Westminster, Huntington acquired, for $728,000, one of the best-known British portraits, Gainsborough's *Blue Boy*. Henry and his wife Arabella planned and constructed buildings on a vast estate among the foothills

of the San Gabriel Mountains for his spectacular residence, library, and museum, surrounded by 120 acres of botanical gardens that included a nonpareil collection of desert plants.

At first glance, Henry C. Folger and Henry E. Huntington led similar lives. Both blue-eyed boys were born in New York State in the 1850s and died in their seventies. Growing up, both imbibed deep parental values of churchgoing, close family ties, and a strong work ethic. Huntington attended Henry Ward Beecher's Plymouth Congregational Church in Brooklyn (where Emily Jordan Folger later taught Sunday school). The collectors' chosen industries—petroleum and railroads— expanded immensely and profitably in their lifetimes. Family or close friends ushered each man into his chosen industry. Unsurprisingly, under these circumstances, they both rose to the top. The two shared impeccable timing that allowed them to play a determining role in pioneer fields begging for creativity and offering wide latitude for imagination, foresight, management skill, and huge profits.

In the late nineteenth century, the public grew to mistrust captains of industry, charging them with predatory practices and immoral behavior. While Huntington and Folger were considered relatively upstanding individuals who avoided the muckrakers' most vituperative attacks, they lived and worked under the shadow of suspicion over John D. Rockefeller in oil and Jay Gould in railroads—two who shared the title of most hated man in America.

"H. C." and "H. E.," as they were called, used steadily growing resources from their businesses to collect books, an avocation that deepened from hobby to lifelong passion for these two avid readers and booklovers. Huntington began collecting in the 1870s, Folger in the 1880s. At first, they assembled their libraries through personal visits to local bookshops, but soon they learned to court owners of private collections and to have booksellers serve as their commission agents at auctions.

Obsessive collectors, both took out loans to finance their purchases, and at times considered themselves close to falling into debt. Huntington bought as many as two hundred entire libraries; Folger many fewer. They both preferred to purchase collections privately before they went on public sale.

As their own libraries grew to hundreds of thousands of items, each man developed plans for a permanent repository. In parallel, they planned, designed, built, and endowed libraries whose designs were honored by the American Institute of Architects. The collectors each arranged a board of trustees to administer their institutions. They distrusted the idea of "politicians" playing a role in library management, yet with a sure public spirit transformed their private capital into a public good; both libraries would be open to scholars and visitors. Huntington and Folger were capitalists with a similar philanthropic bent, to create research centers for academic

study, cultural appreciation, and the advancement of learning that would announce America's arrival as a leading world culture.

Both gentlemen were reserved and modest, avoiding publicity. Huntington granted only one interview in his life; Folger, the same. When Rosenbach wrote both collectors seeking their photos for a book he was writing, he got nothing. When asked whether he would consent to a biography, Huntington replied, "This library will tell the story." They refrained from creating personal bookplates. They turned down many appeals for financial contributions to concentrate on building their collections. Frequently ill during adult life, both died after a second operation following prostate surgery.

British-born sculptor John Gregory carved the friezes for the Huntington Mausoleum; he also designed the friezes on the Folger Library façade and placed Henry's funerary urn in its library niche. Huntington librarian Leslie Bliss described Henry E. Huntington as "somewhat shy, and exceedingly gentlemanly, a very fine person," words that applied equally to the retiring Henry Folger.

Yet the two great collectors also differed significantly. When scholars requested photostats or asked to consult items in their collections, Huntington acquiesced, to the warm gratitude of supplicants. Folger apologized that his library was stored in warehouses, not yet available to scholars. Clearly frustrated, scholar A. W. Pollard wrote about Folger, "I find it hard to be in Christian charity with a man who has had the 1st edition of *Titus Andronicus* for some years and hasn't published a facsimile or at least an accurate reprint of it. I can't complete my Shakespeare work without it & he locks it up in a box."[1] Embarrassed about the inaccessibility of his treasures, Folger longed for the time when he could complete his library and satisfy the requests that streamed in.

As both purchased entire libraries, many duplicates existed among their acquisitions. Folger gave most away to friends, family, students, and college libraries. Huntington, however, traded up, taking his duplicates to the auction house. From 1916 to 1925, he sold more than eight thousand of them at Anderson Galleries in New York, netting more than $550,000. One man's duplicates became another man's treasures. Folger obtained from the lots more than one hundred volumes printed before 1700. In 1918, when Folger sought manuscripts and early printed works, he gave up duplicate Shakespeare folios and quartos for them. He even sold a few books to Huntington, including Shakespeare's *Pericles* (1609).[2]

Huntington pursued bargains and avoided "fancy prices," but he was especially keen on obtaining perfect copies. When Huntington reached his goal of obtaining a flawless book, he shed his imperfect copy. Folger welcomed imperfect copies, as they stretched his dollars. Ahead of his time in anticipating the importance of

variorum editions, Folger believed scholars would recognize the usefulness of textual variants. He preferred copies with marginalia—corrections, notes, and comments; they enhanced a book's usefulness by adding historical context.

Perhaps because he never went to college, Huntington disdained foreign language books. His en bloc purchases inevitably brought his library many such books, which he regularly sold. Excelling in French and Latin in college, both Folgers keenly pursued translations of Shakespeare plays and sonnets. Emily, an excellent student of German, helped her husband chase down foreign books.

Huntington was a loner. He preferred to act and manage alone, after consulting trusted advisers. Financially, Huntington's fortune allowed him to be his own banker most of the time. He proposed credit terms favorable to himself that were usually accepted. By contrast, Folger worked out his want lists with Emily's close assistance. He kept small cash reserves and, in order to buy, was obliged to take out loans hastily and move funds around inventively.

Both joined the Grolier Club, the oldest bibliophilic club in North America. The club then occupied a Romanesque Revival building at 29 East 32nd Street in New York, boasting eating and social activities, publications, a library, and regular exhibitions. From time to time, Folger ordered specially printed editions sponsored by the club. He never loaned works to Grolier exhibitions, however. Although reluctant to let treasures leave his library, Huntington once loaned William Blake illustrations to a Grolier exhibit.

In 1911, Huntington and Folger were founding members of the smaller, less formal, Hobby Club of New York. The group met several times a year at the Metropolitan or University Club, or at members' homes, starting with a sumptuous dinner. Hand-printed Tiffany menus on parchment, sealed in red wax and brown ribbon, adorned each place. Huntington welcomed social interaction with interesting men of means and attended most of these dinners, judging from his frequent signature on menus passed around the table. He hosted two Hobby Club dinners in New York: one to show off his art treasures, the other to give guests a tour of his private library. A reserved man, Huntington ceded the customary speaking opportunities at these banquets to others. Folger simply avoided most social engagements.

Folger and Huntington attended a 1913 club dinner given by George A. Plimpton where the host spoke on "Education before Printing, as Illustrated by Original Manuscripts." At a later dinner, Plimpton spoke on "the education of Shakespeare as illustrated by the school books of that period." Only three of thirty-six Hobby Club members in 1916 were listed as collectors of Shakespeare. Elected to the club's board of governors as vice-president, Huntington displayed a palate eager for delectables well beyond Shakespeare.

Huntington collected the early masters of printed books, decorated manuscripts, and incunabula or incunables (books printed before 1501). He embraced all of Americana, particularly Californiana. He cherished the one-of-a-kind book treasure. He had a taste for the personal possessions of political or literary figures, acquiring Jefferson's account book and Hawthorne's love letters. Folger thought little of "fine bindings," which attracted Huntington. Huntington was more interested in perfect objects, Folger in the literature within the bindings. Huntington esteemed first editions and asked that Hardy's and Conrad's works be purchased automatically for him as soon as they were published. Folger professed no interest in modern first editions.

Folger thoroughly scrutinized all potential purchases. He rarely bought sight unseen. Huntington may not have developed the patience to look over the merchandise when his staff could. George Watson Cole, bibliographer of the prodigious E. Dwight Church Library, worked for Huntington for a decade. Assisted by a stenographer and typist, Cole cataloged the collection of what grew to more than 150,000 volumes. He employed a professional staff of eight bibliographer assistants. In contrast, the Folgers performed all the bibliographical work themselves (granted, without producing a catalog). Alexander Welsh helped with correspondence, ran errands to New York bookshops, and became the Folger collection's institutional memory after twenty years as Folger's personal secretary. But the contrast between the two Folgers and Huntington's staff of nine for roughly the same exacting work indicates the couple's extraordinarily focused obsession.

The two men involved their spouses in their collecting in different ways. Arabella Huntington took charge of art purchases while Henry ruled book acquisitions. She handled the household; her husband planned and supervised the gardens. She showed great interest in the design of the Huntington Museum and Library, dealing directly with the architects. While Huntington was clearly happiest on the West Coast, Arabella preferred the East, where she frequented art galleries and could visit her son Archer from her first marriage. The Folgers formed a closer collaborative team, consulting together on all acquisitions and record-keeping.

The widest gap between the Huntingtons and the Folgers was in their style of living, partly due to their disparity in wealth. Like banker J. P. Morgan and entrepreneur Jay Gould, railroad man Henry E. Huntington traveled the country in a private railway car. Deciding finally to move his home and books from New York to California, he built a ranch complex on 600 acres in San Marino at the foot of the San Gabriel Mountains northeast of Los Angeles. He and Arabella spent summers in New York or abroad at Chateau Beauregard, a 400-acre estate he leased near Versailles. When they dined with company—or even alone—Mr. Huntington wore

a cutaway suit and Mrs. Huntington a long, formal black dress; they were served by butlers and liveried footmen.

By contrast, the only property the Folgers bought consisted of an inland two-acre lot on Long Island, near a railroad station. While the Folgers had no children and rarely entertained, Huntington had four children from his previous marriage. His mansion was often full of family and friends, plus, periodically, art dealer Joseph Duveen and bookseller A. S. W. Rosenbach. Mrs. Huntington had a personal secretary and a maid, her husband a private secretary and a valet. The Folgers lived more simply, with Irish maids Mary and Bridget and a driver named Smith.

Archives reveal no correspondence from Huntington to Folger, and only one letter in the other direction. Since Huntington preceded Folger by a few years in designing, legally establishing, and executing a permanent home for his collection, Folger benefited from his example. He expressed his appreciation directly to Huntington, recognizing that his own collection paled in significance. "Thank you for the copy of your Deed of Trust for the Huntington Library and Art Gallery and thank you still more for the courage and judgement you have shown in establishing this very significant benefaction. It is at once an inspiration and a guide for others who may wish to do something of the same sort, but much more modestly."[3]

The Folgers may have heard that Henry E. Huntington suffered some losses in transporting his possessions to the West Coast. Huntington traveled to California in his private railway car with the most valuable possessions, while the bulk of his collection traveled separately in freight cars. Huntington insured only part of his load, but he collected reimbursement when oak panels were destroyed along the Rock Island Line's portion of the trip.[4] When Mrs. Folger organized the transportation of their collection from New York to Washington, by contrast, she used armored vans.

❧ People who cross the threshold into the arcane world of antiquarian books learn quickly about the *Short-Title Catalogue of Books Printed in England, Scotland, and Ireland*. In 1926, British bibliographers Alfred W. Pollard and Gilbert R. Redgrave produced this exhaustive list (referred to often as the *STC*) of 26,143 books published between 1475 and 1640. As a competitive collector with the wherewithal to acquire the best, Huntington told his staff to count the number of *STC* volumes in his library. When he learned that he had acquired 8,726 of them, or more than a third, he was encouraged. He was delighted to be told that, of that figure, 668 items could be found only in his collection. When informed that the British Museum and the Bodleian Library in Oxford each possessed more *STC* titles than he did, however, Huntington's ego suffered a wound. Since Folger kept his collecting figures under wraps, Huntington had to guess about his holdings. There was nothing to fear, for

TABLE 5.
Folger and Huntington Bid/Win Record for Lots in Huth Sales,
1911–1917

	Folger		Huntington	
	Bids	Wins	Bids	Wins
1st sale, 1911	27	5	119	32
2nd sale, 1912	33	1	250	177
3rd sale, 1913	21	3	1,000	450
4th sale, 1914	4	1	260	145
5th sale, 1916	14	0	140	137
6th sale, 1917	11	2	80	76
Total	110	25	1,849	1,017

Source: Archival information provided to author by Richard Linenthal, former director of Bernard Quaritch, in email messages of June 29, 2010, and January 29, 2011

the Folger library tallied approximately six thousand in the early 1930s. Today, both libraries own virtually the same number of *STC* titles—around 13,700.

Like Henry Folger, E. Dwight Church was a Brooklyn businessman who became a major book collector; he specialized in English and American literature. Also like Folger, Church was a shy man who kept his purchases under wraps. Shortly before his death, Church hired bibliographer George Watson Cole to prepare a catalog of his library. The seven-volume opus revealed two thousand distinguished titles in impeccable condition—including twelve Shakespeare folios and thirty-seven quartos. After Church's death in 1908, bookseller George D. Smith canvassed several serious collectors to try to form a syndicate of New York buyers. Meanwhile, behind the scenes, Henry E. Huntington contacted the executors of the Church estate directly and bought the Church library en bloc in a private agreement. His competitors were aghast when Smith announced the news to the press with characteristic bravura, inflating the purchase price by half a million dollars.[5]

From time to time, auction houses judged private libraries so extensive and rich that they strung out the sales over time. Sotheby's disposed in this fashion of the library of British book collectors Robert Huth and his son Alfred, taking seven years. Folger and Huntington were avid bidders, occasionally competing for the same item. Table 5, produced largely from old "commission ledgers" preserved in London's Quaritch bookshop, attests that both collectors harbored high hopes; their take-home record demonstrates how one buyer overshadowed the other.

Both Folger and Huntington were nonplussed when news reached them that—on the day before the auction all Shakespeare items were withdrawn from the first sale. Alexander S. Cochrane, a carpet manufacturer from Yonkers, New York, had

secretly purchased them. The Henrys suffered the same fate they had so often arranged for other buyers.

In the third sale, Folger bid on twenty-one items but won only three, all pre-1640 items, one of which contained Shakespeare's poems. Huntington walked away with fifteen items Folger had bid on. Folger lost out on other pre-1640 titles that were attributed to Shakespeare, contained a quotation from a Shakespeare play, or included an epigram dedicated to Shakespeare. Henry and Emily were aware of these references because Sotheby's catalog had described them in fine print. The couple spent many laborious hours combing through Huth catalogs, each running about 1,000 pages.

In the fourth Huth Sale, Folger bid £1,800 on a *King Lear* quarto (1608). Although this figure was high for Folger, Quaritch exceeded it by bidding up to £2,470 to obtain it for him. Huntington did not bid on the item. Instead, he walked away with several Ben Jonson titles, a collecting area well within Folger's purview. At the same sale, Folger bid only £75 for a Jonson lot, #4064, which sold to Huntington for £900. Huntington submitted as many bids with commission agent George D. Smith as he did with Quaritch; consequently, the above table does not tell the entire story of their bidding and winning.

Table 5 shows the massive scale at which Huntington bid: seventeen times Folger's number of bids, or 1,849 to 110. Of the 110 lots Folger bid on, he obtained only twenty-five, or 23 percent. Huntington's comparable record was 55 percent, or 1,017 wins from 1,849 bids. In the Huth sales, Huntington walked away with forty times the number of prizes Folger acquired, 1,017 to 25. Folger won substantially less than Huntington throughout.

At the same period, another story of hot competition among book collectors circulated. In early April 1912, young Philadelphia book collector Harry Widener bought at Quaritch's a tiny volume, the second edition of Bacon's *Essayes* (1598). Widener paid £200 for the book, which had belonged to Henry Huth. Harry's farewell to the bookseller was, "I think I'll take that little Bacon with me in my pocket, and if I'm shipwrecked it will go down with me."[6] Soon after, he boarded the *Titanic* for America with his parents George and Eleanor. As the craft was sinking on April 14, father and son accompanied Eleanor Widener and her maid to lifeboat no. 4. George and Harry stayed aboard and went down with the ship. Harvard dedicated the Harry Elkins Widener Memorial Library in 1915. At Bernard Quaritch's request, Henry E. Huntington agreed to let six volumes he had wanted from the second Huth sale go to Eleanor Widener, as they had been on her son Harry's wish list. A competitive collector could still have a heart.

Huntington and Folger jousted not only for books. Sometimes an oversized piece of furniture attracted both. Bookseller George D. Smith thought of his best-paying

customer, Henry H., when he purchased ninety-five volumes of Knight's pictorial edition of the Bard's works in 1914. With the deal—for merely $6,000—came a curious colossal bookcase, ten feet high. The wood of the elaborately carved bookcase came from forty different buildings mentioned in Shakespeare's plays or associated with the playwright. Five years later, Folger wrote Smith, asking him to ask Huntington if he would be willing to part with the bookcase. Not a chance. Today it still looms over staff and researchers in the Huntington Library reading room.

While Folger must have been dismayed to witness Huntington snapping up collections big and small, a major consolation was that he had entered the Shakespeare market earlier than Huntington. Also, their voracious appetites meant that lesser collectors were chased away from Shakespeareana. William K. Bixby of St. Louis, who had made a fortune building railroad cars, dropped Shakespeare to focus on Americana. The two Henrys, as dominant collectors, practiced cordiality. Rosenbach wrote Folger, "You will be glad to know that before Dr. Huntington left for California, he relinquished in your favor his bid on the first edition of Lodge's *Rosalynde* (1590)."[7] Realizing the need to keep his two prime customers happy, Rosenbach walked a fine line between profiting from their purchases and flagrantly pitting one against the other. He wrote, "I never used the bids of Mr. Folger and Mr. Huntington competitively; they acceded to each other's wishes in a most generous way and thus avoided excessive and costly competition."[8]

Huntington and Folger met again over a 1609 quarto edition of Shakespeare's *Sonnets*, during the 1919 sale of the library of Minneapolis newspaper owner Hershel V. Jones. Huntington had sold his copy to Jones for $20,000 before staff from the Anderson Galleries preparing for auction noticed that it contained two facsimile leaves. Just the man for a bargain, and someone who did not insist on perfection, Folger purchased the volume at auction for $10,500.

The same year, Rosenbach purchased the Shakespeare collection of Marsden J. Perry, a railroad magnate from Providence. Perry had the finest Shakespeare collection in America at the turn of the century. After the Panic of 1907, however, he was forced to part with much of it. Henry Folger was the lucky buyer then. After World War I, Perry could not resist getting back into collecting. But frustrated over losing the Duke of Devonshire's Shakespeares to Huntington, Perry decided to quit the chase altogether and sell out. Although George D. Smith hoped he would be lucky enough to buy the Perry collection for resale, Rosenbach won it.

Shortly thereafter, Rosenbach sold the cream of Perry's collection to Folger, J. P. Morgan, and Joseph Widener, Harry's uncle. Only later did he write Huntington a white lie regarding some Perry volumes: "Would like to give you first offer of Shakespeare quartos not in your collection."[9] Before Huntington had time to re-

spond, Rosenbach arrived in San Marino toting the remaining treasures. Huntington bought the lot for $121,000, paying only $21,000 immediately. The remaining $100,000 he paid over eight months, the way he liked to arrange payments. An elated victor, he wrote the bibliographer George W. Cole, "It makes quite a reduction in the number of plays I have to secure to be even with the British Museum."

Huntington paid Rosenbach a total of $4,333,610 during their years of commercial exchange.[10] Folger's comparable figure was $1,388,990.[11] Rosenbach had an uncanny ability to remember the major books already in both gentlemen's libraries. Himself a scholar of the Elizabethan period—and one thoroughly knowledgable of the book market in America and England—he befuddled and bemused Huntington and Folger, leading them by the nose to purchase after purchase. It was as though Dr. Rosenbach were developing their libraries for them; they only had to sign big checks.

Rosenbach often showered them with fawning congratulations. Upon his purchase of Edward Gwynn's Shakespeare quartos, Folger became the proud owner of "THE FINEST SHAKESPEAREAN VOLUME IN EXISTENCE," Rosenbach assured him.[12] And Huntington was offered a lot that he had to consider beyond a doubt "the greatest bargain of the year."[13]

The collectors responded well to Rosenbach's stroking. From Huntington: "I do not see how you could have done better than you did." From Folger: "I very greatly appreciate your interest in my Shakespeare collection, knowing that at times it even affects the profits which you might otherwise make on certain of your sales." Rosenbach smiled twice.[14]

Rosenbach was not above browbeating a buyer for ignoring his expert advice. To Folger: "I greatly regret for your own sake (but not for mine!) that you did not purchase the Legge, as it was offered to you at a very reasonable price."[15] He was referring to one of the manuscripts of *Richardus Tertius* (1579) by Thomas Legge the book dealer had billed as one of the sources of Shakespeare's *Richard III*. Rosenbach had warned Folger that if he did not purchase it, the manuscript would be in the doctor's luggage when he traveled to see Huntington. Rosenbach did sell the volume to Huntington in a big lot.[16]

Rosenbach worked hard to convey that he esteemed the collector's library as much as the collector himself. After a classic Rosenbach softening up, Folger received an irresistible proposition regarding a rare set of books: "As I would like to see this small lot in your library, I shall make you a very special price."[17]

Rosenbach was not above pitting one collector against another. He would offer a book to Folger that might appear all the more seductive because Huntington had never seen it. Folger would know he had to scramble to come up with cash to accept such an irresistible proposition.

He also endeared himself by offering the occasional favor: sending Folger an autographed signed letter by Edmond Malone; a children's book exhibition catalog for Mrs. Folger's attention; photostat copies of Benjamin Franklin letters, as Rosenbach knew that Franklin's mother was a Folger. For Huntington's seventy-fifth birthday, Rosenbach sent him a naughty letter from Lord Nelson to Lady Hamilton.

In 1947, Rosenbach gave a talk in the Folger Shakespeare Theatre about his experiences with rare books and book collectors. He began with one of his favorite stories about Henry Folger.

> Mr. Folger was very fond of the number thirteen. He was on the thirteenth floor of the Standard Oil Building, 26 Broadway or twice thirteen. He often liked to buy books where the price was thirteen. I recall one time that I spoke to him about this and I told him that sometime when the price was $14,000 I liked to make it thirteen to please him. He looked puzzled and said to me, "I imagine you do that occasionally but I suppose when the price is twelve you often make it thirteen!"[18]

Rosenbach adored books and, perhaps even more, profits. Huntington and Folger maintained a constant brisk business with the 10 percent commission on most auction sales. Under other circumstances, Rosenbach was not averse to accepting higher returns. With a straight face he said, "I do not consider 400% a large profit, or 10,000% large."[19] However, the dealer kept his earnings secret.

The only invoice slipup in the house involved Huntington. Inadvertently, a packer included in the envelope not only the cost invoice to the collector but also a letter containing the amount the dealer had paid. Too late, the staff realized this egregious error, but the letter was heading west. After initial curses and lamentations, Rosenbach did something he had never done before and hated to do: he climbed into an airplane. Once in San Marino, he went straight to Huntington's private secretary, George Hapgood, who opened the mail. "No, Doctor Rosenbach, no letter has arrived." Rosenbach was relieved.

Just as Duveen bribed and cajoled Andrew Mellon's servants to inform him about which loaned paintings appealed to the collector and when he might be in a buying mood, so Rosenbach had ingratiated himself with Hapgood via cigars and favors. Several days after his flight, Rosenbach reappeared in his Madison Avenue bookstore. Although he smugly kept the results of the trip to himself, the accountant later noticed an entry of $1,000 to George Hapgood as an expense voucher. Rosenbach's trade practices remained a secret to the outside world.

On occasion, the cordial competitive duo stretched into a trio. When Rosenbach traveled to London in February 1922 for a five-day Britwell sale at Sotheby's, his pockets brimmed with bids for the first edition of Christopher Marlowe's *Hero and*

Leander (1598). The top three buyers he represented were Folger, Huntington, and William A. White. Resisting a temptation to run up the price by bidding one against the other, Rosenbach purchased the coveted item. In deference to White's advanced age, Rosenbach explained, many years later, that he sold the Marlowe gem to him. Both Huntington and White died in May 1927. The White family thoughtfully contacted Folger and sold him the volume.

Always attuned to his clients' peculiarities, Rosenbach pulled off one unparalleled three-way deal. It started when Huntington wanted a copy of *Pericles* (1609). Folger owned two copies, one vastly superior to the other. He confided to Rosenbach that he was on the lookout for an upgrade. William White owned a fine copy of the *Pericles* he was willing to sell for $25,500. A situation such as this would prompt A. S. W. Rosenbach to move into high gear to find a formula to satisfy everyone, including himself. First, he bought White's copy. Second, he sold it to Folger in exchange for his inferior copy of the *Pericles* plus the sum of $18,500. Third, he sold Folger's reject to Huntington for $32,500. While Huntington was averse to paying "fancy prices," he was also a collector who often did not haggle. The doctor walked away with a handsome profit of $25,000. After this exploit, Rosenbach went fishing for most of the summer of 1922.

Alone among the six hundred booksellers with whom Folger corresponded, Rosenbach felt confident in urging his client to expand his collection into new areas. Other dealers were content to send out catalogs and point out potentially appealing lots or merely respond to Folger's requests. It goes without saying that part of Rosenbach's spiel consisted of self-marketing. Nonetheless, Rosenbach appears to have been genuinely troubled by the removal of Huntington's books to the West Coast. In 1922, Rosenbach wrote Folger a plea of sorts:

> I have long thought over the great loss to American students on the removal of Mr. Huntington's Library to California. There is no collection in the East where a student is able to consult a comprehensive collection of books of the original source books of Elizabethan-Jacobean literature . . . If I were you, and I hope you will pardon this, I would try to fill out the authors of the period beginning with the earliest times until the Restoration in 1660s. There are many volumes that can be obtained at most reasonable prices today.[20]

Rosenbach realized that the expenses of building a library would necessarily make a major dent in budgetary priorities for his collectors. The dreaded command had arrived from Huntington starkly: "Stop book buying until further notice." Folger sweetened the unwelcome news with his courteous literary style:

I trust you will not think me unsympathetic with the splendid work you are doing discovering new Shakespeare allusions, nor unappreciative of your kindness in making me the first offers of your discoveries. I am neither. But just now, starting in with our developments in Washington, I think we had better get our bearings more certain before making considerable expenditures for new books.

Not all families would allow booksellers to visit prime clients on their deathbeds. Rosenbach visited Huntington in a Philadelphia hospital after his prostate operation, and Folger in a Brooklyn hospital following his. Feeling chipper before the surgery, Huntington summoned several former business colleagues, Rosenbach, and art dealer Joseph Duveen. Huntington looked up from his hospital bed to see Rosenbach on one side and Duveen on the other. The two were known not to get along as they vied for the collector's attention and commissions. An awkward situation shifted to wry discomfort when Huntington stretched out his arms and cried, "I remind myself of Jesus Christ on the cross between the two thieves."[21]

Rosenbach brought the ailing Huntington appetizing food cooked in his own kitchen, hoping to improve his spirits. When Huntington died, with family by his side, Rosenbach was the one who notified library staff. Rosenbach sent British grapes to the hospitalized Folger, who received the book dealer in his room and exclaimed that the grapes were one of the few foods he could eat.

When, many years later, Rosenbach lay dying from an infected kidney, only his brother, Phillip, and shop assistants attended him. Often his needs translated into a bottle of whiskey. Once, the patient managed to sneak out to the movies. Shortly before Rosenbach's death, his assistants were busy disposing of material in his last storage warehouse when, in a corner under some furniture, they found two dusty cartons of French pornography. This was a real dilemma, because the company did not advertise or sell pornography. At length they decided to sell the finds to Dr. Alfred Kinsey, whose best seller, *Sexual Behavior of the Human Male*, had just hit the stands. In an exchange of letters, Kinsey admitted, "this rare collection has certainly strengthened my collection."[22] When the Rosenbach Company received a check from Kinsey for $2,250, the staff toasted each other for their insightful contribution to medical science.

Rosenbach was the most erudite rascal in the book business. He enjoyed three names. His staff referred to him as "the Doctor." His intimates called him "Rosy." In the trade, he was known as "Dr. R." Already as an undergraduate at the University of Pennsylvania, he was president of Bibliophiles Club and wrote for the Jewish Encyclopedia. Rare among booksellers, he obtained a doctoral degree, writing his thesis in 1901 at Penn on "The Influence of Spanish Literature in the Elizabethan

and Stuart Drama." He later established the Rosenbach Fellowship in Bibliography at Penn. He influenced the Folgers regarding the contents as well as purpose of a Shakespeare library. Rosenbach christened his cabin cruiser yacht *First Folio*.

Today, with considerable assistance from Dr. Rosenbach, the Huntington Library and the Folger Shakespeare Library are two of the most prominent private research institutions in America, attracting scholars from around the world. Visitors admiring Shakespearean objects on display or retrieved from the vaults in each library can only guess at the fiercely competitive struggle to secure them, as two titanic collectors built their monuments.

❧ ❧ ❧

A Monument to Gentle Verse

Designing a Treasure House

Your name from hence immortal life shall have,
Though I, once gone, to all the world must die.
The earth can yield me but a common grave,
When you entombed in men's eyes shall lie.
Your monument shall be my gentle verse,
Which eyes not yet created shall o'erread;
And tongues to be your being shall rehearse
When all the breathers of this world are dead.
　You still shall live—such virtue hath my pen—
　Where breath most breathes, even in the mouths of men.

Sonnet 81.5–14

HENRY FOLGER ACQUIRED THE PROPERTY for his Shakespeare Library through patience, secrecy, and subterfuge. One secret was that he considered other sites than the nation's capital. Among miscellaneous notes in Folger's hand is an undated alphabetical list of possible sites, surprisingly diverse in character and geography: Amherst, Massachusetts; Bernardsville, New Jersey; Brooklyn; Manhattan; Nantucket Island; Princeton; Stratford-upon-Avon; University Heights, Ohio; and Washington, D.C.[1] Another source included Chicago.[2]

With characteristic business acumen, Folger penciled on notepaper comparative land values for possible sites. He estimated that a library plot in Amherst, Nantucket, or Stratford would set him back $25,000. Manhattan land values, at the other extreme, would require an outlay of as much as $550,000. Stratford pressed him hardest to become the Folger collection's permanent home.[3] That would have meant repatriating the Shakespeare treasures Folger acquired largely in England. American patriotism won: "I finally concluded I would give it to Washington; for I am an American."[4] Like Huntington, Isabella Stewart Gardner, Andrew Carnegie, Henry Clay Frick, and others in this period of extraordinary wealth "made

in America," Folger likely considered it was high time for the nation to assert itself as second to none in valuing literary and artistic culture and founding institutions to propagate it.

Folger systematically narrowed the list of potential American sites. He explained to a Massachusetts congressman why he decided against a university:

> I have been importuned by several Colleges and Universities to locate my library of Shakespeareana with them, but I have never felt disposed to consider the suggestions, although some of them were very flattering, because the library is so narrow in scope, and at the same time so large in size, that it could not be very well fitted into a general library, as it would overbalance a general library on account of its bulk, its cost, and, I hope, its endowment.[5]

Folger eyed the lavish home at 1015 Fifth Avenue owned by Jay Gould's granddaughter, as well as socialite Edith Clark's house next door. Brooklyn real estate broker Walter B. Olive wrote Folger's contact, A. A. McCreary, a land speculator from Ohio, that the Clark mansion would cost $300,000. This was more than Folger intended to spend. (The building later became the Goethe Institute.) Folger also inspected properties on East 77th, 83rd, and 88th Streets in Manhattan and near the Pratt Institute in Brooklyn. While Olive and McCreary, his two "accomplices," continued on the trail, husband and wife also kept a lookout.

On their way from Brooklyn to Hot Springs, Virginia, in 1918, the Folgers had a several-hour layover in Washington between train connections. Despite a downpour, they used the unexpected time to explore neighborhoods around the Library of Congress across the street from the Capitol. Folger diagrammed several appealing sites. He contacted Amherst classmate John Franklin Jameson, now director of the department of historical research at the Carnegie Institution in Washington, pressing him for his opinion on situating a Shakespeare library in the city. Jameson replied, "Forty years ago I would have said no, but now I say yes."[6] Buoyed by this encouragement, Folger sent McCreary—who had a reputation for making secret land acquisitions—a diagram and instructed him to inquire "very cautiously" about four locations, each occupying about 20,000 square feet.[7] The site labeled on maps as "future government building" became the Supreme Court a few years later.

McCreary completed his investigation and sent Folger a promising report. Oswald A. Bauer, McCreary's attorney in Sparkill, New York, managed several properties in Washington. Visiting the capital only rarely, Bauer relied on a local real estate firm, J. C. Weedon & Co., to represent him. John C. Weedon lived on B Street SE just opposite the Library of Congress; he was ideally placed to keep a close eye on Folger's targeted sites. With Bauer and Weedon, the accomplice team grew to four.

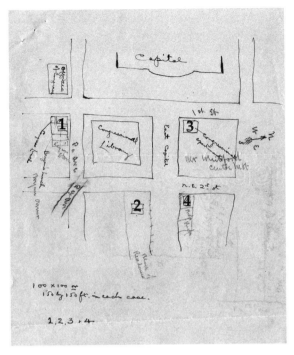

Four possible library sites near the U.S. Capitol. Before selecting the nation's capital to house their Shakespeare collection, the Folgers contemplated New York, Nantucket, and Stratford-upon-Avon. *By permission of the Folger Shakespeare Library*

Based on their sleuthing, the Folgers chose a large 50,000 square-foot tract on the northern half of Square no. 760 on East Capitol Street between 2nd and 3rd Streets SE, for which Bauer was, conveniently, the property manager. Correspondence between Folger and the go-betweens evoked an unnamed client wanting to purchase the fourteen houses—from 201 to 227 East Capitol Street—known as "Grant's Row." Acting as his own middleman, Folger wrote, "On my return from Washington I reported to our client the result of my visit. I have heard nothing from her, and as she is going south in a few days, I doubt if I will for some time. However, if anything comes up I can get in touch with her." In this thinly veiled subterfuge, the client turned out to be Emily Folger.

Grant's Row was one of the most costly, elaborate rows on Capitol Hill. In 1871, a Union veteran from Milwaukee, Albert Grant, hired Berlin-born architect George H. Griebel and borrowed heavily to build the red-brick houses. When Dupont Circle in the city's West End succeeded Capitol Hill as the more desirable neighborhood, Grant went bankrupt and his creditors sold off the properties. Bauer and

Union veteran Capt. Albert Grant hired architect George H. Greibel to build Grant's Row two blocks to the east of the Capitol. It took the Folgers nine years to buy secretly the fourteen red brick rowhouses, then demolish them to build a library. Note the Capitol to the right. *Library of Congress*

Weedon contacted the owners, offering to buy them out for their client. As the deeds became available, Bauer sent them to Emily Folger.

It took almost *nine years* for the patient, determined Folgers to gain title to all fourteen houses. They sneaked into town several times to keep their eye on their new properties. In Henry's real estate acquisitions, as in his book buying, he went to great lengths to keep his business tactics under wraps. The last homeowner, Charles W. Newhouser, a real estate agent, held out for months longer than the others. Folger's patience finally won out in 1927. He paid $317,000 for all the houses, more than the $260,000 he had budgeted. The public appeared to be largely unaware of the gradual buyout, and Henry Folger's name appeared on no official document connected with the home sales.

Elation at the Folger dinner table over acquiring the last property on the row was short lived. One morning in January 1928, reading the *Washington Post*, they learned of a bill pending in Congress that would give *their* Grant's Row properties and a block and a half to the south to the Library of Congress for a planned annex. This would allow the library to double its office and book storage capacities.

Alarmed by this unforeseen obstacle, Folger anxiously queried the Librarian of

Congress, Herbert Putnam: "Should I give up the thought of making Washington the choice for a location?"[8] A less insightful individual might have reacted differently; Putnam, however, saw the bigger picture. He knew that his library could never afford the expensive rare books and manuscripts Folger had acquired. He realized that having the Folger Library nearby was a great advantage to his library. Putnam responded quickly "to express of course appreciation of the paramount interest and importance of your plan, and to assure you that no governmental project would be allowed to interfere with it."[9]

Robert Luce (R-Mass.), chairman of the House Committee on the Library, also agreed. He championed Folger's idea of erecting a Shakespeare library on the northern part of Square 760. Over the next weeks, Putnam and Luce formed an effective lobbying team. They conveyed many pleasing assurances to congressional ears. Folger would not only build but also endow a Shakespeare library "as a gift to the nation."[10] Folger had written, "I am limiting my collecting to early and rare books, and am not including the books that will be found in a general library."[11] The existence of a specialized Shakespeare facility across the street from the Library of Congress would not only complement but also enhance the government institution's mission. Without exaggeration, the building would increase the prestige of the national capital as an axis of culture as well as government.

Thanks to Putnam and Luce, the *Congressional Record* ran several paragraphs on Henry Folger's proposed gift to the nation, including:

> The Capital of the United States is rapidly becoming one of the world's greatest. One of the most recent evidences of that is the proposal of Mr. Henry C. Folger, of New York, to house permanently the most remarkable collection of Shakespeare writings that has ever been collected . . .
>
> Mr. Folger has expressed a desire to deposit this great collection permanently in Washington. He proposes to erect a building east of the Library here in the capital for a permanent housing and dedicate this remarkable collection to the culture of the American public.[12]

Putnam and Luce also pointed out that the government would economize $180,000 by not expropriating the Folger-owned land. Folger would be responsible for a particularly costly design for a dignified façade on East Capitol Street.[13] With the northern perimeter of the planned Library of Congress annex now bordering an alley, the government would not feel obliged to assume the added expense of a decorative façade.

In what appeared a win-win situation, the Congress voted. Realizing how much the couple had at stake, Putnam kept the Folgers informed at every major turning-

point in the drama. On May 8, 1928, he wrote, "The Bill passed the house yesterday by unanimous consent, indicating the favor with which it is regarded. It now goes to the Senate."[14] One week later, the modified bill also passed the Senate unanimously. The Senate version cited Mr. Henry C. Folger as owner of the collection to be a gift to the public.[15] Putnam informed the Folgers they could expect the bill to be signed into law by the president before the weekend. An anxious Emily Folger wrote to Putnam that she had heard President Coolidge was leaving town. In fact, the president did travel over the weekend but returned to Washington and signed the bill (Public Law 70-453) into law on Monday, May 21, 1928. The bill allowed the Library of Congress to acquire the southern half of square no. 760 and all of square no. 761 for the annex, eventually named the Adams Building. Folger would retain the northern half of square 760 down to the alley for a Shakespeare Library.[16] Finally, the Folgers could rest easy after their long effort to obtain a magnificent plot of prime land two blocks from the Capitol and diagonally across from the future Supreme Court building.

While Folger got his way, the price was his privacy. Because committee members learned of the plan, Putnam alerted Folger that the press might ask questions. It was a sore point for the collector, who explained to Putnam:

> I have persistently avoided all publicity, feeling that book buying could be done more cheaply and successfully if there were no advertising. And that is still true, so I shrink from making public any of our plans until it is absolutely necessary. Just at the moment I am negotiating for some twenty Shakespeare books of the very first rank, each unique, or practically so. To secure any one of them would be an event, and to obtain a score at one time is a stroke almost of incredible good-fortune. But I need not tell an experienced collector like yourself that in such matters the Friar's counsel to Romeo is very opportune, "Wisely and slow; they stumble that run fast."[17]

But Folger realized that he could not forever keep the press at bay. He was just not ready to stop collecting, using his successful covert style.

That same spring, newspapers covered Folger's retirement from Standard Oil, calling him one of the last pioneers of the oil industry. The press said he would devote his retirement to housing his Shakespeare collection. Prospectuses and letters from architects offering their services flooded Folger's mailbox. W. L. Stagg proudly pointed out that his "Aquia freestone," quarried since 1685, had been used in the U.S. Capitol, the White House, and the U.S. Treasury. He was sure his product's fireproof qualities would attract Folger. Pierson & Wilson were convinced that their experience designing the Library of Congress eminently qualified them. Shreve

Lamb, New York architects for Standard Oil's headquarters at 26 Broadway, hoped their firm would be chosen. Folger had written the company how much he liked the configuration of 26 Broadway, which became the largest office building in the world in 1921 after a new twenty-seven-floor structure was added beside its fifteen-story edifice. Contenders were divided in their support of a predominant building material, proposing limestone, granite, or marble.

Henry Folger pondered the building proposals and preliminary suggestions for an architect, discussing options with Emily but confiding in few others. Folger envisioned more than a simple repository. He conceived of an efficient, specialized library encased in a handsome edifice that would enhance its privileged location on Capitol Hill.

For years, Folger had known about architect Alexander B. Trowbridge, who had married into the Pratt family. While working for the firm Trowbridge and Acker-man in 1913, Trowbridge rebuilt "Killenworth," the George Pratt home in Glen Cove, Long Island, in the style of an English manor. The Folgers vacationed regularly in Glen Cove and knew the Pratt residence. They may well have been attracted by its old English style, with the future library in mind.

Folger contacted Trowbridge during the summer of 1928 to convey his initial ideas about a library. By fall, Folger had hired Trowbridge as the consulting rather than primary architect. Trowbridge preferred this form of architectural service, which he described as a "sign of the times, an expression of the complex conditions under which we are living. It does not interfere in any way with the prerogatives of the executive architect, but, instead, is an aid to both architect and owner."[18] The idea of hiring a consulting architect—and subsequently a primary architect— appealed to Folger's preference for communicating with a newcomer to his circle through a more familiar acquaintance.

After hearing more from Folger about his concept of a library for Washington, Trowbridge went to Europe to gain inspiration for his new assignment. Upon his return, he sent Folger pictures of library and Renaissance interiors to help the client think about styles and models.[19]

Rather than suggest a competition to choose a primary architect, Trowbridge recommended the services of French-born Paul Philippe Cret. Before the turn of the century, Cret had studied at the Beaux Arts School in Paris, as had Trowbridge. In 1902 Cret had sought out Trowbridge for advice when the Frenchman was considering making his career in America. Cret did emigrate the following year, and was to spend a third of a century training architects as professor of design at the University of Pennsylvania School of Fine Arts. Trowbridge supported Cret's inclination toward a mild neoclassical architecture that avoided mere imitation. He admired

Cret's work with sculptured panels in low relief, and the fact that Cret was not fond of the domed roof and triangular pediment. Cret preferred to strip away extraneous elements of the classical style. Trowbridge was also drawn to Cret's Renaissance design of the white marble Pan-American Union (now the Organization of American States) building erected in Washington in 1908. Folger also admired this structure and asked for photographs of other Cret works to help him make a decision.

As in all matters, Folger took his time. "I am disposed to be a little slow in deciding, feeling that after having arranged to get your assistance our most important move will be this of selecting the architect." Encouraged that Cret had already designed a library and a museum, Folger accepted Trowbridge's recommendation with cautious enthusiasm. For their work, Trowbridge as consulting architect would be paid 1 percent of the total building cost and Cret 6 percent as primary architect. If Folger did not approve Cret's preliminary designs, costing $3,000, however, Cret would not continue. The architect started work immediately.

In December 1928, Trowbridge and Cret visited 26 Broadway to share initial sketches with their client. Folger rarely offered reactions on the spot. Furthermore, Cret's thick French accent hampered discussions, which caused Folger often to enlist an interpreter. Cret's hearing had suffered due to front-line combat during the First World War, compounding the communication issue. Folger declared that he would study the proposed designs with Emily. Less than a week later, he wrote Trowbridge, "Mrs. Folger is inclined to consider the front of the building perhaps a little too somber, and fears Mr. Cret has been influenced by the title we gave to the project, trying to make the general effect a memorial in the technical use of that word. Of course we mean the memorial to be a testimonial, rather than something serious."

This first encounter between the Folgers and their architects established a pattern: Mr. Folger would listen, consult his wife, then represent her at the business meetings, evoking her thoughts and reactions as well as his own. The planning process with dual architects and dual clients proceeded deliberately. Indecision gave way to resolution only after everyone methodically weighed the options.

The Folgers had vacillated about naming the library that would be a treasure house of Shakespeare's "gentle verse" for "eyes not yet created . . ./And tongues to be." Three emphases competed for attention. Folger's 1927 will referred to "said library and building to be known as the 'Folger Shakespeare Memorial.'" Perceiving how the architect funereally interpreted the "memorial" aspect led the couple to reconsider. On New Year's Eve, Folger wrote Trowbridge: "On reflection, it seems best to change the title of our enterprise to "Folger Shakespeare Foundation." Six months later, Folger sent Trowbridge a final name change:

We have never felt quite satisfied that the name for our Washington venture has been the best that could be thought of. Even the last one did not appeal to us very strongly. We have now come to the conclusion that the simplest form will be the best. Let us, then, put on the building 'Folger Shakespeare Library.' After all, our enterprise is primarily a Library, and all other features are supplemental.[20]

The Folgers asked that the word "Folger" on the facade be engraved in smaller letters than "Shakespeare Library." In the final execution, the architects cleverly respected the spirit but not the letter of this request: The font size of "Shakespeare" is larger than "Folger" *and* "Library."

FOLGER SHAKESPEARE LIBRARY

Name games continued. While today, no one calls it the "Memorial Library," when monthly checks come from Amherst College to pay staff and fellows, the name of the payor reads, "The Folger Shakespeare Memorial Library," the legal corporate name. The library is most familiar to Washingtonians as simply "the Folger," the name cabbies recognize.

Design raised more critical issues than name. The Folgers had originally envisioned a wholly Elizabethan structure—inside and out. As Folger often said, if it was Shakespearean, or of Shakespeare's era, it was right. In a letter to Cret's senior partner, John Harbeson, Trowbridge shared how he had tried to dissuade his client: "I found Mr. Folger at first considering the idea of calling for a building in the Elizabethan style. I succeeded in persuading him to forget that idea, by describing to him a certain type of building, i.e., a modern design in which the classic spirit is maintained, I meant the quality which exists in Greek work is not dependent upon Greek orders."[21]

Cret agreed, opining that an Elizabethan structure on Capitol Hill would be "glaringly out of key." The Folgers accepted this, all the more readily when the architects encouraged them to envisage Shakespeare friezes on the exterior and plan an interior that would reflect Elizabethan-Jacobean architectural styles. Trowbridge's precise suggestions for a library design demonstrate the major role he played in overall design, as well as the insightful psychology he used in dealing with the Folgers. The finished library's exterior is a strikingly different style from the interior, an audacious and fitting resolution of the issue.

The Folgers devoted many hours to library planning as they collaborated with the architects. All harbored strong ideas that they shared respectfully. Both architects favored a simple, modern Grecian façade of white Georgian marble. Trowbridge had cautioned Cret that limestone stained and became a cold gray.[22] They championed

Architect Paul Philippe Cret's elevation drawing of the "modern classic" Folger Shakespeare Library on East Capitol Street. The Architects Advisory Council awarded the plans "Class 1, Distinguished Outstanding among buildings of its type." *Author's collection*

"no columns, no cornices, no porticoes, no sign of ornate Gothic architecture anywhere." Ornamentation would be limited to window grilles, side balconies, low-relief tablets, and—above—carved inscriptions from Renaissance authors. Asked by the architects to react to three series of sketches by indicating preferences, Folger responded: make the pilasters as flat as possible, without statues; include sculptures over the entrances; make the ornaments below the windows rectangular instead of circular; have only one roof line for the building's entire length.[23]

For her part, Mrs. Folger liked the general conservative scheme, a "design at once simple and noble, neither old nor new, but very satisfying."[24] The Folgers asked the architects to study the layout of properties surrounding the library and carefully ponder the relation between their library and the nearby Capitol. When plans for the new Supreme Court building became known in 1929, Folger sent a copy to Cret. The Folgers wanted their library placed on the building line on East 3rd Street, rather than situated in the middle of the plot like the Library of Congress. They wanted to leave respectful space around the Capitol. They asked that the auditorium or theater be situated farthest away, on the east end, with a motor entrance at the west end.

The Folgers themselves chose inscriptions for the upper façade: quotations from Ben Jonson; Samuel Johnson; and the editors of Shakespeare's First Folio, John Heminge and Henry Condell. They insisted on historical orthography, such as the etched quote from Ben "Ionson," "Thou art a moniment, without a tombe." Folger told his architects to follow the spelling and the punctuation exactly as he instructed, respecting the early modern style.

Trowbrige later reported that as the inscriptions were being chiseled into the marble, a visitor frantically appeared at the door: "I thought I had better come in and tell you that the men who are doing that carving outside don't know how to spell. They've got 'mirror' spelt with a 'u' and 'again' spelt with a final 'e.' You'd

probably better go out and stop them before they spoil the whole wall." Someone tried valiantly to convince the man that English spelling had changed since the sixteenth and seventeenth centuries.[25]

Besides inscriptions high on the main north façade, the Folgers identified particular scenes from nine well-known Shakespeare plays to be carved in marble and presented in low relief at eye level. Underneath the scenes were etched the plays' titles.

In October 1929, Folger told his architects that a New York sculptor named Frederick MacMonnies needed work. Under the circumstances, Folger thought his services might be obtained for a reasonable price and asked Cret to follow up. Cret reported back that he had looked at some of MacMonnies's work and found it "playful, and light in spirit, and not sufficiently dignified in its lines." When MacMonnies told Cret that he could not undertake any new work, the architect was relieved.

The architects identified four sculptors and asked them to prepare exhibits of their past work. John Harbeson accompanied the Folgers to view the exhibits, after which Folger commented, "Now I would like you to take me to see them in their working studios, to look at what they are doing."[26] By the time the architects suggested the Folgers first visit British-born John Gregory in his New York City studio, Folger demurred: "I think you had better not bring us in until after you and Mr. Cret have decided upon the artist to be employed. After that it may be worth while to confer with the sculptor so as to make sure he clearly understands what we have in mind in the way of the designs he is to execute."[27] When Trowbridge received this letter he was struck by "Folger's modesty, his deferring to the judgment of his architects on so important a matter as choice of sculptor."[28]

After the architects had confirmed Gregory as top of the list, the Folgers agreed to a studio visit. They liked what they saw. Folger learned that Gregory, too, was a bibliophile who collected Charles Lamb and had studied Shakespeare's influence on John Keats. This common passion created a bond between them that prompted Folger to make up his mind straightaway. "We need not visit any others," he said. "I am entirely satisfied to go ahead with Gregory; you fix up the contract, and bring it to me to see." The contract called for one-quarter-size architectural plaster models followed by nine full-size plaster panels. Estimating the work would require three years, Gregory agreed to start immediately.

In May 1930, the Folgers returned to the studio to observe Gregory's progress; the *King Lear* tablet was farthest along. As the couple departed, a relieved Gregory heard Folger murmur, "I shall sleep well tonight." Folger wrote Cret,

> I will confess I have been much worried, fearing that he might not be equal to the task put upon him, but I was satisfied that you had, once more, made a successful

choice in your assistant. I tried not to show too plainly that I was pleased with the work, and of course said little, or nothing, on the subject to Mr. Gregory, preferring, as I do in all cases, that what I say should reach him with your approval and through you as a medium, rather than direct; so I am now writing you, instead of communicating either by word of mouth or by letter, with him, and will leave it to your judgment what you will pass on to him as coming from me.[29]

While Folger generally liked what he saw, he wanted specific changes. In a letter to the architects—not the sculptor—the donor outlined what he wished to see: Lear a bit older and slightly more distraught, his upraised arms a little more muscular, and the Fool a little younger. Cret conveyed these suggestions to the sculptor, who made the changes.

A garden the Folgers wanted to locate on the west side of the library gave them another opportunity to commission a sculptor. The Folgers requested that a marble statue be "embowered in shrubbery," overlook a fountain, and portray Puck gesturing, with the caption, "Lord, what fooles these mortals be!" The Folgers suggested that these lines, from *A Midsummer Night's Dream*, might inspire the artist to devise a suitable design.

In November 1929, while visiting a New York gallery, Mrs. Folger admired a fountain she considered to be Shakespearean and told her husband about it. The following day, Mr. Folger wrote Trowbridge suggesting that the artist in question, Rachel M. Hawks of Maryland, might be a good candidate to design and carve the fountain and Puck figure. The same month, however, Trowbridge wrote to Cret suggesting a different sculptor, Brenda Putnam, for the job. Trowbridge later wrote in his notes about Hawks, "Much to my relief Mr. Folger did not insist upon her appointment and was entirely willing to accept my recommendation of Brenda Putnam."[30] Folger mentioned that he would be pleased to associate with the project the daughter of Herbert Putnam, the Librarian of Congress who had wholeheartedly supported the Shakespeare library. On May 26, 1930, Folger signed an agreement with Brenda Putnam stipulating $6,000 for the task.

The interior design of the theater posed another dilemma. On the library's eastern side, the main concept was to install a small Elizabethan theater. Following a planning meeting with the architect in his New York office, Folger wrote that the space was intended "to show the conditions under which Elizabethan plays were presented, primarily, and any other use by us will be supplemental."[31] He added that it was *not* for moving pictures, the media rage of the day. To be sure that his architects had at hand descriptions of the most authoritative renderings, Folger sent Trowbridge the book "Shakespeare's Playhouses" by Joseph Quincy Adams, whom

he considered the authority on the subject. A Shakespearean scholar, Adams would leave a distinguished teaching career at Cornell University to join the Folger Library as the director of research in 1931, and he later became the library's second director.

Folger also sent the architects sketches of the Fortune playhouse in London, asking them to use it as a model.[32] Then, he changed his mind and suggested as model the Globe theater, the primary playhouse of Shakespeare's acting company from 1599 to 1608. Finally, he decided on a third option: "Better be indefinite and design something which will incorporate features from several of the theatres, and can be described simply as a theatre such as was used during the Shakespeare period. I am sorry to reach this conclusion, but of course lack of knowledge may lead us to offer something which may later be found incorrect."[33] Folger turned out to be prescient on the matter not only in light of future scholarship on the theaters of the Tudor and Stuart periods but also on account of archeological excavations of the Rose and the second Globe in the early 1990s and of the Theatre (the first London outdoor public theater built by James Burbage—the father of the celebrated actor in Shakespeare's company, Richard Burbage) in Shoreditch in 2008. This wiser, safer decision did not protect Folger from later criticism by Shakespeare scholars.[34]

The architects agreed to construct a theater that represented an Elizabethan stage in a generic way, with authentic features. After traveling to London to research Elizabethan theater, Paul Cret returned with a plan. The theater would have no pit but rather resemble an inn courtyard in which traveling players would erect a stage. Cret noted that Mr. Folger had declared that the size of the East Capitol Street lot did not permit a large theater.[35] To produce an intimate setting, only 260 seats would occupy the spectators' area—in double-tiered balconies on three sides and on the main floor, sloping toward the stage. On the theater's vellum ceiling, a sky-curtain would be drawn to hide artificial lighting and display a quotation from *As You Like It*: "All the world's a stage, and all the men and women merely players."

The Folgers conceived of a "Shakespeare Gallery" between the theater and the administrative wing on the library's north side. Later called the "Exhibition Hall" and now the "Great Hall," this large space open to the public was designed to contain fourteen glass display cases for items from the Folger collection. The architects proposed a room 121 feet long, 28 feet wide, and 38 feet high. The Folgers also approved of the coat of arms of Elizabeth I over the east door and the shield and eagle of the United States over the west door.

One day, Trowbridge asked Folger for a Shakespeare bust. Folger replied that they had fourteen of different sizes and material. He sent measurements and pictures for the architects' consideration. Aware that the art collection was inferior to their literary gems, Folger admitted that only a few pieces were of museum quality.

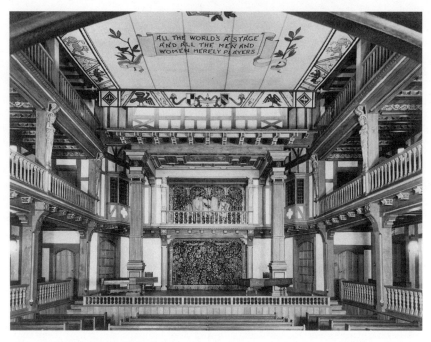

The Folgers wanted their library's generic Elizabethan theater to resemble an inn court-yard in which traveling players would set up a stage. The small, intimate spectator space included doubled-tiered balconies on three sides. *By permission of the Folger Shakespeare Library*

He reminded the architects "our enterprise is first of all a library, not a museum."[36] Non-literary items would be used sparingly.

The Folgers relished choosing literary inscriptions, however, drawn from the vast store of quotations they had pondered and copied into margins and commonplace books. Entering the Exhibition Hall from the west, one walks under this Shake-speare quotation engraved in stone:

I shower a welcome on ye; welcome all.

Entering the administrative wing of the library on the west side, one passes under a Milton quote, an extract from the preliminary pages of the Shakespeare First Folio.

What needs my Shakespeare
For his honor'd bones
The labor of age
In piled stones?
Thov in ovr wonder

Designed to evoke an English sixteenth-century great hall, the Exhibition Hall first used its glass cases to display Shakespeare busts and statues, antique musical instruments, and (what was purportedly) Queen Elizabeth's corset. *By permission of the Folger Shakespeare Library*

And astonishment
Hast bvilt thyself
A live-long monvment.

The Folgers considered the reading room, directly behind the Exhibition Hall, to be the heart of the building. They modeled the Tudor-style Great Hall with its high trussed roof after an Elizabethan banqueting hall, with dimensions similar to those of the gallery. Seven high bays, each with three south-facing windows, were planned to give natural light, although the architect increased that number to nine. He created an Elizabethan atmosphere through lighting fixtures including chandeliers, hanging lanterns, and floor lamps. The floor was made of cork. Folger wanted the reading room to represent a cross between a typical great hall of an English college and "the warm atmosphere of a private home."[37] He instructed his architects to include decorative stained-glass windows and to build an intimate fireplace and hearth. The stone fireplace, made of Bedford stone, large enough to roast an ox exists but has never served, out of fire concerns. Folger thought that only a few tables for

scholars were necessary. He conceived of scholars requesting information by correspondence more than by direct consultation.[38]

On the west wall the Folgers requested a large stained-glass window with tracery reproducing the apsidal window of Holy Trinity Church in Stratford-upon-Avon, which had been presented by American admirers of Shakespeare. Cret hired Italian-born Nicola d'Ascenzo to create the window, depicting the "Seven Ages of Man" from *As You Like It*. The artist was known for using rich primary colors framed within strong lead lines modeled after the work of medieval craftsmen. D'Ascenzo also designed other windows in the room, some with red and blue armorials. In the center of the east wall, the Folgers felt strongly about evoking Shakespeare by mounting their plaster replica of the memorial bust overlooking Shakespeare's grave in the chancel of Stratford's Holy Trinity Church. The funerary bust, although carved after the poet's death, is nevertheless considered an authoritative image of the subject.

Three-quarter-length 1927 oil portraits of the Folgers by the British artist Frank O. Salisbury flanked the bust, dominating the east wall. The Folgers had admired the many Salisbury portraits of prominent people they saw in the Grafton Galleries in London and the Anderson Galleries in New York. Henry had overheard two men discussing a series of Salisbury portraits and been impressed: one onlooker shook his head, exclaiming, "Can it be that we have been living with these distinguished men and women without recognizing them as such?"[39]

Folger complimented Salisbury for having "brought out the best in each sitter." He did not comment on his own likeness but found Emily's nothing short of perfect. Emily, however, later wrote library director Slade that the "new chair will take away that little man look of Mr. Folger's portrait."[40] Folger measured five feet four inches and Emily was sensitive to how he was depicted. Salisbury himself was among the early visitors to the Folger and found the portraits extremely well incorporated into the Elizabethan setting of the reading room. The north wall was commanded by a Tudor-style open fireplace, described above.

The Folgers envisioned the main function of the reading room as space for the essential books and manuscripts from their collection. Double tiers of bookcases on the main and balcony floors could house approximately twenty thousand volumes. The books were first arranged chronologically, with translations on the balcony level, and the lower level devoted to works from the eighteenth and nineteenth centuries. The most valuable items were stored in four fireproof steel vaults situated off the reading room on two levels controlled for temperature and humidity. Most of the lower-deck space was reserved for future expansion. But when the architects suggested from five to eight work tables for scholars in the reading room, Folger did not see it that way:

Fashionable British portraitist Frank O. Salisbury painted this likeness of Henry Folger in 1927. He is wearing his purple Amherst College hood and gown and clasping a unique book of Shakespeare quartos from 1619. *By permission of the Folger Shakespeare Library*

Frank O. Salisbury depicted Emily Folger in her pink Vassar College hood and gown holding an eighteenth-century fan decorated with a wedding scene from Shakespeare's *Henry V. By permission of the Folger Shakespeare Library*

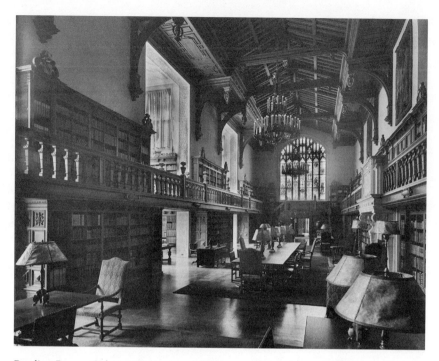

Reading Room. Oak paneling, a stone fireplace, and paintings provided a warm atmosphere for scholars. Behind a bronze tablet lie two urns containing the Folgers' ashes. *By permission of the Folger Shakespeare Library*

> It will not be a reading-room in the way reading-rooms are used generally, nor even as a room for study, because our Library is too special in its character, and the contents are so costly and limited in scope. . . . Our collection should not be offered freely to all comers, and the Library should not be looked upon as a reading-room nor a comfortable rest-room.[41]

When the building was completed, Henry and Emily planned to spend considerable time at the Folger in the founders' room to the rear of the administrative wing on the west side. In a roomy, warm, wood-paneled office, D'Ascenzo stained-glass windows depicted characters from Shakespeare's plays, as well as from his era, including Portia, Romeo, Touchstone, and Cardinal Wolsey. Folger asked for two rooms and a lavatory, with a fireplace, good light and air, "but not necessarily an outlook." He had one: in wintertime the Capitol dome could be seen through the west window.

Cret advised heating the library by means of hot water boilers, with the ability to convert later to coal. A hundred-ton capacity area would be created under the theater dressing rooms on the east side. When Cret suggested that the Library of

Ornamental door of Appalachian white oak leading to a rare book vault in the Reading Room. On the shelves is an eighteenth-century *Works of Shakespeare*, leather bound with elaborate spine tooling in 1932. *Paul P. Cret Collection, Athenaeum of Philadelphia*

Congress might constitute a source of emergency heat, Folger balked. He preferred that the library be totally independent of the government library. For ventilation, Folger inquired about a brand-new concept in the field, "air-conditioning." He approved it for the vaults and book stacks only, not for the other offices or public spaces.

The architects queried Folger on the "conveniences" he had in mind. He agreed to toilets and washrooms. When he saw no provision for elevators to move books from the street to basement and upper floors, Folger suggested it. He asked for parking space—now called Puck Circle—to be provided near the Puck statue and fountain on the west side.

The Folgers were greatly concerned with security. Well aware that many of their items could never be replaced, they worried foremost about assuring a fireproof structure. Folger sent Trowbridge a clipping about a new product called "asbestos" that simulated ancient oak. Folger suggested they use it, unaware of the dangers revealed decades later. The Folgers arranged for a custodian's quarters in the basement, and insisted on a twenty-four-hour guard service.

The Founders' Room is richly decorated with paintings and stained-glass windows depicting characters from Shakespeare's plays. Emily served tea here until her health failed. *Courtesy of the U.S. Commission of Fine Arts*

With much of the initial design and planning completed through meetings and correspondence with the double pair of architects and clients, the next step was to choose a general contractor. As with the architects' selection, no competition was held. The architects recommended the James Baird Company of New York. Baird had a matchless pedigree: he had built the Tomb of the Unknown Soldier and the Lincoln Memorial. In his youth he had captained the University of Michigan football team and served as football coach. Trowbridge assured Folger that Baird's proposed on-site superintendent, William B. Clemmers, was "unusually capable" and had shown his mettle building the Hampton Institute Library. Folger approved of Baird and asked the company to take charge of demolition and construction. Clemmers would give full satisfaction, remaining in the job the entire twenty months of both phases. When Baird suggested erecting a sign at the work site, creating publicity as well as identifying the particulars of the construction project, Folger's reaction was predictable. "We are not seeking any advertising, in fact we are doing our best to avoid calling attention to the enterprise. I have found this

most desirable in connection with our continued purchasing of Shakespeare books and other items."[42] On November 11, 1929, Armistice Day, razing of the fourteen brownstones on Grant's Row began. Asked to remove the first brick, Folger characteristically declined, naming John Weedon to perform that rite. Later, the library cornerstone would also be laid in the absence of the Folgers.

Equally unsurprising, Folger exhorted the James Baird Company to keep a careful eye on costs. On lighting fixtures, Trowbridge was happy to inform Folger that "the final contract price is under the specification allowance, which means a slight saving." James Baird later proudly showed a letter from Henry Folger: "Perhaps I may not have made clear my appreciation of the reduction in estimate of the probable cost of the Shakespeare Library, by some $60,000. This is most gratifying, for all the money we can save in the construction, without hurting its plan and efficiency, will give the library that much more money in the way of endowment for the purchase of additional material, and for up-keep."[43]

Folger regularly quizzed Trowbridge—were large subcontractor budgets reasonable, and would the work be performed within cost estimates? Folger personally wrote the checks to architects, general contractor, and subcontractors. He was impressed with Baird's estimates and wrote Trowbridge to say as much: "It all goes to prove that we have made no mistake in selecting not only our builder but our architects." Folger learned that buying out some of the Grant's Row tenants required paying off their mortgages; however, he had neglected to budget for this. Though he had planned to allocate $1 million to the library project—one quarter to land and three-quarters to building—he had to spend more on both.

"Nothing but the best" was the standard the Folgers sought, and were in the habit of achieving. Trowbridge assured Folger when a subcontractor was "the first choice of all the best architects." "Least cost" served as a second criterion of importance, as long as quality could be guaranteed. For months, Henry Folger had been seeing his dream Shakespeare memorial develop in detailed design, and he was satisfied he had chosen the ideal architects. He wrote Trowbridge, "As to Mr. Cret, we are entirely satisfied that no one could supply what we need better than he, and we are very willing for you to so advise him."[44]

In May 1930, Emily Folger wrote a letter she may not have shown to her husband. In it she raised three concerns she obviously felt strongly about. Two addressed aspects of John Gregory's initial model of *A Midsummer Night's Dream*; the other, the planned Puck fountain. While her letter has not survived, Paul Cret immediately wrote Henry Folger when its contents were made known to him. Cret's letter dispassionately outlines the impasse facing the architects and sculptor, who require clarification from the primary client:

We have received from Mr. Gregory a copy of Mrs. Folger's letter to him of May 15. Mrs. Folger suggests in this that he portray Puck in connection with the panel of *Midsummer Night's Dream*. She mentioned therein that it was impractical to portray Puck in connection with the fountain.

It is our understanding that it was your suggestion that the fountain figure represents Puck, and we see no reason why it cannot be so interpreted. We have considered changing the ornament around the fountain walls to suggest a forest to give the proper setting. We have instructed Miss Putnam to study her figure of Puck, accordingly, and she seems to be very enthusiastic about its possibilities. Of course, there is no reason why Puck should not appear in both the panel and the fountain, but perhaps if you still desire to portray it in the fountain, you may not desire it in the panel also.

Mrs. Folger also mentions that all the feminine parts played in the original plays were taken by boys. This, of course, is true, but it was a matter of circumstance that boys were called upon to portray these feminine characters. You will recall that in the *Midsummer Night's Dream* panel, Mr. Gregory used a charming female figure which was a true poetic interpretation of the meaning of the play. Should you care to show these characters as boys, an entirely different figure would have to be used, and perhaps some of the panel's charm would suffer accordingly.

Naturally we desire to see all this work executed entirely as you wish it, but present the above points to you for your consideration. Please let us have your further directions as soon as you have reached a conclusion, so that proper instructions can be given to both Mr. Gregory and Miss Putnam.[45]

In the end, Folger decided emphatically to permit the architects to make decisions on the fountain and sculptures. Any difference of opinion between Henry and Emily would not stand in the way of instructions the architects gave the two sculptors. In a subsequent letter, Folger clearly stated the outcome: "Mrs. Folger and I are happy to, and very desirous of, leaving entirely to you the decisions about the sculptures and fountains, provided the subjects are Shakespearean."[46] Of the finished sculptures, four of the nine relief panels contain women's figures: Juliet, Portia, Hermia, and the three witches. The statue of Puck appears only in the fountain.

A second question, about the *Midsummer Night's Dream* panel, arose regarding the nudity of one of the figures. Trowbridge found out by calling Gregory in New York City that he had already modified a figure by transforming it into the body of a man with the head of a donkey. This is how it appears today. Most people do not realize that the original model contained a nude. Trowbridge wrote to Cret, "Mrs. Folger did not like the idea of having a nude figure."[47]

Seldom does a project of such grand scope with dual clients settle conflicts as civilly as this foursome did. Every architectural project hides a succession of changes and a litany of compromises. The finished product conceals all manner of dispute—courteous, acrimonious, puzzling—that must be resolved before the final nail is driven. The Folger Library is no exception. Correspondence between the two architects reveals barely a single incident in which they differed. No serious rift was expected, because Trowbridge selected Cret due to their shared penchant for modern classical lines.

Each, however, admitted their views of the project changed. As Trowbridge said, "Originally I had advanced the idea that the art gallery would not be necessary and that we could hang pictures in the reading room and in the public halls."[48] Library visitors, staff, and readers are most grateful that the consulting architect changed his mind. For his part, Cret originally conceived of wooden doors between the exhibit hall and the reading room. He had second thoughts and designed glass doors, so visitors in the hall could view the stately reading room, as, indeed, many do on docent-led tours.

Looking back on his experience with Henry Folger in planning the Library, Cret appreciated his client's virtues: "an imaginative vision that can comprehend possibilities other than what he has seen in similar buildings; and . . . the power of appreciating the architect's plan as an aesthetic whole, in such a way that he will not impose any arbitrary modification that would destroy its organic unity."[49] Trowbridge chimed in, asserting that "Folger was an ideal client. He was deliberate in his decisions, especially with reference to the choice of men who were to work for him, but when the choice was made his habit was to trust his helpers and to hold them to their responsibilities. His natural modesty made him refrain from assuming a specialist's knowledge of architecture and sculpture."[50]

As the library design phase ended and the construction phase was about to begin, two individuals offered important suggestions to the Folgers and their architects. Herbert Putnam's keen interest and participation stemmed from his neighborly concern at the Library of Congress across the street and his long experience in library design and use. When Cret brought Putnam his designs of the four special vaults for the most valuable book treasures, they contained exterior windows. Putnam cautioned that the books could not withstand natural light, so the plans changed. Folger agreed immediately to put toilets and washrooms on the second floor when Putnam pointed out that Cret's designs lacked them. When Putnam suggested a kitchenette that "might not extend beyond the tea to which a visitor from England, for instance, is accustomed," Folger decided on "no provision for serving refreshments in the building." Food would be brought in from outside.

Putnam urged Trowbridge to bring on board Charles Moore, chairman of the United States Fine Arts Commission, referred to as "the official tastemakers of the day." This body had to approve the architectural drawings of certain key private institutions, not just buildings receiving public funds. Given its location, the Commission considered the Folger Library part of the lofty "Capitol Group" of buildings. In 1929, Putnam suggested that Trowbridge invite Moore for an unofficial visit to his office. After reviewing Cret's drawings, Moore exclaimed to Trowbridge, "I am absolutely with you in all that you have described."[51] When he heard about the meeting, Folger congratulated Trowbridge on making such a skillful presentation to Moore and winning unqualified backing from the capital's cultural establishment.

In early 1930, another august body, the office of the Engineer Commissioner in the District of Columbia, announced that the Architects Advisory Council had approved the plans for the library, with highest honors: "Class 1, Distinguished Outstanding among buildings of its type."[52] The Folgers could be pleased and proud: the architects had wholly fulfilled expectations in all domains. Looking back on one significant aspect of the architectural plan, Cret associate Harbeson would write, "It was one of the first buildings to make large use of aluminum, the doors and windows were of aluminum, and exterior balcony railings."[53] In an uplifting atmosphere at the construction site in May, the cornerstone was laid.

As Henry planned to relocate to Washington, ultimately into a new office at the Folger, he ordered a curious physical transformation of a favorite piece of household furniture. Henry had loved to play the organ, a skill learned from his father. His upright Aeolian organ was made of English Circassian walnut, with distinctive black streaks. Now Folger sent the organ to a cabinetmaker to have it converted into a desk.

Folger had devised a series of research and writing projects to carry out on his new desk. He had hoped to spend quiet time in the library undertaking four long-deferred projects:

- Collate his copies of the First Folio, noting all variations.
- Reproduce in facsimile, edit, and distribute the five or six preeminent books in the collection, starting with *Titus Andronicus* (1594).
- Show the connection between the life and letters of James Orchard Halliwell-Phillipps.
- Write a book on "Adventures and Misadventures of Book Collecting."

Sadly, Henry Folger would live to complete none of these items on his personal "bucket list."

CHAPTER TEN

❦ ❦ ❦

Dear, Blessed Plot of Land

The Folgers' Gift to America

This blessed plot, this earth, this realm, . . .

. . . this dear dear land . . .

Richard II, 2.1.55–63

AFTER THE CORNERSTONE of his library had been laid in May 1930, Henry Folger entered St. John's Hospital in Brooklyn for a routine operation under local anesthetic for an enlarged prostate. During convalescence, into the first week of June, Folger worked from his hospital bed. He dictated instructions about library design and contracting matters to Alexander Welsh, who communicated them to Trowbridge. The secretary signed correspondence and the patient signed checks and contracts that the secretary witnessed. After a second operation following prostate removal, Henry Folger died at 72. The death certificate stated the cause as "adenoma of prostate and post-operatory pulmonary embolism." Arterial blockage by clotting was not uncommon after prostate surgery.

The funeral crowd filled the chapel of the Central Congregational Church in Brooklyn, where Folger had been a worshipper, donor, and trustee. The pastor, Rev. Dr. S. Parkes Cadman (who once lived in Warwickshire, Shakespeare's natal county) noted in the eulogy that "Mr. Folger was a singularly mild man: he kept a steady silence which was more eloquent than speech. I do not recall a single instance when an unkind word left his lips. His life was marked by self-discipline and poise." Honorary pallbearers included Alexander Trowbridge and Herbert Putnam. Paul Cret, James Baird, and Dr. A. S. W. Rosenbach attended. Many Standard Oil colleagues and a strong contingent of Pratt family members paid respects to their long-time friend and colleague. For Henry Folger there would be no dearth of "that which should accompany old age, / As honor, love, obedience, troops of friends" (*Macbeth*, 5.3.28–29).

The sad irony was that Folger never saw a single stone of his library in place; he was never able to admire his books, paintings, and other treasures on public display.

Emily Folger was left to face alone the dilemma of whether, or how, to carry on the gigantic enterprise. She wrote, "I do not understand his going, but I am perfectly reconciled, I think."[1]

Alexander Trowbridge thought "Mrs. Folger is in excellent mental and nervous condition. She was not in any sense cast down or overcome by the loss of her husband. . . . [T]hey must have talked the matter over with great frankness, knowing that they both had reached advanced years and that one or both might be called before the library was finished."[2] Newly widowed, Emily was already showing formidable resilience and strength of purpose.

Folger's death dealt a harsh blow to booksellers. Bundles of books continued to arrive from Europe and America, requiring attention. Unfilled book orders had to be confirmed or halted. Folger's estate, which included over two thousand packed crates warehoused under Emily's name, needed to be assessed. Books filled the shelves at 24 Brevoort Place in Brooklyn and at 11 St. Andrews Lane in Glen Cove. In addition, Folger had stashed away three hundred boxes of Shakespeare items at 26 Broadway. Mrs. Folger and Judge Dimock chose Samual Marx, Inc. of New York to perform the assessment of the Folger collection for income tax purposes. Three appraisers labored for seven months before producing separate estimates of total value, each hovering around $2 million.

Emily's nephew and legal counsel, Judge Edward J. Dimock, was present with others at the opening of Uncle Henry's safe at Standard Oil. He described the scene. "Old-fashioned great big doors in front, shelves where books could be put, catacomb holes that could be opened with lock and key. But there was also inside the combination safe another combination safe, filled. And no one knew what the combination to that one was. And so we got the man from the safe company to come down and use his skills, Henry Valentine, to open it. What do you suppose was in it? Various bars of candy."[3] The examiners drew closer, and discovered that the brand was "Oh Henry!" Henry got the last laugh.

In life, Folger had been largely successful in escaping press coverage. After his death, the press carried articles about him, his fortune, and his legacy. The American public knew almost nothing about Henry Folger. Shakespeare and early modern scholars were aware of his growing collection, as was the British public who read the unhappy press accounts as Folger took one literary treasure after another out of the country forever. At the news of Folger's death many feared that the grandiose library project would flounder. They misjudged not only the meticulous planner Henry had been but also Emily's steadfast devotion to their common enterprise. Like Hamlet's loyal Horatio, she would "absent [herself] from felicity awhile . . . To tell" her husband's story and realize his dream (*Hamlet*, 5.2.382–84).

For $100 a month the Folgers rented 24 Brevoort Place in the Bedford-Stuyvesant section of Brooklyn, from 1895 to 1928. *By permission of the Folger Shakespeare Library*

The house at 11 St. Andrews Lane, Glen Cove, Long Island, New York, was the Folger residence from 1928 to 1936 and the first home they owned. *By permission of the Folger Shakespeare Library*

Folger's last will of March 27, 1927, stipulated that after disbursing funds to several Folger relatives—principally Emily, who was named executrix—"all the rest, residue and remainder of my property, both real and personal, I give, devise and bequeath to the Trustees of Amherst College and to their successors in said office as Trustees of said college, to have and to hold, in trust, however, for the uses and purposes and subject to the conditions hereinafter specified and not otherwise."

The will included details and conditions. Emily would receive $50,000 per year in quarterly installments. Henry paid tribute to Emily's role as his partner in special language: "Emily C. J. Folger, has from the beginning aided me greatly with her advice and counsel, and has shared in developing my plan for a Shakespeare Memorial Library, and has assisted me in the selection and care of my collection. I therefore request that the Trustees under said Will permit my said wife to borrow books and other items from said collection freely and without restriction, and that they consult her in the case of all plans of the said library and all regulations and expenditures pertaining to the same, other than routine disbursements." Folger bequeathed lump sums of $50,000 each to his sister and two brothers and $25,000 each to his nephew and five nieces. He also left $5,000 per year to each of his and Emily's siblings and $2,000 per year to each of their nephews and nieces. The trustees would pay these annuities only after the library had been paid for.

Within three years, Amherst College would be responsible for establishing and maintaining the Folger library in Washington "for the promotion and diffusion of knowledge in regard to the history and writings of Shakespeare, and shall keep the said library open to all students of Shakespeare under such reasonable regulations as said Trustees may from time to time adopt." From Folger's estate, the trustees were instructed to create a fund and manage its investment portfolio. Folger decided on a library endowment of $10 million, whose principal was to remain intact. He stipulated that fund income should be spent not only on library administration and maintenance but also to expand the collection and add to the building and its equipment. He set annual management fees to Amherst trustees at $100,000 minimum and $250,000 maximum. If, for any reason, Amherst College could not or would not fulfill the trust administration Folger outlined, he named two institutions in which the same responsibilities could be vested: first, the University of Chicago, then the Library of Congress if Chicago declined. Amherst accepted the terms. The final clause in Folger's will prevented any beneficiary from objecting to any of its provisions. Any attempt to contest his will would lead to being "absolutely barred and cut off from any share in my estate." No family member objected; he had provided generously for them.

The trustees of Amherst College were flabbergasted by the sudden news that they

were invited to administer a library in the nation's capital. Folger had never raised the idea with anyone at the college. His silence on the issue reflected the secretive side of his business activities and, indeed, of his nature.

Amherst College's president confirmed,

> On June 12, 1930, the New York papers reported the death of Henry Clay Folger, which had occurred the previous day. I had not known Mr. Folger personally and it did not occur to me to attend the funeral. . . . A few days later I read in the *New York Times* a dispatch telling of Mr. Folger's will. The paper contained an architect's drawing of the Library and a story that told of his bequest of the Library and the bulk of his estate to the Trustees of Amherst College. This I think was the first intimation the Trustees had of Mr. Folger's princely generosity to his alma mater.[4]

Folger had such a low profile at the college that only two trustees could claim that they knew him. One was publisher and bibliophile, George A. Plimpton, whom Amherst held in supreme regard: no one had ever raised more money for the college. Plimpton and Folger were lifelong acquaintances; they met and corresponded occasionally but had never become intimate friends. It was a curiously distant relationship for two men who had attended Amherst together and become Shakespeare devotees in young adulthood. The other trustee who knew Folger was Dwight Morrow, former senator from New Jersey, ambassador to Mexico, and a partner at J. P. Morgan. The public knew him as the father-in-law of the most famous man in America, Charles Lindbergh.

The college had no experience running an institution three hundred miles away, let alone a huge, recondite collection of rare books and materials. They would have to learn in a hurry; a large construction project was under way in Washington and a stream of Shakespeare books was still arriving for Folger in New York. Bills were piling up. Amherst trustees created a Folger Committee of board members chaired by Dwight Morrow, who handled finance. When he died in 1931, his Amherst classmate and former U.S. president Calvin Coolidge became chairman. In 1933, Supreme Court justice Harlan Fiske Stone of Vermont took over stewardship of the Folger Committee.

Stanley King proved to be the most active committee member. In a business, law, and government career, King had served as special assistant to the secretary of war and a member of President Wilson's industrial conference board. In 1932, he would become the first Amherst College president who was neither a preacher nor a teacher. In June 1930, King shouldered the responsibility of supervising the library building, and soon traveled to Washington to inspect the site and meet with architects and contractor.

The college resolved first to establish payment mechanisms and figure out the extent of the Folger estate's assets. The press had published some figures from the Surrogate's Court in Brooklyn, where the will was filed, and from the Surrogate's Court at Mineola, Long Island, near the Folgers' residence in Glen Cove. Considerable public interest and speculation surrounded the fortune left by the reticent Folger.

Mrs. Folger was instantly transformed from spouse and collecting partner to prime decision maker. The Folgers' collecting days were over. Alone, she faced a swirl of pressing business. Arriving on her desk for urgent action came bills to pay, stock powers to sign, and a new relationship to forge with Amherst trustees. She asked two close relatives to become advisers in helping her deal with her new life: Edward Jordan Dimock, an attorney and nephew of Emily Jordan, and Owen Fithian Smith, a banker and nephew-in-law of Henry Folger. Dimock worked in the old New York law firm of Hawkins, Delafield and Longfellow at 49 Wall Street, where Folger had registered his will. In his will, Henry had suggested Jordan Dimock as an executor, which he became. Smith left his job at National City Bank to work full time with Emily. As counsel to the estate, Dimock served as Emily's adviser; Smith became her co-executor and financial secretary. Alexander Welsh of Standard Oil helped by informing booksellers of Folger's death and indicating they should address correspondence to the "Henry Folger Estate." Mrs. Folger instructed Welsh to return book packages that had not been positively "bought." (Many had been sent on approval.) When someone approached Mrs. Folger about buying books for the library, she responded that such decisions were now in the hands of the Amherst trustees.

On October 31, 1930, in New York, Folger Committee members from Amherst met with Emily Folger and Edward Dimock. It was the first of many such meetings—in Washington, Amherst, Glen Cove, and once at Stanley King's summer home on Martha's Vineyard. Before meetings, King often went over crucial agenda items with Dimock so that Mrs. Folger would be briefed by "her own side" and not surprised by an unexpected item. At this 1930 introductory gathering, Mrs. Folger produced a bill of sale transferring to the trustees the title to the Shakespearean collection. She also signed over the real estate deed to the library in Washington. In another move, Emily offered to forgo her executrix fee of $185,000. Furthermore, she volunteered to pay for library furnishings and pay off the $104,000 mortgage on the library site. Clearly, Mrs. Folger was eager to contribute in any way she could to completing and opening the library.

Emily's funds had built up over the years, thanks to the fact that her husband had given her a substantial percentage of his Standard Oil interests. By the time he

died, her estate was about equal to his. In fact, the October meeting had to address promissory notes Henry had written to his wife. When her husband needed cash to purchase books for their collection, rather than sell his Standard Oil stock—especially when he considered the sale price too low—he borrowed money from Emily. Each time, he would record the amount in a promissory note. The value of these notes ultimately reached as much as $1.5 million.

Amherst sounded out Mrs. Folger about a prospect George Plimpton had already raised with her privately, disposition of these notes. Plimpton had explained that the college sought a donor to endow three professorships at Amherst, each for $160,000, or a total of $480,000. With two other professorships Amherst donors had contributed, the resulting five chairs would fulfill the conditions for a sixth to be funded from another Standard Oil fortune, that of the philanthropist Edward S. Harkness of Cleveland. Mrs. Folger warmed to the idea of establishing endowed chairs in her name, her husband's, and that of her mother-in-law, Eliza J. Clark Folger. However, she was averse to subtracting $480,000 from the library endowment—Emily's allegiance was to the library, not the college. Therefore, in exchange, she shrewdly asked the Amherst trustees to lower their trust management fee to $76,000 from the minimum of $100,000 set by Henry's will. The difference, $24,000, equaled 5 percent of the amount needed for the three chairs. Mrs. Folger then instructed the Folger estate to pay Amherst $480,000 of the notes, which endowed three faculty chairs that continue to this day. Amherst agreed to receive the lower fee in perpetuity, and the college also obtained from Harkness the sixth professorship in perpetuity.

As generous as Emily Folger had been, Amherst soon realized that the Folger Fund could not cover all the expenses Henry had anticipated in his will. They learned that Folger also owed $500,000 to banks that had loaned him money to purchase books. The collector's expenditures had exceeded his income. The stock market crash of 1929 had significantly compromised the Folgers' financial worth: 1931, the biggest year of expenditures on the Folger library, coincided with the lowest stock exchange levels yet seen. Amherst was used to investing in bonds and preferred stocks; the Folgers held common stock, mostly in one company, in a market crushed by the Great Depression.

Faced with managing the Folger Fund and administering a scholarly library in Washington, the college needed more manpower. It moved the treasurer to the post of comptroller and hired a new treasurer, Charles A. Andrews, to handle the finances of the Folger Library. Andrews set up separate books for Folger accounts. But the trustees also wanted their own eyes and ears in Washington. Andrews recommended his next-door neighbor, a young Amherst graduate, William S. Tyler III,

whose grandfather ("Old Ty") had taught at Amherst for decades. Assured of Tyler's loyalty to the college, and persuaded that his MIT training as an electrical engineer would be useful, the college named him superintendent of buildings and grounds at the Folger. He would supervise mechanical staff, security guards, maids, and the gardener. He also took visitors around the library before it officially opened. This was not a position that library staff in Washington anticipated, but Tyler showed up one day. In the words of the Folger's first reference librarian, he was Amherst's "secret agent."[5]

One man in Washington could not wait for the library to open. Every day from his residence on 226 East Capitol Street he walked to the nearby construction site to ascertain progress. His calling card revealed his professional interest in the building: vice president and librarian of the National Shakespeare Federation. He was Henry D. Fruit. As Shakespeare's birthday drew near, he put into action a daring maneuver for a man of seventy-seven. With two accomplices, he breached the security barrier around the construction site and laid a wreath on a stake near the theater. Then he took out a paper and began to read from it. He was adamant to become the first person to deliver lines from the (yet unfinished) Shakespeare theater. Construction superintendent, William B. Clemmers, was immediately summoned. He allowed the delegation to pay their respects to Shakespeare and to take a picture of the wreath that was circulated in the morning newspapers.[6]

Later in 1931, Charles Andrews calculated that the library might not be able to open as scheduled. He realized that $500,000 in cash must be raised to pay legacies, inheritance taxes, and library construction costs.[7] If no cash were available to borrow, securities must be sold. The Folger estate was valued at only $1,495,801, after paying all debts and expenses. This amount—much less than expected for the endowment—prompted more crucial meetings among Morrow, Mrs. Folger, Andrews, and Dimock. The happy conclusion was that Emily Folger offered to contribute from her own securities $3 million to the Folger Fund.[8] She assured Morrow that she was happy to do this, as her own will turned over all her assets to Amherst. This new influx of funds would allow the Folger Fund to pay the library's annual operating budget, which Slade had estimated at $100,000. Thanks to Emily's contribution, the library would be able to open in 1932.

However, by mid-1931, the Folger had no staff and no plan of operation. The unclassified collection had not even been assembled in one place. As the building became ready for occupancy, Mrs. Folger ordered the storage warehouses in New York to prepare the crates for transport to Washington. On some days, she was driven to the warehouse, to silently witness the gathering of small cases and huge crates. The packers wondered who the elderly lady was, clothed all in black, sitting in a corner and quietly watching them work.

In October 1931, the United States Trucking Corporation dispatched an armored truck carrying the first shipment of 350 of the rarest volumes. The five guards were armed with Colt .45s, machine guns, riot guns, and tear-gas bombs. After an uneventful twelve-hour ride to the capital from Brooklyn, they parked in the alley behind the library and unloaded their treasures in the dark of night. The *Newark Star Eagle* dramatically reported, "Loaded guns guard books as famed library moves."[9]

On December 21, Emily Folger attended the meeting of Amherst College trustees presided over by Calvin Coolidge in the Hotel Kimball in Springfield, Massachusetts. The main point on the agenda was how best to advance the library's opening. The book shipments would be completed by the end of March. The trustees felt confident they could finally set a date for the dedication ceremony, choosing Shakespeare's birthday—April 23, 1932.[10]

Friction arose between Amherst and the Folger interest related to staff appointments. The Folgers had hired William Adams Slade, chief bibliographer at the Library of Congress, as the library's first director, based on the recommendation of Herbert Putnam, the Librarian of Congress. Viewing Slade more as a chief of operations, the Folgers also hired a Shakespearean scholar, Joseph Quincy Adams from the English Department at Cornell, as supervisor of research to oversee scholarly matters. The two would have identical salaries and equal power. Amherst did not favor what looked like a co-directorship. Nevertheless, since Mrs. Folger was contributing so heavily to the needs of the Shakespeare library, for the moment Amherst was prepared to go along with her.

Later, Mrs. Folger suggested adding a third equal position in the library administration, a director of elocution. She believed that American schools were derelict in teaching speech. Amherst favored this position even less, hoping the idea would go away. When Emily persisted, and dispatched her preferred elocution candidate to meet library staff, both Slade and Adams were unimpressed. Amherst trustees were relieved when Mrs. Folger eventually gave up the idea of a directorial triumvirate.

In spite of the strained relations between Emily and the Amherst trustees, the college recognized her generosity and dedication to seeing through the library to its completion by bestowing on her in 1932 an honorary doctor of letters degree, eighteen years after Henry had received his. On the occasion, Emily wore Henry's hood.

Differences continued on the question of Folger Library leadership. While Amherst president, Stanley King traveled to Washington to make a survey. The act was an example of hands-on oversight from afar by Amherst top management during the college's first years of administering the library. Using an office on the third floor of the Folger's administrative wing, King interviewed employees one by one. Besides

wanting to gauge staff morale, he probably assessed views staff would share about managing the library. He discussed his findings first with the board of trustees, then with Mrs. Folger and Dimock. Amherst believed the library required a Shakespeare scholar, not a bibliographer, at its head. Moreover, they formed the opinion that William Slade was a weak executive. Mrs. Folger took the news hard. She wrote ruefully that Amherst trustees "must the more consider office rather than man."[11]

Amherst wanted to champion its own man to lead the Folger. While they recognized Joseph Quincy Adams's renown, they would have preferred to offer the lead position to Smith College president William A. Neilson, a well-respected Shakespeare scholar and a proven administrator near retirement. King invited Neilson to his house on the Cape to discuss the possibilities. Neilson saw no room for two Shakespeare scholars at the top.[12] Meanwhile, Paul Cret proposed a British-born Shakespeare scholar who lived in Philadelphia, Austin K. Gray, to run the library. Gray's application with letters of recommendation arrived at the Folger. Nor was Rosenbach without his horse in this race, Leslie Hotson, who worked in the Public Records Office in London.[13]

Without consulting Amherst trustees, Mrs. Folger stirred the pot by writing former president Herbert Hoover asking him to accept the position of director. Hoover declined, suggesting William Henry Irwin, a reporter who had written a biography of the former president.[14] Finally, after many uncomfortable months of equivocation, Amherst engineered Slade's return to the Library of Congress on November 1, 1934, after offering him a final fling on the continent, and named Joseph Quincy Adams acting library director.

In another tense incident, Mrs. Folger continued to encourage her preferred sculptor, Rachel Hawks, to pursue the Puck fountain project at the west end of the library, at the same time the architects were supervising Brenda Putnam, whom Folger had commissioned—for $6,000—to perform the same task. In February 1931, Hawks thanked Mrs. Folger for a $250 check, announcing that the project was coming along well and stating that the balance owed her upon completion would be $200. At this point, the correspondence file mysteriously ends. The large discrepancy between contract amounts, simultaneous pursuit by two artists of the same project, and the unilateral communication between the principals, suddenly cut off, are perplexing. The Puck statue in the Folger garden is Putnam's work. Her signature is on the back, although nearly eroded away.

Brenda Putnam's father, Herbert, played a key role in Folger Library planning as an interested neighbor and experienced librarian. Mrs. Folger grew to depend heavily on Putnam's rich experience and helpful attitude. Although she had never written the Librarian of Congress when her husband was alive, they carried on a

brisk correspondence in the early 1930s. Mrs. Folger submitted samples of library letterhead stationery to Putnam, seeking his approval of color, type, and wording. She asked him to critique the text of a talk on Mr. Folger she had been asked to give. Putnam advised shipping the more than two thousand cases of stored items directly from New York to the library, much to Emily's relief.

She saw it as an honor to continue on the path her husband had laid out so well, feeling that "no prouder privilege ever was granted to any woman" than being able to carry on Henry's work. Emily was ready to begin discussing with the trustees two more memorial acts. While the three Folger chairs at Amherst had been the college's initiative, her two ideas were personal and intimate. The first was to commission a marble bust of her husband. Very pleased by John Gregory's marble panels on the façade, Emily contacted the architects to inquire about a bust of Henry to be placed in an elevated niche in the Exhibition Hall. They asked if she might want a bust of herself as well, to mirror the dual Salisbury oil paintings in the reading room, but Emily declined. Gregory wrote back directly to her that he was "entirely engrossed" in the panels; "any other interest would upset me."[15]

Two years later, though, the sculptor began work on the bust of Henry Folger. Emily gave Gregory twelve photographs of Henry that he used to inspire what he called an "idealized" portrait of the subject in middle age. Gregory produced three plaster busts with different expressions and tilts of the head and installed them in the niche for Mrs. Folger to choose. Finally installed on Shakespeare's birthday in 1934, the bust Emily chose delighted her. Gregory was pleased that he had found "a fine piece of pure white marble without any spots." Unhappy with the angle at which the bust was first installed, Gregory moved it back a half inch and declared the effect perfect.

Emily selected a second memorial piece, a bronze mortuary urn for her husband's ashes. It was to be placed in a niche at the east end of the reading room, under a replica of the Shakespeare bust in the Holy Trinity Church in Stratford-upon-Avon. Cret designed a bronze tablet, adorned by a simple wreath and a Christian emblem, with an engraved enamel plate to cover the urn niche. In March 1932, John Gregory accompanied Emily in her car from New York to Washington carrying Henry's ashes in the urn. While Gregory deposited it in the vault behind the tablet and supervised replacement of the woodwork, Emily preferred to retire to the founders' room. This may have been the same visit when several photos were taken of Emily—in the founders' room and next to the reading room fireplace—where she is dressed in Julia Marlowe's Portia costume (see chapter 2). To be pictured with her late husband, she donned her Amherst hood and gown.

When Gregory prepared to install the Shakespeare bust in the high niche above the tablet, a serious issue arose. The niche was carved, but the bust he was ready

Folger Shakespeare Library in 1931. Scaffolding surrounds marble bas-relief friezes of Shakespeare scenes to be completed on the north façade. *By permission of the Folger Shakespeare Library*

Emily Folger in the Founders' Room dressed as Portia, wearing the gown of British-born Shakespearean actress, Julia Marlowe, 1932. *By permission of the Folger Shakespeare Library*

Emily Folger in 1932 in the Reading Room in front of Salisbury portrait of her husband. Amherst College awarded the Folgers honorary doctor of letters degrees in 1914 and 1932. *By permission of the Folger Shakespeare Library*

to install was too wide to fit. Folger had purchased not one but four copies of the Shakespeare bust in the Holy Trinity Church.[16] The bust was an exact full-size copy; other busts were slightly smaller. Gregory described the nature of the issue and the resolution in a letter to Cret: "I opened your letter regarding the cutting of the Shakespeare bust and in view of the conflicting instructions called a meeting of Mrs. Folger and Mr. Slade. Mr. Slade took the matter up with you by telephone and Mrs. Folger expressed herself as being anxious to use the present bust for sentimental and other reasons. Since you authorized me to use my judgment, I did so by deferring to the wishes of Mrs. Folger. To this end I cut off two vertical slices from the sides of the busts [*sic*] arms and cushions and placed the bust in the niche, fitting snugly between the sides. Mrs. Folger was perfectly satisfied."[17] A few days later the carver Garatti remodeled and recolored the ends of the cushion that supported the Bard's hands—the right holding a quill pen, the left a manuscript. Few knew about the narrowed torso. Stanley King was one who realized that "Mrs. Folger was a woman

of strong will and of extraordinary singleness of purpose; she was used to having her own way."[18] Not lost on anyone was the symbolism of the parallel: twin busts that look down on Shakespeare bones in England and Folger ashes in America.

As spring came to the nation's capital, the library was a flurry of workmen's activity in anticipation of the dedication on April 23. Library staff unpacked the last of the 2,109 cases of the Folger collection on March 30.[19] Library director Slade was working on the address he would deliver. His efforts to play a major role in organizing the event had been spurned by Amherst trustees, who saw themselves in charge. Slade shared his disappointment with Mrs. Folger in a letter.[20] All those caught up in the birth of the Folger Library were well aware that 1932 was the bicentennial of George Washington's birth. Washington himself had laid the cornerstone of the Capitol two blocks away. It was a time to rejoice.

❧ April 23, 1932, was a day of high drama across America. The Lindbergh baby's kidnapping riveted the country. Al Capone, it was rumored, had offered to find the child if he was released from custody. Colonel Lindbergh had already been in touch with Charlie's abductors, a journalist reported. The ransom could be as much as $50,000.

In Washington, Congress was going down a path that deepened the depression, among other things by recommending granting President Hoover special powers to reorganize the government in cost-saving ways. The retrenchment program threatened to result in payroll deductions, which angered federal employees.

On that April 23, the rest of the English-speaking world was celebrating William Shakespeare's 368th birthday in splendid fashion. In a red monoplane, the Prince of Wales flew from Windsor Castle to Stratford. On the banks of the Avon River, he and American ambassador Andrew W. Mellon spoke at the opening of the Shakespeare Memorial Theatre. American donors had raised nearly half the funds to construct the building, rebuilt after a fire; John D. Rockefeller Jr. was the largest American contributor, a fine irony considering that his father's longtime factotum and executive employee had vigorously competed with Britons, Henry E. Huntington, and others, to build a nonpareil Shakespeare collection.

Mellon had arrived on board the steamship *Majestic* of the White Star Line on April 8, presenting his letters of credence to King George V the following day as the new ambassador to Great Britain. His Shakespeare speech marked his first public foray beyond London. "We in America," Mellon intoned, "share with you a feeling of pride that England has given such a man to the world. He was of the heritage which we carried with us in founding a new civilization on the other side of the ocean, and his thoughts and the incomparable language in which he clothed

President and Mrs. Hoover at their arrival to attend the library dedication, April 23, 1932, Shakespeare's birthday and deathday. Like the Folgers, Hoover collected antiquarian books. *By permission of the Folger Shakespeare Library*

them have become with us a part of our very being, as they are with you and all the English-speaking world."[21]

On the other side of the Atlantic from Stratford, a newly confident American culture was about to receive an emblematic gift expressing its arrival as Europe's equal in cultivation and respect for high culture. In Philadelphia, the University of Pennsylvania accepted a fine library assembled by the Folgers' close friend, Shakespeare scholar Horace Howard Furness. In Washington, Emily Jordan Folger—who had studied for her master's degree under Furness—sat on the stage of the Elizabethan-inspired theater in the newly completed Folger Shakespeare Library on its dedication day.

Capitol Police and Secret Service agents had conducted advance reconnaissance to figure out how best to guard the Chief Executive and other dignitaries in this new Washington space. A Capitol Hill crowd cheered as President Hoover's Pierce-Arrow limousine pulled up to the library's north façade on East Capitol Street. The chauffeur then parked the presidential vehicle by the west side door.

President and Mrs. Hoover were seated to Mrs. Folger's left. On her right sat Amherst trustee chairman George Plimpton, in academic gown, beside his wife. Amherst College president Arthur Stanley Pease presided. Sadly and conspicuously absent from the dedication ceremony was the man whose fortune and vision had created this foremost collection of Shakespeareana and then given it to the nation through this great library in view of the Capitol dome. The patriotic thrust of John of Gaunt's panegyric quoted in part at the head of this chapter speaks not only to Henry Folger's own patriotism and amazing generosity but also to the priceless value of the "blessed plot . . . [the] dear dear land" that would be the permanent address of the Folger Shakespeare Library: 201 East Capitol Street SE, Washington, DC.

Emily Folger wore a shoulder corsage of orchids and lilies of the valley over her academic robe. Choked with emotion, she rose to give Plimpton the symbolic key to the library. Nervously fumbling in her lace handbag, she grasped the large key. Her voice quavering, she spoke, "Shakespeare says for Mr. Folger and me, 'I would you would accept of grace and love' this key. It is the key to our hearts." After a long moment's pause, as though trying to absorb both the exaltation and pathos of the moment, the crowd rose and broke into thunderous applause. This was Emily Folger's emotional yet triumphant day, a dream of many decades finally realized.

Fittingly, the British had been invited to participate in the library's dedication. Dapper British ambassador Sir Ronald Lindsay delivered congratulations from King George V. The British Shakespearean actress Edith Wynne Matthison recited lines from Emerson, who had inspired Henry Folger while at Amherst to devote himself to Shakespeare: "The pilgrims came to Plymouth in 1620. The plays of Shakespeare were not published until three years later. Had they been published earlier, our forefathers or the most poetical among them might have stayed home to read them." The crowd also noticed the presence of stage director Sir Philip "Ben" Greet, representing British theater; he was the actor who had probably spoken more lines of Shakespeare than anyone alive.

The reverend Dr. S. Parkes Cadman read the invocation and benediction. The audience recognized Cadman's dramatic voice from his weekly NBC radio programs: "As the pastor of Mr. and Mrs. Folger for the past thirty years, I can testify to the energy, concentration, and devotion which they so boundlessly exhibited in behalf of this patriotic enterprise. It was the dream of their lives and to it they gave all they were, and much of what they had."[22]

The guest list brought together the largest cultural gathering ever held in Washington, according to a press report: cabinet secretaries, political leaders, foreign dignitaries, journalists, artists, professors and scholars, and several college presidents. French playwright and poet Paul Claudel represented his country as ambassador

to the United States. The English department of Amherst College came in force, with Theodore Baird, who taught the Shakespeare classes; George Whicher, the first Amherst student to win the Folger Prize for excellence in writing an essay on Shakespeare; and poet and lecturer Robert Frost. Also present were professors who held the three chairs established at Amherst by the Folgers: for Henry's mother, Eliza Clark Folger, in Bible studies, for Henry in English, and for Emily in German. President Pease expressed gratitude to Emily's older sister, Mary Augusta Jordan, for funding the first scholarship for advanced study at the Folger. Mrs. Woodrow Wilson was in the crowd, as well as Constance Morrow, whose recently deceased father, Senator Dwight Morrow, had been the Amherst trustee most involved in assuring the library's financial security.

Architects Cret and Trowbridge were nervous, hoping for good reviews of their building. Standing shyly but proudly in a corner was Clemmers, who had been superintendent during the twenty months of construction. The press also noticed John Gregory, young sculptor of the Shakespearean friezes in eye-level bas relief on the north exterior. Few recognized in the crowd master marble sculptors Joseph Garatti and Carlo Pigozzi of Piccirilli Bros., but the two Tuscan masons who carved Gregory's marble friezes were not forgotten in the praise that followed.

Brenda Putnam, sculptor of the Puck statue in the library's west garden, attended the opening with her father Herbert Putnam, the longest-serving Librarian of Congress—the man who had eyed the same property Folger bought on Capitol Hill for a Library expansion but bowed to Folger's dream.

Exotic Belle da Costa Greene, chief librarian of New York's Pierpont Morgan Library, would not miss such a celebrity-rich event. Looking around in vain for a representative from the Huntington Library in San Marino, she mused that first Morgan, then Huntington, and now Folger—"the triple pillar[s]" of American bibliophiles—were all gone. In the wake of the income tax, no one would ever again be able to build such colossal collections as theirs. It was the end of an era.

The ceremonial afternoon was long. Never one to mince words, Theodore Baird wrote in his diary, "The Folger Library building is perfect, but the exercises I thought wretched."[23] The Folger's director of research, Joseph Adams, delivered the first "Shakespeare Birthday Lecture"—significantly, in view of Folger's intention to cement America's place in world culture—on "Shakespeare and American Culture." Rising to speak, he gave two customary tugs to the lapels of his blue serge suit. He observed that Americans universally worship three men: George Washington, Abraham Lincoln, and William Shakespeare. Each now possessed a memorial in Washington. The shrines symbolized the "three great personal forces that have molded the political, spiritual, and intellectual life of our nation." The scholar noted

Shakespeare's enormous influence on American life in the preservation of English language, literature, and culture, reminding the audience that no library was without its set of Shakespeare. Adams also pointed out that regular production of the Bard's plays had been delayed until early Puritan sentiment waned; until the eighteenth century, many Americans thought the theater sinful.

A contingent of Emily's Vassar classmates, unable to find seats in the small theater, spilled over into a side room to listen to WJZ-NBC broadcast the proceedings live over its national network. Capturing the magic of the occasion, classmate Nina Dike wrote that evening to their 1879 class president:

> Dear Emily, I must at least begin a word to you on this wonderful day from this wonderful place. *Your* day, and this afternoon your place, too, for we listened in to every word, and I was near you in spirit all that magic hour. How beautiful the old-time music was, how dear and sweet your voice, how fitting and lovely your brief words. They came to me with a thrill, more than Miss Matthison, more than your fine speaker, more than anything, because your heart was in there, and I knew. I thought, too, that Dr. Cadman was describing you in his prayer and wondered how he knew you so well. We sat there, a little group in the radio-room with the sun streaming in and the red maple buds swishing outside.[24]

Dutch-born Ben Stad, founder of the American Society of Ancient Instruments, led the chamber orchestra from the balcony overlooking the stage. They honored the Folgers by playing instruments recently bought for the library. Ben Stad played an English treble viol from 1570; his wife Flora, an Italian pentagonal virginal; and Maurice Stad, the basse de viole. Josef Smit played an English viola da gamba dating from 1615. The audience reveled in the musical interludes, featuring an elegant pavane and galliard by William Byrd and airs from Thomas Morley and Orlando Gibbons.

After the ceremony, First Lady Lou Hoover linked her arm in Emily's, helping her down the steps from the stage. After the presidential couple had departed, Mrs. Folger walked to the founders' room to greet well-wishers, who later were invited to view selected items from the collection in the reading room. As a final gesture, Mrs. Folger planted ivy from Mount Vernon near the theater entrance.

Mary Pratt made Emily's return alone to Glen Cove easier by filling the house with Japanese cherry blossoms so that she "might not pine for Washington." The Hoovers expressed their profound appreciation for the Folger Library by inviting Emily and Henry's sister Mary to the White House for luncheon. On other occasions, Mrs. Hoover entertained Emily and her sister, Mary Augusta Jordan, for tea in her upstairs sitting room in the White House and took them to Davis Cup tennis matches at the Chevy Chase Club.

Although the president had not spoken a public word at the library dedication, in an important but little-known way, his presence was most appropriate. Like the Folgers, and unlike all other American presidents to this day, Hoover was a rare book collector. His bibliographic specialty was mining and metallurgy, which grew out of his work as a mining engineer. Moreover, Herbert and his wife Lou together produced a scholarly work, a translation from Latin to English of Georgius Agricola's 600-page opus, *De Re Metallica* (1556). The copy of the translation in the Folger Collection was inscribed by Herbert Hoover in 1920 and presented to the library by Stanley King.[25]

❧ The Folger Shakespeare Library was barely ready for the grandeur of its dedication. It would not open fully to readers for eight months more, in January 1933. The intervening period was devoted to hiring staff, unpacking books, initial cataloging, shelving of the oldest books, and filling display cases in the Exhibition Gallery.

An early library staff hire was Giles E. Dawson. He had earned his Ph.D. under Adams at Cornell and began his career teaching English at Western Reserve Academy in Cleveland. Dawson agreed to work at the Folger for $3,000 a year as Adams's assistant. After reporting to work on July 1, 1932, and being introduced to Director Slade, he apprehended the vast scope of his specific duties only when he sat down with Professor Adams. Besides serving as general reference librarian, Dawson was to identify the contents of all Folger manuscripts. He later added the title curator of books and manuscripts. If the director was unavailable to take visitors on a guided tour, the responsibility fell to Dawson. Half of his time could be devoted to personal study and research.

Dawson was also put in charge of the bindery, the reading room, and cataloging. He supervised a reading room assistant, Sarah Jenkins Smith, whom everyone called Jenks; Robert Bier, the binder; and an experienced cataloger, Alice Lerch. Both Lerch and Bier came to the Folger from the Library of Congress. Miss Lerch burst into tears at the thought of being "bossed around by a young whippersnapper."

Challenges lay around every corner. Dawson discovered that "perhaps thousands" of books required rebinding, as their old, thin calfskin covers had seriously deteriorated. The Folger collection came with few dictionaries; the founders assumed that staff and readers could use reference works at the Library of Congress. After reference books purchased in England and America were delivered to the basement receiving room, they were brought up and shelved in the reading room. The staff shelved books from the seventeenth and eighteenth centuries; books from the nineteenth and twentieth centuries lay in no order at all for years.

Except for the Huntington Library, there were few research institution models

the Folger could emulate. Director Slade visited the Huntington to see what three years of operations there could teach him for planning the Folger. He learned several interesting things. The Huntington's annual budget was limited: they devoted $9,000 to books and $600 to periodicals. For a time, they had stopped purchasing rare books altogether. Of the 200,000 books in the collection, only 15,000 had been catalogued. Bookworms infested 878 incunabula volumes. He noted that night watchmen patrolled with police dogs. The Huntington had drawn up a list of eighteen regulations for readers. Not to be outdone, Slade returned to Washington with nineteen regulations for Folger readers and many more ideas.

Traditions soon took root. One that continues today was three o'clock tea. The ritual initially took place in the west bay window area of the founders' room. Laura Burford, the African American maid whom the Folgers had employed in New York, served. Both readers and staff attended the stand-up affair. After Mr. Folger died, Burford had moved to Washington to head the small maid service at the Folger Library. She stayed on even after Mrs. Folger's death in 1936, polishing and dusting, as well as preparing and serving tea. In the late 1930s, tea moved downstairs to the "receiving room," where an Oriental rug now covered the floor.

Throughout the 1930s, the uniformed security force was eleven guards under a superintendent, William S. Tyler III, wearing a three-piece suit. Captain of the Guard John J. Murphy wore "Captain" stitched on his cap. The others—William Aber, John Wolff, John Schellenberg, Harold E. Byrd, Warren Anderson, Harry Evans, Turner Allen, Charles Edward Burns, James Sappington, and Edward Nukle—had "F.S.L." embroidered on their caps. Murphy perched at the entry desk to the administrative west wing. If a visitor wanted to apply to be a reader, Murphy notified reference librarian, Giles Dawson, who looked over the applicant's credentials and admitted the petitioner or not. Amherst College was worried about library security. Amherst trustees came to town for periodic meetings in the basement board room, always on a Saturday. Routinely, the newest board member would try to brush by the registrar and walk into the reading room, to see if he would be stopped and checked.[26]

Also responsible for buildings and grounds, Tyler faced challenging crises in the physical plant. A greasy black deposit began to form on shelves—even on books—in the stacks and vaults. The Bureau of Standards diagnosed the problem as atmospheric acids, requiring "removal of the sulfur dioxide content of the air 'breathed' by the collections."[27] Two causes needed mitigation: the huge volume of air forced by the air-conditioning system through the rooms and the disastrous location of the system intake next to the chimney. Oil furnace fumes, as well as the dust and smoke of the city, were being drawn into the plant's fifty-two air ducts. Tyler had air filters installed that appeared to fix the problem.

Four local photographers vied to take picture-postcard photos at the Folger. The most successful was Polish-born Theodor Horydczak, one of Washington's first architectural photographers. Thanks to a modest outlay of $275 by Amherst trustees for a postcard fund, Horydczak took photographs of the library inside and out, using a ten-pound Gold Ansco camera and 8-by-10-inch negatives. The Folger retained Horydczak as the official library photographer and had him prepare negatives of the *Titus Andronicus* quarto for printing.

Before the Folger Theatre produced its first play in 1949, the library sponsored lectures and concerts there. English actress Edith Matthison returned in 1934 to give recitals from Shakespeare, followed by a concert of Elizabethan vocal and instrumental music by the Ypsilanti Singers. Samuel Arthur King of the University of London gave a dramatic reading of *Hamlet*, and Felix Schelling, noted scholar at Penn, spoke on "Shakespeare and Biography." With a nod toward Amherst College, Adams introduced trustee George Plimpton, who delivered a Shakespeare birthday lecture on "The Education of Shakespeare, Illustrated with Textbooks in Use in His Day." Renowned Shakespeare scholars and professors George Lyman Kittridge and William Allen Neilson also gave birthday lectures. The library was gaining a reputation for offering high-quality cultural events open to the public.

❧ Emily Folger played a crucial role throughout the couple's collecting life and in opening the library to the public in 1932 with a peerless collection, a handsome building, a generous endowment, and a dedicated staff. In the four years of life remaining to her, Emily continued to support the library while enjoying her friends and extended family. Had Emily allowed her husband's unexpected death in 1930 to overwhelm her, the whole project could have gone off the rails. She not only saved the Folger financially, she also persevered in executing final design details with library staff, family, and friends.

After the dedication, library staff continued to send bills to be approved and paid by Emily. Between 1931 and 1933, most bills covered library design and construction costs or furnishings, equipment and supplies. She paid for metal shelving, bookbinding supplies, typewriters, blotters, even for no. 2 pencils. For the library guards, she paid $53.95 for two holsters and Colt revolvers and three boxes of cartridges. The library in its early years boasted a shooting range in the basement; the guards were armed.

The Folgers always regretted not having been able to add to their collection Emerson's copy of Shakespeare. But Emily obtained the indefinite loan from the Emerson Memorial Association of one of Emerson's four copies of Shakespeare, one of only two that bore Emerson's signature. The poet's grandson, the Honorable

W. Cameron Forbes, wrote to the supervisor of research at the Folger, Joseph Quincy Adams, that "this copy is one he [Emerson] kept in his bedroom, and from certain annotations it is obviously the one which he let his children take to school and use in their studies." For several months in 1934 the copy lay in the central case in the exhibition hall.[28]

After her husband's death, Emily devoted more time to her family. Each month, she visited her older sister, Mary Augusta, in New Haven. In Washington, they visited the Folger Library together. She continued to host the annual Thanksgiving feast, now in Glen Cove. The dining room was too small for the twenty-five or so relatives who gathered, so the family put up a long table in the downstairs hall. Emily's grandnieces—her namesake Emily and sister Carolyn—recall the obligatory poetry recital at each family gathering. The young orators proudly received from Aunt Emily a book and a five-dollar bill. They savored the ham and turkey with mashed potatoes, less so the hominy grits. The children looked forward most to dessert, as a bevy of maids paraded around the table with heaps of pistachio ice cream and *meringues glacées* on the side.

In her later years, Emily became fast friends with Alice Maury Parmelee, colorful widow of the director of the Corcoran Gallery, James T. Parmelee. When the two ladies first met at the Homestead in Hot Springs, they discovered that they had much in common: widowhood, living among rare treasures collected with their husbands, and being accustomed to their independence. Emily journeyed to Washington for a few weeks each spring and fall to learn how the library was developing. Initially, she lodged at one of two brand-new hotels: the elegant Hay-Adams on Lafayette Square or the modest Plaza Hotel near Union Station, a short walk from the library. During her last visits, she stayed at the "Causeway" (later called "Tregaron") the lavish Parmelee residence on Macomb Street in Cleveland Park, now the site of the Washington International School. Emily may have heard of Mrs. Parmelee's reputation in Washington as a terror, galloping down Massachusetts Avenue in her hansom cab. In the late 1930s, she drove her hansom up to the front door of the National Museum of American History, got out, and declared, "There, it's yours." This vivid friend traveled with her maid to visit Mrs. Folger in Glen Cove, where they would attend open-air Shakespeare performances under the stars. Mrs. Parmelee loved having Emily read Shakespeare plays aloud to her. In Emily's honor, she made a major donation to the Folger: Flemish tapestries for the reading room, a sixteenth-century refectory table, several Jacobean chairs, display cabinets, a Steinway grand piano, and five handsome Oriental rugs.

One day Joseph Adams and Mrs. Parmelee were seen in the reading room, deep in conversation by the large stone fireplace. Soon afterward, her chauffeur, Percy,

appeared carrying logs. Mrs. Parmelee was eager to persuade Adams to make fires in the fireplace, or at least to blacken it. Resisting the idea, Adams had the chimney permanently capped. Mrs. Parmelee did succeed, however, in getting a job for her chauffeur's daughter, Sarah Lilly, as a typist at the Folger.

In the last two years of her life, Emily became a great proponent of Florence Locke, a California-born actress who had studied with Ellen Terry. With the blessing of Terry's daughter, Edith Craig, Locke toured England and America giving recitals of "Shakespeare's Triumphant Women," lectures Terry had written and delivered. Emily helped to arrange a recital at the Folger, where Locke recited excerpts from *Antony and Cleopatra*. Joseph Quincy Adams wrote the performer, rejoicing in her upcoming appearance, but regretting that "an unfavorable dividend action on the part of Socony-Vacuum has sadly reduced our income," and he could spare only $50 for an honorarium. The vicissitudes of the stock market continued to directly affect the Folger's fortunes.

As Locke was performing her *Antony and Cleopatra* program in the Folger Shakespeare Theatre on February 21, 1936, Emily Folger quietly passed away in Glen Cove after many months of heart failure. Her nephew Edward Dimock wrote Florence Locke that Emily's "meeting with you was one of the things which enriched and made happier the last part of her life." Reverend Cadman once again officiated at a Folger funeral.

A second mortuary urn soon occupied the Library reading room alcove, beneath a replica of the Shakespeare bust in Stratford-upon-Avon. The tablet reads:

Henry Clay Folger
June 18, 1857–June 11, 1930

Emily Clara Jordan Folger
May 15, 1858–Feb. 21, 1936

To the Glory of William Shakespeare and the Greater Glory of God.

Emily's 1935 will left $50,000 to her sister Mary Augusta, $25,000 each to nieces and nephews, and $10,000 to Vassar College. The remainder of the document was similar to Henry's in language and in spirit; it reproduced the key articles in his 1927 will regarding the creation, maintenance, and endowment of a library. She clarified that she wanted her property to be administered as a unit with her husband's residual estate. In their approach to death, as well as to life, Emily and Henry Folger shared a common vision that never altered over nearly forty-five years of marriage.

❦ ❦ ❦

Praise in the Eyes of Posterity

The Folger after the Folgers

When wasteful war shall statues overturn,

And broils root out the work of masonry,

Nor Mars his sword nor war's quick fire shall burn

The living record of your memory.

'Gainst death and all oblivious enmity

Shall you pace forth; your praise shall still find room

Even in the eyes of all posterity

That wear this world out to the ending doom.

Sonnet 55.5–12

FOLGER LIBRARY DOORS officially opened for readers on January 2, 1933. Prior to that date, the library allowed a few individuals to consult specific works. The first recorded early bird, in September 1932, did not travel far. Herbert Putnam sent young Oliver Strunk of the Music Division at the Library of Congress across the street to the Folger. Strunk subsequently became chief of the Music Division at the Library of Congress and authored a treatise on early musical notation. In due time, the Folger asked Strunk's curator of the Stradivarius collection, Dr. Henry B. Wilkins, to serve as its honorary curator of rare musical instruments. He regularly inspected the Folger's ancient instruments and storage conditions and evaluated need for their repair.

Another early bird, Professor Ernst Heinrich Mensel of Smith College, analyzed the unique copy of the first German translation of *Romeo and Juliet* (1748). Award-winning author Clara Longworth, Comtesse de Chambrun, consulted several books in the Shakespeare collection, which led to her book *Two Loves I Have: The Romance of William Shakespeare*. Professor James G. McManaway of Johns Hopkins University visited the library. Subsequently hired on a permanent basis, the textual scholar, bibliographer, and classroom teacher served, for a spell, as acting Folger director, all the while producing numerous publications. "Mac" was beloved by young scholars,

whom he mentored with enthusiasm and patience. He was instrumental in putting order into the Folger archives.

Also before the arrival of the first official reader, two gentlemen presented themselves with persuasive arguments as to why they should be able to access the collection: George Winchester Stone Jr. and Seymour de Ricci. "Win" Stone was a teaching fellow at George Washington University while working on a PhD at Harvard under Professor David M. Little, who had his sights set on editing David Garrick's letters. He knew Henry Folger had been an avid collector of Garrick letters and was eager to get his hands on them. However, no one had yet discovered where in the collection the letters had been stashed, much less examined them. Recognizing an opportunity, Folger director Joseph Quincy Adams hired Win as a temporary staff member. Stone found a goldmine. He produced a book on David Garrick's journal. Then he teamed up with George M. Kahrl to write the (fourteenth) biography of Garrick, the first one to benefit from the immensely rich Folger resources.

The bibliographer Seymour de Ricci arrived from France with a recommendation from Herbert Putnam and a grant from the General Education Board. Equally brilliant in French and English, de Ricci was compiling with W. J. Wilson a *Census of Medieval and Renaissance Manuscripts in the United States and Canada*. He, too, struck gold at the Folger. In 1936, the first volume of his *Census* appeared, devoting 183 pages to manuscripts he had found in the library. In contrast, he covered the manuscript collection of the Huntington Library in 111 pages, and that of the Library of Congress in 87 pages. De Ricci's admiration of Folger's book-collecting success in the American and European marketplace led him to sing the praises of the Folger to scholars abroad.

When the reading room finally did open, on January 2, 1933, its first bona fide reader was B. Roland Lewis from the University of Utah. Unlike most, this Shakespeare scholar had conducted a multiyear correspondence with Henry Folger. His first optimistic letter in 1925 asked if he could spend an hour or so looking around the collector's library, for which he received a polite letter of apology, explaining that the documents were locked up in storage. Lewis wrote Folger again in 1928. After a third request, Folger responded with an edge of exasperation. "I am overwhelmed with letters of inquiry, and if I stop in my regular planning for the future to answer these I will be able to do nothing else."[1] Lewis's persistence and patience finally found their reward. As a library reader he at last could savor the literary treasures he had longed to study. He successfully undertook to reprint the major Shakespeare documents. Less than a decade later, Stanford University Press published two large folio volumes entitled *The Shakespeare Documents: Facsimiles, Transliterations, Translations & Commentary.*

Edwin "Eddie" Willoughby also applied for a reader's card the first year. An eccentric and controversial fellow, Willoughby lived in a room at the Dodge Hotel near Union Station.[2] He had earned his doctorate in Library Science at the University of Chicago. After a two-year fellowship at the British Museum, he authored a book on the printing and publishing of Shakespeare's *First Folio*. Recognizing Willoughby's scholarship, Adams hired him as chief bibliographer, and in 1935 put him in charge of producing the library's first catalog of the book collection. Willoughby started with the *Short-Title Catalogue of Books Printed in England, Scotland, and Ireland from 1475 to 1640 (STC)*. Considering the Library of Congress classification system unsuitable for some of the Folger's specialized holdings—with the unwieldy length of call numbers they would require—he devised a modified Dewey Decimal system of classification. Once the library adopted this system, it marketed it at a modest cost to other institutions, such as the University of Pennsylvania. During the directorship of Louis B. Wright in the late 1940s, however, the library shed Willoughby's classification system and adopted that of the Library of Congress.[3] Willoughby continued his own scholarly work and, with over a dozen books and many articles in American and British journals, added considerably to the Folger name.

Another key player in the library's early evolution was Shakespearean collector, Henry N. Paul of Philadelphia, who first visited the Folger in 1936. A patent lawyer, he served as dean of the Shakespeare Society of Philadelphia, a position the Folgers' close friend Horace Howard Furness had held earlier. Working alongside Giles Dawson, Paul started developing a bibliography of Shakespeare editions in English from 1700 to 1864. In doing so, he realized that he possessed as many as two thousand Shakespeare volumes that did not lie on Folger shelves. Paul offered them to the library over a multiyear schedule of bequests, a magnanimous gesture that encouraged efforts by the Folger under Adams to seek out and obtain hundreds of rare and obscure editions while they were still available on the European market at reasonable prices. Just as the Folgers had planned and hoped, the Folger Library was increasing its literary holdings, attracting readers and visitors, and gaining a solid reputation among Elizabethan-Jacobean scholars as a research institution that possessed important and unique resources.

In 1936, Amherst trustees approved two Folger fellowships, the first of many to come. One recipient was British scholar R. C. Bald. He gathered material for books and articles, and later went on to lecture in England, Australia, and South Africa. Professor Elkin C. Wilson, who taught at Northwestern and the University of Mississippi, received the second fellowship. He wrote on the idealization of Queen Elizabeth in the poetry of her reign.

Folger reference librarian Giles Dawson examines a volume among the nine thousand purchased from the Sir Leicester Harmsworth Library, 1939. *Library of Congress*

In 1937, Adams notified Amherst president Stanley King that Sir Leicester Harmsworth's library in Bexhill, East Sussex, was for sale.[4] A virtue of the large collection of sixteenth and seventeenth century books was that it contained few duplicates with holdings at the Folger. Initially King wondered how the college could "find the funds to make such a substantial purchase."[5] Adams dispatched McManaway to London, where he was able to have the collection split into two parts for the sale, where Folger interests were in the pre-1640 books. Adams sent Willoughby to examine the books on site and inquire about the Folger's chances to acquire them. With associate Supreme Court justice—and Amherst trustee—Harlan Fiske Stone giving legal advice throughout the long process, Amherst beat out Harvard in proposing purchase terms that the Harmsworth family accepted in 1939.[6] This addition to the Folger included 9,000 of the 26,143 items published between 1475 and 1640 listed in the *STC.*[7] *Publishers' Weekly* called it "the outstanding bibliographic event of the season in America and Europe, both in magnitude and in importance of rarities."[8] This single purchase transformed the largely Shakespearean nature of the Folger collection to one that embraced almost all aspects of the English-speaking world in

the sixteenth and seventeenth centuries. Adams added to the Exhibition Hall cases popular Harmsworth items on early English voyages of discovery to America and on the settlement of Virginia. In the 1950s, the Folger would purchase three thousand more items from the Harmsworth Trust.

Perhaps because of the large Harmsworth acquisition, in 1939 director Adams was feeling the need for more space in the library. Only seven years after completion, such a consideration may have seemed premature. However, delighted with the original library design, Adams wanted no one but Paul Cret to design any future addition and made the suggestion to him.[9] Adams explained that he had no authority yet to commission Cret but that he wanted the architect to make "tentative sketches" of an extension toward the back (south).[10] Adams sounded out Amherst College president Stanley King on the idea. Before the end of the year, King wrote Cret directly: "the trustees have authorized you to prepare what are called preliminary studies."[11] A Cret extension to the Folger Library never happened. Although ill, Cret continued to design projects all over the east coast until his death in 1945. The major addition would wait forty years.

The year 1940 marked another milestone for the Folger Library. Referring to Hazelton Spencer's *The Art and Life of William Shakespeare*, a British reviewer admitted that "an important book on Shakespeare, with a wide inquiry and synthesis, has been prepared and published without any debt to the great English libraries."[12] In his preface, Spencer noted "matchless resources and brilliant staff" of the Folger Shakespeare Library.

Adams advanced even further while balancing administrative supervision with Elizabethan scholarship. During his tenure from 1934 to 1946, the Modern Language Association of America appointed him general editor of the New Variorum Edition of Shakespeare series, which brought a lot of visibility to the library. Adams produced his own edition of *King Lear*. He wrote the introduction to the facsimile copy of the Folger's unique *Titus Andronicus* (1594) that the *Modern Language Review* of Cambridge, England declared "a publication of the highest scholarly interest, as well as of general interest." Adams gave advice to many graduate students on their doctoral dissertations. He even delivered radio talks on the library for NBC.

By 1940 the exhibition hall had drawn a million visitors. Nine glass-topped cases lining the north wall held temporary displays; another five were for permanent display of some of the library's most exciting possessions. They included books related to Shakespeare, as well as context items: Edwin Booth's costume in *Richard III*, an Elizabethan lute, and Queen Elizabeth's corset, which arrived with a pedigree. The latter created a sensation. *National Geographic* heard about the corset and obtained Adams's permission to take a picture of it. Dawson carried the precious

undergarment to a photographic studio, where a model squeezed into the twenty-inch waist. Dawson sent a color transparency of the corset to the curator of fabrics at the Victoria and Albert Museum for his opinion on the item's authenticity. The linen two-piece corset trimmed in morocco red leather could not have been made before 1725, came the response because it was made with whale-bone stiffening.[13] The misattributed article was quietly removed from the display case where it had been ogled for years. Plimpton, the underbidder to Folger for the undergarment purchase from the Monmartre Gallery in London, may have saved himself some embarrassment.

In less than a decade since its opening, researchers were assembling plenty of evidence that the Folger Library had become a star in the galaxy of Shakespeare centers. Henrietta Bartlett published *A Census of Shakespeare's Plays in Quarto, 1594–1709*, in 1939, recording all existing quartos in public and private libraries throughout the world. When the tally was in, the Folger Library possessed 205, the Huntington 125, the British Museum 101, and the Bodleian 77.[14]

Amherst College was proving to be a vigorous asset to the library's managerial staff in facilitating key acquisitions. Trustee George A. Plimpton seconded Stanley King in this role. At a New York auction, Plimpton helped the library acquire two miniature oil paintings of King James and his Queen, Anne of Denmark, in their original gold frames. Harlan Fiske Stone saw to it that local newspapers gave publicity to the Folger when it displayed Emerson's copy of Shakespeare. He hoped the good press would induce other gifts. Mrs. Stone was instrumental in procuring an early sixteenth-century tapestry to hang over the giant fireplace in the reading room.[15]

The library developed in ways the founders had not planned. When Henry Folger requested that a fireplace be installed in the reading room and in the founders' room, he was picturing the warm atmosphere of a private home where he would receive a handful of Shakespeare scholars as his personal guests. Henry never occupied the Library. While Folger insisted that the memorial institution was to be a library and not a museum, the word "museum" crept into the vocabulary when Folger staff referred to the contents of display cases and wall adornments in the exhibition hall. "The museum of the Folger Shakespeare Library is designed mainly to serve the steady stream of visitors pouring into the nation's capital from all sections of the country."[16]

These were major developments in the library's evolution. The Folgers would have been delighted to see how the library grew, from a Shakespearean mecca to a treasure house holding major collections of other Renaissance books, manuscripts, and works of art. Director Adams faithfully followed their forty years of shrewd buying by fourteen years of zealous complementing and enhancing the collections

the Folgers had begun. His scholarship and knowledge led American colleges to ask him to recommend promising Elizabethan scholars to fill vacancies in English departments, evidence that the growing renown of the Folger Library was attracting younger scholars to make a name for themselves through research and publication.

Around the library, Capitol Hill was transforming. In 1932 the cornerstone for the Supreme Court building was laid diagonally across from the Folger toward the Capitol. Then, in 1936, directly across the street, the Lutheran Church of the Reformation was erected. Coming upon the Folger for the first time, author Paul Collins recently wrote, "If geography is any indication, then the Folger Library is the fourth branch of American government."[17]

Scholars living in or coming to Washington could avail themselves of the vast resources of the Library of Congress across the street from the Folger. They could examine the library of the U.S. Department of Agriculture, with its nearly complete collection of sixteenth and seventeenth century herbals and books on gardening. Libraries of Georgetown University and Catholic University housed their own special collections, offering advantages for scholarly research. The Folger had established its respected place, a well-equipped and handsome library in a stimulating atmosphere. Henry and Emily Folger, the meticulous, determined, consistent, and relentless collectors and institution-builders, created a lasting legacy in the nation's capital that radiates to distant peoples and lands.

The warring European powers in the late 1930s sent ripples to the seat of the American government. At the same time, a project was floated to build a public park across from the Folger Library dedicated to Justice Oliver Wendell Holmes. Planners conceived of bombproof vaults under the park and held talks with the Folger management about including some library treasures in it.[18] The project came to naught.

The attack on Pearl Harbor further focused Amherst College and the Folger Library on an emergency protection plan. By January 1942, four hundred cases containing the most valuable thirty thousand Shakespeare treasures from the Folger vaults were secretly moved to the basement of Converse Library at Amherst College in a private Railway Express Company car with armed guard. In November 1944, the volumes were returned to the Folger.[19] Only a handful of people knew the objects had been removed and returned.

The new Folger administration under director Louis B. Wright in 1948 introduced unaccustomed informality. Following the "Dr. Adams" or "Professor Adams," the first staff meeting started out with "Call me Louis."[20] The longest-serving Folger director to date, Louis is also the only one who has written up his tenure in book form.[21] In the preface to the compilation of his newsletters over twenty years, he explains that while his predecessor concentrated on new acquisitions, Louis

received instructions from the Amherst trustees to make the library a more modern and welcoming research institution. He installed a central air-conditioning system, earning profuse praise from staff and readers who had been long sufferers of Washington's humid summers. Louis found lighting in the reading room "ecclesiastically dim," due to the handsome but ineffective pewter lamps with parchment shades, and replaced them with modern table lamps.[22] He removed the eighteenth- and nineteenth-century editions of Shakespeare from the reading room and replaced them with reference works more useful to most readers. He considered one of his more important legacies establishing a useable working catalog for public use. Louis introduced the Folger's General Reader's Shakespeare series, paperback editions with notes and illustrations.

Amherst College wanted to showcase its Dramatic Society, called the Amherst Masquers, and conceived of the idea of putting on a Shakespeare play at the Folger. The successor company to the Standard Oil Company of New York, of which Henry Folger had been president, sponsored the first nationally televised full-length performance of a Shakespeare play.[23] It also marked the first time the Folger Elizabethan Theatre, inaugurated seventeen years earlier, was used to stage a complete play. The Masquers, in Renaissance costumes, performed *Julius Caesar* on April 3, 1949. The Socony-Vacuum Oil Company funded NBC to offer fourteen cities the mass viewing. The telecast begins with rapid shots of East Capitol Street and pans from the Capitol past the Library of Congress to the Folger Library exterior. A shot of the Folgers' collection of Shakespeare's First Folios on their shelves in the vault is shown, then the title page to *Julius Caesar*. The first and last image on the black-and-white telecast is the Flying Red Horse, Socony's logo. Some say that Emily Folger came up with the Flying Horse as a symbol for Socony, but no evidence has been found. The telecast on 16mm film included commentary at intermission by Louis Wright and Charles W. Cole, president of Amherst College.

On November 28, 1965, a group from the Amherst Masquers performed extracts from *Twelfth Night* in a comic evening in the Folger Theatre entitled "The Gulling of Malvolio." Members of the government and diplomatic community were invited to the black-tie event, organized by the library in connection with an Amherst trustees meeting. Several minutes into the program, the actors wondered why they were getting few laughs. Then they heard a tremendous guffaw from the Nigerian ambassador, resplendent in his colorful robes, sitting in the first row. The hall suddenly became alive with laughter for the rest of the evening. Playing Malvolio, Brett Prentiss was in the wings, in his nightshirt and adjusting his nightcap. He lit a candle and prepared to walk on stage. He felt a tap on his shoulder. "What are you doing with that candle?" asked the fire marshal. "I'm expected on stage with it

right now." "If you go on, I will ban any further performances of the play." "That's all right, Sir, it's a one-night stand."[24] The Folger Theater was not yet certified with the District of Columbia fire authorities. But a milestone had been reached: a candle had been lit. The 1949 production contained the simplest of sets, a table and a chair used in multiple scenes. On the table stood a candlestick. The candle was unlit.

Scholar, poet, and teacher Osborne Bennett Hardison Jr. became Folger director in 1969. Eschewing the house on 2915 Foxhall Road in Wesley Heights that Amherst College had purchased for the library director, he moved his family to 18 3rd Street SE, across from the Folger. "We wanted to be part of the Folger," recalled his wife, Marifrancis Hardison.[25] He initiated a flurry of activities in both the public and academic realm. His predecessor had not developed programs for the theater, writing, "If we used the auditorium for plays, we could not operate a research library. Within our limited space, the two operations are mutually exclusive. For example, any noise on the stage is transmitted through ventilating ducts to the reading room."[26] Hardison vowed to establish a working theater.

O. B.—the only name he went by—had all the wood in the theater, much of which was waxed oak, treated with flame-proofing chemicals. These precautions taken, in April 1970 the fire marshal issued a permit to operate a public theater. In its first season, 110 subscribers signed up to fill the small theater of 260 seats. Twelve thousand spectators attended performances of the Folger Theatre Group, a professional repertory company.

O. B. started in 1970 the Folger Institute, the library's academic consortium of member universities that organizes seminars and colloquia for advanced scholars. It now boasts over forty member institutions. The National Endowment for the Humanities funded institute educators to learn new ways of teaching Shakespeare in college classrooms. O. B. initiated the Folger Poetry Series in 1970. The docent program began in 1970 with thirteen trained volunteers. In 1972 the DC School Project started, where the Folger worked with the District of Columbia school system to develop and test materials to teach Shakespeare to inner-city pupils. The first Acquisitions Night was held in 1973, showcasing in the reading room a wide variety of library purchases during the preceding year.[27] In 1986 the program added an adoption feature. O. B. introduced a Friends of the Folger program in 1971, with the first development office opening in 1973. The original endowment by the Folgers of $10 million might have been sufficient for a small research library. The Folger was becoming a major cultural institution in Washington, branching out in many new and unforeseen directions. Folger's first capital campaign took place in 1996.

A program begun in 1958 to purchase properties across the street from the library on 3rd Street SE ended in 1972. The five buildings house readers, fellows, seminar

participants, visiting curators, actors, and musicians coming from out of town to perform or conduct research at the Folger. In 1972, the Andrew W. Mellon Foundation of New York established the Andrew W. Mellon Fund at the Folger in support of scholarly activities. The *Shakespeare Quarterly*, the preeminent American journal of Shakespeare studies, was founded in 1950 by the Shakespeare Association of America. The journal is published by the Johns Hopkins University Press and has been produced by the Folger since 1973. A grant from the Rockefeller Foundation in 1975 launched the Folger Film Archive. The Folger Consort, an early music ensemble in residence, founded in 1977, performs music from the medieval to the Baroque and occasionally new music composed for old instruments. Thirty-six years later the consort still includes two founding members. O. B. enjoyed thinking up projects for Folger staff. One was to contact nephews and nieces of Henry Folger and gather their memories of the collectors, the fruits of which have been used in the present book. He set the example by traveling to New York City during his first year in office to interview one of Emily's nephews.

By the middle 1970s, Folger facilities had become too small for both staff and reader needs. In addition, humidity in the stacks had reached unacceptably high levels. The Folger turned to a Washington firm, Hartman-Cox Architects in 1977 to design an $8 million renovation.[28] Major objectives were to introduce modern climate control and build a two-story underground vault and a second reading room serviced by the same circulation desk as the first. The American Institute of Architects bestowed on the architects an Honor Award for having "created a dignified space that blends well with the original building yet has a thoroughly modern identity of its own." Doubling reader space, the addition used natural lighting under a ceiling of white plaster. Stone moldings recalled the decorative style of the library's entrance halls. Many library services closed for two years during construction; however, the Rare Book Room at the Library of Congress across the street agreed to keep a reserve shelf stocked with some Folger works for readers.[29] Folger staff concentrated on outreach to the community, including elementary and secondary teacher workshops and a high school fellowship program. The Folger dedicated the new reading room on April 23, 1982, Shakespeare's birthday and the semicentennial of the library, as the Theodora Sedgwick Bond-William Ross Bond Memorial Reading Room. From a literary family, Mrs. Bond was a charter member of the Friends of the Folger; her husband, General William Ross Bond, had died on active duty in Vietnam in 1970.[30]

The Folger founded the Children's Shakespeare Festival in 1980 and the Secondary School Shakespeare Festival the following year. Hundreds of children, parents, and teachers come together as costumed youngsters act out scenes on stage. The

Folger established its first mission statement in 1982, revised during strategic planning reviews.

The library celebrated its fiftieth anniversary in April 1982 with a reception at the White House, where President Reagan observed, "Henry and Emily Folger's gift of 50 years ago is today a priceless treasure which must be preserved and enlarged, as the inheritance of Americans, in generations to come." Departing from prepared remarks, the thespian president then added for the Folger audience a little-known detail from his biography, "I played in *Taming of the Shrew* done in modern costume, and my wardrobe was plus four knickers."[31]

The Folger has organized exhibitions curated on site since 1964. A traveling exhibit in 1982, *Shakespeare: the Globe and the World*, toured eight cities, reaching nearly one million people.[32] The Folger sales office accompanied the exhibit, selling heraldic banners and wooden flutes, among other Renaissance items.[33] The exhibit *Manifold Greatness: The Creation and Afterlife of the King James Bible* was on view in 2011–2012 at three sites: the Bodleian Library in Oxford, England; the Harry Ransom Center in Austin, Texas; and the Folger.[34] A panel version—without rare materials—traveled to forty sites around the United States, reaching twenty-seven states. The PEN/Faulkner Award for Fiction offices moved to the Folger Library from University of Virginia in 1983. The annual award honors the most distinguished book of fiction published by an American writer.

Renaissance scholar Werner Gundersheimer came in 1984 to direct the Folger. During his tenure, he encouraged a major expansion of the Folger's educational programs for students and teachers. The National Endowment for the Humanities funded a Teaching Shakespeare Institute, a summer program for high-school teachers. In addition to fund-raising and major capital campaigns, Werner strengthened the core functions of cataloging and acquisitions, reinvigorated the fellowship program, and placed a new emphasis on exhibitions as both scholarly endeavors and public outreach. The PEN/Faulkner Award for Fiction, organized at the Folger since 1983, and new Folger Poetry Board readings marked a growing involvement with contemporary writers. As the Folger Theatre celebrated its fifteenth anniversary year, the press called its November 1984 production of *King Lear* "majestic and mesmerizing." Mayor Marion Barry set aside December 12, 1984, as Folger Theatre Day.

"The board decided to kill the theater," Ken Bacon, former Amherst College trustee, remembered, evoking a weekend meeting of the trustees' Folger Committee in New York mid-January 1985.[35] The library had invested nearly $2 million in the theater and was expecting to lose at least $200,000 during the season.[36] "It wasn't an easy decision, but it had to be made," said trustee Charles Longsworth, head of

a four-month fiscal study.[37] The news hit the nation's capital like a bombshell on Monday, January 14, 1985. *Washington Post* staff writer David Richards dropped the story he was writing for the style section and took off to interview Folger personnel who had alerted him to the situation. He had copy ready for the afternoon editors' news conference. Tuesday morning he discovered his scoop made the front page.

Where in the world is Amherst College? stunned Washingtonians asked each other. What do they have to do with the Folger? As legal stewards of the Folger Library and close observers of its bottom line, the Amherst trustees considered the Folger Theatre Group an extravagant drag on the rest of the library. There was resentment inside the theater, and outrage spread to the Capitol, where Senator Daniel Patrick Moynihan declared, "The Bard belongs not just on library shelves but on a living stage."[38] The D.C. City Council passed a resolution urging the Amherst trustees to reconsider. With acrimony in the air, the library agreed with the college about the need to put its fiscal house in order but wanted to find a way to keep the theater open. Without disruption of the theater schedule, the Folger Theatre Group was discontinued and then reincorporated as the Shakespeare Theatre at the Folger, an independent nonprofit organization with support from the library. In 1991, under the artistic directorship of Michael Kahn, the former company at the Folger set itself up as the Shakespeare Theater Company and now performs in the much larger Lansburgh Theater in Washington's Penn quarter. They also perform in the still larger Sidney Harman Theater nearby.

This critical incident in the Folger Theater's history—manmade, one could say, rather than in Shakespeare's day when theaters were closed due to the plague—brought out the divergence of views on the library's prime objective. Amid the groundswell of furor over the theater's possible closing, vocal citizens pointed out that while in a given year 1,200 scholars, all specialists with advanced degrees, used the reading rooms for research, as many as sixty thousand theater lovers bought tickets to see five plays a season. In the 1980s there were not the number of city theaters there are today. However, Folger had given instructions to his architect, "After all, our enterprise is primarily a Library, and all other features are supplemental."[39] The first three Folger directors used the space for occasional lectures and conferences, as an "integral part of our permanent exhibition gallery."[40] The Folger Theatre began its life four decades after Henry Folger died and after having been virtually unused. What was key to the Amherst trustees as administrators and to the library as executors had collided with the desires of a culture-hungry capital city. After the incident and the split, Washington had not one but two Shakespeare and classical theaters, both of which have thrived and put on award-winning productions.

Since 1991, the Folger Theatre has garnered 116 nominations and 20 Helen Hayes

Awards for excellence in acting, direction, design, and production. Each year, the generic Renaissance theater welcomes the public to three major plays, generally two of which are Shakespeare. Directors and actors praise the intimacy and immediacy the small space and limited seating create. The Folger has co-produced plays with the Classical Theatre of Harlem and the Two River Theater Company, as well as cross-disciplinary projects with the Folger Consort. It collaborates with the Folger education department to present programs for students and teachers. According to a 2012 press report that analyzed attendance in the major theater venues in the District of Columbia region, the Folger ranks among the highest of area theaters in percentage capacity attendance.[41]

The first visit to the Folger by a reigning British monarch occurred on May 16, 1991, during Queen Elizabeth II's state visit to Washington. Fascinated by the exhibit on royal autographs, where she examined original papers signed by Queen Elizabeth I that Henry Folger had acquired, the queen commented to the Folger director that her first name could seem quite long when signing many official documents. Next she sat in the theater watching Children's Shakespeare Festival participants playing scenes from *The Taming of the Shrew*. She ascended the steps onto the stage and sat down with elementary and middle school pupils clustered around her. "That was quite lovely, wasn't it?" she shared with ten-year-old Alex Jadin on her left. "Yes, it was, Your Majesty," agreed the fourth grader, dressed as servant to Petruchio.

The first volume of the Folger Library Shakespeare Editions was published in 1992. In 2010, the series, edited by Barbara Mowat and Paul Werstine, finished with forty volumes of thirty-eight plays, as well as the poems and sonnets. Updates and revisions continue. The compact and inexpensive books are the most widely used Shakespeare texts in the country. They are available as PDFs, and the most popular five plays have been produced as ePub texts for iPad. Digital texts of twelve of the most popular plays have also been launched, and are available for free on the web. The library started a blog entitled "Making a Scene."

The Folger Library has been the setting for a murder mystery novel and the scene of a nonfiction theft.[42] In 1994, Fox TV's *America's Most Wanted* featured the story of a University of Cambridge PhD who stole and later sold rare documents from the Folger in 1992. Cooperation among Metropolitan Police, the FBI, and alert Folger staff resulted in Stuart L. Adelman's being arrested, and later tried and sentenced to a jail term. Items stolen from the Folger were recovered.

The Folger has opened its doors to undergraduate researchers. The first arrived from Amherst College in 1996, and they have continued to come every year since. Their chosen subjects of inquiry have included Pindaric odes, the sonnet tradition, recusant music theory of the seventeenth century, early English grammar books,

theater and performance history, as well as study of Shakespeare, Milton, Donne, and Dryden. Since 2006, undergraduates from Washington-area universities have attended research seminars at the Folger.

In the mid-1990s, the Department of Education gave a grant for cataloging and conservation. The Mellon Foundation funded long-term fellowships and conversion of the library's bibliographic records into electronic form. The Folger had first direct access to the Internet in 1995, and set up a Web site the following year. The Folger called its online catalog HAMNET, after Shakespeare's only son, who died in 1596 at age eleven. Four hundred years later, in 1996, HAMNET became available to staff and readers; public access was established in 2000.

During two weekends in 1997, fifty staff, readers, and volunteers applied ninety thousand barcode labels to any book in the collection published since 1830. These books are considered "modern." No First Folio bears a barcode. However, the Hinman facsimile of the First Folio received the honor of receiving barcode number 1. In 2000, 301 East Capitol Street (across 3rd Street SE) became the Wyatt R. and Susan N. Haskell Center for Education and Public Programs, in a new structure designed by Andrew K. Stevenson.

A beloved Shakespeare figure on the Folger premises has always been the white marble statue of Puck, with its caption "Lord, what fooles these mortals be!" from *A Midsummer Night's Dream*. Some people like to think that when the "knavish sprite" is pronouncing these words he is gesturing toward the Capitol's inhabitants. The angle of Puck's gaze, however, is rather toward the Library of Congress, where the sculptor Brenda Putnam's father worked. Over the decades, the soft marble selected for the work had begun to erode. But Puck's aging was hastened by neighborhood urchins climbing on the fountain to paint on dark eyeglasses or, worse, to snap off a thumb. The Folger conservation laboratory occasionally had to make repairs.

The new millennium was not good to Puck. On January 1, 2000, Puck's dismembered right hand and wrist were found on the Library of Congress lawn across the street from the fountain. It was time for not only drastic surgery but relocation. With a new arm, Puck took his place safely inside the building at the entrance to the Folger Theater. A sturdy twin aluminum statue made from a wax cast took its place in the west garden, nicely matching the Art Deco aluminum grillwork of the west façade. One day, an elderly gentleman appeared at the Folger. He introduced himself as Peter Gazzola of Rye, New York, who, at age fifteen, had been the model for Puck. Mr. Gazzola and his son made contributions to the library to keep Puck perpetually young.

Shakespeare scholar Gail Kern Paster became Folger director in 2002, two weeks before walls cracked in the dimly lit and cold underground vault and standing water

appeared where the rare collections were stored. The double-membrane waterproofing system had failed. Once again, as during the Second World War, close to thirty thousand Folger treasures were stored in Amherst for safekeeping until the repairs were completed in 2004. State-of-the-art movable compact shelving was installed. Later, a serious fire that started in the theater costume rooms caused substantial water damage—but not to the books—leading to a complete review of all fire-safety procedures.

First Folio expert Donald Farren delved into the human-interest aspect of the Folgers in the exhibit he guest curated in 2002, *A Shared Passion: Henry Clay Folger, Jr., and Emily Jordan Folger as Collectors.* He brought out diverse documents and objects from the Folger collection, focusing on the techniques the couple used and the taste that guided them in their collecting. The Folger celebrated the four hundredth anniversary of the reign of Queen Elizabeth I with public programs in 2003.

Emily Folger had shown a great interest in getting an Elizabethan Garden off to a start on the east side of the library. She planted four magnolia in 1932 that now are higher than the library itself. Dedicated docents have raised funds for the garden and maintained and added to the plantings. Around the central raised knot garden lie herbal varieties mentioned in Shakespeare or existing in his time: English ivy, lavender, rosemary, creeping thyme, chamomile, hellebore, pinks, and white rose of York. Shakespearean statues designed by American sculptor Greg Wyatt were added to the grounds in 2004.

The first legal changes to take place since the library's founding involved its administration. "By the bequest of the late Henry Clay Folger the ownership in trust of the Folger Shakespeare Library in Washington is vested in the trustees of Amherst College."[43] The trust stipulates a three-part responsibility: proper care and use of the collection, maintenance of the library building, and management of the Folger endowment. The Folger library committee was made up of Amherst College trustees, with Dwight Morrow its first chairman and Calvin Coolidge its second. The Amherst trustees thus managed two entities, Amherst College and the Folger Shakespeare Library; the college's annual financial report covers both institutions. When the trustees took stock of the arrangement in 2005, they determined that it made little sense to have the college trustees manage so closely an entity 340 miles away. It was time for a more direct presence in Washington, which would offer several advantages, one being more opportunities for engagement with the Washington community. With the Folger committee of the Amherst board receptive to a more independent relationship, the trustees delegated revocable management authority of the Folger, except for management of the endowment, to a quasi-autonomous Folger Library Board of Governors to replace the Amherst trustees' committee. The

first board of governors chair was Karen Hastie Williams, then a member of the Amherst board. She was succeeded by Paul Ruxin, an Amherst alumnus, but not an Amherst trustee. The Amherst board continues to control the library's financial assets, and is represented on the board of governors by at least two members ex officio at all times. The two boards meet together once every other year in Washington but otherwise meet separately.

The patron of the Royal Shakespeare Company, Prince Charles, paid a visit to the Folger in 2005. He learned that the Folger was a community of scholars, and with a newly created division of education was reaching out to the community with the slogan, "Shakespeare is for all." The two-thousand-square-foot Werner Gundersheimer Conservation Laboratory opened in 2006. With state-of-the-art equipment and consummate skill, staff repair ancient tattered-and-torn items in the collection and design exhibits to preserve them for future generations. A major aim is to prevent further deterioration of an object. Sometimes conservators will undo a harmful repair in the past. They will create custom housing for a delicate item. The Folger created one of the first advanced conservation internship programs in the country.

During the seventy-fifth anniversary year of 2007, the north façade of the Folger was decorated by large, colorful banners proclaiming each of the major activities within: research, conservation, theater, readings, student festivals, music, and books. The library produced a DVD, *Love's Labor: How Henry and Emily Folger Built a Library*, which won first place for arts/cultural films at the Worldfest-Houston International Film Festival, and a handsome volume edited by Esther Ferington, *Infinite Variety: Exploring the Folger Shakespeare Library*. This rich reference declares that the Folger was the third-largest repository in the world for the books listed in the *STC*.[44] The Folger produced an anniversary public radio documentary, *Shakespeare in American Life*, in conjunction with an exhibition. Aiming at a general audience, it also launched the *Folger Magazine*, successor to the *Folger Library Newsletter* (1969–1987) and *Folger News* (1987–2006).

Given its value in both monetary and cultural terms, Shakespeare's First Folio has attracted a few thieves. In 2010, Raymond Scott was sentenced to eight years for handling and exporting stolen goods and taking a seventeenth-century book out of the UK, namely the University of Durham First Folio, reported missing a decade earlier. The Brit was doing time in a Northumberland jail, where he applied for (and got) a job as librarian, before committing suicide.

The Folger docent corps has expanded from thirteen to seventy trained guides. One told the author, "Oh, it's the best! So many volunteers like it here because you can develop your mind." Tours center on the theater and the exhibits, allowing visitors to get a feeling for the institution and the collection. Docents are involved

in activities such as the elementary and secondary school festivals and Shakespeare's Birthday at the Folger. They accommodate annually fifteen thousand visitors and over fifty school tours. After viewing the 2010 exhibition on Henry VIII, a visitor wrote in the guest book, "*Vivat Rex* was so so so so so COOL AS ICE."

In 2011, the library logged in close to eight hundred readers. Scholars from twenty-five countries used the resources in the library to research their articles, editions, and books or put together their courses. A visitor to the library would see as many as seventy-five researchers in the reading rooms at peak periods, with four seminars going on concurrently. Staff responded to one thousand reference queries. Folger's Education Office partnered with Alabama Public Television to allow 320,000 students to interact with the library in real time on the Web via "electronic field trips." Through a new performance-based teaching program, funded in part by the DC Commission on the Arts and Humanities, the Folger reached pupils grades three through twelve, in an effort to overcome "Shakes-FEAR," unfamiliar language from the Bard's period. Gail liked to tell visitors, "we are the humanities in action." In honor of Gail Kern Paster's leadership for nine years as director of the Folger, and on the occasion of her retirement, the old reading room was renamed the Gail Kern Paster Reading Room.

When Shakespeare scholar Michael Witmore arrived as the seventh Folger Library director in 2011, he rejoiced to find a coordinated team of five experienced scholars on whose intellectual judgment he could count: curator of books, curator of manuscripts, head of acquisitions, head of reference, and curator of art and special collections. Not a common position in a library, the latter specializes in visual culture across a wide spectrum, including selection of images used in the Folger exhibitions. Bringing with him a passion for using digital technology for literary analysis, Mike added to this team the library's first director of digital access, who is applying digital initiatives to all aspects of library operations, expanding the library's existing digital outreach, and developing an infrastructure to establish the Folger as a center for the digital humanities.

The Andrew W. Mellon Foundation had already provided a grant to catalog the Folger's sixty thousand manuscript objects in machine-searchable online bibliographic records. The National Endowment for the Humanities funds the Shakespeare Quartos Archive and Picturing Shakespeare, a searchable database of ten thousand digitized Shakespeare illustrations and a collaboration with five other institutions. The Folger now has a searchable database. Nearly two hundred countries access Folger education Web sites for an annual total of over one million page views. Students and teachers have acquired "nerd bling," a thumb drive filled with half a gigabyte of Shakespeare exercises. In 2013 Folger was selected as host site for a

National Digital Stewardship Residency for institutions engaged in the acquisition, stewardship, and preservation of born-digital materials. Mike likes to say that the Folger is "Word Central" and the library of record for Shakespeare. He wrote, "We are, without question, the single greatest documentary source for the most influential writer in the world."[45] Other of Mike Witmore's early legacies include creating state-of-the-art exhibition space in the Great Hall and safely introducing natural daylight into the hall through double window panes with inert gas between them.

Mike delved into the Folger papers and found an item that revealed the founders' intentions about use of the Cret-designed building. Inside an unprepossessing envelope, slipped in among a pile of letters from Emily, Henry had written with pencil and pen these words, undated.

Research:
4 Fellowships for professors @ 3000 = 12,000
5 " " graduate students @ 1800 = 9,000
1 " " foreign students @ 2200 = 2200
Publications
Additions to Book Funds
Extension:
Lectures
Plays[46]

Adams wrote in an accompanying note in 1931 that he considered this Folger list of "inestimable value." He also shared that he had received the list from Amherst College president, Arthur Stanley Pease. Mike expressed his delight that these plans had not been lost in the shuffle between Amherst and Washington in preparation for the library opening.

> The Folger list has helped me to think about the future of the Library. The purpose of the Library was built into its structure, the Cret building. I look to the building for guidance. Eighty years ago, the Folgers were the only ones with a blank piece of paper. We've indeed developed along the lines Folger outlined: research, publication, acquisitions, and extension through lectures and performance of dramatic works in the Theatre. We have, appropriately, also developed along lines the Folgers could not have imagined. I take guidance from the Folgers' respect for scholarship and the advancement of knowledge, able to co-exist alongside performance and exhibitions aimed at the public. Folger's concept of extension confirms that the great literature of Shakespeare is valid for both the reading public and performance. Mr. Folger's note gives documentary evidence

of the Folger Library's role as a public voice for Shakespeare and the humanities. I take guidance from the Folgers for having located the Library in Washington, DC. They wanted a national institution in an international city; they wanted to play a role on the world stage. The founders' hopes were quite ambitious. It is a challenge to my leadership to think as boldly and decisively as they did. In a single envelope that could well have gone astray, I consider Mr. Folger's plans a message in a bottle from the founder.[47]

In conclusion, as a world-class research institution the Folger has become a beacon in Washington, not only a center for advanced scholarship but a cultural mecca for the nation's capital and its surrounding area. As of 2013, the collection holds 275,000 books, with over half of these rare books.[48] The library holds the largest Shakespeare collection in the world, the largest collection of early British printed books in North America, and copies of half of what was published in England before 1640. It all started with one couple and their vision.

Directors of the Folger Shakespeare Library

William Adams Slade	1932–1934
Joseph Quincy Adams	1934–1946
Louis B. Wright	1948–1968
O. B. Hardison Jr.	1969–1983
Werner Gundersheimer	1984–2002
Gail Kern Paster	2002–2011
Michael Witmore	2011–

Abbreviations

AC	Amherst College
ASC	Archives and Special Collections
B	box
BB	black box
BDE	*Brooklyn Daily Eagle*
CMP	Charles M. Pratt
CR	*Congressional Record*
ECF	Eliza Clark Folger
EJF	Emily Jordan Folger
F	file
FC	Folger Collection
FCF	Folger Case Files, including bookseller correspondence
FLN	*Folger Library News*
FSL	Folger Shakespeare Library, Washington, DC
GPO	Government Printing Office
HCF	Henry Clay Folger
HEH	Henry E. Huntington
HEHL	Henry E. Huntington Library, San Marino, California
HHF	Horace Howard Furness
JDR	John D. Rockefeller
LC	Library of Congress
MAJ	Mary Augusta Jordan
MD	Manuscript Division
MS	manuscript
NHA	Nantucket Historical Association, Nantucket, Massachusetts
NYT	*New York Times*
RAC	Rockefeller Archive Center, Sleepy Hollow, New York
RFA	Rockefeller Family Archives
RG	record group
RM&L	Rosenbach Museum & Library, Philadelphia
SC	Smith College

SOCA Standard Oil Company Archive, Austin, Texas
STC *Short-Title Catalogue of Books Printed in England, Scotland, and Ireland*
UPenn RBML University of Pennsylvania Rare Book & Manuscript Library,
 Philadelphia
VC Vassar College
WSJ *Wall Street Journal*
WP *Washington Post*

Prologue

1. FSL, "Strategic Plan for the Folger Shakespeare Library," June 7, 2013, p. 1. Also see www.folger.edu.

2. FSL FC B62 F "Mr. Folger" - James Aswell, *Standard Star* (New Rochelle, NY), July 6, 1931.

3. FSL FC B15 F National Shakespeare Federation - HCF to Charles Craigie, April 12, 1928.

4. *Newsweek*, February 9, 1948.

5. FSL FC B23 F Shakespeare - HCF to Archibald Flower, June 3, 1926.

6. Wolf & Fleming, 122.

Chapter 1 . *Well Read in Poetry, Fair in Knowledge*

1. James, 400.

2. "Worst American CEOs of All Time," CNBC.com, April 30, 2009, www.cnbc.com /id/30502091; "most hated man in America," from H. Smith, "Change Arrives on Tiptoes at the Frick Mansion," *NYT*, August 28, 2008.

3. FSL FC B27 - Owen Smith to Edgar Rogers, August 5, 1935.

4. Hellman, 16.

5. Folger, n.p.

6. HCF Sr. will, Brooklyn Surrogates Court, Brooklyn, NY.

7. Folger, n.p.

8. FSL FC B25 - HCF Sr. to EJF June 13, 1889.

9. Interview with Emily Smith Carter, September 17, 2010.

10. FSL FC B21 - HCF to Henrietta A. Folger, December 1, 1912.

11. FSL FC B28 - Public School no. 15, Brooklyn.

12. FSL FC B37 - EJF Meridian Club Lecture, 1933.

13. FSL FC B30 - HCF tribute to Charles Pratt, 1903.

14. FSL FC B28 - Adelphi Academy.

15. FSL FC B21 - HCF to ECF, September 22, 1875.

16. FSL FC B21 - HCF, freshman letters home.

17. VC Archives - F Biographical file for Folger, Emily (Jordan).

18. FSL FC B37 - President Lincoln and a Little Girl.

19. FSL FC B32 - letters to James W. Fawcett.

20. FSL FC B36 - EJF scrapbook clipping, vol. 2.

21. FSL FC B34 - EJF scrapbook.
22. FSL FC B32 - HCF scrapbook.
23. FSL FC B29 - HCF essays, 1878.
24. Plimpton, 38.
25. FSL FC B29 - HCF essays, 1878.
26. FSL FCF - HCF to George D. Smith, January 4, 1906.
27. Rosenbach, "HCF as a Collector," 105.
28. FSL FCF - HCF to John Howell, November 23, 1921.
29. FSL FC B38 - EJF's book, Places I have visited.
30. FSL FC B38 - EJF's address book.
31. FSL FC B21 - EJF to HCF poem.
32. FSL FC B21 - HHF to EJF, April 17, 1911.
33. FSL FC B22 - CMP to HCF, September 21, 1919.
34. FSL FC BB13 - Interview with Edward J. Dimock, November 1980.
35. FSL FC B32 - Character study, Fawcett, 1932.
36. FSL FC B30 - HCF's will, December 31, 1907.

Chapter 2 . *Thou Lovest Me, My Name Is Will*

1. Vaughan & Vaughan, *Shakespeare in American Life*, 15.
2. Ibid., 14.
3. Bristol, *Shakespeare's America*, 3.
4. Emerson, *Representative Men*, 201.
5. FSL FC B37 - Meridian Club Lecture, 1933.
6. This *Collected Works* volume is in the FSL collection.
7. FSL FC B37 - Meridian Club Lecture, 1933.
8. FSL FC B39 - HCF to Harris, November 11, 1909.
9. FSL FC B37 - EJF Meridian Club Lecture, 1933.
10. Ibid.
11. Emerson, "Solution," in *Collected*, 412.
12. FSL FC B30 - F Ariel to Caliban.
13. FSL FC B24 - HCF to Ellen Terry, February 21, 1911.
14. FSL FC B27 - J. M. Terry to EJF, December 17, 1914.
15. *New York Herald*, April 26, 1916.
16. FSL FC B37 - EJF Meridian Club Lecture, 1933.
17. Kaplan, *Lincoln*, chap. 2.
18. FSL FC B24 - HCF to Sothern, n.d. [ca. 1910].
19. FSL FC B38 - Plays I have seen: *Antony & Cleopatra*, November 15, 1909.
20. Vaughan & Vaughan, *Shakespeare in American Life*, 172.
21. FSL FC B38 - Plays I have seen, 146.
22. FSL FC - Taped interview with Edward J. Dimock by O. B. Hardison, Folger Shakespeare Library director, February 24, 1970.
23. FSL FC B32 - Character study, Fawcett, 1932.
24. Blayney, 42.

25. FSL FC B35 - HHF to EJF, June 12, 1896.

26. FSL FC B44 - Commonplace book.

27. FSL FC B31 - HCF speech on receiving LLD, 1914.

28. FSL FC B37 - EJF Meridian Club Lecture, 1933.

29. FSL FC B30 - F Ariel to Caliban.

30. The caption "Known as Ye Peacocke Inn in Shakespeare's time, 1613" is written under the label "Golden Lion Hotel" on a picture postcard of the hotel mailed from Stratford-upon-Avon in 1905.

31. FSL FC B23 - HCF to Robinson, January 13, 1913.

32. FSL FC B16 - Mayor of Stratford-upon-Avon to HCF, June 1, 1909.

33 FSL FC B23 - HCF to Flower, May 10, 1929.

34. The New Variorum Shakespeare continues today under the sponsorship of the Modern Language Association of America.

35. Reiss, 68.

36. FSL FC B39 - HCF to Harris, November 6, 1909.

37. FSL FC B62 - *Amherst Student*, October 10, 1929.

38. FSL FC B22 - Plimpton to HCF, March 11, 1908.

39. FSL FC B32 - Cret to Fawcett, October 13, 1932.

Chapter 3 . Wise, Circumspect, and Trusted

1. "Dynamite Bomb for J. D. Archbold," *NYT*, November 22, 1915.

2. Whicher, 8.

3. Hidy & Hidy, 59.

4. RAC RFA, RG1 letterbooks, vol. 189, 297 - JDR to HCF, September 21, 1885.

5. RAC RFA, RG1 business correspondence, B56, F418 - HCF memo no. 4645 to Ambrose McGregor, February 6, 1893.

6. Hidy & Hidy, 658.

7. FSL FC B37 - EJF Meridian Club Lecture, 1933.

8. Whiteshot, 709.

9. FSL FC B25 - Fales to EJF, September 20, 1932.

10. RAC RFA, RG1 letterbooks, vol. 226, 77 - JDR to HCF, February 26, 1909.

11. FSL FC B37 - EJF Meridian Club Lecture, 1933.

12. H. A., "By-the Bye in Wall St.," *WSJ*, October 16, 1931.

13. SOCA, F Folger, H. C., 1911–1985 - Harry B. Tower, "Briefs on HCF Jr."

14. FSL FC B32 - Teagle to Fawcett, n.d.

15. Tarbell, 12.

16. RAC RFA, RG1 letterbooks, vol. 226, 324 - JDR to HCF, April 22, 1909.

17. FSL FC B41 - McClure's; Atwood, 409.

18. FSL FC B22 - CMP to HCF, April 6, 1909.

19. RAC RFA, RG1 letterbooks, vol. 226, 270 - JDR to HCF, April 6, 1909.

20. Atwood, 413.

21. RAC RFA, RG1 letterbooks, vol. 225, 502 - JDR to HCF, February 11, 1909.

22. RAC RFA, RG1 letterbooks, vol. 226, 32 - JDR to HCF, February 18, 1909.

23. RAC RFA, RG1, series L - letterbooks, Code Index.

24. See Singer, *Broken Trusts*; Wallace, *Nine Lives*; Duncan, *An Eye Opener*; and Gray, *Rule of Reason*.

25. *U.S.A., petitioner, v. Standard Oil Company of New Jersey et al., defendants, records and briefs for 221 U.S.1* (1911), 7:101–21.

26. All conversions to 2011 dollars have been made using "Measuring Worth," www .measuringworth.com/ppowerus/.

27. *U.S.A., petitioner, v. Standard Oil*, 1:290.

28. Ibid., 7:3316.

29. As stated in the brief for the government in the breakup case (quoted in Gray, *Rule of Reason*, 43): "It is inconceivable that the Standard Oil Company should make a bona fide sale of [the Corsicana Refinery Company], which was paying large profits, for a price practically little over $400,000, selling it in this informal method to two of its principal officials, and taking pay in a verbal obligation . . . Seller and purchaser alike knew the plant . . . would earn much more than enough to pay for it . . . It is asking much of the credibility of any court to believe that it was [a bona fide transaction]. We believe that the court is justified in holding that *this sale was a fraud* and that the Standard Oil Company controls the Corsicana Refinery Company at the present time, as it admittedly did up to . . . 1906."

30. "Texas Refineries in Deal," *NYT*, October 16, 1912.

31. See, generally, "Ousted Oil Company Back to Old Hands, " *NYT*, October 4, 1912; "Magnolia Oil Bonds Go to Rockefeller," *NYT*, October 5, 1912; and RAC, RFA, RG1, letterbooks, vol. 160, 428 - JDR to HCF, July 28, 1913.

32. RAC RFA, RG1 letterbooks - JDR to HCF July 28, 1913.

33. FSL FC B5 - Cancelled checks.

34. September 17, 1908, incident recounted in Chernow, *Titan*, 549.

35. Howarth, *One Hundred Twenty-Five Years*, 58.

36. Testimony before the subcommittee by HCF on December 22, 1922, in U.S. Senate Committee on Manufactures, 1–70.

37. Strait Settlements referred to British territories in southeast Asia; the Levant referred to the crossroads of western Asia, the eastern Mediterranean, and northeast Africa.

38. *CR*, 69th Congress, 1st session, vol. 67, part 9, Washington, DC, May–June 1926, 10097.

39. Ibid., part 10, Washington, DC, June 1926, 10572.

40. FSL FC B 41 - Standard Oil recognition at HCF retirement.

41. *BDE*, August 29, 1935.

42. FSL FC B32 - George W. McKnight to Fawcett, n.d.

43. FSL FC B32 - Fales to Fawcett, n.d.

44. See Schoenbaum's standard biography of the dramatist, *William Shakespeare* (1977).

45. Built by the Union Iron Works Company, a Bethlehem Steel Company affiliate, and belonging to a former Standard Oil Company of New Jersey subsidiary, the Atlantic Refining Company of Philadelphia, the SS *H. C. Folger* weighed over 10,000 tons. It transported 100,000 barrels of different types of petroleum products distributed in eighteen storage tanks. The *Folger*'s maiden voyage took it from its home port of Philadelphia to London, arriving on February 2, 1917, one day after Germany announced resumption of unrestricted submarine

warfare. German submarines often mined the entrances to British harbors. At one time, a torpedo missed the *Folger* by fifty yards. The *Folger* survived dozens of wartime crossings, mainly to British and French ports. Apart from one wartime newspaper article that Emily Folger filed away, no evidence exists that the Folgers particularly followed the career of the eponymous oil tanker.

Chapter 4 . Leading on to Fortune

1. FSL FC B22 F Palmer - Edmund Horace Fellowes, "The Ways of a Millionnaire," n.d. [1928], clipping from Liverpool newspaper.

2. FSL FC B62 F "Mr. Folger" - James Aswell, writing in the *Standard Star* (New Rochelle, NY), July 6, 1931.

3. All conversions to 2011 dollars have been made using "Measuring Worth," www.measur ingworth.com/ppowerus/.

4. Hidy & Hidy, 615.

5. *U.S.A., petitioner, v. Standard Oil Company of New Jersey et al., defendants, records and briefs for 221 U.S.1* (1911), 18:29.

6. Hidy & Hidy, 633, table 50.

7. Gibb & Knowlton, 37, table 5.

8. "Hear Magnolia Oil Figures," *NYT*, January 6, 1923, 23.

9. "Pays Big Stock Dividend," *NYT*, December 19, 1920.

10. "Standard Oil of N.Y. Gets Magnolia Stock," *NYT*, February 2, 1918, 15.

11. RAC RFA RG1 - HCF to JDR, January 25, 1917.

12. RAC RFA RG1 (JDR Papers) - JDR to E. V. Cary, April 25, 1917.

13. RAC RFA RG1 - JDR to Bertram Cutler, February 4, 1919.

Chapter 5 . The Hunt Is Up, the Fields Are Fragrant

1. FSL FC B33 - HCF will, March 10, 1927.

2. FSL FC BB9 - Slade remarks reported in "Shakespeare Library Dedication Saturday," Worcester, MA, April 17, 1932.

3. Garrick may have been more faithful to the Shakespeare text than his predecessors, but he was not above making changes and even rewriting entire plays (see, e.g., his adaptations of *The Taming of the Shrew* and *The Winter's Tale*).

4. FSL FC B22 - HCF to Robert Bateman, December 12, 1916.

5. Rosenbach, "HCF as a Collector."

6. FSL FCF - HCF to Broadbent, January 11, 1928.

7. FSL FC B21 - HCF to Mrs. W. Seymour Edwards, January 5, 1915.

8. Dawson & Kennedy-Skipton, esp. 7–10; see also Preston & Yeandle.

9. Sherman, chap. 2.

10. Folger purchased Dowland scores from both Quaritch and Rosenbach, admitting to the latter that "Dowland gets into the list simply because his name is mentioned by Shakespeare," FSL FC B1, March 9, 1927.

11. FSL FCF - HCF to Bertram Dobell, November 4, 1927.

12. SC B880 - MAJ correspondence, HCF to MAJ, April 21, 1912.

13. Sandburg, *Lincoln Collector*, 20.

14. FSL FCF - HCF to Oliver Barrett, July 26, 1920.

15. *Shakespeare Association Bulletin* 7, no. 3 (July 1932): 113.

16. FSL FC B5 - HCF to Michelmore & Co., June 1, 1922.

17. *Vassar Quarterly* 17, no. 1 (February 1932): 20–22.

18. FSL FC B37 - EJF Meridian Club Lecture, 1933. Stephen Galbraith in *Foliomania* also initially found the conceit "a strange idea," before realizing that certain portraits, inscriptions, stained-glass windows, and other artifacts in the Library, in fact, relate directly to the First Folio.

19. An early playbill in the Folger collection announced a performance of *Troilus and Cressida* in Little Lincolns-Inn Fields in 1697.

20. See Fletcher, 48–50 and four pages of plates, for information about the earliest British playbills.

21. Folger bought his largest collection of playbills in 1898 from Boston auctioneer Chas. F. Libbie following the death of James Hutchinson Brown, a collector of theater playbills. See Folger collection of Libbie auction catalogs.

22. Hoving, 93.

23. FSL FCF - Warwick Library, F2

24. FSL FC B31 - HCF honorary LL.D. acceptance speech, 1914.

25. FSL FCF - Warwick Library, B6, 274.

26. FSL FC B60 - Münch recollections.

27. FSL FCF - Sotheran to HCF, January 18, 1908.

28. RM&L - Rosenbach address at FSL, April 28, 1947.

29. RM&L - Rosenbach talk before Library Club, Atlantic City, April 22, 1939, 1.

30. Wolf & Fleming, 117.

31. FSL FCF F Rosenbach Co. Perry Library.

32. FSL FCF F Rosenbach Co. Perry Library - HCF to Rosenbach, July 21, 1919.

33. Ibid.

34. FSL FCF F Rosenbach Co. Perry Library - Rosenbach to HCF, July 23, 1919.

35. FSL FC B5 - Cancelled checks.

36. FSL FCF F Rosenbach Co. Perry Library.

37. Ibid.

38. Ibid.

39. Stuart Baldridge, in *World Magazine*, December 28, 1919, 12.

40. FSL FCF F Rosenbach Co. Perry Library.

41. FSL FCF F Rosenbach Co. Perry Library - Rosenbach to HCF, July 23, 1919.

42. FSL FC B23 - HCF to JDR, March 13, 1895.

43. Chernow, "Clash of the Titans."

44. A second copy (at McGill University) lacks the A_1–A_4 signature and is cropped with injuries to some catchwords and stage directions. See Matthew W. Black's New Variorum edition of *Richard II* (Philadelphia: Lippincott, 1955), 366.

45. Wolf & Fleming, 160–61.

46. FSL FCF - Rosenbach to HCF, June 27, 1922.

47. *NYT*, June 22, 1928.

48. *NYT*, March 31, 1929.

49. FSL FC B6 F White Library - Rosenbach to HCF, March 18, 1929.

50. FSL director report, 1942, 19.

51. FSL FC B6 - HCF to Rosenbach, March 16, 1929.

52. Courtesy of AC ASC, where Mrs. CMP donated their collection of butterfly books.

53. FSL FCF - HCF to Quaritch, December 17, 1920.

54. FSL FC B32 - Mary Pratt to Fawcett, n.d.

55. FSL FC B27 - Herbert L. Pratt to EJF, February 3, 1931.

56. FSL FC - Taped interview with Edward J. Dimock by O. B. Hardison, Folger Shakespeare Library director, February 24, 1970.

57. FSL FC B20 - HCF to Harry Shelley, December 24, 1917.

58. FSL FC B30 - HCF "Curious story of how Dr. Gott's quartos were bought."

Chapter 6 . *Whole Volumes in Folio*

1. Peter Blayney points to the printing of the First Folio as not "consistent" (10). Michael Bristol refers to its being "careless" ("HCF," 147).

2. The volume contains thirty-six plays; two more, *Pericles* and *The Two Noble Kinsmen*, were added later.

3. Stanley Wells and others have endorsed the Cobbe Portrait—discovered in 2009—but the attribution remains in dispute.

4. See West, vol. 2.

5. Blayney writes, "The pages in the few largest copies measure about 13 1/2 by 8 3/4 inches. Most, however, are at least half an inch shorter and narrower" (9).

6. P. Collins, 43.

7. For a serious challenge to both assumptions—that Shakespeare was indifferent to publication and that publication was always detrimental to theater attendance—see Erne, who argues that the longer texts found in Folio were deliberately composed as reading pages, while the shorter Quarto texts were theatrical versions.

8. FSL FC B59 - Slade, *Library Journal*, July 1932.

9. FSL FCF - Folger copy 2, Robert M. Smith to McManaway, April 8, 1937.

10. LC MD J. Franklin Jameson Papers B22.

11. FSL FC B31 - HCF honorary LL.D. acceptance speech, 1914.

12. Adams, "Library," 14.

13. FSL FC B31 - HCF honorary LL.D. acceptance speech, 1914.

14. See Hinman.

15. Blayney, 10–11.

16. Mayer.

17. FSL FC B38 - EJF Meridian Club lecture, November 9, 1923.

18. FSL FCF - HCF to Mayhew, May 17, 1915.

19. FSL FCF - W. Fulford Adams postcard to Mayhew, June 10, 1915.

20. FSL FCF - Folger copy 9, CMP cable to Bedford, March 31, 1897.

21. The Vincent copy lies closest to the ideal of a totally uncut Folio. See Blayney, n. 9, n. 44).

22. Early in 1622, William Jaggard began work on the First Folio, the same year in which he would complete the printing of Augustine Vincent's *Discoverie of Errours in the First Edition of Catalogue of Nobility*, a genealogy of English nobility by Ralph Brooke that Jaggard had printed in 1619. The author belatedly found factual errors, which he blamed on Jaggard; Augustine's critique vigorously faulted the author, not the printer. Interrupting work on the Folio allowed Jaggard not only to honor a debt to his friend Vincent but also to vent his spleen by way of a letter to Brooke included in the preliminaries to Vincent's book. See Blayney, 5.

23. FSL FCF - Folger copy 1, Railton to HCF, April 1899.

24. FSL FCF - Folger copy 25, HCF to Quaritch, February 11, 1909.

25. FSL FCF - HCF to Alfred Sedgwick, March 17, 1911.

26. Hanmer's immediate predecessors were Nicholas Rowe (1709, 1714), Alexander Pope (1723–25; 1728), and Lewis Theobold (1733). Although lavishly produced, Hanmer's illustrated edition did not go back to the early quartos and folios, relying instead on Pope's edition for his text. Liberal with his own alterations, he chose not to collate the editorial choices of those who went before him.

27. FSL FCF - Folger copy 16, HCF to Anderson, December 14, 1911.

28. FSL FCF - Folger copy 11, see Beaufoy Shakespeares booklet.

29. FSL FCF - Folger copy 11, HCF to E. H. Dring , March 23, 1914.

30. FSL FCF - HCF to Arthur H. Clark, December 19, 1921.

31. *Punch*, May 14, 1922.

32. FSL FCF - HCF to Maggs Bros., September 20, 1923.

33. Blayney, 45–46; West, "How Many First Folios." See also Werstine, who began the dialogue on the accurate number of Folger copies. The prefatory section to each volume of the New Folger Library Shakespeare, edited by Werstine and Barbara Mowat, states, "Mr. Folger was able to acquire more than seventy-five copies [of the First Folio], as well as a large number of fragments" (see under "The Publication of Shakespeare's Plays").

34. FSL FCF - Folger copies 80–82.

35. FSL FCF - HCF to Rosenbach, December 26, 1929.

36. William V. Hester Jr., "Henry Clay Folger Jr.—Financier, Bibliographer," *Brooklyn Daily Eagle*, July 20, 1924, 9.

Chapter 7 . *What News on the Rialto*

1. Sowerby, 82–83.

2. Dickinson, 131.

3. FSL FCF - Estate of George D. Smith to HCF, June 1, 1920.

4. FSL FCF - Rosenbach to HCF, February 17, 1919.

5. RM&L F 1.63.02 - Rosenbach to HCF, November 27, 1926.

6. FSL FCF - Rosenbach to HCF, December 2, 1913.

7. Paul Sampson, "Queen Elizabeth's Corset Expose Stays Myth at Folger," *WP*, March 1, 1956.

8. FSL FC B28 - Welsh to Edgar Rogers, June 23, 1931.

9. FSL FCF - HCF to John Taylor, August 20, 1909.

10. FSL FCF - HCF to Carter, May 1, 1914.

11. FSL FCF - HCF to Thompson, January 28, 1927.

12. FSL FCF - HCF to Pickering & Chatto, January 25, 1928.
13. FSL FCF - HCF to Rosenbach, July 26, 1929.
14. FSL acquisition records.
15. FSL FCF - Dodd to HCF, July 19, 1895.
16. FSL FCF - HCF to Wright, November 10, 1900.
17. FSL FCF - HCF to Clark, February 13, 1920.
18. FSL FCF - HCF to Sessler, September 1924.
19. FSL FCF - HCF to Maggs Bros., November 12, 1926.
20. FSL FCF - HCF to Clark, February 13, 1920.
21. FSL FCF - HCF to Earle, December 17, 1915.
22. FSL FCF - HCF to Rosenbach, February 14, 1919.
23. FSL FCF - HCF to Maggs Bros., May 29, 1907.
24. FSL FCF - HCF to Maggs Bros., July 3, 1924.
25. FSL FCF - HCF to Broadbent, June 15, 1928.
26. FSL FCF - HCF to Arthur Reader, February 6, 1913.
27. FSL FCF - HCF to Rosenbach, March 7, 1930.
28. FSL FCF - HCF to Rosenbach, February 27, 1928.
29. FSL FCF - HCF to Rosenbach, May 19, 1922.
30. FSL FCF - HCF to Rosenbach, November 1, 1923.
31. FSL FCF - HCF to Rosenbach, April 11, 1918.
32. FSL FCF - HCF to George Dimock, November 22, 1917.
33. FSL FCF - HCF to Walters, April 15, 1926.
34. FSL FC B60 - Münch recollections.
35. FSL FCF - Dring to HCF, May 20, 1920.
36. FSL FCF - Quaritch to HCF, January 7, 1922.
37. FSL FCF - HCF to Smith, February 10, 1906.
38. FSL FCF - HCF to Barrett, July 26, 1920.
39. FSL FCF - HCF to Dodd, June 17, 1901.
40. FSL FCF - HCF to Smith, November 2, 1925.
41. FSL FCF - HCF to Smith, March 27, 1915.
42. FSL FCF - HCF to Maggs Bros., July 30, 1926.
43. FSL FCF - HCF to Gabriel Wells, January 13, 1929.
44. FSL FCF - HCF to Rosenbach, April 29, 1909.
45. FSL FCF - Wright to HCF, December 19, 1905.
46. FSL FCF - Wells to HCF, April 26, 1929.
47. FSL FCF - Rosenbach to HCF, March 23, 1921.
48. FSL FCF - Rosenbach cable to HCF, February 12, 1922.
49. FSL FCF - White to HCF, December 22, 1898.
50. FSL FCF - HCF to Forsyth, January 11, 1929.
51. FSL FCF - HCF to Marsden Perry, October 26, 1907.
52. FSL FC B57 - HCF to Putnam, February 16, 1928.
53. FSL FC BB9 - H.A., "By-the-bye in Wall Street," *WSJ*, October 16, 1931.
54. FSL FCF - HCF to Chait, September 1, 1910.
55. FSL FCF - HCF to Broadbent, July 6, 1927.

56. FSL FCF - HCF to Broadbent, August 24, 1927.
57. FSL FCF - HCF to Sessler, October 5, 1926.
58. FSL FCF - HCF to Maggs Bros., September 3, 1926.
59. FSL FCF - Rosenbach to HCF, June 5, 1918.
60. Sowerby, 193–94.
61. FSL FCF - HCF to Rosenbach, April 8, 1929.
62. FSL FCF - HCF to Rosenbach, March 3, 1930.

Chapter 8 . *Hotspur and Hal*

1. Thorpe, 350.
2. Dickinson, 173.
3. HEHL F31.1.1.16.2 B1 - HCF to Huntington, June 30, 1922.
4. FSL FC B58 - Slade's notes on HEHL.
5. Dickinson, 38.
6. Wolf & Fleming, 76.
7. Ibid., 152.
8. Rosenbach, "HCF as a Collector," 85.
9. Dickinson, 128.
10. Wolf & Fleming, 268.
11. Pressly, 4, and email to author, September 22, 2010.
12. Wolf & Fleming, 118.
13. Dickinson, 144.
14. FSL FCF - HCF to Rosenbach, April 26, 1922.
15. RM&L - Rosenbach to HCF, August 13, 1919. Rosenbach's proposed price to Folger was $5,550 net; he had written to Folger in a telegram, August 12, 1919.
16. See Dickinson, 128–29. The *Richardus Tertius* manuscript was not published until 1844.
17. FSL FCF - Rosenbach to HCF, October 15, 1921.
18. RM&L - Rosenbach address at FSL, April 28, 1947.
19. Wolf & Fleming, 236.
20. RM&L F I.62.20 - Rosenbach to HCF, June 22, 1923.
21. Thorpe, 495.
22. Wolf & Fleming, 585.

Chapter 9 . *A Monument to Gentle Verse*

1. FSL FC B56 - Possible sites for the library.
2. FSL FC B60 - Münch recollections.
3. FSL FC B33 - HCF to Putnam, January 19, 1928.
4. Burton & Perry, 1.
5. FSL FC B57 - HCF to Luce, April 23, 1928.
6. LC MD J. Franklin Jameson Papers, LD152.6 - AC class of 1879.
7. FSL FC B56 - HCF to McCreary, February 11, 1918.

8. FSL FC B33 - HCF to Putnam, January 19, 1928.

9. FSL FC B33 - Putnam to HCF, January 25, 1928.

10. FSL FC B33 - HCF will, March 10, 1927.

11. FSL FCF - HCF to Arthur H. Clark, December 14, 1922.

12. *CR*, 70th Cong., 1st sess., H.R. 9355, vol. 69, no. 114, April 30, 1928.

13. The savings lowered the budgeted cost of the annex from $780,000 to $600,000. *CR*, 70th Cong., 1st sess., H.R. Report no. 938, 3.

14. LC MD Herbert Putnam Papers - Putnam to HCF, May 8, 1928.

15. *CR*, 70th Cong., 1st sess., Calendar no. 1210, S. Report no. 1175, 3.

16. Statutes at Large, December 1927 to March 1929, vol. 45, part 1, 622–23.

17. *Romeo and Juliet*, 2.3.101. FSL FC B57 - HCF to Putnam, February 16, 1928.

18. FSL FC B57 - Trowbridge booklet.

19. FSL FC B57 - HCF to Trowbridge, October 9, 1928.

20. FSL FC B57 - HCF to Trowbridge, June 20, 1929.

21. UPenn RBML Cret papers - Trowbridge to Harbeson, November 12, 1928.

22. Philadelphia Athenaeum F FSL - Trowbridge to Cret, March 21, 1929.

23. FSL FC B57 - HCF to Trowbridge, March 5, 1929.

24. FSL FC B37 - EJF Meridian Club Lecture, 1933.

25. FSL FC BB9 - Fawcett, "Charm of Ordinary Print," *Sunday Star*, Washington, DC, January 24, 1932.

26. FSL FC B57 - Harbeson to Hardison, April 25, 1972.

27. FSL FC B57 - HCF to Trowbridge, October 21, 1929.

28. FSL FC B57 - HCF to Trowbridge, October 21, 1929 (annotation by Trowbridge at the bottom of the original letter).

29. FSL FC B57 - HCF to Cret, May 9, 1930.

30. FSL FC B57 - HCF to Trowbridge, who added handwritten note, December 12, 1929.

31. FSL FC B57 - HCF to Cret, August 10, 1929.

32. The Fortune was an open-air playhouse built by Philip Henslowe in 1599–1600 north of the Thames. Breaking with the polygonal model of the Rose and the Globe, Henslowe favored a square shape for the Fortune.

33. UPenn RBML Cret papers - HCF to Trowbridge, May 20, 1929.

34. For a good discussion of playhouses in Shakespeare's time, see Gurr, *Playgoing* and *Shakespeare Stage*. In Wickham, Berry, & Ingram, Berry discusses the twenty-three different London playhouses from 1560 to 1660 for which we have records.

35. Philadelphia Athenaeum F FSL - Cret notes, February 8, 1929.

36. FSL FC B57 - HCF to Trowbridge, February 28, 1929.

37. FSL FC B57 - HCF to Trowbridge, December 20, 1928.

38. Adams, *Folger Shakespeare Memorial Library*, 50.

39. FSL FC B23 - HCF to Frank O. Salisbury, December 24, 1928.

40. FSL FC B58 - EJF to Slade, March 7, 1932.

41. FSL FC B57 - HCF to Trowbridge, December 20, 1928.

42. FSL FC B57 - HCF to Trowbridge, December 13, 1929.

43. FSL FC B32 - Baird to Fawcett, n.d.

44. FSL FC B57 - HCF to Trowbridge, February 28, 1929.

45. UPenn RBML Cret papers - Cret to Harbeson, May 17, 1930.
46. UPenn RBML Cret papers - HCF to Cret, May 21, 1930.
47. UPenn RBML Cret papers - Trowbridge to Cret, June 20, 1930.
48. UPenn RBML Cret papers - Trowbridge to Harbeson, January 5, 1929.
49. FSL FC B32 - Cret to Fawcett, n.d.
50. FSL FC B32 - Trowbridge to Fawcett, n.d.
51. LC MD Putnam Papers - Trowbridge to HCF, February 28, 1929.
52. FSL FC B57 - HCF to Cret, January 28, 1930.
53. Philadelphia Athenaeum F FSL - Harbeson to E. F. Brinker of the Aluminum Co. of America, May 23, 1951.

Chapter 10 . *Dear, Blessed Plot of Land*

1. LC MD, Herbert Putnam Papers - EJF to Putnam, June 20, 1930.
2. UPenn RBML, Cret papers - Trowbridge to Cret, June 20, 1930.
3. FSL FC - Hardison taped interview with Edward J. Dimock, February 24, 1970.
4. King, *Recollections*, 2–3.
5. Dawson, 14.
6. FSL FC BB9 - *WP*, April 23, 1932.
7. AC ASC - Andrews to Morrow, February 27, 1931.
8. King, *Endowment*, 166.
9. FSL FC BB9 - *Newark Star Eagle*, October 22, 1931.
10. This is the day traditionally celebrated. There is no surviving birth certificate for Shakespeare, but we do have a baptismal record dated April 26, 1564. Because baptisms were held close to the date of birth, because April 23, 1616, is the day on which Shakespeare died, and because April 23 is also (rather attractively) the feast day of Saint George, the patron saint of England, biographers have settled on it as Shakespeare's birthday. See Schoenbaum, 23–26.
11. FSL FC B58 - EJF to Adams, July 17, 1934.
12. King, *Recollections*, 21.
13. Wolf & Fleming, 325.
14. Hoover Presidential Library, F FSL - EJF to Hoover, July 28, 1934; Hoover to EJF, August 1, 1934; Hoover to EJF, October 17, 1934.
15. FSL FC B58 - Gregory to EJF, March 12, 1931.
16. FSL FC B57 - HCF to Trowbridge, July 3, 1929.
17. UPenn RBML, F HCF - Gregory to Cret, March 1, 1932.
18. King, *Recollections*, 8.
19. FSL director's report, 1932–33, 6.
20. FSL FC B58 - Slade to EJF, December 4, 1931.
21. National Archives and Records Administration, Ambassador Andrew W. Mellon Papers.
22. "High Dignitaries Laud New Folger Library," *WP*, April 23, 1932.
23. Author's telephone interview with Walter Auclair, August 11, 2011.
24. FSL FC B25 - Dike to EJF, April 23, 1932.
25. FSL acquisition records. The Hoover rare book collection, with scientific volumes

from as early as 1472, was donated by the Hoover family to the Claremont Colleges Library in 1970.

26. Author's interview with Rachel Doggett, former curator of books and exhibitions, February 1, 2010.

27. FSL director's report, 1933–34, 28.

28. Ibid., 16–17.

Epilogue . *Praise in the Eyes of Posterity*

1. FSL FC B20 - HCF to Roland Lewis, October 19, 1928.

2. Wright, *Of Books and Men*, 134,

3. Ibid., 135.

4. FSL J.Q.Adams correspondence - Adams to King, September 20, 1937.

5. FSL J.Q.Adams correspondence - King to Adams, September 23, 1937.

6. Mason, 750.

7. Ferington, 10.

8. King, *Recollections*, 32.

9. UPenn RBML, Cret Papers - Cret to Adams, September 28, 1939.

10. UPenn RBML, Cret Papers - Adams to Cret, October 2, 1939.

11. Philadelphia Athenaeum, F FSL - King to Cret, November 11, 1939.

12. FSL director's report, 1939–1940, 2

13. Dawson, 30.

14. FSL director's report, 1938–1939, 16.

15. FSL director's report, 1934–1935, 35.

16. FSL director's report, 1938–1939, 39.

17. P. Collins, 147.

18. King, *Recollections*, 36.

19. Ibid., 39.

20. Dawson, 94.

21. Wright, *Folger Library, Of Books and Men*.

22. Wright, *Of Books and Men*, 134.

23. Vaughan & Vaughan, *Shakespeare in America*, 172.

24. Prentiss to author, email, January 16, 2013.

25. Author's interview with Mrs. O. B. Hardison, February 8, 2013.

26. Wright, *Folger Library*, 267.

27. For reasons of space, no attempt has been made in this epilogue to give a summary of acquisitions or exhibitions.

28. *FLN*, June 1980.

29. *FLN*, June 1979.

30. *FLN*, June 1982.

31. Ibid.

32. *FLN*, October 1982.

33. *FLN*, February 1983.

34. See www.folger.edu/kjb.

35. Author's interview with Bacon, July 16, 2008.

36. Richards, "Folger Will Shut Theatre," *WP*, January 15, 1985.

37. Author's phone interview with Longsworth, February 11, 2013.

38. Molotsky, "Panel Hopes to Save Folger Theater," *WP*, January 31, 1985.

39. FSL FC B57 - HCF to Trowbridge, June 20, 1929.

40. Wright, *Folger Library*, 268.

41. "A snapshot of major theater venues in the Washington region," *WP*, January 8, 2012.

42. The novel is Jennifer Lee Carrell, *Interred with their Bones* (New York: Dutton, 2007).

43. *Folger Shakespeare Library*, foreword.

44. Ferington, 95.

45. "Strategic Plan for the Folger Shakespeare Library," June 7, 2013, p. 3.

46. FSL FC B58 - HCF note among EJF correspondence with Adams.

47. Author's interview with Michael Witmore, April 3, 2013.

48. The Folger defines rare books in its library as books published before 1830.

BIBLIOGRAPHY

Archives

Amherst College Archives & Special Collections, Amherst, MA

British Library, London

Brooklyn Botanic Garden, NY

Brooklyn Historical Society, NY

Brooklyn Public Library, NY

Century Association Archives Foundation, New York, NY

Dolph Briscoe Center for American History, ExxonMobil Collection, University of Texas, Austin

Elizabeth Historical Society, NJ

Elizabeth Public Library, NJ

Folger Shakespeare Library, Washington, DC

Glen Cove Public Library, NY

Huntington Library, San Marino, CA

Library of Congress, Washington, DC

Martin Luther King Jr. Library, Washingtonian Division, Washington, DC

Morgan Library, New York, NY

Nantucket Athenaeum, MA

Nantucket Historical Association, MA

National Archives, Washington, DC

New York Public Library, NY

Philadelphia Athenaeum, PA

Quaritch Booksellers, London

Queens Public Library, NY

Rockefeller Archive Center, Sleepy Hollow, NY

Rosenbach Library, Philadelphia, PA

San Francisco Maritime Museum Library, CA

Shakespeare Centre, Stratford-upon-Avon, England

Smith College Archives, Northampton, MA

Smithsonian Institution Archives of American Art, Washington, DC

University of Pennsylvania Rare Book & Manuscript Library, Philadelphia, PA

U.S. Commission of Fine Arts, Washington, DC

Vassar College Archives, Poughkeepsie, NY
Washington, DC, Historical Society

Periodicals

Amherst College Biographical Record. 1826–1951.
Baist's Real Estate Atlas of Surveys of Washington, District of Columbia. 1924.
Boyd's Directory of the District of Columbia. 1914–1929.
Brooklyn Daily Eagle. 1924.
Folger Shakespeare Library, Washington. Annual Reports, 1932–1940.
Folger Library Newsletter. 1969–1987.
Folger News. 1987–2006.
Folger Magazine. 2007–2013.
New York Times. 1900–1940.
Punch. 1922.
Sanborn Fire Insurance Maps of District of Columbia. 1888, 1928.
Shakespeare Association Bulletin. 1932.
U.S. Congressional Record. 1926, 1928.
Vassar Quarterly. 1932.
Who's Who in America. 1930–1932.
Who's Who in New York City and State. 1930–1932.
World Magazine. 1919.

Individual Works

Adams, Joseph Quincy. *The Folger Shakespeare Memorial Library, A Report on Progress, 1931–1941.* Washington, DC: Published for the Trustees of Amherst College, 1942.
———. "The Library." In *The Folger Shakespeare Library, Washington.* Washington, DC: Published for the Trustees of Amherst College, 1933.
Adams, Joseph Quincy, ed. *Shakespeare's "Titus Andronicus," the First Quarto, 1594.* New York: Charles Scribner's Sons, 1936.
Akin, Edward N. *Flagler: Rockefeller Partner and Florida Baron.* Gainesville: University Press of Florida, 1991.
Altick, Richard D. *The Scholar Adventurers.* New York: Macmillan, 1950.
Atwood, Albert W. "The Greatest Killing in Wall Street." *McClure's,* August 1912, 409.
Basbanes, Nicholas, A. *A Gentle Madness.* New York: Henry Holt, 1995.
———. *A Splendor of Letters: The Permanence of Books in an Impermanent World.* New York: HarperCollins, 2003.
Beckert, Sven. *The Monied Metropolis: New York City and the Consolidation of the American Bourgeoisie, 1850–1896.* Cambridge: Cambridge University Press, 2001.
Berg, Scott W. *Grand Avenues: The Story of the French Visionary Who Designed Washington, DC.* New York: Pantheon, 2007.
Blayney, Peter W. M. *The First Folio of Shakespeare.* Washington, DC: Folger Shakespeare Library, 1991.

Bristol, Michael D. "Henry Clay Folger." In *Great Shakespeareans: Bradley, Greg, Folger*, ed. Gary DiPietro, chap. 3. New York: Continuum International, 2011.

———. *Shakespeare's America, America's Shakespeare*. London: Routledge, 1990.

Bruccoli, Matthew J. *The Fortunes of Mitchell Kennerley, Bookman*. New York: Harcourt Brace Jovanovich, 1986.

Burton, Katherine, and Louise S. G. Perry. *Idolatry of Books*. Norton, MA: Periwinkle Press, 1939.

Cannadine, David. *Mellon: An American Life*. New York: Knopf, 2006.

Carrell, Jennifer Lee. *Interred with Their Bones*. New York: Dutton, 2007.

Chandler, Alfred. *Strategy and Structure: Chapters in the History of the Industrial Enterprise*. Cambridge, MA: MIT Press, 1962.

Charteris, Richard. *Annotated Catalogue of the Music Manuscripts in the Folger Shakespeare Library*. Hillsdale NY: Pendragon Press, 2005.

Chernow, Ron. "Clash of the Titans." *University of Chicago* 90, no. 5 (June 1998): 18–24.

———. *Titan: The Life of John D. Rockefeller*. New York: Random House, 1998.

Collins, Kathleen. *Washingtoniana Photographs*. Washington, DC: Library of Congress, 1989.

Collins, Paul. *The Book of William*. New York: Bloomsbury, 2009.

Crum, A. R., ed. *Romance of American Petroleum and Gas*. Vol. 1. Oil City, PA: Derrick Publishing, 1911.

Currie, Barton. *Fishers of Books*. Boston: Little, Brown, 1931.

Dawson, Giles. "History of the Folger Shakespeare Library, 1932–1968." Unpublished manuscript, 1994. Folger Shakespeare Library, Washington, DC.

Dawson, Giles, and Laetitia Kennedy-Skipton. *Elizabethan Handwriting, 1500–1650: A Manual*. New York: W. W. Norton, 1966.

Depew, Chauncey M., ed. *1795–1895: One Hundred Years of American Commerce, Consisting of One Hundred Original Articles on Commercial Topics*. New York: D. O. Haynes, 1895.

Dickinson, Donald C. *Henry E. Huntington's Library of Libraries*. San Marino, CA: Huntington Library, 1995.

Dimock, George E. "Henry Clay Folger, Biographical Sketch." In *Henry C. Folger: 18 June 1857–11 June 1930*, 22–30. New Haven, CT, 1931.

Duncan, John M. *An Eye-Opener: The Standard Oil-Magnolia Compromise: The Whole Cold Truth*. San Antonio, TX, 1915.

Dunton, John *The Dublin Scuffle*. Introduction and notes by Andrew Carpenter. Dublin: Four Courts Press, 2000.

Emerson, Ralph Waldo. *Collected Works*. Vol. 9. Cambridge, MA: Belknap Press of Harvard University Press, 2011.

———. *Representative Men*. Boston: Phillips, Sampson, 1850.

Engelbourg, Saul. *Power and Morality: American Business Ethics, 1840–1914*. Westport, CT: Greenwood Press, 1980.

Erne, Lucas. *Shakespeare as Literary Dramatist*. Cambridge: Cambridge University Press, 2003.

Ettinghausen, Maurice L. *Rare Books and Royal Collectors: Memoirs of an Antiquarian Bookseller*. New York: Simon & Schuster, 1966.

Ferington, Esther, ed. *Infinite Variety: Exploring the Folger Shakespeare Library*. Washington, DC: Folger Shakespeare Library, 2002.

Fletcher, Ifan Kyrle. "British Playbills Before 1718." *Theatre Notebook* 17 (1963): 48–50.

Folger, Henry Clay, Sr. "Autobiography." Unpublished manuscript, February 1907. Nantucket Historical Association, Nantucket, MA.

The Folger Shakespeare Library, Washington. Foreword by Harlan Fiske Stone and William Adams Slade. Washington, DC: Trustees of Amherst College, 1933.

Foster, Joseph T. "Folger: Biggest Little Library in the World." *National Geographic*, September 1951.

Freeman, Arthur, and Janet Freeman. *Anatomy of an Auction.* London: Book Collector, 1990.

Friedricks, William B. *Henry E. Huntington and the Creation of Southern California.* Columbus: Ohio State University Press, 1992.

Furness, Horace Howard Jayne, ed. *The Letters of Horace Howard Furness.* 2 vols. Boston: Houghton Mifflin, 1922.

Gibb, George Sweet, and Evelyn H. Knowlton. *History of Standard Oil Company (New Jersey): The Resurgent Years, 1911–1927.* New York: Harper & Bros., 1956.

Gibson, James M. *The Philadelphia Shakespeare Story: Horace Howard Furness and the New Variorum Shakespeare.* New York: AMS Press, 1990.

Goff, Frederick R. *Incunabula in American Libraries.* New York: American Bibliographical Society, 1964.

Goode, James M. *Capital Losses: A Cultural History of Washington's Destroyed Buildings.* Washington, DC: Smithsonian, 2003.

———. *Lost Washington.* Washington, DC: Smithsonian, 2003.

Grant, Stephen H. "Emily Jordan Folger." Vassar Encyclopedia, http://vcencyclopedia.vassar.edu/alumni/emily-jordan-folger.html.

———. "Henry and Emily Folger Educate Children through Shakespeare Gardens." *Brooklyn Botanic Garden Newsletter* 10, no. 1 (December 2009): 19.

———. "John D. Rockefeller and Henry Clay Folger at Senior Golf." *GCS Bulletin* (Golf Collectors Society), December 2009, 14–15.

———. "Mary Augusta Jordan." Vassar Encyclopedia, http://vcencyclopedia.vassar.edu/alumni/mary-augusta-jordan.html.

———. "A Most Interesting and Attractive Problem: Creating Washington's Folger Shakespeare Library." *Washington History* (Historical Society of Washington, DC) 24, no. 1 (2012): 2–19.

Gray, Mary Z. *301 East Capitol: Tales from the Heart of the Hill.* Washington, DC: Overbeck History Press, 2012.

Gray, William H. *The Rule of Reason in Texas.* Houston, 1912.

Greer, Germaine. *Shakespeare's Wife.* New York: HarperCollins, 2007.

Gromley, Beatrice. *Maria Mitchell: The Soul of an Astronomer.* Grand Rapids, MI: Eerdmans, 1995.

Grossman, Elizabeth Greenwell. *The Civic Architecture of Paul Cret.* Cambridge: Cambridge University Press, 1996.

Grosvenor, Gilbert. "Washington through the Years." *National Geographic*, November 1931.

Grover, Harriet M. *Highlights of the Folger Family with a Brief Genealogy.* Berkeley, CA, 1939.

Gurr, Andrew. *Playgoing in Shakespeare's London.* Cambridge: Cambridge University Press, 1987.

————. *Shakespeare Stage, 1574–1642*. 3rd ed. Cambridge: Cambridge University Press, 1992.

Hard, Frederick. *The Sculptured Scenes from Shakespeare: A Description of John Gregory's Marble Reliefs on the Folger Library Building*. Washington, DC: Folger Shakespeare Library, 1959.

Harrison, Joan. *Glen Cove*. Charleston, SC: Arcadia, 2008.

Harrison, Robert L. "The Folgers and Shakespeare: A Long Island Story." *Nassau County Historical Society Journal* 61 (2001): 11–18.

Hellman, Robert. "Some Remarks about Nantucket Whalecraft Makers." *Historic Nantucket* 61, no. 3 (Fall 2011): 15–20.

Hidy, Ralph W., and Muriel E. Hidy. *History of Standard Oil Company (New Jersey) Pioneering in Big Business, 1882–1911*. New York: Harper & Bros., 1955.

Hinchman, L. C. *Early Settlers of Nantucket*. Philadelphia: W. A. Henry Press, 1926.

Hinman, Charlton. *The Printing and Proof-Reading of the First Folio of Shakespeare*. 2 vols. Oxford: Clarendon Press, 1963.

Holland, Leicester B. "The Folger Shakespeare Library." *American Magazine of Art* 24, no. 3 (March 1932): 183–90.

Holroyd, Michael. *A Strange, Eventful History: The Dramatic Lives of Ellen Terry, Henry Irving, and Their Remarkable Families*. New York: Farrar, Straus & Giroux, 2009.

Hoving, Thomas. *Making the Mummies Dance: Inside the Metropolitan Museum of Art*. New York: Simon & Schuster, 1993.

Howarth, Stephen. *A Brief History of Mobil*. New York: Mobil Corporation, 1997.

————. *A Century in Oil: The "Shell" Transport and Trading Company, 1897–1997*. London, Weidenfeld & Nicolson, 1997.

————. *Mobil at 125*. N.p.: Mobil Corporation, 1991.

————. *One Hundred Twenty-Five Years of History: ExxonMobil*. Irving, TX: ExxonMobil Corporation, 2007.

The Huntington Library: Treasures from Ten Centuries. London: Scala, 2004.

Issacson, Walter. *Benjamin Franklin: An American Life*. New York: Simon & Schuster, 2003.

James, Henry. *The American Scene*. In *Collected Travel Writings: Great Britain and America*. New York: Library of America, 1993.

Johnston, William R. *William and Henry Walters: The Reticent Collectors*. Baltimore: Johns Hopkins University Press, 1999.

Kane, Betty Ann. *The Widening Circle: The Story of the Folger Shakespeare Library and Its Collections*. Washington, DC: Folger Shakespeare Library, 1976.

Kaplan, Fred. *Lincoln: Biography of a Writer*. New York: HarperCollins, 2008.

————. "Shakespeare Garden Is Still Wowing Audiences after Thirty Years." *Brooklyn Botanic Garden Volunteer and Staff Newsletter*, February 2009.

King, Stanley. *History of the Endowment of Amherst College*. Norwood, MA: Plimpton Press, 1950.

————. *Recollections of the Folger Shakespeare Library*. Ithaca, NY: Cornell University Press, 1950.

Klein, Maury. *Life and Legend of Jay Gould*. Baltimore: Johns Hopkins University Press, 1986.

Le Duc, Thomas. *Piety and Intellect at Amherst College: 1865–1912*. New York: Columbia University Press, 1946.

Lewis, Tom. *The Hudson: A History*. New Haven, CT: Yale University Press, 2005.

Levine, Lawrence W. *Highbrow/Lowbrow: The Emergence of Cultural Hierarchy in America*. Cambridge, MA: Harvard University Press, 1988.

Linenthal, Richard, ed. *A Special Number to Commemorate the 150th Anniversary of Bernard Quaritch Ltd*. London: Book Collector, 1997.

Love's Labor: How Henry and Emily Folger Built a Library. DVD. Washington, DC: Folger Shakespeare Library, 2007.

MacKay, Robert B., Anthony K. Baker, and Carol A. Traynor. *Long Island Country Houses and Their Architects, 1860–1940*. New York: Society for the Preservation of Long Island Antiquities in association with W. W. Norton, 1997.

Manbeck, John B., ed. *The Neighborhoods of Brooklyn*. New Haven, CT: Yale University Press, 1998.

Mandelbrote, Giles. *Out of Print and into Profit: A History of the Rare and Secondhand Book Trade in Britain in the Twentieth Century*. London: British Library, 2006.

Mason, Alpheus Thomas. *Harlan Fiske Stone: Pillar of the Law*. New York: Viking, 1956.

Mayer, Jean-Christophe. "Reading Shakespeare's Readers." Presented at the Folger Shakespeare Library, Washington, DC, March 31, 2011.

McDonald, Travis C. "Modernized Classicism: The Architecture of Paul Philippe Cret in Washington, DC." Master's thesis, School of Architecture, University of Virginia, 1980.

McManaway, James, G. "Folger Library." *South Atlantic Bulletin, South Atlantic Modern Language Association* 6, no. 2 (October 1940): 1–4.

———. "The Folger Shakespeare Library." *Shakespeare Survey* 1 (1948): 57–78.

———. "The Folger Shakespeare Library in Wartime." *General Federation Clubwoman, American Home and Fine Arts*, December 1943.

Nasaw, David. *Andrew Carnegie*. New York: Penguin, 2006.

———. *The Chief: The Life of William Randolph Hearst*. Boston: Houghton Mifflin, 2000.

National Commission of Fine Arts. 11th report, January 1, 1926–June 30, 1929. Washington, DC: Government Printing Office, 1930.

———. 12th report, July 1, 1929–December 31, 1934. Washington, DC: Government Printing Office, 1934.

Nevins, Allan. *John D. Rockefeller: The Heroic Age of American Enterprise*. 2 vols. New York: Charles Scribner's Sons, 1940.

———. *Study in Power: John D. Rockefeller, Industrialist and Philanthropist*. New York: Charles Scribner's Sons, 1953.

Newcomer, Mabel. *A Century of Higher Education for American Women*. New York: Harper, 1959.

Newton, A. Edward. *The Amenities of Book-Collecting*. Boston: Atlantic Monthly Press, 1918.

———. *A Magnificent Farce*. Boston: Atlantic Monthly Press, 1921.

———. *This Book-Collecting Game*. Boston: Little, Brown, 1928.

Olien, Roger M., and Diana Davids Olien. *Oil in Texas: The Gusher Age, 1895–1945*. Austin: University of Texas Press, 2002.

Paullin, Charles O. "History of the Site of the Congressional and Folger Libraries." In *Records of the Columbia Historical Society of Washington, DC* 37–38 (1937): 173–94.

Plimpton, George Arthur. *A Collector's Recollections*. New York: Columbia University Libraries, 1993.

Pressly, William L. *A Catalogue of Paintings in the Folger Shakespeare Library*. New Haven, CT: Yale University Press, 1993.

Preston, Jean F., and Laetitia Yeandle. *English Handwriting, 1400–1650: An Introductory Manual*. Binghamton: State University of New York at Binghamton Center for Medieval and Early Renaissance Studies, 1992.

Reiss, Marcia. *Brooklyn Then and Now*. San Diego: Thunder Bay Press, 2002.

Rockefeller, John D. *Random Reminiscences of Men and Events*. Tarrytown, NY: Sleepy Hollow Press and Rockefeller Archive Center, 1984.

Rosenbach, A. S. W. *A Book Hunter's Holiday*. Boston: Houghton Mifflin, 1936.

———. *Books and Bidders: The Adventures of a Bibliophile*. Boston: Little, Brown, 1927.

———. "Henry C. Folger as a Collector." In *Henry C. Folger: 18 June 1857–11 June 1930*, 74–105. New Haven, CT, 1931.

Rundell, Walter, Jr. *Early Texas Oil: A Photographic History, 1866–1936*. College Station: Texas A&M University Press, 1977.

Sandburg, Carl. *Lincoln Collector: The Story of Oliver R. Barrett's Great Private Collection*. New York: Harcourt, Brace, 1949.

Schoenbaum, Sam. *William Shakespeare: A Compact Documentary Life*. New York: Oxford University Press, 1977.

Shapiro, James. *Contested Will: Who Wrote Shakespeare?* New York: Simon & Schuster, 2010.

Sherman, William. *Used Books*. Philadelphia: University of Pennsylvania Press, 2008.

Singer, Jonathan. *Broken Trusts: The Texas Attorney General versus the Oil Industry, 1889–1909*. College Station: Texas A&M University Press, 2002.

Slade, William Adams. "The Folger Shakespeare Library." *Library Journal* 57, no. 13 (July 1932): 601–7.

———. "The Significance of the Folger Shakespeare Memorial: An Essay toward Interpretation." In *Henry C. Folger: 18 June 1857–11 June 1930*, 40–71. New Haven, CT, 1931.

Smith, Robert M. "Why a First Folio Shakespeare Remained in England." *Review of English Studies* 15, no. 59 (July 1939): 65–74.

Smith, Robert M. "The Formation of Shakespeare Libraries in America." *Shakespeare Association Bulletin* 4, no. 3 (July 1929): 65–73.

Solomon, Barbara Miller. *In the Company of Educated Women: A History of Women and Higher Education in America*. New Haven, CT: Yale University Press, 1985.

Soskis, Benjamin. "The Problem of Charity in Industrial America, 1873–1915." Ph.D. diss., Columbia University, 2010.

Sowerby, E. Millicent. *Rare People and Rare Books*. Williamsburg, VA: Bookpress, 1987.

Spurgeon, Selena A. *Henry E. Huntington: His Life and His Collections*. San Marino, CA: Huntington Library, 2008.

Starbuck, Alexander. *History of Nantucket County, Island, and Town*. Boston: C. E. Goodspeed, 1924.

Strouse, Jean. *Morgan, American Financier*. New York: HarperCollins, 2000.

Sukert, Lancelot. "The Folger Shakespeare Library." *American Architect*, September 1932.

Tarbell, Ida M. *The History of the Standard Oil Company*. New York: McClure, Phillips, 1905.

Thorpe, James. *Henry Edwards Huntington: A Biography*. Berkeley: University of California Press, 1994.

Tolhurst, Desmond. *Nassau Country Club: The Place to Be, 1896–1996*. Glen Cove, NY, 1995.

Towner, Wesley. *The Elegant Auctioners*. Completed by Stephen Varble. New York: Hill & Wang, 1970.

U.S. Senate Committee on Manufactures. "High Cost of Gasoline and Other Petroleum Products." 67th Congress, 4th session, report no. 1263. Washington, DC: Government Printing Office, 1923.

Vaughan, Alden T., and Virginia Mason Vaughan, eds. *Shakespeare in America*. London: Oxford University Press, 2012.

———. eds., *Shakespeare in American Life*. Washington, DC: Folger Shakespeare Library, 2007.

Wallace, Charles B. *Nine Lives: The Story of the Magnolia Companies and the Antitrust Laws*. Dallas, TX, 1955.

Weinberg, Steve. *Taking on the Trust: The Epic Battle of Ida Tarbell and John D. Rockefeller*. New York: W. W. Norton, 2008.

Werstine, Paul. "More Unrecorded States in the Folger Shakespeare Library's Collection of First Folios." *The Library* 11 (1989): 47–51.

West, Anthony James. "How Many First Folios Does the Folger Hold?" *Shakespeare Quarterly* 47 (1996): 190–94.

———. *The Shakespeare First Folio: The History of the Book*, vol. 1: *An Account of the First Folio Based on Its Sales and Prices, 1623–2000*. Oxford: Oxford University Press, 2001.

———. *The Shakespeare First Folio: The History of the Book*, vol. 2: *A New Worldwide Census of First Folios*. Oxford: Oxford University Press, 2003.

Whicher, George F. "Henry Clay Folger and the Shakespeare Library." *Amherst Graduates' Quarterly*, November 1930, 2–16.

White, David G. "The Folger Shakespeare Library Architectural Woodwork of Appalachian White Oak." Brochure no. 7, Appalachian Hardwood Manufacturers, Inc., . Cincinatti, OH, 1932.

White, Gerald T. *Formative Years in the Far West: A History of Standard Oil Company of California and Predecessors through 1919*. New York: Appleton-Century-Crofts, 1962.

White, Theo B., ed. *Paul Philippe Cret: Architect and Teacher*. Cranbury, NJ: Associated University Presses, 1973.

Whiteshot, Charles A. *The Oil-Well Driller: A History of the World's Greatest Enterprise, the Oil Industry*. Mannington, WV, 1905.

Wickham, Glynne, Herbert Berry, and William Ingram, eds. *English Professional Theatre, 1530–1660*. Cambridge: Cambridge University Press, 2000.

Williams, Owen, and Caryn Lazzuri, eds. *Foliomania!* Washington, DC: Folger Shakespeare Library, 2011.

Williamson, Harold F., and Arnold R. Daum. *The American Petroleum Industry: The Age of Illumination, 1859–1899*. Evanston, IL: Northwestern University Press, 1959.

Willoughby, E. E. "The Folger Shakespeare Library." *Library World* 38, no. 442 (April 1936): 227–29.

———. "The Classification of the Folger Shakespeare Library." *Library Quarterly* 7, no. 3 (July 1937): 395–400.

Wolf, Edwin, II, with John F. Fleming. *Rosenbach: A Biography*. New York: World, 1960.

Wolfe, Heather, ed. *The Pen's Excellence: Treasures from the Manuscripts Collection of the Folger Shakespeare Library*. Seattle: University of Washington Press, 2002.

Wright, Louis B. *The Folger Library: Two Decades of Growth, an Informal Account*. Charlottesville: University Press of Virginia, 1968.

———. "Henry Clay Folger." In *Grolier 75: A Biographical Retrospective to Celebrate the Seventy-Fifth Anniversary of the Grolier Club in New York*, 85–88. New York: Grolier Club, 1959.

———. "Huntington and Folger, Book Collectors with a Purpose." *Atlantic Monthly*, April 1962, 70–74.

———. *Of Books and Men*. Columbia: University of South Carolina, 1976.

Yergin, Daniel. *The Prize: The Epic Quest for Oil, Money, and Power*. New York: Simon & Schuster, 1991.

Ziegler, Georgianna. "Duty and Enjoyment: The Folgers as Shakespeare Collectors in the Gilded Age." In Vaughan and Vaughan, *Shakespeare in American Life*, 101–11. Washington, DC: Folger Shakespeare Library, 2007.

INDEX

Page numbers in *italics* refer to illustrations and tables.

Abbott, Lawrence F., 100

Ackermann, Frederick, 70

Adams, Henry, 1

Adams, John, 27, 77

Adams, Joseph Quincy: career of, 171, 172, 192–93; chimney in reading room and, 184–85; Dawson and, 181; on Folger priorities, 204; Harmsworth collection and, 190–91; "Shakespeare Birthday Lecture," 179–80; "Shakespeare's Playhouses," 150–51; Stone and, 188; Willoughby and, 189

Adelman, Stuart L., 199

Adelphi Academy, 8–9, 13, 30

All's Well That Ends Well, 29

allusion books, 77

Alpha Delta Phi fraternity, 11–12, *12,* 13

Amherst, Jeffrey, 100, 101

Amherst, Massachusetts, 9

Amherst College: Dramatic Society, 194; EJF honorary degree from, 171; endowed professorships at, 169, 179; English reading room at, 42; Folger Prize, 40, 179; Folger Theatre Group and, 197–98; gifts to, 42, 93, 120; Glee Club, 21; HCF as student at, 9–13, *12,* 45; HCF death and, 166–67; HCF honorary degree from, 37, 83, 99; HCF scrapbook about, 19–22; library administration by, 166–68, 169–70, 171–72, 192, 201–2; Masquers, 194; opening and dedication of library and, 178, 179; Shakespeare discussion group at, 30; Shakespeare prize at, 29–30

Anderson, John, 38, 102

Anderson Galleries, New York, 38, 127

Andrews, Charles A., 169–70

Andrew W. Mellon Foundation, 203

Andrew W. Mellon Fund, 196, 200

Anglo-American Oil Company, 112

antitrust actions, 59

Antony and Cleopatra, 29, 185

Archbold, John, 45, 49, 56, 57–59, 68

Architects Advisor Council award, *148*

Architects Advisory Council award, 162

association books, 77

As You Like It, 2, 7, 29, 70, 76, 79, 95, 105, 151, 154

Babbott, Frank, 30

Bacon, Francis, 78

Bacon, Ken, 197

Baird, James, 158, 159, 163

Baird, Theodore, 179

Bald, R. C., 189

Bardolatry, 34

Barlow, Montague, 108

Barrett, Oliver, 80, 119

Barry, Marion, 197

Bartlett, Henrietta, 192

Bauer, Oswald A., 140, 141–42

Beaumont Refinery Company, 55, 56, 57

Beecher, Catherine, 15

Beecher, Henry Ward, 8, 11–12, 15, 126

Bernhardt, Sarah, 34

Bier, Robert, 181

Bixby, William K., 133

Blayney, Peter, 36, 98, 102, 105

Bliss, Leslie, 127

Bodleian Library, England, 130, 192, 197

Bond, William Ross and Theodora Sedgwick, 196

book auctions: acquisitions and, 83; agents at, 108; catalogs of, 109

books: on butterflies, 90–91; marginal notations by HCF in, 31; types of in collection, 77–78; visual beauty of, 115–16

booksellers: auctions and, 121; correspondence with, 110–11, 113–15, 116–17, 136–37; death of HCF and, 164; return of books to, 116–17, 124. *See also specific booksellers, i.e.,* Rosenbach, A. S. W.

Booth, Edwin, 37, 77, 119, 191

Bristol, Michael, 28

British Museum, 38, 107, 130, 192

Britwell-Court Library collection, 88, 108, 135–36

Brooke, Ralph, 217n. 22

Brooklyn, home in, *165*

Brown, James Hutchinson, 215n. 21

Browning, Elizabeth Barrett, 3, 29, 37

Browning, Robert, 37, 77

Bryce, James, 1

Burford, Laura, 182

Burns, Robert, 3, 37, 77

butterflies, books on, 90–91

Byron, Lord, 3

Cadman, Samuel Parkes, 91–92, 163, 178, 180, 185

capital gains taxes, 69, 73

card catalog, 111

Carlyle, Thomas, 28, 31, 37, 77

Carter, Howard, xiii

catalogs of book auctions, 109

Census of Medieval and Renaissance Manuscripts in the United States and Canada (de Ricci and Wilson), 188

Central Congregational Church, 91–92, 163

Central Park, Manhattan, 40

Charles (prince), 202

Charles Pratt & Company, 46

checks saved and written by HCF, 69–70, 71, *71, 73, 87*

Chernow, Ron, 88

Christie-Miller, S. R., 88

Church, E. Dwight, 131

Churchill, George B., 40

Churchill, Winston, 44

Claudel, Paul, 178–79

Clay, Henry, 4

Clemens, Samuel, 38

Clemmers, William B., 158, 170, 179

clipping bureaus, 109

Cochrane, Alexander S., 131–32

Cole, Charles W., 194

Cole, George Watson, 129, 131, 134

Coles, William C., 70

collection: access to, 127; allusion books in, 77; assessment of upon death of HCF, 164; association books in, 77; classification system for, 189; desired items for, 82, 111; duplicate volumes in, 120; exchanging and selling from, 119–20; expansion of, 189, 190–91, 192–93; extra-illustrated books in, 77–78, 117; literary focus of, 75–76, 114, 116; manuscripts in, 79; musical literature and period instruments in, 79; paintings in, 80; physical task of handling, 116; plagiarisms in, 80; playbills in, 81; prompt books in, 77; rare book, first purchase of, 82; reference materials in, 81–82; scope of, 205; Shakespeare authorship as category for, 78; signatures in, 80–81; Slade on, 76; source books in, 76; storage of, 118; strategies for growing, 109–10, 113–14, 119, 120, 121–22, 129; transportation of to library, 170–71

collectors, types of, 82

Collins, Paul, 96, 193

Columbia College, 46

Comedy of Errors, The, 29, 105

commonplace books of HCF, 30, 36–37

communication with booksellers, 110–11, 113–15, 116–17, 136–37

Complete Works (Lippincott), 28–29

Condell, Henry, 96, 148

Cook, Joseph, 22

Coolidge, Calvin, 167, 171, 201

Coriolanus, 29

Corsicana Refinery Company, 56, 57

Corwin, A. F., 63

court manuscript hand, 79

Craig, Edith, 185

Cret, Paul Philippe: as architect, 147–48, 159–60, 161; award for design by, 162;

death of, 191; death of HCF and, 163; at dedication, 179; drawing of library by, *148*; on HCF, 42; heating system and, 156–57; MacMonnies and, 149; theater design and, 151; Trowbridge and, 145–46

Cutler, Bertram, 72

Cymbeline, 29

Daly, Augustin, 77

d'Ascenzo, Nicola, 154, 156

Davis, William W., 30

Dawson, Giles E., 181, 182, 189, *190, 191*–92

de Ricci, Seymour, 188

Dering, Edward, 79

desk of HCF, 62–63, *63, 162*

diary of EJF, 34, 37

Dickens, Charles, 1, 21, 118

Dickinson, William Austin, 22

digital technology, 203–4

Dike, Nina, 180

Dimock, Edward J., 26, 35, 71, 164, 168, 170, 185

docents, 202–3

Drake, Edwin, 43

Dring, E. H., 105, 108–9, 119

Duveen, Joseph, 130, 135, 137

early modern age, x, 75–76

early modern style, 148

Edmister, Willard E., 72

Elizabeth I, corset of, 111, 191–92

Elizabeth II, 199

Emerson, Ralph Waldo, 28, 29, 30, 31, 183–84

England: Bodleian Library, 130, 192, 197; British Museum, 38, 107, 130, 192; Shakespeare societies in, 39; Warwick Castle, 83. *See also* Stratford-upon-Avon

extra-illustrated books, 77–78, 117

Fairbanks, Douglas, 35

Fales, Frederick S., 49, 64, 118

false folio, 85

family: bequests to, 166; EJF and, 184; letters to and from during college, 10–11, 12–13; limits set on gatherings of, x, 66; recollections of, 26; support given to, 6–7, 66; Thanksgiving visits by, x–xi

Farren, Donald, 201

Fawcett, James Waldo, 26, 35, 63

federal income taxes, 72–73

Fellowes, Edmund Horace, 65

Ferington, Esther, *Infinite Variety,* 202

First Folio (1623): acquisition of, 99–101, 105–6, 106–7; analyses of printing of, 97–98; annotations in, 98, 105–6; Beaufoy copy, 102–3; Burdett-Coutts copy, 103; census of, 97, 99; copies of, 76; description of, 95; facsimile factories and, 96; Gilburne copy, 103; Hamner copy, 102; Hinman facsimile, 200; importance of, 95, 106; Kimberley copy, 105; numbering system for, 99; publication of, 96; pursuit of, 36, 96–97, 101–2; Roden copy, 102; title page of, *101*; Vincent copy, 100; Williams copy, 106

Flagler, Henry, 44, 45

Flower, Archibald, 39

Folger, Edward (uncle), 4

Folger, Edward Pell (brother), 6, 62

Folger, Eliza Jane Clark, 4–5, 28, 169

Folger, Emily Clara Jordan (EJF): birth of, 14; as child, *14*; as collector, x, 35, 128, *129*; death of, 185; on death of HCF, 164, 168; at dedication of library, 178, 180; early years and education of, 2–3, 14–15, 16–19; on First Folio, 97; in Founders' Room, *174*; friends of, 184–85; on HCF, 49; HCF will and, 166; honorary degree for, 171; interview given by, 107; King on, 175–76; library administration and, 171–73, 183; master's degree of, 35, 36; on mother-in-law, 5; objects passed down from, xi; portraits of, *41, 155*; with Pratts, *25*; in Reading Room, *175*; relationship with HCF, 23–26; at Sands Point picnic, 2, 3; sculptures and, 159–60; on Shakespeare and culture, 28; speech at Meridian Club, 32; as teacher, 19, 23; umbrella of, xiii; wealth of, 168–69, 185; wedding of, 22. *See also* collection

Folger, Henry Clay, Jr.: Adelphi commencement address of, 9; birth of, 4; business qualities of, 63–64; bust of, 173; career of, xi, 46–47, 48–50, 51, 52–54, *53,* 60; as child, with book, 5; as collector, x, xi–xii, 37, 51, 83, 93–94; death of, 127, 163; "Dick" as nickname for, 22, 24; education of, 7 13, *12,* 19–22, 46; on First Folio, 97; frugality of,

Folger, Henry Clay, Jr. (*cont.*)
65, 66; as golfer, *xiii,* 66, 91, *92;* honorary degree of, 37, 99; interview given by, 107; Irving Literary Circle and, 3; on knowledge of Shakespeare, 31; limits set on social and business engagements, xi; as loner, 50–51; philanthropy of, 7; physical appearance of, 20; portraits of, *41, 67,* 87, *155, 175;* Pratt and, 2, 8; with Pratts, *25;* relationship with EJF, 23–26; retirement of, 62, 144; at Sands Point picnic, 2, 3; as secretive, xi; testimony of, 55–56, 61; umbrella of, xiii–xiv; wealth of, 65; wedding of, 22; will of, 26, 166. *See also* collection

Folger, Henry Clay, Sr., 4, 5–6, 66

Folger, James A., 4

Folger, Mary Morrel, 3

Folger, Peter, 3

Folger, Samuel Brown, 3–4, 43

Folger, Stephen Lane, 6, 28, 62

Folger, William, 6

Folger Consort, 196, 199

Folger Film Archive, 196

Folger Institute, 195

Folger Library Board of Governors, 201–2

Folger Library Shakespeare Editions, 199

Folger Magazine, 202

Folger Shakespeare Library: addition to, 191; afternoon tea at, 182; Amherst College and, 166–68, 169–70, 171–72, 178, 179, 192, 201–2; anniversaries of, 197, 202; architects for, 144–46, *148,* 161; busts for, 151–52, 154, 173, 175; compared to private libraries, ix; conveniences in, 157, 161; dedication of, xii, 176, *177,* 177–81; design of, 147–48; directors of, 207; endowment for, 166, 185, 195; evolution of, 192–93; Exhibition/Great Hall, 151, 153, *153;* exhibits of, 197; exterior of, *174;* fellowships to, 189; Founders' Room, 156, *158, 174;* general contractor for, 158–59; HCF bust and, 173; HCF priorities for use of, 204–5; heat for, 156–57; inscriptions for, 148–49, 152–53; as mausoleum, xii; mission of, x, 75; mortuary urns placed in, 173, 185; naming of, 146–47; opening of, 171, 181, 187; original collection of, 75; portraits for, 154, *155;* postcard photos of, 183; property for, 139, 140–44, *141,* 195–96; publicity

about, 144; Reading Room, 87, 153–54, 156, *156, 157, 175,* 203; renovation of, 196; repairs to, 200–201; as research center, ix–x, 199–200, 203, 205; sculptures for, 149–50, 159–60; security for, 157, 170, 182, 183, 193, 199; site for, 139–40; stained-glass windows for, 154, 156, *158;* theater for, 150–51, *152,* 183. *See also* collection

Folger Theatre, 194, 198–99

Folger Theatre Group, 195, 197–98

folios: description of, 105; Fourth, 76, 82; Second, 76; Third, 76. *See also* First Folio

Forbes, W. Cameron, 184

foul papers, 84

Fourth Folio (1685), 76, 82

Franklin, Abiah Folger, 3

Franklin, Benjamin, 3, 27, 135

Franklin, Josiah, 3

Frick, Henry Clay, and Frick Collection, 2

Frost, Robert, 179

Fruit, Henry D., 170

Furness, Helen, 36

Furness, Horace Howard, 24, 31, 35, 36–37, 97, 177, 189

Furness, Horace Howard, Jr., 39–40

furniture: acquisitions of, 132–33; desk of HCF, 62–63, *63,* 162

Garatti, Joseph, 175, 179

gardens: Elizabethan, 201; of library, 150; Shakespearean, 40; in Stratford, 39

Garrick, David, 29, 37, 77–78, 81, 118, 188

Gazzola, Peter, 200

General Petroleum Company, 61

George V, 178

gifts: to Amherst College, 42, 93, 120; to Cadman, 92; of dimes by Rockefeller, 91, *92;* of duplicate volumes, 120; from HCF to EJF, 26; to Pratts, 90; to and from Robinson, 38–39

Gilded Age, 1–2

Glen Cove, New York: home in, x, 23, 111, 164, *165,* 180, 184; Nassau Country Club, 91; Pratt home in, 145; summer rental in, 66

Golden Lion Hotel, Stratford-upon-Avon, 38

Goldsmith, Oliver, 7

golf, *xiii,* 66, 91, *92*

Gott, John, quartos of, 93–94

Gould, Jay, 126, 129

Grant, Albert, 141

Grant's Row, Washington, D. C., 141–42, *142,* 159

Gray, Austin K., 172

Gray, Thomas, 37, 77

Greeley, Horace, 8

Greene, Belle da Costa, 118, 179

Greet, Philip, 178

Gregory, John, 149, 173, 175, 179

Griffith, Elizabeth, 26

Grolier Club, 128

Gundersheimer, Werner, 197

Gunther, Charles Frederick, 80

Gutenberg Bible: HCF and leaves from, 42, 93; Huntington and, 125

Gwynn, Edward, 85, 87, 134

Hallam, Henry, 29

Halliwell-Phillipps Shakespearean Rarities, 84–85, 87, 122

Hamilton Trust Company of Brooklyn, 72

Hamlet, 29, 33–34, 70, 76, 114, 123, 164, 183

Hamner, Thomas, 102

HAMNET, 200

Hapgood, George, 135

Harbeson, John, 149, 162

Hardison, Marifrancis, 195

Hardison, Osborne Bennett, Jr., 26, 195, 196

Harkness, Edward S., 169

Harmsworth, Leicester, collection of, *190,* 190–91

Harris, George, 40

Hartman-Cox Architects, 196

Harvard University, sale of White collection to, 89

Hawks, Rachel M., 150, 172

Hawthorne, Nathaniel, 37, 77

Hearst, William Randolph, 58–59

Heminge, John, 96, 148

Henry IV, Part 1, 29, 79, 119, 125

Henry IV, Part 2, 29, 62, 79

Henry Sotheran and Company, 83

Henry V, 29, 120, *155*

Henry VI, Part 1, 29

Henry VI, Part 2, 29, 84, *86*

Henry VI, Part 3, 29

Hester, William V., Jr., 107

Hinman, Charlton, 97–98

HMS Pinafore, 21–22

Hobby Club of New York, 128

Hogarth, William, armchair designed by, 78

homes of Folgers: in Brooklyn, 23, 66, *165*; in Glen Cove, x, 23, 66, 111, 164, *165,* 180, 184

Homestead in Hot Springs, Virginia, 25–26, 32, 37–38, 66, 85

Hoover, Herbert, 172, *177,* 177–78, 180–81

Hoover, Lou, *177,* 178, 180, 181

Horydczak, Theodor, 80–81, 183

Hotson, Leslie, 172

Hoving, Thomas, 82

Howell, John, 23–24

Huntington, Arabella, 129

Huntington, Henry E.: bindings and, 102; career of, 125; collections acquired by, 122, 131, 133–34; collection strategies of, 127–28, 129; death of, 137; dominance of in art and book markets, 125–26; Gainsborough painting and, 103–4, 125; HCF compared to, 126–30; lifestyle of, 129–30; Rosenbach and, 134–35, 137; Smith and, 110; *STC* and, 130–31; strategy of, 120; *Venus and Adonis* and, 108; wealth of, 179

Huntington Museum and Library, 124, 129, 133, 181–82

Huth, Robert and Alfred, collection of, *131,* 131–32

"idealism" of Shakespeare, 32–33

indictments on antitrust violations, 59–60

instruments, musical, 79, 180

investments, 66–69

Ireland, William-Henry, 80, 81

Irving, Henry, 37, 77

Irving Literary Circle of Brooklyn, 2, 3

Irwin, William Henry, 172

italic (Italian) manuscript hand, 79

Jaggard, William, 217n. 22

James, Henry, 1

James Baird Company, 158–59

Jameson, John Franklin, 13, 140

Jefferson, Thomas, ix, 27

John of Gaunt, panegyric of, 178

Johnson, Samuel, 37, 76, 148

Jones, Herschel V., 133

Jonson, Ben, 21, 78, 148; folio of "Workes," 106

Jordan, Augusta Woodbury Ricker, 14–15

Jordan, Edward W., 14, 22

Jordan, Elizabeth, 15, 16

Jordan, Emily Clara. *See* Folger, Emily Clara Jordan

Jordan, Francis, 15, 78

Jordan, Mary Augusta, 15, 16, 18, 179, 180, 184, 185

Julius Caesar, 29, 95, 105, 194

Kahn, Michael, 198

Kahrl, George M., 188

Kaplan, Fred, 33

Kean, Charles, 37, 118

Keats, John, 7, 149

Keller, Helen, 50

kerosene lighting, 43–44

King, Samuel Arthur, 183, 190

King, Stanley, 167, 168, 171–72, 175–76, 181

King John, 29, 52

King Lear, 27, 29, 132, 149–50, 191, 197

Kinsey, Alfred, 137

Kittridge, George Lyman, 183

La Follette, Robert, 61

Lamb, Charles, 29, 77, 115, 149

Lee, Sidney, 97, 99, 116

Lerch, Alice, 181

letters: to booksellers, 110–11, 113–15, 116–17, 136–37; from colleagues and friends about HCF, 63–64; from Cret to HCF, 159–60; to Folger prizewinners, 40; from Furness to EJF, 36; of Garrick, 188; from HCF to Huntington, 130; from HCF to Rockefeller, 87–88; from Homestead, 38; from Lewis, 188; from National Shakespeare Federation, 39; from Queen Elizabeth, 79; from Rockefeller to HCF, 47; from Rosenbach to HCF, 133, 134, 136; routine correspondence, 112

Lewis, B. Roland, 188

Library of Congress, ix, 9, 142–44, 188, 196. *See also* Putnam, Herbert

Library of Congress classification system, 189

Lincoln, Abraham, 14–15, 23, 29, 33, 77

Lindsay, Ronald, 178

Little, David M., 188

loans: from EJF, 169; from financial institutions, 70–72, 169; from Pratts, 45, 69–70, 100; from Standard Oil and Rockefeller, 72, *73*

Locke, Florence, 185

Longfellow, Henry Wadsworth, 3, 7

Longsworth, Charles, 197–98

Longworth, Clara, 187

Love's Labor (DVD), 202

Love's Labor's Lost, 29

love story, story of Folgers as, x, 26, 82

Luce, Robert, 143

Lucrece, 77, 88, 110

Macaulay, Thomas Babbington, 29

Macbeth, 23, 29, 76, 95, 105, 163

MacMonnies, Frederick, 149

Macy, Andrew, 4

Maggs Bros., 105, 109

Magnolia Petroleum Company: in antitrust case, 59–60; debt of, 57–58; HCF involvement with, 74; investment in, 65, 68–69; origins of, 57; purchase of HCF shares of, 73; Socony and, 61

Malone Society, 39

Mantell, Robert B., 77

manuscripts in collection, 79

Marlborough, Duke of, 1

Marlowe, Christopher, *Hero and Leander,* 135–36

Marlowe, Julia, 32, 34–35; Portia gown of, *174*

Matthison, Edith Wynne, 178, 180, 183

Mayer, Jean-Christophe, 98

Mayhew, A. H., 99

McClure, Samuel S., 51

McCreary, A. A., 140

McKnight, George W., 64

McManaway, James G., 187–88, 190

Measure for Measure, 29

Mellon, Andrew, 2, 135, 176–77

Mensel, Ernst Heinrich, 187

Merchant of Venice, The, 29, 32, 67, 76, 98, 113

Merry Wives of Windsor, The, 29

Midsummer Night's Dream, A, 29, 150, 159, 160, 200. *See also* Puck statue

Mill, John Stuart, 37

Milton, John, 7, 21, 152–53

Mitchell, Maria, 16–17
Modern Language Association of America, New Variorum Edition of Shakespeare series, 191
Moore, Charles, 162
Morgan, J. Pierpont, 97, 120, 129, 133, 179
Morrow, Dwight, 167, 170, 179, 201
Mossman, Walter, 86
Mowat, Barbara A., xiv, 199
Moynihan, Daniel Patrick, 198
Much Ado About Nothing, 29, 32, 106
Murphy, John J., 182
musical literature, 79

Nantucket, xi, 3–4, 7, 43, 139, 141, 209, 225
Nassau Institute, 19, 23
National Shakespeare Federation, 39
Navarro Refining Company, 56–57
negotiations/bidding strategy of HCF, 112–13, 115, 121
Neill, Herman Humphrey, 29
Neilson, William Allen, 172, 183
Newhouser, Charles W., *142*
New Place, mulberry tree pieces from, 81
Nickerson, Albert L., 62

oil marketing practices, congressional inquiries into, 61–62
Olive, Walter B., 140
Olmsted, Frederick Law, Sr., 40
oratorical prizes of HCF, 21
organ, 6, 92, 162
organizations in U.S. joined by Folgers, 39–40
Othello, 2, 29, 119, 121–22

paintings: in collection, 80; of Hathaway cottage, 38–39
Palmer, George H., 106
paper stock, 105
Paris, Standard Oil business trip to, 24
Parmelee, Alice Maury, 184–85
Parmelee, James T., 184
Partridge, Bernard, *Punch* cartoon by, *104*
Paster, Gail Kern, 200–201, 203
Paul, Henry N., 189
Pavier quartos, xii, 85–86, *86*
payment for merchandise, 112–13, 114–15
Payne, Calvin, 55, 56, 57

Payne, Roger, 102–3
Pease, Arthur Stanley, 178, 179, 204
Peckham, William Clark, 10, 11
PEN/Faulkner Award for Fiction, 197
Pericles, 29, *86,* 110, 127, 136
Perry, Marsden, 84, 112–13, 122, 133; collection of, 84–87, *86, 87,* 133–34
"Petroleum" (H. C. Folger), 49
Phelps, Samuel, 77
Phi Beta Kappa, 13, 16
Philalethean Society of Vassar College, 17–18
Philbrick, Nathaniel, 43
Pickering & Chatto, 116, 120
Pickford, Mary, 35
Pierce, Sarah, 15
Pigozzi, Carlo, 179
plagiarism of Shakespeare, 80
playbills, 81
plays, printed, 96
Plimpton, George A.: at Amherst, 21; as collector, 42, 111, 192; at dedication, 178; "Education before Printing, as Illustrated by Original Manuscripts," 128; "The Education of Shakespeare, Illustrated with Textbooks in Use in His Day," 183; HCF and, 167; Lee census and, 97
Pollard, Alfred W., 127, 130
Pratt, Charles, Jr.: Amherst and, 10, *12;* books given to, 90; career of, 45; on HCF, 52; Killenworth home of, 145; loan from, 100; as newlywed, *25;* on relationship between EJF and HCF, 24–25
Pratt, Charles, Sr., 2, 8, 44–45, 46, 50, 69–70
Pratt, George D., 100
Pratt, Herbert, 64, 91
Pratt, Lillie, 2, 3, 22
Pratt, Mary, *25,* 90, 180
Pratt Oil Works, 49
Prentiss, Brett, 194–95
Pressly, William L., 80
prompt books, 77
Prospect Park, Brooklyn, 40
provenance, importance of, 122–23
publicity, avoidance of, 122
Puck statue/fountain, 150, 157, 159, 172, 200
Putnam, Brenda, 150, 160, 171, 172, 179
Putnam, Herbert, 143–44, 150, 161–62, *163,* 172–73, 179, 187

Quaritch, Bernard, 88, 91, 100, 101, 102, 119, 132
Quaritch Ltd., London, 110–11. *See also* Dring, E. H.
quartos: Bartlett census of, 192; description of, 76; of Gott, 93–94; Pavier, xii, 85–86, *86*; printed in 1594, 84

Railton, Alexander B., 100
Ranney, Nancy D., 15
Reagan, Ronald, 197
Redgrave, Gilbert R., 130
reference materials, 81–82
relics, EJF on, 81
religion: of HCF, 22; theater and, 27
Representative Men (Emerson), 30
research institutions, 181–82
Reynolds, Joshua, 39, 78, 80
Richard II, 29, 88–89, 112
Richard III, 29, *86,* 134, 191
Richards, David, 198
Robinson, John, 38–39
Robinson, Renee, 39
Rockefeller, John D.: Archbold and, 59; committees and, 46; Halliwell-Phillipps collection and, 87–88; HCF and, xi, 50; on investment, 67; kerosene and, 44; loans from, 72, *73*; Magnolia Petroleum Company and, 58; management style of, 47–48; philanthropies of, 2; Pratt and, 45; on price paid for book, xii; public perception of, 126; reward of dimes by, 91, *92*; Tarbell on, 51–52; during trial, *53,* 53–54. *See also* Standard Oil Company
Rockefeller, John D., Jr., 176
Rogers, Edgar, 109–10
Rogers, Henry H., 46, 49, 50
Rohrer, George, 50
Romeo and Juliet, 27, 29, 34, 76, 187
Roosevelt, Theodore, 51
Rosenbach, A. S. W.: attempts to hook HCF on books, 123; books returned to, 117; Britwell-Court Library collection and, 88; clients of, 25–26, 124, 134–38; on collection, 78; dealings with, xii, 110, 111; death of, 137; First Folio of, 106; on handling collection, 116; on HCF, 135; HCF funeral and, 163; Huntington and, 130; letter to HCF from, 133; *London Mercury* and, 110; Perry collection and, 85–86, *86, 87,* 133–34; on purchases, 82; on relationship between HCF and EJF, 23; White collection and, 88–89, *90*
Ruxin, Paul, 202

Salisbury, Frank O., xii, 154, *155*
Sangorski, Alberto, 115
Schelling, Felix, 183
Scott, Raymond, 202
Scott, Walter, 37, 77
scrapbooks: of EJF, 16–19, 22; of HCF, 19–22
Second Folio (1632), copies of, 76
secretary (workaday) manuscript hand, 79
Sessler, Charles, 115, 118, 123
Shakespeare, William: autograph of, 22; birthday of, 171, 176; breadth of knowledge of, 31; bust and grave of, xii; EJF on HCF attraction to, 37; Folger views of writings of, 32–33; HCF essays on characters of, 20–21; HCF study of, 29–30, 33; plays of, in America, 27–28; son of, 200; theatrical interpretations of, 31–32. *See also* First Folio; *specific works*
Shakespeare Association of America, 196
Shakespeare authorship as category for collection, 78
Shakespeare Documents, The (Lewis), 188
Shakespeare Quarterly, 196
"Shakespeare's Heroines Triumphant" (Terry), 32, 185
Shakespeare Society of Philadelphia, 28
Shakespeare Theatre Company, 198
Shapiro, James, *Contested Will,* 78
Sharp, Thomas, 81
Sherman, William, 79
Sherman Antitrust Act, 49, 59
Short-Title Catalogue of Books Printed in England, Scotland, and Ireland (STC), 89, 130–31, 189, 202
signatures of Shakespeare, 80–81
singing, 11, 21–22, 92
Slade, William Adams, 76, 170, 171, 172, 176, 182
Smit, Josef, 180

Smith, George D., 108–9, 110, 114, 119, 131, 132–33
Smith, Owen Fithian, 7, 168
Smith, Sarah Jenkins, 181
Socony (Standard Oil Company of New York), 55, 57, 58, 61, 62, 68–69, 73
Socony-Vacuum Oil Company, 194
"Solutions" (Emerson), 30
Sonnets, quarto edition of, 133
Sonnets and Poems (1926), 115–16
Sotheby's, London, 108, 131–32
Sotheran, Henry, 83, 84, 99, 100
Sothern, Hugh, 33, 34
source books, 76
Southey, Robert, 37
Sowerby, E. Millicent, 123
Spencer, Hazelton, 191
Sprague, Homer Baxter, 8–9, 28
SS *H. C. Folger,* 44, 64
SS *Minnehaha,* 38
Stad, Ben, Flora, and Maurice, 180
Standard Oil Company: cipher code of, 54, *54*; collection in safe at, 164; disaffiliation of, 54–55; executive committee, 50; Folger brothers at, 6; Folger wealth and, 65; founding of, 44; HCF career at, xi, 46–47, 48–50, 51, 52–54, *53, 60*; HCF salary from, 66; headquarters building of, 145; investment in, 67–68; loans from, 72; manufacturing committee, 46–48, 49; petroleum and, 44; signed shares of, 22; Tarbell attacks on, 51–52; Texas and, 55–58, 60
Standard Oil Company of New Jersey, 49–50, 52–54, 68
Standard Oil Company of New York (Socony), 55, 57, 58, 61, 62, 68–69, 73
Standard Oil Trust, 47, 49
Stanton, Elizabeth Cady, 18
STC (Short-Title Catalogue of Books Printed in England, Scotland, and Ireland), 89, 130–31, 189, 202
Stevenson, Andrew K., 200
Stone, George Winchester, Jr., 188
Stone, Harlan Fiske, 167, 190, 192
Stowe, Calvin, 22
Stowe, Harriet Beecher, 22
Stratford-upon-Avon: as library site, 139;

Shakespeare Club, 39; Shakespeare Memorial Theatre, 176; trips to, xii, 38
Strunk, Oliver, 187
Swift, Mrs. L. M., 111

Taft, William Howard, 99
Taine, Hippolyte, 28
Taming of the Shrew, The, 29, 35, 199
Tarbell, Ida Minerva, 51
Taylor, Stephen Gale, 7
Teagle, Walter C., 59, 60, 64
Tempest, The, 27, 29, 38, 95, 115
Tennyson, Alfred Lord, 3, 7, 21, 77
Terry, Ellen, 31–32, 185
Texas and Standard Oil, 55–58, 60
Thackeray, William, 37, 77
theatrical criticisms, EJF diary of, 34–35, 37
theatrical interpretations of Shakespeare, 31–32
thefts from library, 199, 202
Third Folio (1664), copies of, 76
Timon of Athens, 29
Titus Andronicus, 29, 84, 89, 119, 127, 162, 183, 191
Tocqueville, Alexis de, 1
Transcendentalist thought, 30–31
Troilus and Cressida, 29
Trollope, Anthony, 1–2
Trollope, Frances, 1
Trowbridge, Alexander B.: Baird Company and, 158; as consulting architect, 145–46, 147–48, 159, 160–61, 162; on death of HCF, 163, 164; at dedication, 179; on HCF, 149
"True Text of Shakespeare, The" (EJF thesis), 36
Twelfth Night, 29, 34, 194
Two Gentlemen of Verona, The, 29
Tyler, William S., III, 169–70, 182

United States Fine Arts Commission, 162
United States Trucking Corporation, 171

Vassar, Matthew, 15
Vassar College, 15–19, 35, 36, 185
Vaughan, Virginia and Alden, 27
Venus and Adonis, auction of, *86,* 108–9

Warwick Castle Shakespeare Collection, 83, 99–100

Washington, George, 27, 77, 176
Waters-Pierce Oil Company, 55, 59
Weedon, John C., 140, 142, 159
Wells, Enoch Harden, 6
Wells, Gabriel, 103, 105–6
Wells, Mary Folger, 6
Welsh, Alexander G., 74, 111–12, 129, 163, 168
Werner Gundersheimer Conservation Laboratory, 202
Werstine, Paul, xiv, 105, 199
West, Anthony James, 95, 105, 106
whaling trade, 43
Wharton, Edith, 1
Whicher, George, 179
White, William A., *90,* 110, 136; collection of, 88–89, 112, 121–22
Whitman, Walt, 37, 77
Wickersham, George, 60
Widener, Harry, 132
Widener, Joseph, 133
Wilkins, Henry B., 187

Willard, Emma, 15
Williams, Karen Hastie, 202
will of HCF, 26, 166
Willoughby, Edwin, 189, 190
Wilson, Elkin C., 189
Wilson, Mrs. Woodrow, 179
Wilson, W. J., 188
Winter, William, 34
Winter's Tale, The, 29, 76, 121
Witmore, Michael, 203, 204–5
World War I, 44, 118
World War II, 193
Wright, Christopher, xiii
Wright, J. O., 114–15, 121
Wright, Louis B., xiii, 62, 189, 193–94
Wyatt, Greg, 201
Wyatt R. and Susan N. Haskell Center for Education and Public Programs, 200

Ypsilanti Singers, 183

About the Author

Stephen H. Grant attended Noble & Greenough School, graduated from Amherst College, and earned his doctorate in Education from the University of Massachusetts. He earned a Middlebury College master's degree in French at the Sorbonne in Paris and taught as a Peace Corps Volunteer in Ivory Coast, West Africa. He was a career Foreign Service officer with the U.S. Agency for International Development holding long-term assignments in Ivory Coast, Guinea, Egypt, Indonesia, and El Salvador. Grant serves as Senior Fellow at the Association for Diplomatic Studies and Training in Arlington, Virginia, where he helps retired diplomats prepare their manuscripts for publication. He is the author of *Peter Strickland: New London Shipmaster, Boston Merchant, First Consul to Senegal*. His website is www.stephenhgrant.com.